NEW RHYMING DICTIONARY

AND

POETS' HANDBOOK

NEW RHYMING DICTIONARY

AND

POETS' HANDBOOK

By

Burges Johnson, Litt. D.

Author of "Essaying an Essay"; "As I Was Saying";
"Campus vs. Classroom"; "Sonnets from the Pekinese";
"The Lost Art of Profanity," etc.

REVISED EDITION

HarperPerennial
A Division of HarperCollinsPublishers

First HarperPerennial edition published 1991

Library of Congress catalog card number: 57-9585

ISBN 0-06-272014-7 (pbk)
96 97 98 99 RRD 10 9

ACKNOWLEDGMENTS

Lines illustrating the various meters and stanzas, and a number of poems illustrating lyric forms are quoted in this book. The compiler wishes to express grateful acknowledgment to authors or publishers who have allowed the use of copyright material in this way. Following is a list of those who have given such consent:

AUTHOR	LINES FROM	PUBLISHER
William V. Moody	Of Wounds and Sore Defeat	Houghton Mifflin Company
Olive Kilmer	After Grieving	Doubleday, Doran & Company
Sara Teasdale	Spring Night	The Macmillan Company
Austin Dobson	In After Days	Alban Dobson and the Oxford University Press
" "	When I saw you last, Rose	" " "
" "	A Ballad to Queen Elizabeth of the Spanish Armada	" " "
" "	A Ballad of Prose and Rhyme	" " "
" "	On a Nankin Plate	" " "
" "	Rose-Leaves	" " "
" "	In Town	" " "
" "	For a Copy of Theocritus	" " "
" "	"More Poets Yet"	" " "
David Morton	Who Walks with Beauty	G. P. Putnam's Sons
Siegfried Sassoon	Absolution	E. P. Dutton & Co., Inc.
Robert Bridges	And beautiful must be the mountains whence ye come	Oxford University Press
Charles Hanson Towne	The Best Road of All	Doubleday, Doran & Company
Henry Herbert Knibbs	The Sun Worshippers	Houghton Mifflin Company
Florence W. Evans	The Flower Factory	Florence W. Evans
Angela Morgan	Resurrection	Dodd, Mead and Company
Dorothy Parker	Razors pain you	Horace Liveright
Thomas Bailey Aldrich	I would be the lyric	Houghton Mifflin Company
Bret Harte	Plain Language from Truthful James	Houghton Mifflin Company
Thomas Augustine Daly	Wid her basket of apples come Nora McHugh	Harcourt, Brace and Company
" " "	Still we'll be sp'ilin' you	David McKay
D. H. Lawrence	The dawn was apple green	B. W. Huebsch & Co.
" " "	She opened her eyes	" " " " "
Louis Untermeyer	What are those ravens doing in our trees	Harcourt, Brace and Company
Edna St. Vincent Millay	Lethe	Harper & Brothers

AUTHOR	LINES FROM	PUBLISHER
Emily Dickinson	I'll tell you how the sun rose	Little, Brown and Company
" "	To Make a Prairie	" " " "
Alice Meynell	A Dead Harvest	John Lane & Company
Max Michelson	A Hymn to Night	Poetry Magazine
John Gould Fletcher	The Swan	The Macmillan Company
Herman Hagedorn	Broadway	" " "
Harriet Munroe	On the Porch	" " "
Frances Shaw	The Harp of the Wind	Poetry Magazine
Walter Conrad Arensberg	Song of Souls Set Free	Houghton Mifflin Company
Gelett Burgess	There is nothing in afternoon tea	Frederick A. Stokes Company
" "	Chant-Royal of the True Romance	Small, Maynard & Co.
" "	A Daughter of the North	" " "
" "	Rondel of Perfect Friendship	" " "
" "	Sestina of Youth and Old Age	" " "
R. W. Gilder	What is a sonnet?	Century Company
H. C. Bunner	Ready for the Ride	Privately printed
Samuel Minturn Peck	Under the Rose	Frederick A. Stokes Company
Wilfred Wilson Gibson	He's Gone	Macmillan, Ltd.
Don Marquis	The Triolet	Doubleday, Doran & Company
James Branch Cabell	The Conqueror Passes	Robert M. McBride & Company
" " "	Villon Quits France	" " "
Brander Matthews	Les Morts Vout Vite	Privately printed
Arthur Guiterman	Betel Nuts	E. P. Dutton & Co.
James Whitcomb Riley	When the Frost is on the Punkin	Bobbs-Merrill Co.
Frank D. Sherman	Dear Priscilla	Houghton Mifflin Company
Robert Frost	The Tuft of Flowers	Henry Holt & Co.
Jean Starr Untermeyer	The lapping of lake water	B. W. Huebsch
Eugene Field	Seein' things	Chas. Scribner's Sons
Guy Wetmore Carryl	How Jack Found	Harper & Bros.
Charlotte P. S. Gilman	I thought that life	Small Maynard & Co.
Burges Johnson	Alak the Yak	Harper & Bros.
" "	Find first thy meter	" " "
" "	Little things that count	E. P. Dutton & Co.
Sidney Lanier	Marshes of Glynn	Chas. Scribner's Sons
Ogden Nash	"Tomorrow, Partly Cloudy"	Little, Brown & Company
Vachel Lindsay	The Congo	The Macmillan Company

Contents

Introduction

Prose is the language of reason; poetry the language of feeling, the verbal expression of emotional experience. Music is mankind's purest means of expressing emotion, so when he seeks to communicate his message he borrows musical devices such as rhythm, and harmony of word sound, and gives to his words emotional or "poetic" meanings.

Consciousness of rhythm must carry back to the infancy of the human race. The primitive human was conscious of the rhythmic beating of his own heart, and aware that it was affected by external rhythms and was speeded or retarded by hope or fear or joy or anger. Just as children of today, recalling the childhood of our race, will run beside the bass drum in a street parade, feeling their own hearts throbbing in response to its rhythm, so primitive man believed his tom-tom would bring hope to the sick or incite a tribe to war.

Rhyme and rhythm in poetry are two forms of the same thing. Rhythm is the regular beat of accent in successive lines of verse; rhyme is the echoing beat of sound, occurring at regular intervals, according to a pattern. Poetic words are those which when grouped together harmonize in sound; and they are words which have an emotional rather than a literal interpretation. The poet writes that he saw an army of birch trees in their white uniforms marching up a hillside, guarded by a stately sentinel pine. We know there is no army, and no uniforms, and no marching, and no guarding and no sentinel; yet the poet has described the scene more clearly than if he had used prosaically truthful words.

This is a dictionary which brings words together in groups because they "rhyme," and for no other reason. No group can be complete for various reasons: new words are constantly being invented; a local dialect may destroy commonly accepted rhymes or create new ones. Inventive rhymesters may put two or three one-syllable words together so that they rhyme with one word having two or three syllables. (More about that on page 464.)

The greatest value in such a dictionary lies in the fact that it serves as a stimulant to the eager versifier, "activating" all the vocabulary he already possesses, and causing him to accumulate more.

Thought is inner speech. All human thinking is done by the inward use of coined words; so the richer a man's active vocabulary the wider are the range and the effectiveness of his thinking, whether expressed in prose or poetry.

BURGES JOHNSON

POETS' HANDBOOK

Forms of English Versification

RHYTHM

Even rhythm by itself, without words, is an effective means of emotional appeal, as is proved by the chanting of primitive tribes when meaningless sounds make varying impressions because of their effect upon the pulse-beat of their hearers.

It is natural for poets to seek new rhythms in order to gain new emotional effects, but an abandonment of all rhythm is an abandonment of poetry.

Poetic art as practiced by the ancients developed certain rigid rhythmic patterns based upon *quantity* and *accent*, but took no account of *rhyming*, as we understand it. Quantity, as the name implies, meant the length of time to be allowed for the pronunciation of a syllable. Poetic feet in classic verse were made up of two or three syllables, some long and some short, in various arrangements. Whether or not a syllable was long or short depended upon certain vowel and consonant combinations.

QUANTITY

Modern English *rules* of verse consider only accent, but the old quantitative classic names have been transferred to our modern English meter. Quantity, however, still exists as an element in English verse. Syllables are still slow-spoken or quick-spoken, according to the way they are spelled. But nothing would be gained by the user of this handbook if more space were devoted to quantity. The English verse-writer must feel instinctively whether or not his metrical line "sings" well; and it will not sing well if too many of the syllables in

the line are long in quantity. Even though there be the right number and they are properly accented, the line will nevertheless seem overcrowded (witness the difference between "The cat that watched" and "The splendor falls"). An ambitious student may find a discussion of classic "prosidy" in any good Latin textbook or in any technical study of poetry.

FEET

In English verse, where accuracy of rhythm depends upon recurrent accents alone, an accented syllable accompanied by one or two unaccented syllables is known as a *foot*; and a definite pattern composed of feet in a fixed and recurrent arrangement is known as *meter*.

The practical verse-writer may wish to go a little further in technical knowledge and learn the ancient names of the four different feet generally used in English verse, and the three others used less frequently. They can be most simply presented in a diagram.

Name of Foot	Accents	Name of Meter
Iambus	◡ —	Iambic
Trochee	— ◡	Trochaic
Anapest	◡ ◡ —	Anapestic
Dactyl	— ◡ ◡	Dactylic
Feet used only occasionally in a line		
Spondee	— —	
Pyrrhic	◡ ◡	
Amphibrach	◡ — ◡	

The word verse *originally meant and still means a single metric line divided into feet. As commonly used it has come to mean metric composition as distinguished from prose; and more loosely still, it has come to mean the lighter forms of poetry in stanza form.*

METERS

Poetic lines, or verses, are classified according to the number of feet in a line. A verse, for instance, containing only a single foot is monometer, two feet dimeter, and so on up to the eight-foot line— trimeter, tetrameter, pentameter, hexameter, heptameter and octameter. The number of feet in a line of English verse rarely exceeds eight; but it is possible for verses to contain more.

The best known and most used foot in English verse is the **iambus**. Single words illustrating a foot of the iambic meter are

undue, excite, retard, indeed, etc.

Iambic monometer (‿ ‒) is verse which presents the iambus in a one-foot line. There are few generally known poems written entirely in iambic monometer. Usually, when written, they are mere exercises of verbal trickery. But here is a serious example.

<div align="center">

Thus Ĭ Ī
Pass by,
And die:
As one
Unknown
And gone.
I'm made
A shade
And laid
I'th' grave:
There have
My cave
Where tell
I dwell
Farewell.
</div>

<div align="right">

—*Upon His Departure Hence*, ROBERT HERRICK
</div>

Iambic monometer is more often used in refrain lines which belong to poems of other meters:

<div align="center">

'Mid pathless deserts I groan and grieve;
In weariest solitudes I leave
 My track;
Bemoaning the fate that has christened me,
In spite of my whiskered dignity,
 A Yak!

O happy child with the epithet
Of Abe or Ike or Eliphalet,
 Or Jack,
You little wot of the blush of shame
That dyes my cheek when I hear the name
 Of Yak!
</div>

<div align="right">

—*Alack the Yak*, BURGES JOHNSON
</div>

Iambic dimeter (⏑ – | ⏑ –) verse is two iambic feet long.
Examples are:

Gĭve āll | tŏ lōve
Obey thy heart.

—R. W. EMERSON

Whŏ lōves | thĕ rāin
And loves his home
And looks on life
With quiet eyes . . .

—FRANCES SHAW

Jĭm wās | mў chūm
Up on the bar:
That's why I come
Down from up yar,
Lookin' for Jim.
Thank ye, sir! YOU
Ain't of that crew,—
Blest if you are!

—*Jim,* BRET HARTE

Iambic trimeter (⏑ – | ⏑ – | ⏑ –) verse contains three iambic feet:

Sŏ fāre | wĕll Ēng | lănd ōld |
If evil times ensue,
Let good men come to us,
We'll welcome them to New.

—From *The Simple Cobbler of Aggawam*
NATHANIEL WARD

Yŏu cāll | mў tāle | "Rŏmānce,"
And still the thing may be.
The Jungle Peacocks dance,
Though none is there to see.

—*Betel Nuts,* ARTHUR GUITERMAN

Sŏ mūch | ŏne mān | căn dō,
That does both act and know.

—ANDREW MARVELL

Ŏf wounds | ănd sōre | dĕfēat
I made my battle stay
Winged sandals for my feet
I wove of my delay.
—*Of Wounds of Sore Defeat*, WILLIAM V. MOODY

Iambic tetrameter (⌣ – | ⌣ – | ⌣ – | ⌣ –) is four iambic feet long. It is more popular and more generally used than the former meters. Examples are:

Whĕn Ī | wăs yōung, | Ĭ wās | sŏ sād,
I was so sad! I did not know
Why any living thing was glad
When one must some day sorrow so.
—*After Grieving*, OLIVE KILMER

Thĕ pārk | ĭs fīlled | wĭth nīght | ănd fōg,
The veils are drawn about the world,
The drowsy lights along the path
Are dim and pearled. . . .
—*Spring Night*, SARA TEASDALE

Whăt īs | thĭs līfe, | ĭf fūll | ŏf cāre
We have no time to stand and stare?
—*Leisure*, W. H. DAVIES

Iambic tetrameter is particularly adapted to the themes and styles of the French verse forms. Ballades, triolets, rondeaus, and so forth, usually are written in this light meter. A typical and well-known example of French form in iambic tetrameter is the rondeau by Dobson:

IN AFTER DAYS

In after days when grasses high
O'ertop the stone where I shall lie,
 Though ill or well the world adjust
 My slender claim to honored dust,
I shall not question or reply.

I shall not see the morning sky;
I shall not hear the night-winds' sigh;
 I shall be mute, as all men must
 In after days!

> But, yet, now living, fain were I
> That some one then should testify,
> Saying—"He held his pen in trust
> To Art, not serving shame or lust."
> Will none?—Then let my memory die
> In after days!

Iambic pentameter (˘ – | ˘ – | ˘ – | ˘ – | ˘ –) verse contains five iambic feet. Probably more English poetry is written in this meter than in any other. The sonnet form is usually written in this measure. Examples of the meter are:

> Who walks | with beau | ty has | no need | of fear.
> The sun and moon and stars keep pace with him.
> —*Who Walks With Beauty*, DAVID MORTON

> The an | guish of | the earth | absolves | our eyes
> 'Til beauty shines in all that we can see.
> —*Absolution*, SIEGFRIED SASSOON

> I lived | with vi | sions for | my com | pany
> Instead of men and women, years ago. . . .
> —MRS. BROWNING

> The learned | reflect | on what | before | they knew:
> Careless of censure, nor too fond of fame;
> Still pleased to praise, yet not afraid to blame,
> Averse alike to flatter or offend,
> Not free from faults, nor yet too vain to mend.
> —*Criticism*, POPE

> My Rom | ney! Lift | ing up | my hand | in his
> As wheeled by seeing spirits toward the east,
> He turned instinctively, where faint and far,
> Along the tingling desert of the sky
> Beyond the circle of the conscious hills,
> Were laid in jasper-stone as clear as glass
> The first foundations of that new, near day,
> Which should be builded out of Heaven and God.
> —MRS. BROWNING

Iambic hexameter (˘ – | ˘ – | ˘ – | ˘ – | ˘ – | ˘ –) contains six

iambic feet. This measure is difficult to handle. Usually only occasional lines are found throughout a poem, in order to vary the meter. Examples are:

And beau | tiful | must be | the moun | tains whence | ye come.

—ROBERT BRIDGES

We search out dead men's words and works . . .

And spend | our wit | to name | what most | employ | unnamed.

—MATTHEW ARNOLD

. . . let the ocean dash
In fiercest tumult on the rocking shore!

Destroy | this life | or let | earth's fa | bric be | no more.

—*Despair*, SHELLEY

Will sleep at midnight o'er the wildered wave.

Wilt thou | our low | ly beds | with tears | of pi | ty love?

—*Fragment*, SHELLEY

Iambic heptameter (˘ – | ˘ – | ˘ – | ˘ – | ˘ – | ˘ – | ˘ –) contains seven iambic feet. Examples:

I like | a road | that wan | ders straight; | the King's | highway | is fair,
And lovely are the sheltered lanes that take you here and there;
But best of all, I love a road that leads to God knows where.

—*The Best Road of All*, CHARLES HANSON TOWNE

I think | he loved | the spring: | not that | he cared | for flowers— | most men
Think such things foolishment—but we were first acquainted then.

—*The Quaker Widow*, BAYARD TAYLOR

The husk | y, rust | y rus | sel of | the tos | sels of | the corn,
And the raspin' of the tangled leaves as golden as the morn;
The stubble in the furries—kindo' lonesome-like, but still
A-preachin' sermons to us of the barns they growed to fill;
The strawstack in the medder, and the reaper in the shed;
The hosses in theyr stalls below—the clover overhead!—
O, it sets my hart a-clickin' like the tickin' of a clock,
When the frost is on the punkin and the fodder's in the shock.

—*When the Frost Is on the Punkin*, JAMES WHITCOMB RILEY

Iambic octameter (˘ – | ˘ – | ˘ – | ˘ – | ˘ – | ˘ – | ˘ – | ˘ –) con-
tains eight iambic feet in each line. Examples:

My lips | would sing | a song | for you, | a soul | ful lit | tle song |
for you

<div style="text-align:right">—EDMUND LEAMY</div>

The trail | is high | whereon | we ride, | with all | the world | below |
to see
The cleft of canyon, sweep of range and winter-white of lonely peak;
Lean foothold on the mountain-side, and on, beyond the Mystery
The unattained, the hidden land we may not find, but ever seek.

<div style="text-align:right">—*The Sun Worshippers*, HENRY HERBERT KNIBBS</div>

Trochaic.—The trochaic foot contains two syllables. The first is
long or stressed; the second short or unstressed. Single words illustrat-
ing it are armor, helmet, useful, missile, letter. Because of the light-
ness of the rhythm which the trochaic meter affects, it is often called
the Tripping Measure. It is difficult to find perfect examples of most
of the trochaic meters, because the rhythm lends itself so readily to
variation. Often hypermetrical verse results from the addition of un-
accented syllables to the line. Example:

Tiny | Fea | mitta | nodding | when the | twilight | slips in, | grey

<div style="text-align:right">—*The Flower Factory*, FLORENCE W. EVANS</div>

Often unaccented syllables are introduced at the beginning of lines,
and the resultant verse is called *anacrusis*. Example:

So! | Mid the | splendor | of e | ternal | spaces!

<div style="text-align:right">—*Resurrection*, ANGELA MORGAN</div>

Besides these, truncated lines are often used; that is, lines from which
the last unaccented syllables in the final feet have been dropped.
Example:

Wept for | me, for | thee, for | all.
When he was an infant smail.

Trochaic monometer (– ˘) combines the one-foot line and the
trochee. A complete poem in trochaic monometer is, usually, a
rhythmic exercise. A complete poem in four syllables by Strickland

Gillilan, called "Lines on the Antiquity of the Microbe," illustrates this meter:

Ā́dăm
Had 'em.

Trochaic dimeter (– ◡ | – ◡) contains lines which are two trochaic feet in length.

The first, third, fifth, and seventh lines of the following poem are trochaic dimeter; the remaining lines are various metrical lengths:

Rā́zŏrs | pāin yŏu;
Rivers are damp;
Acids stain you;
And drugs cause cramp.
Guns aren't lawful;
Nooses give;
Gas smells awful;
You might as well live.

—Dorothy Parker

Here is an example of truncated trochaic dimeter from which the last unaccented syllable in the second foot has been dropped:

Welcome, Maids of Honor,
Yōu dŏ | brīng
Īn thĕ | sprīng
And wait upon her.

—*To Violets*, Robert Herrick

Trochaic trimeter (– ◡ | – ◡ | – ◡) is three trochaic feet in length:

Ī wŏuld | bē thĕ | Lȳrĭc
Ever on the lip
Rather than the Epic
Memory lets slip.

—Thomas Bailey Aldrich

Trochaic tetrameter (– ◡ | – ◡ | – ◡ | – ◡) contains four trochaic feet in one line. Of all the trochaic meters, the tetrameter seems to

lend itself most easily to expression. Longfellow's "Hiawatha" is a well-known example of the rhythm involved:

> Should you | ask me, | Whence these | stories?
> Whence these legends and traditions,
> With the odors of the forest,
> With the dew and damp of meadows,
> With the curling smoke of wigwams,
> With the rushing of great rivers,
> With their frequent repetitions
> And their wild reverberations
> As to thunder in the mountain?

While Longfellow thus carries the trochaic meter perfectly through a whole poem, poets more generally omit the last unaccented syllable from some or all lines. This practice lends a variety which relieves the insistent monotony of the flawless trochaic line. Examples:

> Carol, | every | violet | has
> Heaven for a looking-glass!
> Every little valley lies
> Under many-clouded skies;
> Every little cottage stands
> Girt about with boundless lands.

> Dear Pris | cilla, | quaint and | very
> Like a | modern | Puri | tan,
> Is a modest literary
> Merry young American.
> —FRANK D. SHERMAN

Trochaic pentameter (– ˘ | – ˘ | – ˘ | – ˘ | – ˘) contains five trochaic feet in each line. Example:

> When the | sunlight | through a | mountain | crevise
> Sends long rays aslant across the desert.

Matthew Arnold's, "Self Dependence" contains some trochaic pentameter lines:

> Weary | of my | self and | sick of | asking
> What I am and what I ought to be.

Trochaic hexameter (– ◡ | – ◡ | – ◡ | – ◡ | – ◡ | – ◡) contains six trochaic feet in each line.

It is almost impossible to find lines in perfect trochaic hexameter. The six-foot length is unusual in the easier iambic line; it is more unusual in the trochaic.

> ˉ ˘ ˉ ˘ ˉ ˘ ˉ ˘ ˉ ˘ ˉ ˘
> Then we | wandered | after | snowfall | in the | darkness,
> Blithe and free,
> But our footprints left a record, that the others
> Laughed to see.

<div align="right">—L. K. K.</div>

The first and third lines of "Epilogue to Asolando" are trochaic hexameter:

> ˉ ˘ ˉ ˘ ˉ ˘ ˉ ˘ ˉ ˘ ˉ ˘
> At the | midnight | in the | silence | of the | sleep time
> When you set your fancies free

Trochaic heptameter (– ◡ | – ◡ | – ◡ | – ◡ | – ◡ | – ◡ | – ◡) contains seven trochaic feet in each line. Example:

> ˉ ˘ ˉ ˘ ˉ ˘ ˉ ˘ ˉ ˘ ˉ ˘ ˉ ˘
> Stepping | lightly | in their | dancing, | horses | forelegs | skitter |
> Down the driveway, faint staccato as the pebbles pitter
> Like a fall of iron raindrops; and the wind-stopped laughter
> Of the riders send a tinkling alto floating after.

Trochaic octometer (– ◡ | – ◡ | – ◡ | – ◡ | – ◡ | – ◡ | – ◡ | – ◡) contains eight trochaic feet.

Poe's "Raven" exemplifies the meter. The first and third lines of each stanza are good examples of flawless trochaic octameter. The unaccented syllables of the final foot in each of the remaining lines have been dropped:

> ˉ ˘ ˉ ˘ ˉ ˘ ˉ ˘ ˉ ˘ ˉ ˘ ˉ ˘
> Once up | on a | midnight | dreary, | while I | pondered, | weak and |
> ˉ ˘
> weary,
> Over many a quaint and curious volume of forgotten lore
> While I nodded, nearly napping, suddenly there came a tapping
> As of some one gently rapping, rapping at my chamber door.
> ''Tis some visitor,' I muttered, 'tapping at my chamber door,
> Only this and nothing more.'

"Grandmother's Story of Bunker Hill Battle" by Oliver Wendell Holmes is trochaic octometer.

'Tis like | stirring | living | embers | when, at | eighty, one re | members
 All the achings and the quakings of "the times that tried men's souls,"
When I talk of Whig and Tory, when I tell the Rebel story,
 To you the words are ashes, but to me they're burning coals.

There's a | woman | like a | dewdrop, | she's so | purer | than the | purest;
And her noble heart's the noblest, yes, and her sure faith's the surest;
 —*There's a Woman Like a Dewdrop*, ROBERT BROWNING

I could | hear their | voices | calling | like an | echo | 'cross the | water

 Lakeside, A. E. BURNHAM

The following lines are all truncated:

Then to | side with | Truth is | noble | when we | share her | wretched | crust,
Ere her cause bring fame and profit, and 'tis prosperous to be just;
Then it is the brave man chooses, while the coward stands aside,
Doubting in his abject spirit, till his Lord is crucified.
 —*Present Crisis*, JAMES RUSSELL LOWELL

Anapestic.—The anapestic foot ($\smile \smile -$) contains three syllables, the first two short and unstressed, the third long and stressed. This trisyllable is difficult to handle and it has not been used as considerably in perfect anapestic lines as the disyllabic foot has been used. The anapest is usually inserted in various other measures for the sake of variance and to relieve monotony. Words and phrases illustrating the meter are:

 chiffonier, devotee, luncheonette, violin, to devote, to erase.

The anapestic form in English becomes stilted and artificial because English inflections do not coincide with the form. The effect, however, is musical and some poets have made the form their favorite medium of expression.

Exceptions to the rhythm are usual, and it is rarely that a complete perfect anapestic couplet is found.

Anapestic monometer (˘ ˘ ‾) contains one anapestic foot in each line: several lines in this stanza illustrate:

> ˘ ˘ ‾
> In and out
> And round about,
> Here you go,
> There you go!
> Tinkle, tinkle,
> Periwinkle!
> Here and there,
> Everywhere,
> Floats the music on the air.
> —*Periwinkle,* JULIA C. R. DORR

Often an anapestic foot makes an interesting refrain or a short recurrent line in a poem of a longer and different meter. Oliver Wendell Holmes used the foot effectively in "The Last Leaf":

> I know it is a sin
> For me to sit and grin
> ˘ ˘ ‾
> At him here;
> But the old three-cornered hat,
> And his breeches, and all that,
> ˘ ˘ ‾
> Are so queer!
>
> And if I should live to be
> The last leaf upon the tree
> ˘ ˘ ‾
> In the spring,
> Let them smile as I do now,
> At the old forsaken bough
> ˘ ˘ ‾
> Where I cling.

Anapestic dimeter (˘ ˘ ‾ | ˘ ˘ ‾) contains two anapestic feet in one line. An example of the meter is contained in the first four lines in each stanza of Bret Harte's "Plain Language from Truthful James":

> ˘ ˘ ‾ ˘ ˘ ‾
> Which I wish | to remark,
> And my language is plain,
> That for ways that are dark
> And for tricks that are vain,

> The heathen Chinee is peculiar,
>> Which the same I would rise to explain: . . .
>>

> In his sleeves, which were long,
>> He had twenty-four packs—
> Which was coming it strong,
>> Yet I state but the facts;
> And we found on his nails, which were taper,
>> What is frequent in tapers,—that's wax.

> $\smile \quad \smile \quad - \quad \smile \quad \smile \quad -$
> When I saw | you last, Rose,
>> You were only so high;—
> How fast the time goes!

> Like a bud ere it blows,
>> You just peeped at the sky,
> When I saw you last, Rose!
>> —Austin Dobson

Anapestic trimeter ($\smile \smile - | \smile \smile - | \smile \smile -$) contains three anapestic feet in a line:

> Hear the drops | on the back | of the roof
> As the house crouches low in its pain,
> As it sprawls in the clutches of wind,—
> Under flickering whips of the rain.

Anapestic tetrameter ($\smile \smile - | \smile \smile - | \smile \smile - | \smile \smile -$) contains four anapestic feet in each line. Browning's, "How We Carried the News From Ghent to Aix" is an example. Note the galloping rhythm the anapestic meter lends to that, and to Bonny Dundee.

> $\smile \quad \smile \quad - \quad \smile \quad \smile \quad - \quad \smile \quad \smile \quad - \quad \smile \quad \smile \quad -$
> To the Lords | of Conven | tion 'twas Clav | er'se who spoke,
> "Ere the King's crown shall fall there are crowns to be broke;
> So let each Cavalier who loves honor and me,
> Come follow the bonnet of Bonny Dundee.
>> —*Bonny Dundee*, Sir Walter Scott

There comes Em | erson first, | whose rich words, | every one,
Are like gold nails in temples to hang trophies on,
Whose prose is grand verse, while his verse, the Lord knows,
Is some of it pro—no, 'tis not even prose;
I'm speaking of meters; some poems have welled
From those rare depths of soul that have ne'er been excelled;
They're not epics, but that doesn't matter a pin.
In creating, the only hard thing's to begin.

<div style="text-align:right">—A Fable for Critics, JAMES RUSSELL LOWELL</div>

Wid her bas | ket of ap | ples comes No | ra McHugh
Wid her candies an' cakes an' wan thing an' another,
But the best thing she brings to commind her to you
Is the smile in her eyes that no throuble can smother.

<div style="text-align:right">—THOMAS AUGUSTINE DALY</div>

Anapestic pentameter (˘ ˘ – | ˘ ˘ – | ˘ ˘ – | ˘ ˘ – | ˘ ˘ –) contains five anapestic feet in each line. The trisyllabic foot in the pentameter measure gives fifteen syllables to each line. It is a number not easily used in English poetry:

For a mere, | measly snake | in a cy | press our fa | thers went
wrong.
It was Adam and Eve in vast Eden who met the first fake,
O Satan-sent serpent whose leaf-lurking wiles were so strong
For a mere measly snake.

Because of the artificial rhythm which results from the use of the perfect anapestic pentameter, poets have generally introduced other feet to vary the meter. A well-known example is from one of Swinburne's roundels:

That the heart | of the hear | er may smile | if to pleas | ure his ear
A roundel is wrought.

Anapestic hexameter (˘ ˘ – | ˘ ˘ – | ˘ ˘ – | ˘ ˘ – | ˘ ˘ – | ˘ ˘ –) contains six anapestic feet in each line. Some occasional lines of

Swinburne's "Hertha" illustrate the meter: (Although the rhythm is popular, it is rarely that hexameter is found which has not extra syllables, or a number dropped.)

God chan | ges, and man, | and the form | of them bo | dily; I | am
the soul.

Sidney Lanier, in *The Marshes of Glynn*, beautifully varies his meter to suit the mood of his poem. The following example shows anapests in hexameter, many of them truncated:

Ye marsh | es, how can | did and sim | ple and noth | ing with hold
ing and | free
Ye publish yourselves to the sky and offer yourselves to the sea!
Tolerant plains, that suffer the sea and the rains and the sun,
Ye spread and span like the catholic man who hath mightily won
God out of knowledge and good out of infinite pain
And sight out of blindness and purity out of a stain.
As the marsh-hen secretly builds on the watery sod,
Behold I will build me a nest on the greatness of God:
I will fly in the greatness of God as the marsh-hen flies
In the freedom that fills all the space 'twixt the marsh and the skies.
 —SIDNEY LANIER

Anapestic heptameter (˘ ˘ – | ˘ ˘ – | ˘ ˘ – | ˘ ˘ – | ˘ ˘ – | ˘ ˘ – |
˘ ˘ –) contains seven anapestic feet in one line. An example:

Hear the sea | rushing co | lour and suds | as it swells | in a vi | olet
ridge | near the sky—
And it rolls, sweeping in, with its fingers curled up at the children
 at play on the beach,
It whispers and crashes a song—with a softing refrain that's a sigh—
Then it washes, sinks back, leaving part the sand dry, that the next
 rounding wave tries to reach.
 —G. F.

————

From my youth | hath she shown | me the joy | of her bays, that
I crossed, | of her cliffs | that I clomb.
 —*In the Water*, SWINBURNE

When my lips | tried to sing | they were sealed | by the touch |
of a ghost | ly invis | ible hand |

—L. K. K.

Anapestic octameter contains eight anapestic feet in each line. Because it is easier to split eight long feet into two lines of tetrameter length, the rhythm is very rarely found.

So the rid | er went gal | oping on; | as he sped | down the long |
curving high | way, the wind | at his head—
The trees seemed to race with him, dizzily, tall; and the horse ran
on madly, not seeing at all.

—G. F.

Dactylic.—The dactylic foot (– ◡ ◡) contains three syllables, the first long or stressed, and the last two short or unstressed. Single illustrating words are anything, terrible, beautiful, anapest, covering.

Like the three-syllable anapest, the dactyl is often used in lines of other meters to vary the form. Because of the articifial meter obtained by using the pure dactylic, poets often leave the last two unaccented syllables from the last foot. (Some of the following examples are characteristic and contain two syllables less than the perfect meter.)

Dactylic monometer (– ◡ ◡) contains one dactylic foot in each line. Like other monometers, examples are generally mere rhythmic tricks.

> Come to me,
> Sing to me,
> Cling to me;
> Bring to me
> Sorrow or
> Joy.

Dactylic dimeter (– ◡ ◡ | – ◡ ◡) contains two dactylic feet in each line of poetry:

> Still we'll be | spilin' you,
> Blind to the guile in you,
> While there's a smile in you,
> Nora McHugh!
> —Thomas Augustine Daly

 ‾ ◡ ◡ ‾ ◡ ◡

Fast they come, | fast they come;
 See how they gather;
Wide waves the eagle plume,
 Blended with heather.
Cast your plaids, draw your blades,
 Forward each man set!
Pibroch of Donuil Dhu,
 Knell for the onset!
 —Pibroch of Donuil Dhu, Sir Walter Scott

Dactylic trimeter (‾ ◡ ◡ | ‾ ◡ ◡ | ‾ ◡ ◡) contains three dactylic feet in each line. The line is most unusual when the pure measure is used. The following are some occasional truncated excerpts:

 ‾ ◡ ◡ ‾ ◡ ◡ ‾

Laughing, dish | eveled and | gay,
Dancing with jubilant feet,
Homeward the children returned
Leaving their books in the school;
Lessons were over till fall.
 —Holidays, E. T. Wilson

 ‾ ◡ ◡ ‾ ◡ ◡ ‾ ◡ ◡

All through the | nighttime a | symphony
Plays on my windowpanes lightfully
Breathing of wind for the instruments—
Thunder for drums coming frightfully;
Chorus ensemble roars mightfully.
 Drops on the roof, pianissimo;
 Trees, in the lull, singing,—whisper low.
 —G. F.

Dactylic tetrameter (‾ ◡ ◡ | ‾ ◡ ◡ | ‾ ◡ ◡ | ‾ ◡ ◡) has four dactylic feet in each line. The following lines are truncated:

 ‾ ◡ ◡ ‾ ◡ ◡ ‾ ◡ ◡ ‾ ◡

Slowly the | mist o'er the | meadow was | creeping,
 Bright on the dewy buds glistened the sun,
When from his couch, while his children were sleeping,
 Rose the bold rebel and shouldered his gun.
 —Lexington, Oliver Wendell Holmes

Brightest and | best of the | sons of the | morning;
Dawn on our darkness, and lend us Thine aid;
Star of the east, the horizon adorning,
Guide where our Infant Redeemer is laid!

<div align="right">Bishop Heber</div>

Dactylic pentameter (– ˘ ˘ | – ˘ ˘ | – ˘ ˘ | – ˘ ˘ | – ˘ ˘) contains five dactylic feet in one line: Few examples are to be found.

Crashing in | breakers that | rise in green | washing and | levelly
Sink in dark dizzying swirls, throaty sea-waters sing to us.
Fingers of suds are thrown out of the waves, churning heavily,
Rash in their madness the tempest-teased ocean gods fling to us
All of the whorls and the carvings that hide in the soul of the sea.

<div align="right">—G. F.</div>

Dactylic hexameter (– ˘ ˘ | – ˘ ˘ | – ˘ ˘ | – ˘ ˘ | – ˘ ˘ | – ˘ ˘) contains six dactylic feet in each line. Rarely is the meter used in its perfect form. Syllables are usually added or taken away:

Always it | seems that the | long day is | endless; the | evening is | lonelier.
Night comes and darkness; we wish that the dawn of the day were beginning. . . .

Not of the | princes and | prelates with | periwigged | chario | teers
Riding triumphantly laurelled to lap the fat of the years.

<div align="right">—*A Consecration*, John Masefield</div>

So I am | come to you | now with an | offer and | proffer of | marriage,
Made of a good man and true—Miles Standish, the Captain of Plymouth.

<div align="right">—*John Alden and Priscilla*, Henry Wadsworth Longfellow</div>

Dactylic heptameter (– ˘ ˘ | – ˘ ˘ | – ˘ ˘ | – ˘ ˘ | – ˘ ˘ | – ˘ ˘ | – ˘ ˘) contains seven dactylic feet. Of this meter, too, there are few examples.

Oxen go | trundling through | sod with their | eyes staring | thickly, their | legs stepping | heavily, |

Dumb as the clumps that they walk on, they wabble with dirge-like
 and passive persistence.
Fastened to earth which they mutilate, pounding, relentless their
 industry—
Swaying and turning, and dragging and beating, not caring nor
 counting the distance.

<div align="right">—G. F.</div>

Dactylic octameter $(- \smile \smile \, | - \smile \smile \, | - \smile \smile \, | - \smile \smile \, | - \smile \smile \, | - \smile \smile \, |$
$- \smile \smile \, | - \smile \smile)$ contains eight dactylic feet. Ordinarily this eight-foot
line of twenty-four syllables would be broken into tetrameter lines.

Into the | black and the | swell of the | sea, twenty | men launched
 the | lifeboat; the | shouts of en | couragement
Fainted in distance. . . .

Among the "occasional" feet, spondees alone may be said to pro-
vide a meter of their own, the spondaic. Tennyson uses the spondee
in his line:

 Break, break, break on thy cold grey stones, O sea!

Poems cannot easily be written in spondees because any inflected two-
syllable word in English mars the meter. An exercise in monosyllabic
spondees which attempts to describe the movement of the waves in
the even words is this:

 Sea, sighs, wash, swish, crash—
 Waves, wash, low, wash, back;
 Sound, moves, lulls, slows, stops.
 Sea, sighs, wash, swish, crash!

 Even is come; and from the dark park, hark,
 The signal of the setting sun—one gun!
 Now puss, while folks are in their beds, treads leads,
 And sleepers waken, grumble—"Drat that cat!"

<div align="right">—A Nocturnal Sketch, Thomas Hood</div>

Other measures have been defined, but practically all poetry can
be scanned as pure or varied forms of the meters listed above.

STANZAS

The greatest conceptions of poets, past and present, have usually been in continuous verse, not broken into stanzas. But when the recurrent echoes of sound are used at the ends of lines, stanzas (or fixed groupings of lines) aid in the establishment of a musical pattern. Many patterns are offered in this chapter.

The *couplet*, or *distich*, simplest of stanzas, contains two rhyming lines. A poem containing but a single couplet can be only the vehicle for an epigram, such as

> When I am dead, I hope it may be said,
> His sins were scarlet, but his books were read.
> —HILAIRE BELLOC

> He first deceased, she for a little tried
> To live without him, liked it not, and died.
> —*Old epitaph*

The longer poem, made up of successive couplets, is common:

> I went to turn the grass once after one
> Who mowed it in the dew before the sun.

> The dew was gone that made his blade so keen
> Before I came to view the leveled scene.
> —*The Tuft of Flowers*, ROBERT FROST

Shakespeare's use of the couplet to round out the blank verse of his dramatic narrative is familiar to everyone:

> Now forth, lord constable and princes all,
> And quickly bring us word of England's fall.

The *triplet*, or three-line stanza, uses only one rhyme sound, (aaa); or may have the first line rhyming with the last (aba). Poems comprised of three-line stanzas (the Villanelle, for example) often alternate the rhyme schemes, as aba, bab, aba, etc. In other forms of triplet the first two lines rhyme, the last line differing throughout the poem, or *vice versa*. Often the triplet is not rhymed.

> a) Youth's for an hour
> a) Beauty's a flower
> b) But love is a jewel that wins the world. . . .
> —MOIRA O'NEIL

a) Whoe'er she be,
a) That not impossible she,
a) That shall command my heart and me.

—RICHARD CRASHAW

a) The dawn was apple green,
b) The sky was green wine held up in the sun,
a) The moon was a golden petal between.

a) She opened her eyes, and green
b) They shone, clear, like flowers undone
a) For the first time, now for the last time seen.

—D. H. LAWRENCI

a) What are those ravens doing in our trees,
a) Calling on doom and outworn prophecies?
a) Flying in threes. . . .

—LOUIS UNTERMEYER

The *quatrain*, or four-line stanza, lends itself easily to verse. The obvious rhyme arrangements are aabb, abab, and abba. The introduction of an unrhymed line makes possible still other forms. Any rhyme scheme is permissible; no rhyme scheme is necessary.

a) The forward youth that would appear,
a) Must now forsake his Muses dear,
b) Nor in the shadows sing
b) His numbers languishing.

—A. MARVELL

a) His songs were a little phrase
b) Of eternal song.
a) Drowned in the harping of lays
b) More loud and long. . . .

—THOMAS MACDONAGH

a) Black lie the hills, swiftly doth daylight flee,
b) And, catching gleams of sunset's dying smile,
b) Through the dusk land for many a changing mile
a) The river runneth softly to the sea.

—CELIA LEIGHTON THAXTER

a) These pearls of thought in Persian gulfs were bred,
b) Each softly lucent as a rounded moon;

a) The diver Omar plucked them from their bed,
a) Fitzgerald strung them on an English thread.

—JAMES RUSSELL LOWELL

a) In the cool waves
b) What can be lost?—
b) Only the sorry cost
c) Of the lovely thing, ah, never the thing itself!

a) The level flood that laves
d) The hot brow
e) And the stiff shoulder
d) Is at our temples now. . . .

—EDNA ST. VINCENT MILLAY

a) A ruddy drop of manly blood
b) The surging sea outweighs;
c) The world uncertain comes and goes,
d) The lover rooted stays.

—RALPH WALDO EMERSON

a) The lapping of lake water
b) Is like the weeping of women,
c) The weeping of ancient women
d) Who grieved without rebellion.

—JEAN STARR UNTERMEYER

a) I'll tell you how the sun rose—
b) A ribbon at a time.
c) The steeples swam in amethyst
d) The news like squirrels ran.

—EMILY DICKINSON

a) The innocent, sweet Day is dead.
a) Dark night hath slain her in her bed.
a) O, Moors are as fierce to kill as to wed!
b) —Put out the light, said he.

—SIDNEY LANIER

a) In the hush of early even
b) The clouds come flocking over,
a) Till the last wind fell from heaven
c) And no bird cried.

—JOHN DREEMAN

A pleasing and distinctive quatrain form is that used in FitzGerald's translation of the "Rubaiyat":

a) Ah, my Belovèd, fill the cup that clears
a) Today of past Regrets and future Fears:
b) Tomorrow!—Why, Tomorrow I may be
a) Myself with Yesterday's Sev'n Thousand Years.

a) Wake! For the Sun, who scatter'd into flight
a) The stars before him from the field of Night,
b) Drives North along with them from Heav'n, and strikes
a) The Sultan's Turret with a Shaft of Light.

Quintet.—Possible arrangements of the five-line stanza are of course still more numerous. The stanza is a varied combination of the couplet and triplet, with the lines usually rhymed in the proportion of two to three, such as aabbb, abbaa, etc. The following are noteworthy illustrations:

a) Here, with one leap,
b) The bridge that spans the cutting; on its back
c) The load
c) Of the main road
b) And under it the railway track.
 —The Bridge, J. REDWOOD ANDERSON

a) Look—on the topmost branches of the world
b) The blossoms of the myriad stars are thick;
b) Over the huddled rows of stone and brick,
c) A few sad wisps of empty smoke are curled
b) Like ghosts, languid and sick.
 Sunday Evening In the Common, JOHN HALL WHEELOCK

a) Along the graceless grass of town
a) They rake the rows of red and brown,—
b) Dead leaves, unlike the rows of hay
b) Delicate, touched with gold and gray,
b) Raked long ago and far away.
 —A Dead Harvest, ALICE MEYNELL

a) Across the mesa flying,
a) The hawks come swooping, crying;
a) The wind, already dying,
a) Through cedar tops is sighing,—
b) The canyons now are dark.
 —C. J.

a) When God at first made man,
b) Having a glass of blessings standing by;
a) Let us (said he) pour on him all we can:
b) Let the world's riches, which dispersèd lie,
a) Contract into a span.

—The Gifts of God, GEORGE HERBERT

a) Go, lovely Rose,
b) Tell her that wastes her time and me,
a) That now she knows,
b) When I resemble her to thee,
b) How sweet and fair she seems to be.

*—*EDMUND WALLER

a) Stay, stay at home, my heart, and rest,
a) Home-keeping hearts are happiest,
b) For those that wander they know not where
b) Are full of trouble and full of care;
a) To stay at home is best.

—Song, HENRY W. LONGFELLOW

a) To make a prairie it takes a clover and one bee,—
a) One clover, and a bee,
a) And revery.
b) The revery alone will do
b) If bees are few.

—To Make a Prairie, EMILY DICKINSON

a) Hail to thee, blithe spirit,
b) Bird thou never wert
a) That from heaven, or near it,
b) Pourest thy full heart
b) In profuse strains of unpremeditated art.

—To a Skylark, PERCY BYSSHE SHELLEY

a) Descend softly on the houses
b) We built with pride,
c) Without worship.
d) Fold them in your veil
e) Spill your shadows.

—A Hymn to Night, MAX MICHELSON

The *sestet*, or six-line stanza, uses various combinations of the shorter couplet, triplet, and quatrain. The Petrarchan sonnet closes

with a sestet limited to one of the rhyme-schemes, abcabc, ababab; abbaab, ababba, or abbaba.

The following stanzas illustrate some noteworthy forms. There are, obviously, many other possible arrangements:

a) I ain't afraid uv snakes or toads, or bugs or worms or mice,
a) An' things 'at girls are skeered uv I think are awful nice!
b) I'm pretty brave I guess; an' yet I hate to go to bed,
b) For, when I'm tucked up warm an' snug an' when my prayers are said,
c) Mother tells me "Happy Dreams" an' takes away the light,
c) An' leaves me lyin' all alone an' seein' things at night!
—*Seein' Things*, EUGENE FIELD

a) Here room and kingly silence keep
b) Companionship in state austere;
b) The dignity of death is here,
a) The large, lone vastness of the deep.
c) Here toil has pitched his camp to rest:
c) The west is banked against the west.
—*By the Pacific Ocean*, JOAQUIN MILLER

a) Under a wall of bronze,
b) Where beeches dip and trail
c) Their branches in the water;
d) With red-tipped head and wings
b) A beaked ship under sail—
e) There glides a single swan . . .
—*The Swan*, JOHN GOULD FLETCHER

a) How like the stars are these white, nameless faces—
b) These for innumerable burning coals!
a) This pale procession out of stellar spaces
b) This Milky Way of Souls!
c) Each in its own bright nebulæ enfurled,
c) Each face, dear God, a world!
—*Broadway*, HERMAN HAGEDORN

a) As I lie roofed in, screened in,
b) From the pattering rain,
b) The summer rain—
c) As I lie,
c) Snug and dry,
b) And hear the birds complain.
—*On the Porch*, HARRIET MUNROE

a) But Jack, no panic showing,
a) Just watched his beanstalk growing,
b) And twined with tender fingers the tendrils up the pole.
c) At all her words funereal
c) He smiled a smile ethereal,
b) Or sighed an absent-minded "Bless my soul!"
—*How Jack Found That Beans May Go Back on a Chap,* GUY WETMORE CARRYL

a) Which I wish to remark,
b) And my language is plain,
a) That for ways that are dark
b) And for tricks that are vain,
c) The heathen Chinee is peculiar,
b) Which the same I would rise to explain.
—*Plain Language from Truthful James,* BRET HARTE

a) I thought that life could have no sting
b) To infant butterflies,
a) So I gazed on this unhappy thing
b) With wonder and surprise.
a) While sadly with his waving wing
b) He wiped his weeping eyes.
—*A Conservative,* CHARLOTTE P. S. GILMAN

a) What was he doing, the great god Pan,
b) Down in the reeds by the river?
a) Spreading ruin and scattering ban,
c) Splashing and paddling with hoofs of a goat,
c) And breaking the golden lilies afloat
b) With the dragon-fly on the river?
—*A Musical Instrument,* MRS. BROWNING

a) Happy is the man that findeth wisdom,
b) And the man that getteth understanding.
c) For the merchandise of it is better than the merchandise of
 silver,
d) And the gain thereof than fine gold.
e) She is more precious than rubies:
f) And none of the things thou canst desire are to be compared
 unto her.
—*Sonnets of Wisdom,* RICHARD MOULTON

a) Thou little bird, thou dweller by the sea,
b) Why takest thou its melancholy voice,
c) And with that boding cry

c) Why o'er the waves dost fly?
a) O, rather, with me
b) Through the fair land rejoice!
 —*The Little Beach-Bird*, RICHARD HENRY DANA

a) I wandered lonely where the pine trees made
a) Against the bitter East their barricade,
b) And guided by its sweet
c) Perfume, I found, within a narrow dell,
c) The trailing spring flower tinted like a shell,
b) Amid dry leaves and mosses at my feet.
 —*The Trailing Arbutus*, JOHN GREENLEAF WHITTIER

a) Wee, modest, crimson-tipped flow'r,
a) Thou's met me in an evil hour;
b) For I maun crush among the stoure
c) Thy slender stem:
b) To spare thee now is past my pow'r,
c) Thou bonie gem.
 —*To a Mountain Daisy*, ROBERT BURNS

a) Good-bye, proud world! I'm going home:
b) Thou art not my friend, and I'm not thine:
a) Long through thy weary crowds I roam;
b) A river-ark on the ocean brine,
a) Long I've been like the driven foam;
a) But now, proud world! I'm going home.
 —*Good-bye*, RALPH WALDO EMERSON

a) Ha! whaur ye gaun, ye crawlin ferlie!
a) Your impudence protects you sairly;
a) I canna say but ye strunt rarely
b) Owre gauge and lace;
a) Tho' faith! I fear ye dine but sparely
b) On sic a place.
 —*To a Louse*, ROBERT BURNS

The *septet* may be rhymed in a hundred different ways and is obviously a combination of the shorter forms, couplet, triplet, and quatrain. One famous variation in iambic pentameter or "heroics" is called the *rime royal* (ababbcc), and was used by Chaucer and Spenser and many later English poets. One example is here given, followed by a few of the many other rhyme-schemes of which the septet is capable:

a) So every spirit as it is most pure,
b) And hath in it the more of heavenly light,
a) So it the fairer body doth procure
b) To habit it, and is more fairly dight
b) With cheerful grace and amiable sight;
c) For of the soul the body form doth take
c) For soul is form and doth the body make.

—SPENSER

a) Three corpses lay out on the shining sands
b) In the morning gleam as the tide went down;
a) And the women were weeping and wringing their hands
b) For those who will never come back to the town.
c) For men must work, and women must weep,
c) And the sooner it's over, the sooner to sleep,
d) And good-bye to the bar and its moaning.

—KINGSLEY

a) The flower that smiles today
b) Tomorrow dies;
a) All that we wish to stay
b) Tempts and then flies:
c) What is this world's delight?
c) Lightning that mocks the night,
c) Brief even as bright.

—SHELLEY

a) Swiftly walk o'er the western wave,
b) Spirit of night!
a) Out of the misty eastern cave,
b) Where all the long and lone daylight
c) Thou wovest dreams of joy and fear,
c) Which make thee terrible and dear,—
b) Swift be thy flight!

—*To Night*, PERCY BYSSHE SHELLEY

a) This is the ship of pearl, which, poets feign,
a) Sails the unshadowed main,—
b) The venturous bark that flings
b) On the sweet summer wind its purpled wings
b) In gulfs enchanted, where the Siren sings,
c) And coral reefs lie bare,
c) Where the cold sea-maids rise to sun their streaming hair.

—*The Chambered Nautilus*, OLIVER WENDELL HOLMES

 a) Where the bee sucks, there suck I:
 a) In a cowslip's bell I lie;
 a) There I couch when owls do cry.
 a) On the bat's back I do fly
 a) After summer merrily.
 b) Merrily, merrily, shall I live now
 b) Under the blossom that hangs on the bough.
 —The Tempest, WILLIAM SHAKESPEARE

Octave.—The eight-line stanza is most commonly a combination of the couplet, triplet, and quatrain forms. In the Petrarchan sonnet's detached octave (see p. 39), the rhyme-scheme is abba, abba. Probably each of the many other rhyming combinations that can be formed of eight lines has been used by some poet.

 a) Ah, what is love? It is a pretty thing,
 a) As sweet unto a shepherd as a king;
 b) And sweeter too;
 c) For kings have cares that wait upon a crown,
 c) And cares can make the sweetest love to frown.
 d) Ah then, ah then!
 e) If country loves such sweet desires gain,
 e) What lady would not love a shepherd swain?
 —ROBERT GREENE

 a) The spacious firmament on high,
 a) With all the blue ethereal sky,
 b) And spangled heavens, a shining frame,
 b) Their great Original proclaim.
 c) Th' unwearied Sun from day to day
 c) Does his creator's power display;
 d) And publishes to every land
 d) The work of an Almighty hand.
 —*Hymn*, JOSEPH ADDISON

 a) Drink to me only with thine eyes,
 b) And I will pledge with mine,
 c) Or leave a kiss but in the cup
 b) And I'll not look for wine.
 a) The thirst that from the soul doth rise
 b) Doth ask a drink divine,
 c) But might I of Jove's nectar sup,
 b) I would not change for thine.
 —BEN JONSON

a) Spirit that breathest through my lattice: thou
b) That cool'st the twilight of the sultry day!
a) Gratefully flows thy freshness round my brow;
b) Thou hast been out upon the deep at play,
a) Riding all day the wild blue waves till now,
b) Roughening their crests, and scattering high their spray,
c) And swelling the white sail. I welcome thee
c) To the scorched land, thou wanderer of the sea!

—*The Evening Wind*, WILLIAM CULLEN BRYANT

a) Thou art a female, Katydid!
b) I know it by the trill
c) That quivers through thy piercing notes,
b) So petulant and shrill;
d) I think there is a knot of you
e) Beneath the hollow tree,—
f) A knot of spinster Katydids,—
e) Do Katydids drink tea?

—*To an Insect*, OLIVER WENDELL HOLMES

a) He's gone.
b) I do not understand.
c) I only know
c) That as he turned to go
b) And waved his hand,
d) In his young eyes a sudden glory shone:
c) And I was dazzled by a sunset glow,
a) And he was gone.

-WILFRED WILSON GIBSON

a) Under the greenwood tree
a) Who loves to lie with me,
b) And turn his merry note
b) Unto the sweet bird's throat,
c) Come hither! Come hither! Come hither!
a) Here shall he see
a) No enemy
c) But winter and rough weather!

—*As You Like It*, WILLIAM SHAKESPEARE

The *nine-line stanza* has innumerable possibilities. The most noted form is that used first by Spenser. Its rhyme scheme is exacting: ababbcbcc; the form is written usually in pentameter lines. The last line of the stanza, called the Alexandrine, contains twelve syllables, and ends the stanza with a finish that is rich and distinctive. This Spenserian form has been used in many noted English poems.

Following are two examples, one famous and one infamous:

a) Not vainly did the early Persian make
b) His altar the high places, and the peak
a) Of earth-o'er gazing mountains, and thus take
b) A fit and unwalled temple, there to seek
b) The spirit in whose honour shrines are weak,
c) Upreared of human hands. Come and compare
b) Columns and idol-dwellings, Goth or Greek,
c) With nature's realms of worship, earth and air,
c) Nor fix on fond abodes to circumscribe thy prayer!
 —*Childe Harold's Pilgrimage*, LORD BYRON

a) Find first thy meter. If the task be hard
b) Consult thy Keats and Shelley—in them is
a) Some measure that will suit a busy bard,
b) ('Twas "Adonais" I used in writing this!).
b) Then, if thy rhymthic feeling run amiss,
c) Heed thou the ticking clock—it may transfer
b) Those beats from out its cranial abyss
c) All choked with wheels, to where thine own works whirr—
c) Then sit thee calmly down before thy typewritér.

Seek next thy subject. Let the matter be
 Not as a stranger, but some old, old friend,
As "Death," "A Daisy," "Spring," or "Constancy."
 Then for thy rhyming dictionary send,
 For oft its echoing columns hap to lend
A few poetic thoughts to him who gleans.
 And keep in mind until the very end—
That line is best if none know what it means.
Thus do the poets write their verse for magazines.
 —BURGES JOHNSON

Other forms of the nine-line stanza follow:

a) My heart aches and a drowsy numbness pains
b) My sense, as though of hemlock I had drunk,

a) Or emptied some dull opiate to the drains.
b) One minute passed, and Lethe-words had sunk:
c) 'Tis not through envy of thy happy lot,
d) But being too happy in thy happiness,—
e) That thou, light-winged Dryad of the trees,
c) In some melodious plot
d) Of beechen green, and shadows numberless,
e) Singest of summer in full-throated ease.

—Ode to a Nightingale, JOHN KEATS

a) Fair daffodils, we weep to see
b) You haste away so soon;
c) As yet the early rising sun
b) Has not attained his noon.
d) Stay, stay,
d) Until the hasting day
c) Has run
f) But to the even-song;
a) And, having prayed together, we
f) Will go with you along.

—To Daffodils, ROBERT HERRICK

a) My heart leaps up when I behold
b) A rainbow in the sky:
c) So was it when my life began;
c) So is it now I am a man;
a) So be it when I shall grow old
b) Or let me die!
c) The Child is father of the Man;
d) And I could wish my days to be
d) Bound each to each by natural piety.

*—*WILLIAM WORDSWORTH

Ballad.—The oldest lyric form in English had no rigidity of form, though dependent upon rhythm and rhyme to give it musical character; but both rhyme and rhythm often lacked disciplined regularity. Ballads were sung or chanted, and frequently had a chorus. They always told a story in which characters played a part and action reached a climax.

Kipling's *Barrack-room Ballads* and *Macaulay's Lays of Ancient Rome* furnish examples of the way in which the ballad has been adapted by modern English writers. A fragment of a typical fourteenth-century ballad follows.

CHEVY-CHACE
(Fourteenth Century)

God prosper long our noble king,
 Our lives and safeties all;
A woeful hunting once there did
 In Chevy-Chace befall.

To drive the deer with hound and horn,
 Earl Percy took his way;
The child may rue that is unborn,
 The hunting of that day.

The stout Earl of Northumberland
 A vow to God did make,
His pleasure in the Scottish woods
 Three summer days to take;

The chiefest harts in Chevy-Chace
 To kill and bear away.
These tidings to Earl Douglas came
 In Scotland where he lay:

Who sent Earl Percy present word,
 He would prevent his sport;
The English Earl, not fearing that,
 Did to the woods resort.

.

And of the rest, of small account,
 Did many hundreds die.
Thus endeth the hunting of Chevy-Chace,
 Made by the Earl Percy.

God save the King and bless this land
 With plenty, joy, and peace;
And grant, henceforth, that foul debate
'Twixt noblemen may cease.

AND POETS' HANDBOOK

FIXED LYRIC FORMS OF VERSE

Poets throughout the ages have sung as their fancy pleased them, seeking patterns of rhythm and rhyme which suited their mood and seemed the most appropriate vehicle by which to convey the emotional experience they wished to record.

The Limerick.—Most of these fixed forms which English poets have adopted are native to France; a few came from Italy, and still fewer are English born. Undoubtedly England's oldest and commonest is the humble limerick, popularized by Edward Lear in his Nonsense Books, and called by him "nonsense rhymes,"—the name now generally given them in England. The same verse form, however, appears in ancient Latin, and later in ecclesiastical Latin, and there is at least one sacred hymn found in hymnals of today which follows the pattern exactly. The name "limerick," according to legend, grew out of a custom among Irish mercenaries who fought in all the armies of Europe in the fifteenth century. At parties between battles each would improvise a verse about one of his comrades. All would then join in a chorus: "When we get back to Limerick town 'twill be a glorious morning."

The Lear variety of rhyme usually concerns a person or place, and the rhyming word at the end of the first line is repeated in the last line (see Appendix, p. 457). Examples follow, the first of which is variously quoted. The form used here is certified by a member of the Beecher family.

> The Reverend Henry Ward Beecher
> Called a hen a most elegant creature.
> The hen, pleased with that,
> Laid an egg in his hat—
> And thus did the hen reward Beecher!
> —OLIVER WENDELL HOLMES

> There was an Old Man who said, "How
> Shall I flee from this horrible Cow?
> I will sit on this stile
> And continue to smile
> Which may soften the heart of that Cow."
> —EDWARD LEAR

W. S. Gilbert has contributed to the world its only limerick thus far in free verse:

> There was an old man of St. Bees
> Who was stung on the arm by a wasp.
> When asked, "Does it hurt?"
> He replied, "Not at all,
> But I thought all the time 'twas a hornet."

> There is nothing in afternoon tea
> To appeal to a person like me.
> Polite conversation
> Evokes the elation
> A cow might enjoy in a tree.
> —GELETT BURGESS

> There was a young man in Schenectady
> Who was hit by a brick in the neck today.
> They massaged his thorax
> With coal oil and borax
> But now he talks quite disconnectady.
> —ANON.

The Sonnet.—Of all the fixed forms, the sonnet properly should come first. It is a form that has been used by English poets of all types and temperaments and abilities since the sixteenth century, though originating in Italy as early as 1294.

That the sonnet must have fourteen lines is beyond dispute. As to other characteristics, there is ancient argument. The most exacting (if not necessarily the most exact) sonnet is that generally called the Petrarchan. Its rhyme scheme is abbaabba cdecde. In this form, which purists have insisted is the only true sonnet, the first eight lines present an argument, and the final six present a conclusion or reflection based upon the first. The only variation from this form of "true" sonnet permitted by its defenders is in the final sestet; cdcdcd, or cddccd, or any other arrangement of two or three rhyme sounds is allowable so long as the sonnet does not end with a couplet.

The fact that Shakespeare wrote a great number of fourteen-line poems which ignore several of these restraints, and called them sonnets, has encouraged many to refuse to accept the rigid Petrarchan definition. Charles Lamb referred to Shakespeare's sonnets as "four-

teeners," refusing to grant them the name; but other great poets have used the irregular or Shakespearean pattern,—ababcdcdefefgg.

Between these two extremes of definition there are forms of the sonnet with a different arrangement of the octave—ababbaba—and a couplet at the end of the sestet. Examples of several forms follows:

The Petrarchan Sonnet (abbaabbacdecde):

> I lift mine eyes, and all the windows blaze,
> With forms of Saints, and holy men who died,
> Here martyred and hereafter glorified;
> And the great Rose upon its leaves displays
> Christ's Triumph, and the angelic roundelays,
> With splendor upon splendor multiplied;
> And Beatrice again at Dante's side
> No more rebukes, but smiles her words of praise.
> And then the organ sounds, and unseen choirs
> Sing the old Latin hymns of peace and love
> And benedictions of the Holy Ghost;
> And the melodious bells among the spires
> O'er all the house-tops and through heaven above
> Proclaim the elevation of the Host!
>
> <div align="right">—Divina Comedia, V, H. W. Longfellow</div>

> What is a sonnet? 'Tis a pearly shell
> That murmurs of the far-off murmuring sea;
> A precious jewel carved most curiously;
> It is a little picture painted well.
>
> What is a sonnet? 'Tis the tear that fell
> From a great poet's hidden ecstasy;
> A two-edged sword, a star, a song—ah me!
> Sometimes a heavy-tolling funeral bell.
>
> This was the flame that shook with Dante's breath,
> The solemn organ whereon Milton played.
> And the clear glass where Shakespeare's
> shadow falls:
>
> A sea this is—beware who ventureth!
> For like a fiord the narrow floor is laid
> Deep as mid-ocean to sheer mountain walls.
>
> <div align="right">—R. W. Gilder</div>

Two variant forms (abbaabbacdcdcd and abbaaccadedeff):

Sonnets from the Portuguese
(No. XXII.)

When our two souls stand up erect and strong,
 Face to face, silent, drawing nigh and nigher,
 Until the lengthening wings break into fire
At either curved point,—what bitter wrong
Can the earth do to us, that we should not long
 Be here contented? Think. In mounting higher,
 The angels would press on us and aspire
To drop some golden orb of perfect song
Into our deep, dear silence. Let us stay
 Rather on earth, Beloved,—where the unfit
Contrarious moods of men recoil away
 And isolate pure spirits, and permit
A place to stand and love in for a day,
 With darkness and the death-hour rounding it.
 —ELIZABETH BARRETT BROWNING

Scorn not the Sonnet; Critic, you have frowned,
Mindless of its just honours; with this key
Shakespeare unlocked his heart; the melody
Of this small lute gave ease to Petrarch's wound;
A thousand times this pipe did Tasso sound;
With it Camoens soothed an exile's grief;
The Sonnet glittered a gay myrtle leaf
Amid the cypress with which Dante crowned
His visionary brow; a glow-worm lamp,
It cheered mild Spenser, called from Faery-land
To struggle through dark ways; and, when a damp
Fell round the path of Milton, in his hand
The Thing became a trumpet, whence he blew
Soul-animating strains—alas, too few!
 —WILLIAM WORDSWORTH

Shakespearean Sonnets:

BRIGHT STAR!

Bright Star! would I were steadfast as thou art—
 Not in lone splendour hung aloft the night,
 And watching, with eternal lids apart,

Like Nature's patient, sleepless Eremite,
The moving waters at their priest-like task
 Of pure ablution round earth's human shores,
Or gazing on the new soft fallen mask
 Of snow upon the mountains and the moors—

No—yet still steadfast, still unchangeable,
 Pillowed upon my fair love's ripening breast
To feel for ever its soft fall and swell,
 Awake for ever in a sweet unrest,
Still, still to hear her tender-taken breath,
Half-passionless, and so swoon on to death.

—JOHN KEATS

SONNET XVIII

Shall I compare thee to a summer's day?
Thou art more lovely and more temperate;
Rough winds do shake the darling buds of May,
And summer's lease hath all too short a date:
Sometime too hot the eye of heaven shines,
And often is his gold complexion dimm'd;
And every fair from fair sometime declines,
By chance or nature's changing course untrimm'd;
But thy eternal summer shall not fade,
Nor lose possession of that fair thou owest;
Nor shall Death brag thou wander'st in his shade,
When in eternal lines to time thou grow'st:
 So long as men can breathe, or eyes can see,
 So long lives this, and this gives life to thee.

—WILLIAM SHAKESPEARE

FIXED FORMS FROM FRANCE

If this were a historical study of English verse it would be profitable to trace the development of the French forms in the land of their birth, and the dates and fashions of their English adoption. Such study is well worth while, and there are several books that make it easy and delightful. For the purposes of this handbook it is sufficient to give examples of ballade, rondeau, rondel, roundel, villanelle, triolet, sestina and pantoum in their most generally accepted English forms, and name a few less familiar types.

The ballade, as perhaps the earliest in origin, and the oldest by English adoption, comes first. Its similarity in name to the English ballad is no accident. Originally it too was intended to be sung. Its period of growth and change extended over four centuries, but only those forms are given here into which it finally crystallized. A noteworthy characteristic is the "envoy" addressed to some prince or power, patron or lady-love.

Ballade, type I, (ababbcbc, ababbcbc, ababbcbc, bcbc).—Three stanzas of eight lines each, and an envoy of four lines. There are only three rhyme-sounds in all. The final line of the first stanza is repeated at the end of the three following stanzas:

A BALLAD TO QUEEN ELIZABETH
of the Spanish Armada

King Philip had vaunted his claims;
 He had sworn for a year he would sack us;
With an army of heathenish names
 He was coming to fagot and stack us;
 Like the thieves of the sea he would track us,
And shatter our ships on the main;
 But we had bold Neptune to back us,—
And where are the galleons[1] of Spain?

His carackes were christened of dames
 To the kirtles whereof he would tack us;
With his saints and his gilded stern-frames,
 He had thought like an egg-shell to crack us;
 Now Howard may get to his Flaccus,
And Drake to his Devon again,
 And Hawkins bowl rubbers to Bacchus,—
For where are the galleons of Spain?

Let his Majesty hang to St. James
 The axe that he whetted to hack us;
He must play at some lustier games
 Or at sea he can hope to out-thwack us;
 To his mines of Peru he would pack us
To tug at his bullet and chain;
 Alas! that his Greatness should lack us!—
But where are the galleons of Spain?

[1] Pronounced *galyons.*

ENVOY

GLORIANA!—the don may attack us
Whenever his stomach be fain;
 He must reach us before he can rack us, . . .
And where are the galleons of Spain?

 —AUSTIN DOBSON

BALLADE OF THE LITTLE THINGS THAT COUNT

The furrow's long behind my plow—
 My field is strewn with stones of care,
And trouble gathers thick enow
 As years add silver to my hair.
 Could I an easier path prepare
For baby feet that start to mount?—
 Save them a bit of wear and tear,—
And show the little things that count?

I see a tiny maiden bow
 O'er slate and pencil, in her chair:
A little pucker on her brow,
 A little tousle in her hair.
 And one wee tear has fallen where
The crooked figures grin and flount;
 My heart goes reaching to her there—
I love the little things that count!

Arithmetic is such a slough—
 A pilgrim's swamp of dull despair,
But Discipline will not allow
 My hand to point a thoro'fare.
 Harsh figures face us everywhere,
O'erwhelming in their vast amount;
 Must she so soon their burden bear?—
I love the little things that count!

Stern Teacher, must she ever fare
 Alone to Learning's chilly fount?
There is so much I long to share—
 I *love* the Little Things That Count!

 —BURGES JOHNSON

Ballade, type II, (ababbccdcd, ababbccdcd, ababbccdcd, ccdcd).— Three stanzas of ten lines each, and an envoy of five lines. There are four rhyme-sounds, and a refrain-line appears at the end of each stanza:

VILLON QUITS FRANCE

"Demain tous nous mourrons; c'est juste notre affaire."
—*Theodore Passerat*

We hang tomorrow then? That doom is fit
For most of us, I think. Yet, harkee, friend,
I have a ballad here which I have writ
Of us and our high ending. Pray you, send
The scrawl to Cayeux, bidding him commend
Francois to grace. Old Colin loves me well,
For no good reason, save it so befell
We two were young together . . . when I am hung,
Colin will weep—and then will laugh, and tell
How many pranks we played when we were young.

Dear lads of yesterday! . . . We had no wit
To live always so we might not offend,
Yet—how we laughed! I marvel now at it,
Because that merry company will spend
No more mad nights together. Some are penned
In abbeys, some in dungeons, others fell
In battle . . . Time assesses Death's *gabelle*,—
Salt must be taxed, eh?—well, we ranked among
The salt of earth, once, who are old and tell
How many pranks we played when we were young.

Afraid to die, you ask?—Why, not a whit.
Ah, no! whole-heartedly I mean to wend
Out of a world I have found exquisite
By every testing. For I apprehend
Life was not made all lovely to the end
That life ensnare us, nor the miracle
Of youth devised but as a trap to swell
Old Legion's legions; and must give full tongue
To praise no less than prayer, when bidden tell
How many pranks we played when we were young.

Nay, cheerily, we of the Cockle-shell,
And all whose youth was nor to stay nor quell,
Will dare foregather when earth's knell is rung,
And Calvary's young conqueror bids us tell
How many pranks we played when we were young.

—JAMES BRANCH CABELL

The Double Ballade [ababbcbc, ababbcbc, ababbcbc, ababbcbc, ababbcbc, ababbcbc (bcbc); or ababbccdcd, ababbccdcd, ababbccdcd, ababbccdcd, ababbccdcd, ababbccdcd (ccdcd)].—Six stanzas of either eight or ten lines each, similar in rhyme-scheme to the ballade, but with or without an envoy:

DOUBLE BALLAD
Of the Singers of the Time

I

Why are our songs like the moan of the main,
 When the wild winds buffet it to and fro,
(Our brothers ask us again and again)
 A weary burden of hopes laid low?
 Have birds ceased singing or flowers to blow?
Is Life cast down from its fair estate?
 This I answer them—nothing mo'—
Songs and singers are out of date.

II

What shall we sing of? Our hearts are fain,
 Our bosoms burn with a sterile glow.
Shall we sing of the sordid strife for gain,
 For shameful honour, for wealth and woe,
 Hunger and luxury,—weeds that throw
Up from one seeding their flowers of hate?
 Can we tune our lutes to these themes? Ah no!
Songs and singers are out of date.

III

Our songs should be of Faith without stain,
 Of haughty honour and deaths that sow
The seeds of life on the battle-plain,
 Of loves unsullied and eyes that show
 The fair white soul in the deeps below.
Where are they, these that our songs await
 To wake to joyance? Doth any know?
Songs and singers are out of date.

IV

What have we done with meadow and lane?
 Where are the flowers and the hawthorn-snow?
Acres of brick in the pitiless rain,—
 These are our gardens for thorpe and stow!
 Summer has left us long ago,
Gone to the lands where the turtles mate
 And the crickets chirp in the wild-rose row.
Songs and singers are out of date.

V

We sit and sing in a world in pain;
 Our heartstrings quiver sadly and slow:
But, aye and anon, the murmurous strain
 Swells up to a clangour of strife and throw,
 And the folk that hearken, or friend or foe,
Are ware that the stress of the time is great
 And say to themselves, as they come and go,
Songs and singers are out of date.

VI

Winter holds us, body and grain:
 Ice is over our being's flow;
Song is a flower that will droop and wane,
 If it have no heaven towards which to grow.
 Faith and beauty are dead, I trow
Nothing is left but fear and fate:
 Men are weary of hope; and so
Songs and singers are out of date.

—John Payne

Ballade with a double refrain (ababbcbc, ababbcbc, ababbcbc, bbcc).—Three stanzas of eight lines each, with an envoy of 4 lines; the lines 4, 12, 20 and 26 are alike; and 8, 16, 24 and 28:

THE BALLADE OF PROSE AND RHYME
(Ballade a double refrain)

When the roads are heavy with mire and rut,
 In November fogs, in December snows,
When the North Wind howls, and the doors are shut,
 There is place and enough for the pains of prose;—
 But whenever a scent from the whitethorn blows,
And the jasmine-stars to the casement climb,
 And a Rosalind-face at the lattice shows,
Then hey!—for the ripple of laughing rhyme!

When the brain gets dry as an empty nut,
 When the reason stands on its squarest toes,
When the mind (like a beard) has a "formal cut,"
 There is place and enough for the pains of prose;—
 But whenever the May-blood stirs and glows,
And the young year draws to the "golden prime,"—
 And Sir Romeo sticks in his ear a rose,
Then hey!—for the ripple of laughing rhyme!

In a theme where the thoughts have a pedant-strut
 In a changing quarrel of "Ayes" and "Noes,"
In a starched procession of "If" and "But,"
 There is place and enough for the pains of prose;—
 But whenever a soft glance softer grows,
And the light hours dance to the trysting-time,
 And the secret is told "that no one knows,"
Then hey!—for the ripple of laughing rhyme!

ENVOY

In the work-a-day world,—for its needs and woes,
There is place and enough for the pains of prose;
But whenever the May-bells clash and chime,
Then hey!—for the ripple of laughing rhyme!

 —AUSTIN DOBSON

Chant royal (ababccddede, ababccddede, ababccddede, ababccddede, ababccddede, ddede).—Five stanzas of eleven lines each, with an envoy of five lines. Only five rhyme-sounds are permitted. The final line of the first stanza is repeated as a refrain at the end of each following stanza and envoy:

CHANT-ROYAL OF THE TRUE ROMANCE

Romance is dead, say some, and so, to-day,
 Honour and Chivalry are faint and cold;
And now, Adventure has no modern way
 To stir the blood, as in the days of old.
They mourn the times of Gallantry as done,
Knighthood has seen the setting of its sun,
And fairy, nymph and genie, grown too shy,
No more, in these new lands, hold revel high;
 There lives no mystery, now, and they cry woe
To this old world, so twisted and awry!
 Romance is dead, say some; but I say No!

Haroun-al-Raschid, so the sceptics say,
 Would seek in vain for sights his book has told—
Crusoe could find no island far away
 Enough, his life with glamour to enfold—
Ulysses now might rove, nor fear to run
The risks of perils Homer's fable spun—
And Hiawatha's white canoe would try
In vain to find some beach, whence to descry
 The hunting-grounds where once he bent his bow.
Gone are the Halcyon Days, they sadly sigh;
 Romance is dead, say some; but I say No!

Not while the ancient sea casts up its spray
 Upon the laughing beach, and I behold
The myriad dancing ripples of the bay
 Speed out to meet the sunset's robe of gold;
Not till the last ship's voyage has begun;
Not till the storm god's lightnings cease to stun!
Not till the mountains lift no more to sky
Their secret fastnesses, and forests vie
 No more with winds and mists, with sun and snow,
And rustling fields no more to streams reply!
 Romance is dead, say some; but I say No!

Not while the Night maintains her mystic sway,
 And conjures, in the haunted wood and wold,
Her eerie shadows, fanciful and fey,
 With priests of Darkness, pale and sombre-stoled;
Not while upon the Sea of Dreams are won
Strange ventures, escapades, and frolic fun;
Where tricksy phantoms, whimsically sly,
Order your deeds, you know not how nor why;
 Where Reason, Wit, and Conscience drunken go.
Have you e'er dreamed, and still can question? Fie!
 Romance is dead, say some; but I say No!

Not while Youth lives and Springtime bids be gay!
 Not while love blooms, and lovers dare be bold!
Not while a poet sings his roundelay,
 Or men by maiden's kisses are cajoled!
You have not seen her, or you, too, would shun
The thought that in this world Romance there's none;
For oh, my Love has power to beautify

My whole life long, and all its charm supply;
 My bliss, my youth, my dreams, to her I owe!
And so, ye scornful cynics, I deny;
 Romance is dead, say some; but I say No!

ENVOY

God, keep my youth and love alive, that I
May wonder at this world until I die!
 Let sea and mountain speak to me, that so,
Waking or sleeping, I may fight the lie;
 Romance is dead, say some; but I say No!

 —GELETT BURGESS

Villanelle (aba, aba, aba, aba, aba, abaa).—Five stanzas of three lines each, and a final stanza of 4 lines. Only two rhyme-sounds are permitted throughout. The first and third lines in the first stanza are refrain lines. Line 1 reappears at the end of the second and fourth stanzas and as the third line in the sixth stanza; line 3 reappears at the end of the 3rd, 5th and 6th stanzas.

Ingenious and musical, this form has been a vehicle throughout four centuries for light and dainty fancies, with a few notable examples of verses with a serious, mystical or religious purport:

ON A NANKIN PLATE

"Ah me, but it might have been!
Was there ever so dismal a fate?"—
Quoth the little blue mandarin.

"Such a maid as was never seen!
She passed, tho' I cried to her, 'Wait,'—
Ah me, but it might have been!

"I cried, 'O my Flower, my Queen,
Be mine!' 'Twas precipitate,"—
Quoth the little blue mandarin,—

"But then . . . she was just sixteen,—
Long-eyed,—as a lily straight,—
Ah me, but it might have been!

"As it was, from her palankeen,
She laughed—'You're a week too late!'"
(Quoth the little blue mandarin.)

"That is why, in a mist of spleen,
I mourn on this Nankin Plate.
Ah me, but it might have been!"—
Quoth the little blue mandarin.
 —AUSTIN DOBSON

FOR A COPY OF THEOCRITUS

O singer of the field and fold,
Theocritus! Pan's pipe was thine,—
Thine was the happier Age of Gold.

For thee the scent of new-turned mould,
The bee-hives, and the murmuring pine,
O Singer of the field and fold!

Thou sang'st the simple feasts of old,—
The beechen bowl made glad with wine . . .
Thine was the happier Age of Gold.

Thou bad'st the rustic loves be told,—
Thou bad'st the tuneful reeds combine,
O Singer of the field and fold!

And round thee, ever-laughing, rolled
The blithe and blue Sicilian brine . . .
Thine was the happier Age of Gold.

Alas for us! Our songs are cold;
Our Northern suns too sadly shine:—
O Singer of the field and fold,
Thine was the happier Age of Gold!
 —AUSTIN DOBSON

Rondel, type I, [ABab; baAB; ababAB (the capitals indicate identical lines)]. A poem of fourteen lines in which a two-line refrain appears three times. Various rhyme orders may be followed so long as only two rhyme-sounds are used, and the two refrain-lines.

"Rondel" is an earlier form of the word rondeau, just as the final crystallized forms of these two French lyrics are closely allied. Originally the rondel was a song for a round dance, and it is as ancient as the ballade. Both the rondel and the rondeau have undergone many changes, and only the final forms are illustrated here. In 1597 the

rondeau was actually banished from French literature by a papal
bull, in favor of the sonnet. But it returned to become a vehicle of the
graceful fancies of some of the greatest French and English poets:

READY FOR THE RIDE—1795

Through the fresh fairness of the Spring to ride,
 As in the old days when he rode with her,
With joy of Love that has fond Hope to bride,
 One year ago had made her pulses stir.
 Now shall no wish with any day recur
(For Love and Death part year and year full wide),
Through the fresh fairness of the Spring to ride,
 As in the old days when he rode with her.

No ghost there lingers of the smile that died
 On the sweet pale lip where his kisses were—
Yet still she turns her delicate head aside,
 If she may hear him come, with jingling spur—
Through the fresh fairness of the Spring to ride,
 As in the old days when he rode with her.

 —H. C. BUNNER

Rondel, type II, [ABba, abAB, abbaA (the capitals indicate identi-
cal lines)].—Thirteen lines in which a two-line refrain appears twice
in the first eight lines; and the first line reappears, generally with
new meaning, as a final line. Only two rhyme-sounds may be used.

RONDEL OF PERFECT FRIENDSHIP

Friend of my soul, forever true,
 What do we care for flying years,
 Unburdened all by doubts or fears,
Trusting what naught can e'er subdue?

Fate leads! Her path is out of view;
 Nor time nor distance interferes!
Friend of my soul, forever true,
 What do we care for flying years?

For, planted when the world was new,
 In other lives, in other spheres,
 Our love today a bud appears—
Not yet the blossom's perfect hue,
Friend of my soul, forever true!

 —GELETT BURGESS

THE WANDERER

Love comes back to his vacant dwelling,—
 The old, old Love that we knew of yoreel!
 We see him stand by the open door,
With his great eyes sad, and his bosom swling.

He makes as though in our arms repelling,
 He fain would lie as he lay before;—
Love comes back to his vacant dwelling,—
 The old, old Love that we knew of yore!

Ah, who shall help us from over-spelling
 That sweet, forgotten, forbidden lore!
 E'en as we doubt in our heart once more,
With a rush of tears to our eyelids welling,
Love comes back to his vacant dwelling.
 —AUSTIN DOBSON

Rondeau, type I, aabba, aabC, aabbaC (C indicates a repeated unrhymed refrain)]. Fifteen lines in which the first part of the first line serves as an unrhymed refrain, lines 9 and 15. Only two rhyme-sounds and refrain, which generally contains a play on meaning:

LES MORTS VONT VITE

Les morts vont vite: The dead go fast!
So runs the motto France has cast.
 To nature man must pay his debt;
 Despite all struggle, despite all fret,
He journeys swift to the future vast.

It needs no ghost from out the past,
To make mere mortals stand aghast,—
 To make them dream of death—and yet
 Les morts vont vite.

Although the sails (bellowed by blast)
Of Charon's bark may strain the mast—
 The dead are not dead while we regret;
 The dead are not dead till we forget;
But true the motto, or first or last:
 Les morts vont vite.
 —BRANDER MATTHEWS

RONDEAU

Thou fool! if madness be so rife,
That, spite of wit, thou'lt have a wife,
I'll tell thee what thou must expect—
After the honeymoon neglect,
All the sad days of thy whole life;

To that a world of woe and strife,
Which is of marriage the effect—
And thou thy woe's own architect,
 Thou fool!

Thou'lt nothing find but disrespect,
Ill words i' th' scolding dialect,
For she'll all tabor be, or fife;
Then prythee go and whet thy knife,
And from this fate thyself protect,
 Thou fool!
 —COTTON (17th Cent.)

Rondeau, type II, [abbaabC; abbaC (C indicates a one-word refrain, which also appears as the first word in the first line)]. Twelve lines, but the 7th and 12th lines are but a single word, which was the first word in the poem. Here also a play on meanings is desired:

A RONDEL OF MYSTERY

Blood on the moon, and the breakers roar—
 And a villa near where a ship was wrecked—
 And a diagram by its architect—
And sets of footprints along the shore.
An old man guarding his golden store—
 And eager readers who all expect
 Blood.

A stain—a grain of sand on the floor—
 A hearth with curious ashes flecked;
Clues that only His eyes detect.
 WHAT'S THAT CREEPING BENEATH THE DOOR?
 BLOOD!
 —B. J.

Rondeau Redoublé [abab baba abab baba abab baba c (c indicates the first phrase of the first line)].—Six stanzas of four lines each, with a reappearance, as a refrain, at the end of the poem, of the first words of the opening line. Only two rhyme-sounds may be used:

A DAUGHTER OF THE NORTH

Who wins my hand must do these three things well:
 Skate fast as winter wind across the glare;
Swim through the fiord, past breaker, rip and swell;
 Ride like the Storm Fiend on my snow-white mare!

Shall a maid do what Viking may not dare?
 I wed no lover I can aught excel—
Skate, swim and ride with me, and I declare,
 Who wins my hand must do these three things well!

Bind on your skates, and after me pell-mell;
 Follow me, Carles, and catch my streaming hair!
(Keep the black ice—O Bolstrom, if you fell!)
 Skate fast as winter wind across the glare!

Thrice have I swum from this grey cliff to where
 On the far side, the angry surges yell;
(Into the surf! O Bolstrom, have a care!)
 Swim through the fiord, past breaker, rip and swell!

Bring out my Frieda, none but I can quell;
 (Watch her eye, Bolstrom, when you mount—beware!)
Ride bareback now and find the master-spell;
 Ride like the Storm Fiend on my snow-white mare!

Skohl! Vikings, Skohl! Am I not bold and fair?
 Who would not barter Heaven, and venture Hell,
Striving the flower of my love to wear?
 (Mind my words, Bolstrom, hark to what I tell!)
 Who wins my hand?
 —Gelett Burgess

Roundel [abaB; bab; abaB (capital letter indicates repeated line)].—
The *roundel*, as distinct from *rondel*, uses as a refrain the first part of

the first line, but it must have the rhyme-sound of b. Swinburne favored a line of six feet with frequent anapaests:

NORTH-EASTER

The north wind blows; the air is filled with spray,
The light within the beacon ebbs and glows,
A sailor's wife stops from her work to pray;
The north wind blows.

The night is bitter cold, and no one knows
What happenings will come when winters flay
The windward coast. Hark! how the tempest throws
The waves against the shore in cruel play;
Waves mountain high in endless, foamy rows.
Invader, screaming in his lust to slay,
The north wind blows.

—C. J.

A ROUNDEL

I love to write these little Gallic things;
 They do not call for matter erudite,
And though the words be crude, the meter sings
 I love to write.
But when some pleasing fancy *does* alight
 Upon my pen, what happiness it brings!
Swift thoughts rush out to meet it, phrased aright;
 Each after each in rhythmic order swings.
Until my form's complete,—all poised for flight,
 Then all my words are lifted up on wings.
I love to write!

—Burges Johnson

HATE

Hate is a cruel thing,
Cometh it soon or late,
Nought of joy doth it bring,
Hate.

Dark as the Nordic Fate,
Black as the raven's wing,
Hidden it lies in wait;

Only death can it bring
To the heart insensate
Sinfully sheltering
Hate!

—C. J.

Triolet [ABaAabAB (capital letters indicate the "refrain" or duplicated lines)].—One stanza of eight lines, in which lines 1 and 2 are repeated in 7 and 8. Line 1 also is repeated as line 4:

ROSE-LEAVES

"Sans peser.—Sans rester."

A KISS

Rose kissed me to-day.
 Will she kiss me to-morow?
Let it be as it may,
Rose kissed me to-day.
But the pleasure gives way
 To a savour of sorrow;—
Rose kissed me to-day,—
 Will she kiss me to-morrow?

CIRCE

In the School of Coquettes
 Madam Rose is a scholar:—
O, they fish with all nets
In the School of Coquettes!
When her brooch she forgets
 'Tis to show her new collar;
In the School of Coquettes
 Madam Rose is a scholar!

A TEAR

There's a tear in her eye,—
 Such a clear little jewel!
What *can* make her cry?
There's a tear in her eye.
"Puck has killed a big fly,—
 And it's *horribly* cruel";

There's a tear in her eye,—
Such a clear little jewel!

A GREEK GIFT

Here's a present for Rose,
 How pleased she is looking!
Is it verse?—is it prose?
Here's a present for Rose!
"*Plats*," *Entrées*," and "*Rots*,"—
 Why, it's "Gouffe on Cooking"!
Here's a present for Rose,
 How pleased she is looking!

"URCEUS EXIT"

I intended an Ode,
 And it turned to a Sonnet.
It began *à la mode*,
I intended an Ode;
But Rose crossed the road
 In her latest new bonnet;
I intended an Ode;
 And it turned to a Sonnet.

—AUSTIN DOBSON

UNDER THE ROSE

HE (*aside*)

If I should steal a little kiss,
 Oh, would she weep, I wonder?
I tremble at the thought of bliss,—
If I should steal a little kiss!
Such pouting lips would never miss
 The dainty bit of plunder;
If I should steal a little kiss,
 Oh, would she weep, I wonder?

SHE (*aside*)

He longs to steal a kiss of mine—
 He may, if he'll return it:
If I can read the tender sign,
He longs to steal a kiss of mine;

"In love and war"—you know the line
Why cannot he discern it?
He longs to steal a kiss of mine—
He may if he'll return it.

BOTH (*five minutes later*)
A little kiss when no one sees,
Where is the impropriety?
How sweet amid the birds and bees
A little kiss when no one sees!
Nor is it wrong, the world agrees,
If taken with sobriety.
A little kiss when no one sees,
Where is the impropriety?

—SAMUEL MINTURN PECK

Oh, that men would praise the Lord
For his goodness unto men!
Forth he sends his saving word,
—Oh, that men would praise the Lord!—
And from shades of death abhorred
Lift them up to life again;
Oh, that men would praise the Lord
For his goodness unto men.

—GEORGE MACDONALD

THE TRIOLET

Your triolet should glimmer
Like a butterfly;
In golden light, or dimmer,
Your triolet should glimmer,
Tremble, turn, and shimmer,
Flash, and flutter by;
Your triolet should glimmer
Like a butterfly.

—DON MARQUIS

Sestina (ababab, bababa, ababab, bababa, ababab, bababa, bab).—
This ingenious form was first "invented" in the twelfth century. Its
distinguishing characteristic is a rearrangement of the final words
of the six lines of the first stanza as the final words in succeeding
stanzas, but no two arrangements are alike. Numbering the final

words of the first stanza 1 to 6, the final word schemes of each of the six stanzas must be as follows:

<div align="center">

1-2-3-4-5-6

6-1-5-2-4-3

3-6-4-1-2-5

5-3-2-6-1-4

4-5-1-3-6-2

2-4-6-5-3-1

</div>

The envoi (or tornada) contains all of these ending-words, arranged as follows: 2 in middle of first line; 5 at end of first line; 4 in middle of second line, and 3 at end; 6 in middle of third line and 1 at end. The sestina is frequently unrhymed, though with perfect rhythm:

SESTINA OF YOUTH AND AGE

My father died when I was all too young,
And he too old, too crowded with his care,
For me to know he knew my hot fierce hopes;
Youth sees wide chasms between itself and Age—
How could I think he, too, had lived my life?
My dreams were all of war, and his of rest.

And so he sleeps (please God), at last at rest,
And, it may be, with soul refreshed, more young
Than when he left me, for that other life—
Free, for a while, at least, from that old Care,
The hard, relentless torturer of his age,
That cooled his youth, and bridled all his hopes.

For now I know he had the longing hopes,
The wild desires of youth, and all the rest
Of my ambitions ere he came to age;
He, too, was bold, when he was free and young—
Had I but known that he could feel, and care!
How could I know the secret of his life?

In my own youth I see his early life
So reckless, and so full of flaming hopes—
I see him jubilant, without a care,
The days too short, and grudging time for rest;
He knew the wild delight of being young—
Shall I, too, know the calmer joys of age?

His words come back, to mind me of that age
When, livingly, he watched my broadening life—
And, dreaming of the days when he was young,
Smiled at my joys, and shared my fears and hopes.
His words still live, for in my heart they rest,
Too few not to be kept with jealous care!

Ah, little did I know how he could care!
That, in my youth, lay joys to comfort age!
Not in this world, for him, was granted rest,
But as he lived, in me, a happier life,
He prayed more earnestly to win my hopes
Than ever for his own, when he was young!

ENVOI

He once was young; I too must fight with Care;
He knew my hopes, and I must share his age;
God grant my life be worthy, too, of rest!
—Gelett Burgess

THE CONQUEROR PASSES

"Non dormatz plus! les messatges de douz pascor"
—Raimbaut de Vaqueiras

Awaken! for the servitors of Spring
Proclaim his triumph! oh, make haste to see
With what tempestuous pageantry they bring
The victor homeward! haste, for this is he
That cast out Winter, and all woes that cling
To Winter's garments, and bade April be!

And now that Spring is master, let us be
Content, and laugh as anciently in spring
The battle-wearied Tristan laughed, when he
Was come again Tintagel-ward, to bring
Glad news of Arthur's victory—and see
Ysoude, with parted lips that waver and cling.

Not yet in Brittany must Tristan cling
To this or that sad memory, and be
Alone, as she in Cornwall; for in spring
Love sows against far harvestings,—and he
Is blind, and scatters baleful seed that bring
Such fruitage as blind Love lacks eyes to see.

Love sows, but lovers reap; and ye will see
The loved eyes lighten, feel the loved lips cling,
Never again when in the grave ye be
Incurious of your happiness in spring,
And get no grace of Love there, whither he
That bartered life for love no love may bring.

No braggart Heracles avails to bring
Alcestis hence; nor here may Roland see
The eyes of Aude; nor here the wakening spring
Vex any man with memories; for there be
No memories that cling as cerements cling,
No force that baffles Death, more strong than he.

Us hath he noted, and for us hath he
An hour appointed; and that hour will bring
Oblivion,—Then laugh! Laugh, dear, and see
The tyrant mocked, while yet our bosoms cling,
While yet our lips obey us, and we be
Untrammeled in our little hour of spring!

Thus in the spring we jeer at Death, though he
Will see our children perish, and will bring
Asunder all that cling while love may be.
—JAMES BRANCH CABELL

Double Sestina: twelve stanzas of twelve lines each, with a six-line envoy. This is a *tour de force* so elaborate and difficult that few poets other than Swinburne have attempted it. Obviously, twelve final words rather than six are required, and are found in twelve different arrangements in the successive stanzas. Swinburne, in "The Complaint of Lisa," not only accomplishes this, but does it with the added complication of rhyme. Because of its length, the example will not be reprinted here.

The *pantoum* (also *pantun*) is a fixed verse form originating in the Malay Peninsula as a song or chanty, and coming to England by way of France, where Victor Hugo gave it dignity in his *Orientales*.

The pantoum has an indefinite number of stanzas. Its rigidity lies in the fact that the final line of the poem is identical with the opening

line. Stanzas are of four lines each, and the second and fourth line of each stanza become the first and third of the next. In the final stanza the fourth line is identical with the first line of the first stanza. "In Town" by Austin Dobson is a sufficient illustration. Other worthwhile examples are equally long.

> Toiling in Town is "horrid,"
> (There is that woman again!)
> June in the zenith is torrid,
> Thought gets dry in the brain.
>
> There is that woman again:
> "Strawberries! fourpence a pottle!"
> Thought gets dry in the brain;
> Ink gets dry in the bottle.
>
> "Strawberries! fourpence a pottle!"
> Oh for the green of a lane!—
> Ink gets dry in the bottle;
> "Buzz" goes a fly in the pane!
>
> Oh, for the green of a lane,
> Where one might lie and be lazy!
> "Buzz" goes a fly in the pane;
> Bluebottles drive me crazy!
>
> Where one might lie and be lazy,
> Careless of Town and all in it!—
> Bluebottles drive me crazy:
> I shall go mad in a minute!
>
> Careless of Town and all in it,
> With some one to soothe and to still you;—
> I shall go mad in a minute;
> Bluebottle, then I shall kill you!
>
> With some one to soothe and to still you,
> As only one's feminine kin do,—
> Bluebottle, then I shall kill you:
> There now! I've broken the window!

As only one's feminine kin do,—
　　Some muslin-clad Mabel or May!—
There now! I've broken the window!
　　Bluebottle's off and away!

Some muslin-clad Mabel or May,
　　To dash one with eau de Cologne;—
Bluebottle's off and away!
　　And why should I stay here alone!

To dash one with eau de Cologne,
　　All over one's eminent forehead;—
And why should I stay here alone!
　　Toiling in Town now is "horrid."
　　　　　　　　　　　　　　—AUSTIN DOBSON

OTHER FIXED FORMS

The various fixed lyric forms illustrated on preceding pages, though originating in France and Italy, have become naturalized. They are English forms. Interest in them has waxed and waned throughout the centuries and one may safely assert that it will continue to do so. Each one provides a certain "melody" which may add to the beauty or charm of the poetic thoughts which the poet has fitted into it.

On the other hand it is possible for the poet to choose a form or a rhythm which does not harmonize with his poetic mood. Some meters dance in jig time and do not harmonize with solemn thoughts. Dactylic lines are too rollicking for dirges, as one must realize when reading Hood's

"Take her up tenderly, lift her with care,
Fashioned so slenderly, young and so fair."

Or O. W. Holmes's

Slowly the mist o'er the meadow was creeping,
　　Bright on the dewy buds glistened the sun,
When from his couch, while his children were sleeping,
　　Rose the bold rebel and shouldered his gun.

The fact that although many of these forms are centuries old, our children are still reciting poems set to their measure, and poets are still making good use of them, gives assurance that they will not die. Other forms from the literature of Spain and Portugal have now and then been put to English use, and enthusiastic versifiers may yet

popularize them in English; a few less common forms from the French also deserve place here.

The *rondelet* has been used by many poets, but the form is so obviously a simplification of the rondel and the rondeau that it lacks their distinction.

RONDELET

I wish I knew
 Which dress I want to wear tonight!
I wish I knew
Whether to wear the pink or blue.
 Does pink look well by evening light?
 He said he liked me best in white.
I wish I knew!

<div align="right">CONSTANCE JOHNSON</div>

Another form, even more simple, is the *lai*. This is a series of three-line stanzas, as many as desired, but in the entire poem there are but two rhyme-sounds. Each stanza is composed of a couplet and a short line two syllables in length.

LE LAI

La grandeur humaine
Est une ombre vaine
 Qui fuit;
Une ame mondaine,
A perte d'haleine
 La suit.

LAI

Success is a folly,—
Come, let us be jolly,
 Content!
Go hence, Melancholy,
Though we haven't, by golly,
 A cent!

The *virelai* is more elaborate, yet it is so natural a form that it has often appeared without the author's consciousness that he was following a classic model.

A VIRELAY

Thou cruel fair, I go
To seek out any fate but thee,
Since there is none can wound me so,
Nor that has half thy cruelty;
 Thou cruel fair, I go.

Forever, then, farewell,
'Tis a long leave I take, but oh!
To tarry with thee here is hell,
And twenty thousand hells to go;
 For ever, then, farewell.

<div align="right">CHARLES COTTON (17th Cent.)</div>

All of the lyric forms thus far illustrated have a certain perfection and dignity due to their ancient tradition. But there is nothing to prevent our modern poets from arranging new forms to suit a mood, and many have done so.

It is evident, for instance, that the possible varieties of the sextet are many, and of the septet and octet, and the possible varieties of the nine-line stanza seem numberless. Any verse writer who wishes to combine a sextet and an octet so as to make a unified whole with a limited number of rhyme sounds is not prevented from doing so merely because the sonnet has given the dignity of tradition to one and another combination of that sort.

Gelett Burgess had especial praise for one twelve-line form which he chose to call the *douzet*. Here is an approved example contributed to Franklin P. Adams's column. The rhyme scheme is abba cddc abdc.

A STANZA

Into Chapala, when, with banners streaming,
 Day's leader stood triumphant on the hills,
Duquesne rode laughing. When the valley fills
These dawns of March with slow white fountains steaming
Out of the yellow lake, could I forget
 How he rode down between the gloomy boulders
 Where crookedly the quartz vein gleams and smoulders
Like topaz? Dancing rawhides twinkle wet—
Star grass has caught his stirrup—lather creaming
 Over the girths—a West of daffodils,
 And dazzling as the heron's crystal shoulders
 The teeth that hold a fainting cigarette.
 —Marian Storm

Inner Rhymes

Future poetasters may find names for some of those forms which depend for their novelty and individuality upon inner rhymes. Thomas Hood offered proof of his skill as a rhymester in this field when he wrote "A Nocturnal Sketch," quoted here in part:

Even is come; and from the dark Park, hark,
The signal of the setting sun—one gun!
. .
Now thieves do enter for your cash, smash, crash,
Past drowsy Charley in a deep sleep, creep,
But frightened by Policeman B 3, flee,
And while they're going, whisper low, "No go!"

Rhyme and rhythm are musical devices of equal value to the poet or rhymester who wishes his words to sing. But it seems to be a fact that our present-day verse writers have applied their ingenuity even more to rhyme than to inventing new patterns of rhythm. Inner rhymes, rhymes suddenly injected as pleasant surprises, skillfully manufactured rhymes where any rhyme at all seems impossible— these are characteristic of the light verse of today.

Ogden Nash, for instance, substitutes enormity for conformity and wins the allegiance of lovers of nonsense. As, for instance, the following:

<div align="center">

"TOMORROW, PARTLY CLOUDY" [1]

(incomplete)

</div>

Rainy vacations
Try people's patience.
To expect rain in the autumn
Experience has tautumn,
And rain in the spring and winter
Makes no stories for the printer,
But rain on summer colonies
Breeds misdemeanors and felonies.
Summer cottages are meant just to sleep in,
Not to huddle all day in a heap in,
And whether at sea level or in higher places
There are not enough fireplaces,
And the bookcase stares at you starkly
And seems to be full of nothing but Volume II
 of the life of Rutherford B. Hayes, and The
 Rosary, by Florence M. Barclay . . .

On the other hand, Vachel Lindsay, a few years earlier, has a debauch of pure rhythm in his *Congo and Other Poems*. Both ignore the stanza.

Fat black bucks in a wine-barrel room,
Barrel-house kings with feet unstable,
Sagged and reeled and pounded on the table,
Pounded on the table,
Beat an empty barrel with the handle of a broom,
Hard as they were able,
Boom, boom, Boom,
With a silk umbrella and the handle of a broom,
Boomlay, boomlay, boomlay, Boom.

[1] Copyright 1942 by Ogden Nash.

NEW RHYMING DICTIONARY

৵৵

EDITOR'S NOTE: This dictionary is complete insofar as a sincere effort has been made to include all common rhyme-sounds, and to suggest technical vocabularies as well as words in common use. But the compiler well knows that no such collection could include all possible rhymes. For new words are added to our language from day to day in unknown numbers. They come in through the front door from other languages and from the laboratories of science and from factories where new foods and garments and gadgets are created and from the Patent Office; and also through the back door as one slang term after another becomes socially acceptable. There is no authoritative list of the new words added to our language in the past quarter century.

Nor is this dictionary a final authority as to true and false rhymes, since usage alone is the final authority, and pronunciation rather than spelling is the deciding factor as to rhyme. Where English and American usages differ, the American has been followed or else both are indicated. Where a rhyme is included which is not a legitimate dictionary word, but might be useful in any informal verse, it has been enclosed within quotation marks.

A few "manufactured" rhymes have been included by way of suggestion. By this term is meant the building of a rhyme such as "fail her" to rhyme with "sailor." Such rhymes are numberless and are found oftenest in humorous verse, such as the writings of W. S. Gilbert and Lewis Carroll and the *Ingoldsby Legends* (which provide a treasury of them), and in the verse of such outstanding rhymesters of today as Ogden Nash and Dorothy Parker. Even Browning and Swinburne found them useful.

But a rhyming dictionary must be as complete as possible to cut down the labors of a busy poet.

APOLOGY

I'd rather do rhymes of a morning betimes
Than anything else on the gamut of crimes.
Discursing with versing began with my nursing,
And chasing a metrical thought as it climbs
Is sweet, I repeat—why, e'en as I eat
The chewing I'm doing quite lyric'ly chimes.
Alas, what a pass! My head's a morass
Of singular jingular meters en masse.

Nor do they retreat at the noise of the street,
But tread through my head to the beat of my feet,
The while each particular ruption auricular
(Jars of the cars, or a hubbub vehicular)
Falls into line, as though by design,
To act as a dactyl or trochee of mine.
Ah me, you can see by the force of my plea,
How troublesome bubblesome meter may be.

One hint is enough for some stuff in the rough,
And I promptly advert to my shirt-sleeve or cuff;
A word I have heard that is odd, or a name
That's odder, is fodder for feeding the flame.
Also the vernacular adds a spectacular
Shine to a line that were otherwise tame.
This shows, I suppose, as far as it goes,
A skill with the quill quite unsuited to prose.

And so, when I'm hit by a rhythmical fit,
I rhyme against time, and I don't, I admit,
Disturb with a curb any verbular bit,
But build up upon it a sonnet or skit.
I never expect its course to direct,
But let it express its excesses unchecked.
'Tis better than drinking, to my way of thinking,
For others, not I, must endure the effect.

Forgive this smug praise of my ways, but for days
I've itched to be rich in reward for my lays;
And maybe I might, so much I indite,
If only I had some ideas when I write.

ONE-SYLLABLE RHYMES

A (*as in* ah)

ah	la	hurrah	shah
baa	ma	huzza	spa
fa	aha	mamma	pah
hah	faux pas	papa	

A (*as in* call), *see* Aw

A (*as in* say), *see* Ay

Ab

bab	contab	gab	nab
bedab	crab	grab	scab
blab	dab	lab	slab
cab	drab	jab	stab
confab	frab	mab	tab

Abe

abe	babe	astrolabe	outgrabe

Ac, Ack, Ak, Ach

alack	pack	aback	elegiac
arrack	pickaback	attack	cul-de-sac
back	rack	jimcrack	good-lack
black	ransack	knickknack	monomaniac
brack	sac	almanac	Union-jack
claque	sack	bric-a-brac	wool-back
crack	shack	cardiac	thrack
hack	slack	maniac	mocaque
hatchmatack	smack	zodiac	symposiac
haversack	snack	demoniac	ladybrack
huckaback	stack	hypochondriac	seawrack
jack	tack	salammoniac	tick-tack
knack	thwack	ammoniac	quack
lac	track	bivouac	wrack
lack	whack	chack	dipsomaniac
clack	repack	hysteriac	haystack
Polack	calpack	dionysiac	ipecac
shellac	iliac	slapjack	anzac
Sassenach	Frontenac	megalomaniac	yak
natterack	cognac	kayak	stickleback
anglomaniac	holdback	hunchback	skipjack
theriac	iliac	sumoniac	champak
kleptomaniac	Slovak	Cluniac	dyak
hogback	blackjack	*bootjack*, etc.	*knapsack*, etc.

Ace

ace	race	efface	retrace
base	space	embrace	underbrace
bass	trace	grimace	commonplace
brace	abase	unlace	vase
case	apace	interlace	thrace
chase	debase	interspace	carapace
dace	deface	*populace*	anelace
face	misplace	rebrace	begrace
grace	outface	unbrace	boniface
lace	outpace	enchase	chariot-race
mace	replace	discase	footpace
pace	disgrace	encase	fortlace
place	displace	erase	idocrase
plaice			

Ach, Atch

batch	scratch	dispatch	mismatch
catch	smatch	unlatch	overmatch
hatch	snatch	unattach	reattach
latch	thatch	cratch	brach
match	attach	scratch	butterhatch
patch	bandersnatch	slatch	tach
ratch	detach	swatch	

Ache, *see* Ake

Act

act	precontract	redact	retract
backed (*and*	(verb)	distract	diffract
past of verbs	pact	enact	subact
ending Ack)	tact	epact	subtract
fact	tract	exact	transact
fract	attract	extract	cataphract
intact	co-act	impact (verb)	cataract
contract (verb)	compact (adj.)	infract	counteract
entr'acte	*contact*	react	incompact
retroact	detract	protract	interact
interact	abstract (verb)	unbacked	anteact
matter-of-fact	re-enact	transact	

Ad

add	marinade	mad	winterclad
bad	superade	pad	yclad
bade	dad	plaid	bedad

Ad—(Cont.)

brad	fad	rad	ironclad
cad	gad	sad	olympiad
clad	glad	shad	scad
egad	had	unclad	englad
ivy-clad	lad	"undergrad"	*footpad*
pine-clad, etc.	forbade		

Ad (*as in* wad), *see* Od

Ade (*French*)

psha'd	façade	pomade	huzzaed
baa'd	couvade	promenade	estanfade
chamade	fougade	dragonnade	noyade
estrade	roulade	lancepesade	pavesade

Ade (*English*)

aid	slade	persuade	fusillade
blade	alcaid	escalade	gasconade
braid	pesade	galiconnade	lemonade
bayed (*and*	plantigrade	co-aid	marmalade
past of verbs	trade	pomade	escapade
ending Ay)	wade	harlequinade	gallopade
cade	afraid	sacrade	stockade
dade	arcade	pervade	parade
fade	blockade	relaid	ready-made
glade	brigade	repaid	rodomontade
grade	brocade	tirade	charade
jade	cascade	unlade	masquerade
lade	cockade	unpaid	overlaid
laid	crusade	unmade	pasquinade
made	decade	upbraid	renegade
maid	degrade	accolade	retrograde
paid	dissuade	ambuscade	serenade
raid	evade	barricade	underlaid
shade	grenade	bastinade	abraid
spade	inlaid	cannonade	ambassade
staid	invade	cavalcade	arquebusade
enfilade	obeyed	centigrade	balustrade
fanfaronade	parade	esplanade	bejade
camisade	*milkmaid*	defilade	passade
cassonade	croupade	flanconnade	pistolade
old maid	Damascus-	glissade	promenade
mermaid	blade	colonnade	

ADZE, ADS

adze adds (*add s to nouns and verbs ending* AD)

AFE

chafe waif vouchsafe
safe unsafe enchafe

AFF, APH (*either flat or broad* a)

chaff *riffraff* anagraph phonograph
gaff *tipstaff* autograph photograph
staff cenotaph chronograph cinematograph
carafe behalf cryptograph dictograph
calf epitaph draff lithograph
half paragraph flagstaff monograph
laugh quarterstaff heliograph penny-gaff
quaff actinograph idiograph shandygaff
distaff agraffe telegraph stenograph
giraffe

AFT (*either flat or broad* a)

aft haft handicraft chaffed (*and*
craft raft fellow-craft *past of verbs*
daft shaft overdraft *ending in*
draft waft river craft AFF *and*
draught abaft sea craft APH*)*
graft ingraft

AG

bag lag stag cag
brag nag swag fishfag
crag quag tag knag
drag rag wag *mag*
fag sag rag-tag saddle-bag
flag scrag zigzag scallowag
gag shag battle-flag shrag
hag slag bullyrag sprag
jag snag

AGE

age sage presage (verb) mid-age
cage stage disengage outrage
gage wage discage swage
gauge assuage foot-page weather-gauge

Age—(*Cont.*)

page	engage	mage	*cortége*
rage	enrage		

Age (*French*)

barage	menage	equipage	appanage

Age (*as* idg)

appanage	parentage	pilgrimage	anchorage
equipage	parsonage	villanage	arbitrage
foliage	pasturage	vicarage	average
heritage	patronage	concubinage	baronage
hermitage	personage	acreage	cartilage
beverage	brigandage	alienage	sacralage

Ail, Ale

ale	entail (verb)	swale	detail (verb)
bail	mail	tail	exhale
brail	male	tale	impale
dale	nail	trail	prevail
fail	pale	vale	regale
flail	pail	veil	retail (verb)
frail	quail	wail	unveil
gale	rail	wale	*wholesale*
gaol	sail	whale	countervail
grail	sale	assail	farthingale
hail	scale	avail	nightingale
hale	shale	*blackmail*	they'll
jail	snail	bewail	aventaile
kail	stale	curtail	bale
bepale	camail	canaille	engaol
countervail	death-pale	divale	martingale
engrail	*entrail*	fairy-tale	unveil
grisaille	inhale	interpale	vail
paravail	sliding-scale	taille	

Aim, Ame

ashame	dame	shame	exclaim
disfame	fame	tame	inflame
entame	flame	acclaim	misname
hame	frame	aflame	*nickname*
melodrame	game	became	proclaim
aim	lame	declaim	reclaim
blame	maim	defame	surname

Aim, Ame—(Cont.)

came	name	disclaim	overcame
claim	same		

Ain, Ane

aëroplane	inurbane	reign	abstain
alecampane	bane	rein	amain
allophane	blain	profane	arraign
ativain	brain	restrain	attain
bestain	cain	entertain	campaign
bower-thane	chain	sane	champagne
bridle-rein	crane	skein	complain
compane	deign	slain	regain
chamberlain	drain	sprain	sustain
chatelaine	fain	stain	constrain
chicain	fane	strain	detain
cocaine	feign	swain	disdain
counterpane	gain	ta'en	distrain
Dane	grain	thane	domain
delaine	lain	train	enchain
demain	lane	twain	explain
diaphane	main	refrain	henbane
frangipane	mane	retain	maintain
germane	pain	vain	obtain
humane	pane	vane	ordain
hurricane	plain	vein	pertain
hydroplane	plane	wain	remain
inane	rain	wane	appertain

Aint

ain't	plaint	attaint	bepaint
faint	quaint	complaint	besaint
feint	saint	constraint	daint
mayn't	taint	distraint	straint
paint	acquaint	restraint	

Air, Are, Aire

air	lair	tear	vin-ordinaire
bare	mare	their	forswear
bear	mayor	there	howe'er
blare	ne'er	ware	impair
care	pair	wear	prepare
chair	pare	were	repair
dare	pear	where	whate'er

AIR, ARE, AIRE—(*Cont.*)

e'er	*prayer*	yare	whene'er
ere	rare	affair	where'er
fair	scare	armchair	debonair
fare	share	aware	howsoe'er
flair	snare	beware	solitaire
flare	spare	co-heir	unaware
gare	square	compare	whatso'er
glair	stair	declare	millionaire
hair	sware	*elsewhere*	commissionaire
hare	swear	ensnare	concessionaire
heir	tare	forbear	anywhere
agre	backstair	bêche-de-mer	arrière
chargé	cockle-stair	mal de mer	capillaire
d'affaires	etagère	devil-may-care	doctrinaire
earthenware	outstare	jardinère	laissez-faire
maidenhair	sedan-chair	outwear	parterre
proletaire	underwear	thoroughfare	*threadbare*
unfair			

AIRD

laird	haired	bared (*and past of verbs ending in* ARE, AIR)

AIRS, ARES

theirs	unawares	airs (*and add s to nouns and verbs ending in* AIR, *etc.*)

AISE, AZE

chrysoprase	amaze	appraise	glaze
blaze	sideways	mayonnaise	craze
braise	paraphrase	daze	maize
graze	braze	laze	phase
haze	marseillaise	naze	raise
mays	chaise	praise	ablaze
phrase	maze	gaze	crase
rays (*and add s to nouns and verbs ending* AY, *etc.*)		paraphrase	raze

AIT, ATE (*long*)

bait	fate	great	plate
bate	freight	hate	prate
crate	gait	late	rate
date	gate	mate	sate
eight	grate	pate	skate

AIT, ATE (*long*)—(*Cont.*)

slate
spate
desecrate
dictate
execrate
fluctuate
glaciate
immigrate
liberate
navigate
obviate
percolate
proximate
state
straight
strait
wait
weight
abate
await
belate
collate
create
cremate
debate
dilate
elate
estate
frustrate
ingrate
innate
irate
migrate
narrate
orate
designate
dominate
fabricate
fulminate
graduate
implicate
liquidate

modulate
operate
permeate
punctuate
placate
prostrate
rebate
relate
sedate
translate
vacate
abdicate
abrogate
advocate
decorate
aggravate
agitate
alienate
animate (verb)
demonstrate
annotate
antedate
arbitrate
arrogate
aspirate (verb)
cachinnate
devastate
emanate
fascinate
fumigate
granulate
inficate
lubricate
mutilate
opiate
populate
relegate
calculate
candidate
captivate
castigate
celebrate

circulate
congregate
consecrate
contemplate
dedicate
cultivate
delegate
deprecate
derogate
decimate
desolate (verb)
dislocate
dissipate
educate
elevate
emigrate
emulate
deviate
excavate
flood-gate
germinate
gravitate
irrigate
masticate
obligate
osculate
procreate
abnegate
absinthiate
aërate
antiquate
compensate
consummate
criminate
saturate
situate
stimulate
supplicate
triturate
validate
venerate
estimate (verb)

generate
immolate
instigate
magistrate
perforate
potentate
reprobate
 (verb)
syndicate
 (verb)
titivate
ciolate
accommodate
anticipate
capitulate
communicate
contaminate
degenerate
 (verb)
discriminate
equivocate
exasperate
facilitate
importunate
 (verb)
invalidate
participate
premeditate
regenerate
excommunicate
acclamate
aggregate
approximate
concentrate
coronate
culminate
scintillate
speculate
stridulate
syncopate
undulate
variate

AIT, ATE (*long*)—(*Cont.*)

ventilate
extricate
hestitate
intimate (verb)
nominate
perpetrate
predicate
stipulate
temperate
(verb)
tolerate
abominate
accumulate
articulate
(verb)
coagulate
compassionate
(verb)
co-operate
deliberate
(verb)
elaborate
(verb)
eradicate
expectorate
felicitate
initiate
investigate
precipitate
(verb)
prevaricate
reiterate
incapacitate
emaciate
incriminate
actuate
alternate
cogitate
confiscate
correlate
renovate
segrate

spoliate
stylobate
syndicate
vaccinate
vassalate
verberate
formulate
hibernate
imprecate
irritate
oscillate
personate
propagate
subjugate
terminate
accelerate
adulterate
assassinate
commemorate
confederate
(verb)
corrobate
denominate
emancipate
evaporate
expostulate
illuminate
intimidate
matriculate
predestinate
(verb)
procrastinate
reverberate
candidate
illustrate
adulate
amputate
comminate
conjugate
corrugate
runagate
simulate

stellulate
sublimate
tabulate
vacillate
vegetate
vitiate
fornicate
imitate
innovate
inundate
penetrate
postulate
(verb)
regulate
suffocate
tête-à tête
vindicate
accentuate
annihilate
capacitate
commiserate
congratulate
debilitate
depopulate
emasculate
exaggerate
exterminate
impersonate
intoxicate
necessitate
predominate
recriminate
subordinate
(verb)
reprobate
depreciate
manipulate
orginate
prognosticate
recuperate
rejuvenate
retaliate

substantiate
abbacinate
acuminate
ameliorate
appreciate
associate
circumstantiate
delineate
deteriorate
disintegrate
ejaculate
enumerate
exhilarate
habituate
inaugurate
infatuate
inoculate
invigorate
negociate
perambulate
promulgate
refrigerate
remonstrate
reverberate
abbreviate
affiliate
annunciate
asphyxiate
authenticate
disseminate
eliminate
episcopate
expatiate
humiliate
incarcerate
infuriate
insinuate
irradiate
obliterate
perpetuate
recalcitrate
renumerate

Aɪᴛ, Aᴛᴇ (*long*)—(*Cont.*)

somnambulate	elucidate	luxuriate	vociferate
vituperate	evacuate	officiate	acidulate
ablaqueate	extenuate	preponderate	agglutinate
asseverate	hypothecate	reciprocate	apostolate
binoculate	incorporate	regurgitate	assimilate
consolidate	ingerminate	repudiate	captivate
differentiate	interpolate	sophisticate	decapitate
dissociate			

Aᴛᴇ (*short, as in* obstinate). *Sometimes used either as rhymes to* Aɪᴛ, Aᴛᴇ (*long*) *or* Iᴛ

accurate	articulate	obstinate	chocolate
adequate	(adj.)	separate (adj.)	federate
advocate	unfortunate	precipitate	inveterate
(noun)	intimate (adj.)	(adj.)	compassionate
animate (adj.)	intricate	predestinate	(adj.)
aspirate (noun)	literate	(adj.)	legitimate
temperate	moderate	inaminate	determinate
(adj.)	(adj.)	insatiate	agglomerate
syndicate	desperate	disconsolate	antepenulti-
(noun)	passionate	triumverate	mate
affectionate	illiterate	inveterate	appropriate
subordinate	immoderate	inviolate	collegiate
intemperate	importunate	undenominate	immaculate
celibate	(adj.)	invertebrate	inconsiderate
delicate	deliberate	certificate	laureate
desolate (adj.)	(adj.)	duplicate	regenerate
estimate	chalybeate	inadequate	effeminate
fortunate	postulate	intermediate	elaborate (adj.)
confederate	(noun)	obdurate	baccalaureate
(adj.)	predicate	inarticulate	conglomerate
considerate	(noun)	insubordinate	immediate
degenerate	profligate	commensurate	inebriate
(adj.)			

Aɪᴛʜ

baith	wraith	rathe	snathe
faith			

Aᴋᴇ

ache	break	fake	aslake
bake	cake	flake	johnnycake
brake	drake	hake	lake

AKE—(*Cont.*)

make	outbreak	corn-crake	partake
quake	stake	forsake	snowflake
rake	steak	daybreak	overtake
sake	take	keepsake	undertake
shake	wake	mandrake	heartbreak
slake	awake	mistake	wedding-cake
snake	bespake	*namesake*	stomach-ache
spake	betake	opaque	back-ache, etc.
crake			

AL (*flat*)

mall	corral	cabal	"musicale"
pal	shall	canal	madrigal
banal	morale		

AL (*short ending*), *false rhymes, sometimes used with either* AL *or* ALL

trivial	matinal	funeral	lyrical
animal	mythical	general	matronal
annual	optical	genial	nautical
arsenal	punctual	hospital	patronal
cannibal	rhythmical	inimical	quizzical
capital	spherical	initial	ritual
cardinal	virtual	interval	stoical
carnival	zodiacal	liberal	visional
clinical	pictorial	literal	piratical
comical	precautional	littoral	primordial
conical	recessional	madrigal	remedial
conjugal	sensational	magical	sophistical
corporal	empirical	mareschal	ephemeral
aboriginal	fanatical	medical	fantastical
allodial	harmonical	mineral	heretical
arborial	hysterical	academical	identical
conditional	inaugural	alluvial	industrial
conventional	memorial	baccharal	mercurial
dramatical	nonsensical	confessional	numerical
electrical	perennial	devotional	allegorical
aerial	economical	dynamical	energetical
caracal	intellectual	elliptical	oratorical
communal	reciprocal	cardinal	oratical
cynical	satirical	copal	hypercritical
ethical	hypocritical	destinal	national
firical	decimal	faldernall	natural
logical	festival	functional	pastoral

AL (*short ending*)—(*Cont.*)

pedestal
personal
physical
principal
prodigal
rational
seneschal
several
temporal
terminal
tragical
whimsical
asthmatical
colloquial
accentual
antiphonal
botanical
congressional
didactical
ecstatical
emotional
biblical
doctrinal
forcical
geminal
marginal
metrical
nominal
pictural
radical

sceptical
synchronal
visual
perpetual
platonical
professional
residual
symbolical
ethereal
funeral
heroical
illogical
intentional
methodical
occasional
architectural
immaterial
periodical
tyrannical
rheumatical
dogmatical
equinoctial
equivocal
hymeneal
hexagonal
imperial
impersonal
intellectual
municipal
octagonal

orginal
pentagonal
poetical
political
pragmatical
problematical
prophetical
affectional
antipodal
conclusional
conjectural
dilurial
effectual
admiral
boreal
clerical
cosmical
epical
federal
jovial
marital
mutual
notional
pivotal
retinal
scriptual
virginal
vortical
phenomenal
pontifical

pyramidal
sartorical
symmetrical
eventual
habitual
historical
imaginal
ironical
monarchical
pathetical
diabolical
individual
puritanical
rhetorical
schismatical
reciprocal
rhetorical
rheumatical
musical
oratorical
satirical
cortical
tyrannical
hypercritical
hypocritical
criminal
mystical
diaconal
diagonal

ALC

talc catafalque

ALD

bald bawled (*and* piebald so-called
balled *verbs ending* scald
 in ALL)

ALE, *see* AIL

ALF, *see* AFF

ALK, AUK, AWK

auk	awk	mawk	walk
balk	chalk	*Mohawk*	tomahawk
baulk	gawk	stalk	pawk
calk	hawk	talk	squawk

ALL, AUL, AWL

all	dwaul	scrawl	wherewithal
all-in-all	evenfall	sea-wall	yawl
awl	fall	shawl	appal
ball	footfall	*snowball*	enthral
bawl	forestall	small	*football*
befall	gall	spawl	install
bemawl	Gaul	sprawl	overhaul
Bengal	hall	squall	waterfall
brawl	haul	stall	*windfall*
call	*kraal*	tall	*blackball*
caterwall	mall	thrall	*baseball*
caul	maul	trawl	basket-ball
crawl	pall	wall	volley-ball, etc.
drawl	recall		

ALM

alm	calm	psalm	becalm
balm	palm	qualm	salaam

ALMS

alms psalms (etc.) *See* ALM

ALSE

false	valse	waltz	salts (*and add* s *to nouns and verbs in* ALT)

ALT (*short*)

alt	*asphalt*	shalt

ALT (*long*), **AULT**

fault	vault	exalt	somersault
halt	assault	basalt	spalt
malt	cobalt	envault	asphalt
salt	default	gault	

ALVE (*silent L*)

calve	enclave	*salve*	Zouave
halve	Slav	suave	

Alve (*L sounded*)

salve	valve

Am

am	jam	diagram	cham
cam	jamb	diaphragm	ma'am
clam	lam	epigram	nizam
cram	lamb	monogram	shram
dam	pram	oriflamb	slam
damn	ram	telegram	tram
dram	sham	parallelogram	yam
drachm	swam	*ad nauseam*	dithyramb
flam	anagram	auriflamme	gambe
gramme	cryptogam	cablegram	madame
ham	cryptogram	caimacam	salaam

Ame, *see* Aim

Amp

camp	gamp	stamp	encamp
champ	lamp	tramp	Davy's-lamp
clamp	ramp	vamp	samp
cramp	scamp	decamp	tamp
damp			

Amp (*as in* swamp) *see* Omp

An (*accented*)

an	japan	trepan	pavane
ban	rattan	unman	pecan
bran	sedan	anan	redan
can	pan	inspan	trapan
clan	plan	*merman*	caravan
fan	ran	van	also-ran
man	scan	flan	Castellan
began	span	khan	Catalan
divan	tan	superman	catamaran
foreran	than	orang-utan	

An (*short*), questionable rhymes, often used either with An or Un

alderman	clergyman	journeyman	oppidan
anglican	countryman	lighterman	ortolan
artisan	courtesan	merchantman	Ottoman
barbican	highwayman	midshipman	overman
barracan	husbandman	Mussulman	partisan
charlatan	juryman	nobleman	pelican

AN (short)—(Cont.)

publican	diocesan	liveryman	sacristan
puritan	African	Mohammedan	talisman
suffragan	Alcoran	Parmesan	Vatican
veteran	echinidan	American	republican
waterman	kaimakan	pemmican	

AN (as in swan and wan), see ON

ANCE, ANSE (long)

chance	stance	expanse	complaisance
dance	trance	intrance	perchance
glance	advance	mischance	entrance
lance	askance	romance	finance
manse	*elegance*	seance	bechance
prance	enhance	circumstance	

ANCE, ANSE (short); *questionable rhymes used with* ANCE, ENCE *or* UNCE

ambulance	temperance	concomitance	irrelevance
arrogance	utterance	continuance	luxuriance
consonance	vigilance	conversance	ordinance
countenance	deliverance	dominance	precipitance
dissonance	exorbitance	furtherance	preponderance
ignorance	extravagance	heritance	protruberance
maintenance	exuberance	impuissance	radiance
ordinance	inheritance	incogitance	suppliance
petulance	intemperance	incognisance	tolerance
sufferance	significance	inhabitance	variance
sustenance	appurtenance	intolerance	

ANCH

blanch	ganch	stanch	carte-blanche
branch	ranche	scranch	avalanche
flanch			

AND

and	land	disband	withstand
band	rand	expand	caravaned
bland	sand	fairyland	contraband
fanned	stand	aband	countermand
gland	strand	ampersand	deodand
grand	command	brand	reprimand
hand	demand	fatherland	understand

And—(*Cont.*)

wonderland	lotus-land	remand	banned, *and*
four-in-hand	multiplicand	sarabande	*past of verbs in* An

And (*as in* wand), *see* **Ond**

Ane, *see* **Ain**

Ang

bang	pang	swang	*mustang*
clang	rang	tang	boomerang
fang	sang	twang	sprang
gang	slang	harangue	orang-autang
hang	stang	meringue	zamang

Ange

change	range	arrange	exchange
grange	strange	estrange	interchange
mange			

Ank

bank	disrank	mountebank	slank
blank	drank	plank	spank
brank	enrank	point-blank	stank
cank	franc	prank	swank
chank	frank	rank	tank
clank	flank	sank	thank
crank	hank	shank	twank
dank	lank	shrank	

Anse, *see* **Ance**

Ant (*short*)

ant	displant	confidant-e	*cormorant*
bant	decant	dilettant	*covenant*
cant	discant	extant	*disputant*
chant	enchant	gallivant	*dissonant*
grant	gallant	germinant	*dominant*
pant	implant	gratulant	*elegant*
plant	levant	habitant	*elephant*
rant	recant	romant	*ignorant*
slant	supplant	*arrogant*	*jubilant*
scant	transplant	*combatant*	*militant*
tant	adamant	*complaisant*	*petulant*
aslant	commandant	*consonant*	*recreant*

ANT (*short*)—(*Cont.*)

recusant	congratulant	inhabitant	protuberant
ruminant	corposant	intolerant	pursuivant
termagant	corroborant	intoxicant	variant
vigilant	corybant	irradiant	recalcitrant
visitant	courant	irrelevant	recusant
exorbitant	determinant	undulant	reiterant
extravagant	emigrant	irritant	relevant
exuberant	excommunicant	itinerant	resonant
inhabitant	executant	litigant	resuscitant
significant	figurant	luminant	reverberant
insignificant	flagellant	luxuriant	scintallant
abdicant	fulminant	mendicant	sibilant
adultenant	hesitant	occupant	stimulant
altivalant	hierophant	odorant	suppliant
annuitant	illuminant	penetrant	supplicant
anticipant	imaginant	postulant	sycophant
applicant	immigrant	precipitant	tintinnabulant
appurtenant	impuissant	predominant	tolerant
communicant	incogitant	preponderant	vaciverant
concomitant	incognisant	procreant	

ANT (*long*), *see also above*

chant	aunt	debutante	shan't
grant	can't		

ANT (*as in* want), *see* **ONT**

AP

cap	pap	entrap	heel-tap
chap	rap	enwrap	"Jap"
clap	sap	mayhap	knap
dap	scrap	mishap	nightcap
flap	slap	afterclap	overlap
gap	snap	flip-flap	rattletrap
hap	strap	foolscap	shoulder-strap
jap	tap	frap	unlap
lap	trap	genappe	unwrap
map	wrap	handicap	wapp
nap	yap		

APE

ape	chape	drape	grape
cape	crape	gape	jape

APE—(*Cont.*)

pape	undrape	jackanape	*seascape*
rape	scrape	*landscape*	*shipshape*
scape	agape	red-tape	trape
escape	crêpe		

APES

traipse	apes (*and add s to nouns and verbs in* APE)

APH, *see* AFF

APSE, APS

caps (*add s to nouns and verbs in* AP)	apse	elapse	relaps
	flaps	relapse	collapse
	lapse	perhaps	schnapps

APT

capped (*and past of verbs in* AP)	apt	adapt	inapt
	rapt		

AQUE, *see* ACK

AR (*long*)

are	spar	guitar	bizarre
bar	star	hussar	cymar
car	tar	unbar	czar, tzar
char	afar	avatar	Exalibar
far	bazaar	caviare	registrar
jar	catarrh	cinnabar	saddle-bar
mar	cigar	gnarr	shooting-star
par	debar	jaguar	evening-star,
scar	disbar	afar	etc.
parr	felspar	ajar	

AR (*short*); *all questionable rhymes sometimes used with either* AR *or* ER

angular	titular	binocular	jemidar
calendar	vinegar	circular	jocular
popular	dissimilar	consular	jugular
regular	irregular	crepuscular	peninsular
secular	particular	funicular	scapular
scimitar	perpendicular	globular	somnambular
similar	animalcular	hospodar	spectacular
singular	annular	insular	stellular

Ar (*short*)—(*Cont.*)

tabernacular	triangular	uvular	zemindar
tabular	tutelar	vernacular	

Ar (*as in* war) (*see* Or)

Arb

barb	garb	*rhubarb*	"yarb"

Arc, *see* Ark

Arce, Arse

farce	sparse	parse	"sarse"

Arch (*soft*)

arch	outmarch	starch	inarch
larch	parch	countermarch	

Arch (*hard*) *see* Ark

Ard

bard	shard	retard	milliard
card	yard	disregard	placard
guard	blackyard	interlard	sard
hard	bombard	boulevard	shard
lard	discard	brocard	barred (*also*
mard	petard	canard	*past tense of*
pard	regard	foulard	*verbs in* Ar)

Ard (*as in* ward) *see* Ord (*short*)

Are, *see* Air

Arf

dwarf	wharf	corf

Arf (*as in* scarf); *no rhymes except dialect, as* "larf"

Arge

barge	marge	enlarge	surcharge
charge	targe	o'ercharge	sparge
large	discharge	recharge	

Ark

arc	hark	park	genearck
ark	flood-mark	shark	knark
bark	footmark	spark	remark
barque	lark	stark	hierarch
dark	mark	embark	obligarch

ARK—(*Cont.*)

heresiarch	cark	marc	sark
bedark	disembark	patriarch	

ARL

carl	marl	snarl	jarl
gnarl	parle	harl	

ARM

arm	charm	harm	disarm
barm	farm	alarm	gendarme

ARM (*as in* warm), *see* ORM

ARN

barn	darn	tarn	incarn
yarn	imbarn		

ARN (*as in* warn), *see* ORN

ARP

carp	monocarp	pericarp	sharp
escarp	harp	scarp-e	counterscarp

ARS

Mars (*and plural nouns and verbs ending in* AR)

ARSE (*hard*), *see* ARCE

ARSH

harsh	marsh

ART

art	counterpart	smart	depart
cart	lion-heart	start	dispart
carte	heart	sweetheart	impart
chart	mart	tart	indart
dart	part	apart	upstart
hart	sart		

ART (*as in* wart), *see* ORT

ARTH

hearth	garth	swarth

ARVE

carve	starve	larve

AS

as	has	*topaz*	whereas

As (*short*); *questionable rhymes often used with* Us

candlemas	Michaelmas	erysipelas

Ase, *see* Ace *and* Aise

Ash (*as in* ash)

ash	calabash	smash	rash
bash	*lache*	abash	trash
brash	sabretache	*brache*	sash
cash	dash	calash	splash
clash	flash	mountain-ash	moustache
crash	gash	squabash	*cache*
slash	gnash	mash	fash
thrash	hash	push	patache
balberdash	lash	plash	tache

Ash (*as in* wash), Osh

bosh	debosh	splosh	swash
gosh	troche	musquash	tosh
josh	losh	goloshe	bervash
wash	quash	squash	mackintosh

Ask

ask	casque	antimask	mask
bask	cask	masque	immask
task	flask	hask	Pasch

Asm

spasm	phasm	iconoclasm	bioplasm
chasm	miasm	plasm	metaplasm
enthusiasm	phantasm	sarcasm	pleonasm
demoniasm	protoplasm	cataplasm	

Ass

ass	paillasse	bonnilass	surpass
bass	sassafras	damasse	hippocras
brass	en-masse	isinglass	kavass
class	grass	*paterfamilias*	overpass
crass	glass	tarantass	rubasse
gas	lass	amass	demi-tasse
unclass	mass	cuirass	*declasse*
balass	pass	morass	Khyber Pass,
crevasse	alas	outclass	etc.
hour-glass	"coup de	repass	
looking-glass	grâce"		

Ast

blast	paraphrast	elegiast	iconoclast
cast	steadfast	jury-mast	downcast
caste	last	protoplast	flabbergast
fast	bombast	symposiast	metaplast
hast	forecast (verb)	avast	scholiast
aghast	past	metaphrast	classed (*also*
contrast (verb)	vast	overcast	*past tense of*
ecclesiast	enthusiast	outcast	*verbs in* Ass)
idoloclast	devast	repast	

Aste

baste	taste	waist	raced (*also past*
chaste	unchaste	waste	*of verbs in*
haste	foretaste	impaste	Ace)
paste	distaste		

At

at	hat	tat	diplomat
bat	mat	cravat	heliostat
brat	pat	acrobat	plutocrat
cat	vat	aristocrat	slat
chat	*polecat*	civet-cat	caveat
fat	*plait*	democrat	dandiprat
that	rat	habitat	drat
cushat	sat	*proletariat*	monocrat
flat	spat	autocrat	*secretariat*
gat	sprat	*commissariat*	thermostat
gnat			

Atch, *see* **Ach**

Ate, *see* **Ait**

Ath

bath	math	path	scath
hath	aftermath	rath	pilomath
lath	snath		

Athe

bathe	lathe	unswathe	scathe
swathe			

Aub

daub	"baub"		

Aud

bawd	gaud	laud	cawed, (and
broad	fraud	abroad	past tense of
applaud	defraud	maraud	verbs in Au)

Augh, see **Aff**

Aught (as in laught), see **Aft**

Aught (as in taught)

aught	forethought	bethought	wrought
bought	fraught	methought	besought
brought	naught	overwrought	distraught
caught	nought	taught	over-thought
fought	ought	taut	argonaut
maut	sought	thought	

Auk, Aulk, see **Alk**

Aun, see **Awn**

Aunch

haunch	launch	paunch	craunch

Aunt, (see also **Ant**)

daunt	haunt	romaunt	vaunt
gaunt	jaunt	taunt	avaunt
flaunt			

Aur, see **Or**

Ause, Auze

cause	hawse	pause	saws (and add s
clause	because	applause	to verbs and
gauze			nouns in Au)

Aust

exhaust	lost	tossed (and past of verbs in Oss)
holocaust	frost	

Ave

brave	margrave	pave	belave
cave	augusticlave	rave	beslave
crave	drave	save	galley-slave
gave	encave	shave	slave
grave	impave	snave	stave
knave	lave	engrave	they've
deprave	nave	outbrave	wave

Ave—(*Cont.*)

behave	architrave	eleve	thrave
conclave	concave	glaive	waive
forgave			

Aw

awe	gnaw	macaw	guffaw
caw	haw	scaw	overawe
chaw	jaw	thraw	braw
claw	law	seesaw	haw
craw	maw	saw	*pawpaw*
daw	paw	squaw	slaw
draw	pshaw	straw	tau
flaw	raw	thaw	overdraw
jackdaw	withdraw	yaw	oversaw
usuquebaugh	begnaw	foresaw	underjaw
shah	faugh	heehaw	
taw			

Awl, *see* All

Awn

awn	drawn	impawn	yawn
bawn	faun	pawn	indrawn
brawn	fawn	prawn	sawn
dawn	lawn	spawn	*gone*

Ax

axe	zax	parallax	tax
flax	lax	almanacs	relax
lacs	wax	(*and add* s *to*	climax
thorax	*borax*	*nouns and*	pax
		verbs in Ac)	

Ay

aye (ever)	Chevrolet	pay	stay
bay	foray	play	stray
bray	holiday	pray	sway
clay	inveigh	prey	they
gay	Milky Way	ray	repay
may	prepay	say	survey
assegai	nay	matinée	disarray
bey	née	slay	runaway
caroway	neigh	spray	day

Ay—(*Cont.*)

dray	shay	popinjay	cabriolet, *and*
eh?	astray	decay	*French end-*
fay	away	defray	*ings such as*
hay	betray	denay	employé
agley	bewray	dismay	reveille
bobsleigh	convey	display	toupet
castaway	waylay	essay (*verb*)	tourniquet
estray	disobey	gainsay	habitué
galloway	roundelay	hooray	negligée
heyday	flay	inlay (*verb*)	papier maché
horseplay	fray	assay	au fait
leeway	jay	obey	distrait
outlay	gray	outweigh	passée
missay	lay	portray	protégé
sachet	alackaday	purvey	soirée
tray	bouquet	relay (*verb*)	auti-de-fé
tway	drey	belay	coupé
way	footway	stowaway	gourmet
weigh	*highway*	*subway*	outré
whey	*crossway*	*tramway*	resumé
affray	interplay	déjeuner	sobriquet
allay	mainstay		visé
array	malay		

Aze, *see* Aise

E, Ea, Ee

be	we	toupet, *and*	she
bee	wee	*other English*	oversea
dree	aborigine	*adaptations of*	pedigree
fee	reveille	*French words*	recipe
flea	rupee	*with final* e	repartee
flee	scotfree	he	animalculæ
gee	settee	key	felo-de-se
free	trustee	knee	recognizee
levee	absentee	lea	addressee
spree	apogee	lee	apostrophe
tea	assignee	me	bel-esprit
tee	bargainee	pea	bourgeoisie
thee	employe	plea	calorie
three		quay	chimpansee
tree		sea	diablerie

E, Ea, Ee—(*Cont.*)

fiddle-de-dee	on dit	sesame	refugee
Gethsemane	oversee	*Terpsichore*	vis-à-vis
licensee	perigee	facsimile	*extempore*
mobee	referee	cap-a-pie	hyperbole
pot-pourri	*simile*	cognisee	abandonee
systole	covenantee	coterie	antistrophe
glee	*facsimile*	debauchee	bailee
ye	*agapomene*	devotee	Bon Ami
agree	*anemone*	disagree	calliope
bawbee	appointee	eau-de-vie	chickadee
bohea	blea	filigree	debris
decree	bumblebee	guarantee	ennui
degree	catastrophe	jubilee	fricassee
donee	Cybele	jeu d'esprit	interrogatee
foresee	dominie	mortgagee	marquee
fusee	fleur-de-lis	nominee	Pharisee
grandee	goatee	patentee	topee
grantee	maravedi	presentee	vertebræ
lessee	Penelope		

Words ending in Y (short) are also freely used by poets as rhymes in E

Eace (*hard*)

cease	semese	Singalese	obese
crease	niece	Chinese, etc.	police
fleece	peace	chimneypiece	release
geese	piece	verdigris	surcease
grease	apiece	coulisse	frontispiece
lease	caprice	mease	afterpiece
chersonese	decease	valise	esquisse
masterpiece	Siamese	decrease	pelisse
cantatrice	Buonese	increase	creese
griece			

Each, Eech

beach	leech	teach	overreach
beech	peach	impeach	sleetch
bleach	reach	outreach	beseech
breach	screech	leach	queach
each	speech		

Ead (*long*), **Ede, Eed**

bead	breed	creed	feed
bleed	cede	deed	heed

EAD (*long*), EDE, EED—(*Cont.*)

keyed	read	gleed	stampede
knead	rede	indeed	succeed
lead	reed	retrocede	antecede
mead	seed	concede	intercede
supersede	speed	exceed	aniseed
brede	steed	impede	Ganymede
glede	weed	misdeed	God-speed
greed	accede	linseed	interbreed
meed	centipede	precede	swede
need	velocipede	proceed	tweed
plead	djereed	recede	

treed (*and past participle of verbs in* E)

EAD (*short*), *see* ED

EAF (*short*), EF

deaf	chef	clef

EAF (*long*), *see* EEF

EAGUE, IGUE

league	teague	*colleague*	enleague
fatigue	intrigue		

EAK, EEK, IQUE

beak	cleek	bespeak	streak
bleak	fleak	chic	teak
cheek	physique	antique	tweak
clique	leak	cacique	weak
creak	leek	*clinique*	antique
creek	meek	gluk	critique
eek	peak	*relique*	after-peak
eke	peek	Sikh	apeak
freak	pique	shriek	caïque
week	reek	sleek	comique
bezique	seek	sneak	meak
oblique	sheik	speak	Salique
aleak	wreak	squeak	unique
areek			

EAK (*as in* steak), *see* AKE

EAL, EEL

deal	eel	heal	keel
deil	feel	heel	leal

EAL, EEL—(Cont.)

meal	seal	Kabyle	reveal
profile	squeal	postille	*deshabille*
cochineal	steal	sheal	she'll
we'll	sweal	tweel	automobile
barleymeal	teal	weal	chenille
creel	veal	wheal	enseal
interdeal	repeal	wheel	mercantile
ne'er-do-weel	commonweal	zeal	real
seel	he'll	anneal	teel
peal	alquazil	conceal	vakeel
peel	Bastile	congeal	Camile, etc.
reel	difficile	genteel	

EALD, IELD

field	yield	afield	healed (*and*
weald	enshield	harvest-field	*past tense of*
battlefield	wield	(etc.)	*verbs in* EAL,
shield			EEL)

EALM, ELM

elm	realm	overwhelm	dishelm
helm	whelm	unhelm	Anselm

EALTH

health	stealth	wealth	commonwealth

EAM, EEM

beam	hareem	supreme	theme
bream	moonbeam	academe	beseam
cream	ream	daydream	blaspheme
deem	scheme	ice-cream	misdeem
dream	scream	reem	disesteem
gleam	seam	riem	fleam
esteem	seem	stream	leam
redeem	steam	team	regime
abeam	extreme	teem	weather-gleam
centime			

EAMT, EMPT

dreamt	attempt	pre-empt	unkempt
tempt	contempt	exempt	undreamt
kempt			

EAN, EEN, ENE, INE

been	miocene	cadene	toureen
bean	opaline	chagrine	misdemean
clean	peen	crystalline	nectarine
dean	poteen	dene	nicotine
e'en	quinine	eighteen	overseen
glean	sappharine	fifteen	overween
green	serene	galantine	quarantine
keen	squireen	heterogene	saccharine
careen	subrene	infantine	(noun)
demesne	trephine	lien	ultramarine
marine	lean	mesne	atropine
routine	mean	moreen	bandoline
sardine	mien	palanquin	bottine
serene	quean	petaline	caffein
shagreen	queen	protein	codeine
unclean	scene	ravine	cuisine
unseen	screen	sateen	ean
aniline	seen	serpentine	epicene
bombazine	convene	stein	Florentine
advene	foreseen	supervene	gozogene
aquamarine	obscene	vespertine	incarnadine
atween	contrabene	Jean	lateen
barkentine	crinoline	shean	magazine
brigantine	evergreen	spleen	mezzanine
carrogeen	gabardine	teen	pean
coralline	gelatine	wean	pistareen
damascene	guillotine	ween	preen
eglantine	go-between	yean	routine
fascine	intervene	between	scalene
fourteen	velveteen	canteen	sibylline
gradine	algerine	demean	subterrene
indigene	Argentine	machine	terreen
libertine	baleen	tambourine	Wolverine
mazarine	Beguine		

EAND, IEND, etc.

fiend cleaned (and
 past of verbs
 above)

EANT, see ENT

Eap, Eep

cheap	adeep	outleap	weep
cheep	chimneysweep	oversleep	asleep
clepe	keep	bo-peep	outsleep
creep	leap	estrepe	unasleep
deep	neap	sleep	chepe
heap	peep	steep	seep
beweep	reap	sweep	swepe
overleap	sheep	threap	

Ear, Eer, Ere, Eir, Ier

beer	caravaneer	besmear	uprear
bier	circuiteer	chevalier	veneer
blear	electioneer	disappear	auctioneer
cere	financier	fusilier	atmosphere
cheer	garreteer	grenadier	bandolier
clear	harpooneer	insincere	bombardier
dear	Indianeer	muleteer	brigadier
deer	mir	overhear	buccaneer
drear	planisphere	aërosphere	cannoneer
ear	reappear	arear	cavalier
sincere	specksioneer	belvedere	chandelier
fleer	rear	carbineer	chiffonier
gear	sear	crotcheteer	domineer
here	seer	ensphere	gazetteer
hear	sere	fineer	halberdier
jeer	shear	gaselier	interfere
leer	sheer	heer	musketeer
mere	skeer	madrier	*overseer*
near	smear	muffineer	affeer
peer	sneer	sermoneer	asmear
pier	spear	tabasheer	canceleer
queer	fear	brevier	chimere
chanticleer	steer	career	cuirossier
cordelier	tear	cashier	*fakir*
engineer	veer	cohere	frontier
gondolier	tier	compeer	gonfalonier
hemisphere	weir	endear	indear
mountaineer	year	inhere	meer
mutineer	adhere	rehear	pistoleer
pamphleteer	appear	revere	putpiteer
ameer	arrear	severe	souvenir
bayadere	austere	sphere	targeteer

EAR, EER, ERE, EIR, IER—(*Cont.*)

teer	privateer	sonneteer	persevere
Tyr	timbestere	volunteer	carabinier
vizier	underpeer	timoneer	charioteer
pioneer	walleteer	undersphere	*congé d'élire*

EARCH, ERCH, IRCH, URCH

birch	lurch	search	smirch
church	perch		

EARD (*short*), ERD, IRD, URD

bird	sherd	begird	storm-bird
curd	surd	third	verd
heard	word	engird	occurred (*and*
herd	absurd	ungird	*past tense of*
gird	Kurd	ladybird	*verbs ending*
love-bird	mocking-bird	sea-bird	*in* ER *or* RE)
snow-bird	song-bird		

EARD (*long*), EIRD

beard	weird	feared (*and past of verbs ending* EER, EAR, ERE)

EARL, IRL, URL

churl	furl	merle	unfurl
curl	girl	swirl	kerl
earl	hurl	pearl	querl
whirl	uncurl	purl	thurl
burl	impearl	twirl	

EARN, ERN, URN, OURN

burn	erne	turn	stern
churn	inurn	urn	fern
dern	learn	eterne	intern
discern	quern	lucerne	return
concern	spurn	yearn	extern
hern	earn	adjourn	pirn
kerne	tern	astern	taciturn

EARSE, *see* ERCE

EART, *see* ART

EARTH, ERTH, IRTH

birth	dearth	girth	worth
berth	earth	mirth	unearth
firth	*hearth*		

EARTH (*as in* hearth), *see* ARTH

EASE (*hard*), *see* EACE

EASE (*soft*), EESE, EEZE

bees (*and add s to nouns and verbs in* E)
breeze
cheese
drees
ease
freeze
he's
leas
mise
pease
please
overseas
these
trapeze
chevaux-de-frise
friese
heeze
ambergris
antipodes
bise
congeries
syntheses
valise
seize
she's
sneeze
squeeze
tease
wheeze
appease
bawbees
boheas
chemise
presentees
covenantees
feaze
hypotheses
indices
analyses
antitheses
Bolognese
obsequies
rabies
vortices
demise
disease
displease
donees
houris
forseize
heart's ease
journalese
anterides
balize
cerise
parentheses
remise
tweeze

Plurals of words ending in Y (short) are also legitimate rhymes.

EAST, IEST
beast
east
feast
fleeced
least
priest
yeast
artiste
ceased (*and past tense of verbs in* EACE, etc.)

EAST (*as in* breast), *see* EST

EAT (*long*), EET, ETE, EIT
beat
beet
bleat
greit
accrete
bittersweet
cleat
country-seat
facete
judgment-seat
maltreat
preconceit
meat
secrete
meet
mete
neat
peat
pleat
escheat
sheet
sleet
street
cheat
eat
feat
heat
afrete
carte-de-visite
cleet
dead-beat
geat
leat
overeat
receipt
retreat
suite
sweet
teat
treat
wheat
complete
seat
concrete
deceit
defeat
feet
fleet
greet
leet
athlete
cheet
compete
deplete
guerite
lorikeet

Eat (*long*), Eet, Ete, Eit—(*Cont.*)

parrakeet	discreet	élite	estreat
vegete	discrete	entreat	repeat
weet	effete	conceit	replete
delete			

Eat (*as in* great), *see* Ait

Eat (*as in* sweat), *see* Et

Eath (*long*)

heath	teeth	unsheath	bequeath
neath	wreath	underneath	sneath
beneath	sheath		

Eath (*short*)

breath	death	saith	Seth

Eathe

inbreathe	ensheathe	enwreathe	sneathe
seethe	teethe	bequeathe	

Eave, Eive, Ieve, Eve

beeve	conceive	reive	receive
cleave	deceive	we've	relieve
eave	perceive	achieve	reprieve
eve	greave	aggrieve	disbelieve
grieve	heave	unweave	preconceive
lieve	leave	interweave	deev
reeve	retrieve	breve	Khedive
sleeve	interleave	keeve	naïve
thieve	undeceive	misconceive	recitative
weave	engrieve	reave	sheave
believe	make-believe	seave	steeve
bereave	qui vive	solive	vive

Eb, Ebb

ebb	web	keb	Seb
cubeb	neb	sub-deb	

Eck

beck	henpeck	peck	speck
check	trek	reck	wreck
cheque	fleck	bewreck	bedeck
deck	neck	spec	kneck

ECT

sect	detect	insect	project
analect	traject	inspect	prospect
correct	dialect	introspect	protect
exsect	indirect	neglect	refect
interject	intersect	object (*verb*)	reflect
porrect	adject	architect	reject
aspect	annect	disaffect	respect
pandect	disconnect	intellect	select
bisect	genuflect	retrospect	subject (*verb*)
collect	misdirect	affect	suspect
confect	prelect	arrect	circumspect
conject	effect	disinfect	disrespect
connect	elect	indirect	incorrect
deflect	erect	non-elect	recollect
deject	expect	resurrect	decked
direct	infect	trisect	deckt (*and past*
defect	inflect	perfect (*verb*)	*tense of verbs*
dissect	inject	prefect	*in* ECK)

ED, EAD (*short*)

bed	lead	unsaid	bettle-head
bled	instead	maidenhead	breviped
bread	unread	arrowhead	embed
bred	loggerhead	blunderhead	watershed
dead	adread	dunderhead	jolter-head
led	bespread	go-head	quadruped
pled	deadhead	homebred	ted
read	foresaid	overfed	unwed
red	highbred	surbed	trundlebed
said	outspread	underbred	visited
stead	redd	woolly-head	*spirited* (*and all*
thread	thoroughbred	abed	*preterites and*
tread	unthread	ahead	*past partici-*
wed	shed	behead	*ples ending in*
zed	shred	bestead	*ed when the* e
dread	sled	inbred	*is not silent*
fed	sped	o'erspread	*are possible*
fled	spread	gingerbread	*rhymes*)
head	misled	trucklebed	

EDGE

edge	fledge	sacrilege	ledge
dredge	hedge	kedge	pledge

Edge—(*Cont.*)

sedge	sledge	allege	tedge
cledge	wedge	privilege	unedge

Ee, *see* **E**

Eece, *see* **Eace**

Eech, *see* **Each**

Eed, *see* **Ead**

Eef, Ief

beef	neckerchief	handkerchief	relief
brief	grief	unbelief	bas-relief
chief	leaf	shereef	misbelief
fief	lief	thief	interleaf
feof	sheaf	belief	hief
disbelief	reef	enfeof	

Eek, *see* **Eak**

Eel, *see* **Eal**

Eem, *see* **Eam**

Een, *see* **Ean**

Eer, *see* **Ear**

Eese, Eeze, *see* **Ease**

Eet, *see* **Eat**

Ef, *see* **Eaf**

Eft

cleft	heft	theft	unbereft
deft	left	weft	wheft
eft	reft	aleft	bereft

Eg, Egg

beg	keg	skeg	philabeg
egg	peg	tegg	unpeg
leg	seg	*nutmeg*	

Ege, *see* **Edge**, *also* **Idge**

Egm, *see* **Em**

Eign, *see* **Ain**

E_{IN}, *see* A_{IN}

E_{INT}, *see* A_{INT}

E_{IT}, *see* E_{AT}

E_L

Astrophel	intermell	cell	foretell
bechamel	jargonelle	dell	gazelle
bel	Jezebel	dwell	hotel
bonnibel	kell	ell	impel
brocatel	lapel	fell	pell-mell
caravel	locustelle	hell	rebel (verb)
chanterelle	mademoiselle	jell	repel
chaumontelle	mongorel	knell	rondel
cockle-shell	nonpareil	mell	asphodel
cordelle	pennoncelle	quell	bagatelle
coronel	personnel	sell	calomel
crenelle	petronel	shell	caramel
dameisel	pimpernel	smell	citadel
damoiselle	propel	spell	*cockerel*
death bell	pucelle	swell	*doggerel*
dentelle	refel	tell	*infidel*
dinner-bell	sea-shell	well	*mackerel*
fricandel	snell	yell	muscatel
gabelle	tourelle	befell	parallel
horebell	treille	compel	philomel
heather-bell	vielle	dispel	*sentinel*
hydromel	zel	excel	undersell
immortelle	bell	expel	villanelle
insbell	belle	farewell	

E_{LD}

seld	weld	geld	belled (*and past*
unbeheld	withheld	held	*tense of verbs*
unquelled	eld	beheld	*in* E_{LL})
upheld			

E_{LF}

delf	ourself	myself	himself
elf	self	itself	herself
pelf	shelf	thyself	mantel-shelf

E_{LM}, *see* E_{ALM}

Elp

help	whelp	skelp	self-help
kelp	yelp		

Elt

belt	felt	pelt	swelt
celt	gelt	smelt	welt
dealt	knelt	spelt	veldt
dwelt	melt	svelte	

Elve

delve	shelve	twelve	elve
helve			

Em

clem	them	requiem	bediadem
gem	condemn	*theorem*	Bethlehem
hem	contemn	*stratagem*	protem
phlegm	apothegm	anadem	em
stem	diadem	adbominem	"mem"

Eme, *see* **Eam**

Empt, *see* **Eamt**

En

den	wen	oxygen	endogen
fen	when	nitrogen	equestrienne
glen	wren	waterhen	fountain pen
hen	again	aldermen	Parisienne
ken	amen	ben	*regimen*
men	*citizen*	brevipen	*specimen*
pen	*denizen*	cayenne	tragedienne
ten	hydrogen	cyclamen	tren
then			

Ens

lens	cleanse	dens (*and add s to nouns and verbs above*)

Ence, Ense

cense	sense	condense	incense
dense	tense	defence	intense
fence	thence	dispense	offence
hence	whence	expense	nescience
pence	commence	immense	pretence

 Ence, Ense—*(Cont.)*

prepense	imminence	blandiloquence	percipience
propense	impotence	dissidense	quantivalence
suspense	impudence	grandiloquence	somnolence
nonsense	incidence	incompetence	inconsequence
abstinence	indigence	maleficence	incontinence
accidence	indolence	salience	indifference
affluence	inference	supereminence	insipience
audience	influence	turbulence	intelligence
competence	innocence	vehemence	irreverence
condolence	insolence	violence	magnificence
conference	opulence	beneficence	malevolence
confidence	penitence	benevolence	mellifluence
confluence	permanence	circumference	munificence
consequence	pertinence	circumfluence	obedience
continence	pestilence	coincidence	omnipotence
corpulence	prescience	concupiscence	omniscience
crapulence	preference	convenience	pre-eminence
deference	prevalence	equivalence	resilience
difference	prominence	expidence	subservience
diffidence	providence	expedience	transilience
negligence	prurience	experience	disobedience
diligence	recompense	impenitence	inexperience
eloquence	redolence	impertinence	commonsense
eminence	reference	improvidence	fructescence
evidence	residence	incongruence	incoincidence
excellence	reverence	inexpedience	magniloquence
exigence	sapience	breviloquence	plenipotence
feculence	subsidence	flocculence	reticence
frankincense	truculence	imprevalence	succulence
fraudulence	inconvenience	incomprehense	

Ench

bench	bedrench	retrench	intrench
blench	quench	tench	flench
clench	stench	wench	monkey-wrench
drench	trench	wrench	squench

End

bend	friend	rend	trend
blend	lend	send	vend
end	mend	spend	wend
fend	propend	tend	amend

End—(*Cont.*)

append	intend	comprehend	an-end
ascend	misspend	condescend	amend
attend	obtend	discommend	forelend
befriend	offend	dividend	forespend
commend	perpend	re-ascend	forewend
compend	pretend	recommend	gable-end
contend	portend	reprehend	*Godsend*
defend	transcend	*reverend*	interblend
depend	minuend	pitch-blende	subtend
descend	supend	unfriend	upsend
distend	vilipend	weather-fend	penned (*and*
expend	unbend	misapprehend	*past tense of*
forefend	apprehend	superintend	*verbs in* En)
impend			

Ene, *see* Ean

Enge

Avenge	revenge	Stonehenge

Ength

length	strength

Ense, *see* Ence

Ent

bent	anent	indent	misrepresent
blent	ascent	intent	misspent
brent	assent	invent	o'erspent
cent	attent	lament	ostent
fent	augment	discontent	present
gent	besprent	circumvent	prevent
lent	cement	coaugment	relent
meant	comment	malcontent	repent
pent	(verb)	accent (verb)	resent
rent	consent	detent	torment (verb)
scent	content	forewent	unbent
sent	descent	leant	represent
spent	dissent	overspent	*abstinent*
tent	event	sprent	*accident*
vent	extent	stent	*affluent*
went	ferment	unkent	*aliment*
absent (verb)	foment	unmeant	*ambient*
acquent	frequent (verb)	underwent	*argument*

ENT—(*Cont.*)

armament
banishment
battlement
blandishment
chastisement
competent
complement
compliment
condiment
confident
confluent
congruent
consequent
continent
corpulent
decrement
deferent
detriment
different
diffident
diligent
document
effluent
element
eloquent
eminent
esculent
evident
excellent
excrement
measurement
merriment
mollient
monument
muniment
negligent
nourishment
nutriment
occident
opulent
orient
exigent

feculent
filament
firmament
flatulent
fraudulent
fundament
government
gradient
immanent
imminent
implement
impotent
impudent
incident
increment
indigent
indolent
innocent
insolent
instrument
languishment
lenient
ligament
liniment
management
ornament
parliament
pediment
penitent
permanent
pertinent
pestilent
precedent
prescient
president
prevalent
prisonment
prominent
provident
prurient
punishment
ravishment

redolent
regiment
resident
reticent
abandonment
abolishment
accipient
admeasurement
affamishment
affranchisement
babblement
bedevilment
bedizenment
betterment
bewilderment
blazonment
blemishment
botherment
brabblement
cherishment
dazzlement
decipherment
demolishment
development
devilment
diffluent
diminishment
dimplement
disablement
disarmament
disobedient
dispiritment
dissident
distinguishment
embattlement
embitterment
emblazonment
embodiment
empannelment
enablement
encompassment
endeavourment

enfeeblement
enlightenment
envelopment
environment
envisagement
expedient
extinguishment
flacculent
foreanent
fosterment
dissonent
franchisement
garnishment
gracilent
grandiloquent
harassment
ignipotent
imperilment
impoverishment
incipient
incongruent
inexpedient
influent
ingredient
insentient
insipient
inveiglement
lavishment
luculent
magniloquent
obedient
percipient
pesterment
portent
prattlement
premonishment
presentiment
refluent
replenishment
somnolent
thercanent
tremblement

Ent—(*Cont.*)

vaniloquent
vanishment
vanquishment
veriloquent
vinolent
wanderment
wilderment
worriment
reverent
rudiment
sacrament
salient
sapient
sediment
sentient
sentiment
settlement
subsequent
succulent
supplement
tegument
tenement
testament
tournament
transient
truculent
turbulent
vehement
violent

virulent
wonderment
accompaniment
accomplishment
accoutrement
acknowledgment
admonishment
advertisement
aggrandizement
aperient
apportionment
arbitrament
armipotent
astonishment
belligerent
bellipotent
beneficent
benevolent
circumfluent
coincident
concupiscent
constituent
convenient
discouragement
disfigurement
disfranchise-
 ment
disparagement
divertisement

embarrassment
embellishment
embezzlement
emolient
emolument
encompassment
encouragement
enfranchise-
 ment
ennoblement
enravishment
entanglement
equivalent
establishment
esurient
experiment
habiliment
impediment
impenitent
impertinent
imprisonment
improvident
incompetent
inconsequent
incontinent
indifferent
integument
intelligent

irreverent
lineament
magnificent
maleficent
malevolent
medicament
mellifluent
misgovernment
mismanagement
munificent
omnipotent
parturient
plenipotent
predicament
pre-eminent
recipient
relinquishment
resilient
subservient
temperament
circumambient
hereditament
impoverishment
inconvenient
pre-establish-
 ment
re-establishment
supereminent

Ep

nep
repp

skep
step

steppe
demirep

"rep"

Ept

crept
kept
pept
sept
slept

wept
accept
adept
except

yclept
overslept
intercept
inept

unkept
leapt
swept
stepped

ER, ERR, IR, UR, RE

aberr	arbiter	administer	milliner
astir	armiger	adulterer	murmurer
befur	barrister	artificer	nourisher
chirr	canister	astronomer	posturer
concur	chorister	astrologer	perjurer
confer	conjurer	idolater	pesterer
defer	cottager	interpreter	photographer
incur	cylinder	philosopher	plasterer
infer	dowager	admonisher	plunderer
occur	flatterer	adventurer	polisher
per	forager	baluster	profferer
recur	foreigner	bannister	publisher
refer	gardener	banterer	punisher
shirr	grasshopper	bargainer	rioter
amateur	harbinger	barometer	riveter
chauffeur	islander	biographer	roisterer
connoisseur	lavender	blunderer	saunterer
hauteur	loiterer	calender	scimiter
blur	lucifer	carpenter	sepulchre
burr	mariner	caterer	sinister
cur	massacre	chronicler	stenographer
err	messenger	comforter	sufferer
fir	minister	commoner	thermometer
fur	murderer	coroner	treasurer
her	officer	customer	trumpeter
knur	passenger	determiner	vanquisher
myrrh	pillager	diameter	venturer
purr	presbyter	disparager	vintager
sir	prisoner	distributer	visiter
slur	provender	driveler	wagerer
spur	register	enlightener	wanderer
stir	slanderer	examiner	whimperer
whir	sophister	forester	widower
aver	sorcerer	forfeiter	worshiper
bestir	terrier	gossamer	cheerier
demur	thunderer	harvester	merrier (etc.)
deter	traveler	hexameter	(and com-
douceur	usurer	jabberer	parative of
disinter	villager	languisher	adjectives for
inter	victualer	lavender	other doubtful
prefer	voyager	lecturer	rhymes)
transfer	wagoner	measurer	

ERS, ERRS, IRS, URZE

furze	refers	errs	stirs (*and add s to nouns and verbs above*)

ERB, URB

curb	serb	reverb	gerb
herb	verb	*suburb*	perturb
kerb	disturb	superb	

ERCE, ERSE, URSE, EARSE

curse	accurse	diverse	reverse
erse	adverse	imburse	sesterce
hearse	amerce	immerse	subverse
nurse	asperse	inverse	transverse
herse	averse	perverse	traverse
purse	coerce	reimburse	intersperse
terse	converse	*universe*	terce
verse	*commerce*	submerse	burse
worse	disburse	precurse	excurse
abterse	disperse	rehearse	

ERCH, *see* EARCH

ERD, *see* EARD

ERE, *see* EAR

ERF, URF

scurf	serf	surf	turf

ERGE, IRGE, URGE, OURGE

dirge	submerge	immerge	deterge
gurge	scourge	tharematurge	diverge
merge	serge	verge	demurge
purge	surge	converge	berge
emerge	urge		

ERK, IRK, URK

burke	yerk	quirk	stirk
dirk	kirk	handiwork	Turk
firk	lurk	derk	work
irk	murk	shirk	cirk
jerk	perk	smirk	mirk

ERM, IRM

firm	derm	affirm	infirm
sperm	term	germ	misterm
squirm	worm	confirm	pachyderm

Ern, *see* Earn

Erse, *see* Erce

Erst, *see* Irst

Ert, Irt, Urt

blurt	chert	desert (verb)	insert (verb)
cert	exsert	unhurt	invert
curt	extrovert	inexpert	obvert
dirt	introvert	animadvert	pervert (verb)
flirt	squirt	engirt	revert
girt	vert	gurt	subvert
hurt	*wert*	preconcert	controvert
pert	wort	syrt	intersert
shirt	advert	dessert	begirt
skirt	alert	divert	evert
spurt	assert	exert	intervert
ungirt	avert	expert (adj.)	retrovert
disconcert	concert (verb)	inert	transvert
malapert	convert (verb)	sea-girt	

Erth, *see* Earth

Erve, Urve

curve	conserve	preserve	incurve
nerve	deserve	reserve	unnerve
serve	disserve	subserve	verve
swerve	observe		

Es, Esce, Ess

bless	redress	guess	*prophetess*
cess	possess	less	digress
chess	*princess*	mess	distress
cress	profess	press	duress
dress	progress (verb)	agress	express
address	recess	compress	excess
caress	*mayoress*	(verb)	impress
baroness	overdress	*canoness*	largess
covoless	*poetess*	deliquesce	noblesse
egress	prepossess	evanesce	obsess
frondesce	*prioress*	ingress	oppress
jess	*sorceress*	obsolesce	underdress
quiesce	*ambassadress*	regress	*proprietress*
turgesce	fesse	confess	stress

Es, Esce, Ess—(*Cont.*)

tress	effloresce	repress	coalesce
yes	finesse	success	dispossess
abscess	intermesce	suppress	effervesce
access	opalesce	transgress	*giantess*
assess	transgress	unless	*adulteress*
accresce	depress	acquiesce	nevertheless
conqueress	repossess		

also comfortless, happiness *and any compounds in* Less *and* Ness *in which the accent is not on the penultimate syllable. There are over a thousand of these.*

Ese, *see* Eace *and* Ease

Esh

flesh	mesh	enmesh	afresh
fresh	nesh	thresh	"secesh"
refresh			

Esk, Esque

desk	grotesque	arabesque	picturesque
burlesque	Romanesque		

Est

best	arrest	behest	manifest
blest	invest	detest	acquest
breast	*interest*	obtest	divest
chest	nest	reinvest	ingest
crest	rest	anapest	unbreast
guest	divest	furest	dressed (*and*
inquest	suggest	vest	*past tense of*
hest	unblest	bequest	*verbs in* Ess,
lest	unrest	digest	Esce.)
quest	*incest*	protest	answerest
west	infest	*disinterest*	troublest (*and*
wrest	molest	cest	*other third*
yest	jest	geste	*person sing.*
zest	pest	attest	*of two syllable*
abreast	contest (verb)	congest	*verbs*)
	test	request	

Et, Ette

et	fret	let	pet
bet	get	met	set
debt	jet	net	sweat

Et, Ette—(*Cont.*)

threat
vet
wet
whet
yet
abet
beget
beset
martinet
minuet
overset
pirouette
summerset
wagonette
aigrette
angelet
annulet
banquet
brochette
castoret
croquette
estafette
formeret
lacunette
Lett
medalet
revet

somerset
vedette
bewet
brunette
cadet
coquet
coquette
curvet
duet
forget
gazette
lunette
piquet
quartet
quintet
regret
rosette
roulette
sestet
serviette
upset
vignette
mignonette
novelette
parapet
rivulet
suffragrette

quodlibet
alette
amourette
backset
bassinet
calumet
clarionet
crossett
facette
genet
landaulet
varquette
silhouette
sunset
vergette
alphabet
amulet
anchoret
banneret
baronet
bayonet
cabinet
canzonette
cigarette
coronet
coverlet
epaulette

epithet
etiquette
falconette
floweret
leveret
marionette
marmoset
minaret
omelette
parroquet
sarcenet
violet
allumette
anisette
baguet
benet
carcaret
corvette
egrette
flet
globulet
lorgnette
planchette
soubrette
tabouret
zonulet
tourniquet

Etch

etch
fetch

vetch
retch

sketch
outstretch

stretch
wretch

Ete, *see* Eat

Eve, *see* Eave

Eud, *see* Ude, *and also* Ood *for imperfect rhymes*

Eum, *see* Oom

Ew, *see* Oo *and* Ue

 Note: the vowel in Ew is pronounced sometimes as a diphthong
(eu) and sometimes with the single sound of oo. The two sounds
are so nearly alike that they are often rhymed; yet a precise
speaker or writer should be conscious of the distinction.

Ex, Ecks

sex	ex	circumflex	henpecks
annex	specs	reflex	checks (and
complex	*apex*	kex	add s to
index	convex	vex	nouns and
vortex	perplex	codex	verbs in Eck)

Ext

next	text	annexed (and past of verbs in Ex)
vext	pretext	

Ey, *see* **Ay**

Ez

fez	says	Cortez	"oyez"

I, *see* **Y** (*long*)

Ib

bib	fib	o'ersib	sib
crib	glib	nib	quib
drib	jib	rib	gib
squib			

Ibe

bribe	interscribe	prescribe	subscribe
gibe	ascribe	superscribe	transcribe
kibe	describe	gybe	circumscribe
scribe	imbibe	proscribe	diatribe
tribe	inscribe		

Ic, Ick

brick	arithmetic	wick	*choleric*
chick	bailiwick	politic	*empiric*
click	flick	*turmeric*	fiddlestick
crick	rick	impolitic	heretic
lick	sic	benedick	lunatic
candlestick	sick	kinnikinic	rhetoric
nick	slick	*picnic*	archbishopric
pick	thick	arsenic	impolitic
prick	kick	bishopric	*chivalric*
quick	tic	stick	snick
plethoric	tick	catholic	**stick**
splenetic	trick		

Ics, *see* **Ix**

Ice (*short*), *see* Is

Ice (*long*), Ise (*hard*)

bice	gneiss	entice	bespice
dice	sice	paradise	concise
ice	rice	gnice	precise
mice	slice	syce	sacrifice
nice	spice	trice	lice
price	splice	twice	thrice
device	thrice	vice	vise
suffice	tice	advice	

Ich, *see* Itch

Ick, *see* Ic

Icks, *see* Ix

Ict, Icked

pict	addict (verb)	afflict	derelict
convict (verb)	conflict (verb)	constrict	maladict
depict	evict	inflict	licked (*and past*
predict	relict	restrict	*of verbs in*
benedict	contradict	interdict	Ick)
strict	astrict		

Id

bid	mid	forbid	outdid
brid	quid	outbid	skid
chid	rid	underbid	pyramid
cid	slid	fordid	fid
did	squid	katydid	invalid
hid	thrid	scrid	overdid
"grid"	amid	overbid	unbid
kid	bestrid	cid	undid
lid	*eyelid*	gid	

Ide, Ied

bide	confide	Whitsuntide	eyed
gride	divide	alongside	guide
nide	misguide	hyde	pride
side	provide	lapicide	slide
tide	Christmastide	outride	wide
arride	eventide	riverside	aside
backslide	matricide	uxoricide	beside
betide	stillicide	bride	*broadside*

Ide, Ied—(*Cont.*)

decide	parenticide	bestride	foreside
elide	sororicide	collide	insecticide
outside	vaticide	deride	*noontide*
reside	chide	inside	patricide
decide	herpicide	preside	unbetide
fratricide	glide	subside	vermicide
parricide	hide	Eastertide	vulpicide
subdivide	ride	homicide	cried (*and past*
infanticide	stride	regicide	*of verbs in*
barmecide	abide	suicide	Y (e), Igh,
hillside	astride	tyrannicide	Ie)
liberticide			

Ides

ides

besides

tides (*and add s to nouns and verbs above*)

Idge

bridge	midge	enridge	*privilege*
fidge	ridge	abridge	nidge
sacrilege			

See also Age (*short*)

Idst

amidst	hidst	slidst	forbidst
bidst	kidst	overbidst	outbidst
chidst	midst	bestridst	underbidst
didst	ridst		

Ie, *see* Y

Ief, *see* Eef

Iege

liege	siege	assiege	*prestige*
besiege			

Ield, *see* Eald

Ien, *see* Ean

Iend, *see* Eand *and* End

Ier, *see* Ear

Ierce

fierce	impierce	tierce	transpierce
pierce			

IES, *see* IS *and* ISE

IEST, *see* EAST

IEVE, *see* EAVE

IF, IFF, YPH

cliff	glyph	tiff	hieroglyph
if	sniff	griff	hippogriff
skiff	stiff	whiff	miff

IFE

fife	life	*fishwife*	strife
knife	rife	*goodwife*	wife

IFT

drift	snowdrift	sniffed	whiffed
gift	shift	uplift	adrift
lift	shrift	thrift	miffed
rift	sift	tiffed	spindrift

IG

big	rig	snig	twig
dig	jig	whirligig	whig
fig	pig	thingumajig	wig
gig	prig	sprig	brig
grig	rig	swig	trig
periwig	thimblerig		

IGE

oblige	tige

IGH, *see* Y (*long*)

IGHT, *see* ITE

IGUE, *see* EAGUE

IKE

dike	fyke	mislike	belike
like	shrike	"bike"	unlike
pike	spike	tyke	*oblique*
dislike	strike	alike	tike

IL, ILL

bill	drill	frill	grille
brill	dill	gill	hill
chill	fill	grill	fulfill

IL, ILL—(*Cont.*)

quadrille	quill	upfill	downhill
uphill	rill	volatile	freewill
domicile	shrill	squill	instil
bestill	sill	still	until
kiln	skill	swill	daffodil
'twill	spill	thill	befrill
vill	stockstill	thrill	cill
ill	codicil	till	jill
kill	watermill	trill	spadille
mill	chrysophyll	will	*versatile*
pill	enthrill	distil	whippoorwill
nil	prill		

ILD (*short*), ILLED

build	gild	billed (*and past*	
begild	guild	*of verbs in* ILL)	

ILD (*long*), ILED

aisled	child	guiled	filed (*and past of*
mild	styled	wild	*verbs in* ILE)

ILE

aisle	style	rile	juvenile
bryle	taille	smile	peristyle
erstwhile	tile	stile	versatile
"spile"	vile	domicile (verb)	anglophile, etc.
enisle	erewhile	pentastyle	bibliophile
meanwhile	exile	reconcile	wile
vibratile	*gentile*	isle	awhile
ensile	pensile	mile	camomile
resile	while	beguile	crocodile
bile	revile	compile	diastyle
chyle	aquatile	defile	infantile
file	pile	edile	mercantile
guile			

ILK

bilk	silk	ilk	milk

ILM

bilm	film

ILT

built	guilt	wilt	jilt
begilt	hilt	unspilt	kilt

ILT—(*Cont.*)

milt	lilt	tilt	unbuilt
quilt	spilt	twilt	silt
atilt	stilt		

ILTH

bilth	illth	spilth	tilth
filth			

IM

brim	betrim	interim	whim
dim	lym	seraphim	bedim
glim	limb	enlimn	*pilgrim*
grim	limn	shim	pseudonym
him	prim	swim	synonym
hymn	rim	trim	"gym"
cherubim	skim	vim	zimb
sanhedrim	slim	Jim	

IME

chime	lime	thyme	pantomime
chyme	mime	time	I'm
climb	prime	begrime	berhyme
clime	rhyme	sublime	*meantime*
crime	rime	*sometime*	beslime
dime	maritime	*aforetime*	upclimb
aftertime	slime	overtime	paradigm
grime			

IMES

betimes	ofttimes	sometimes	chimes (*and add s to nouns and verbs above*)

IMP

crimp	imp	limp	"simp"
gimp	jimp	pimp	tymp
shrimp	primp	skrimp	blimp

IMPSE

glimpse	crimps (*and add s to nouns and verbs above*)

In, Inn, Ine (*short*)

bin	discipline	francolin	herein
chin	feminine	gyn	unpin
din	finickin	tourmalin	baldachin
djinn	harlequin	heroine	baldaquin
fin	peregrine	jacobin	been
gin	in	javelin	chinkapin
glynn	inn	jessamine	genuine
grin	kin	kilderkin	jinn
Berlin	lin	*libertine*	opaline
maudlin	pin	mandarin	whin
wherein	shin	ravelin	mandolin
agrin	sin	spin	mannikin
baudekin	skin	thin	masculine
bulletin	chagrin	tin	minikin
gelatine	therein	twin	*origin*
saccharine	within	whin	paladin
cannakin	alizarine	win	*palanquin*
capuchin	*bearskin*	akin	violin
culverin	cherubin	begin	widdership

Ince

mince	quince	since	unprince
prince	rinse	wince	chintz
convince	evince		

Inch

cinch	clinch	chinch	linch
finch	winch	bepinch	lynch
inch	flinch	pinch	

Inct, Inked

tinct	depinct	distinct	blinked (*and*
extinct	*instinct*	*precinct*	*past of verbs*
succinct	indistinct	procinct	*in* Ink)

Ind (*short*), **Inned**

tind	wind	tamarind	chinned (*and*
rescind	disciplined	abscind	*past of verbs*
			in In)

IND (*long*), **INED**

bind	humankind	womankind	unwind
grind	blind	inbind	crined
mind	hind	find	rynd
behind	rind	kind	dined (*and*
remind	mankind	wind	*past of verbs*
gavelkind	unkind	purblind	*in* INE)

INE (*French*), *see* **EAN**

INE (*long*)

brine	combine	aquiline	agatine
chine	compline	asinine	aniline
dine	condign	brigantine	appenine
eyne	confine	byzantine	benign
fine	consign	columbine	capitoline
kine	decline	celandine	dessiatine
line	define	concubine	fescennine
mine	design	coralline	infantine
nine	divine	countermine	libertine
pine	enshrine	eglantine	opaline
shine	*feline*	leonine	quarantine
sign	entwine	saccharine	serpentine
sine	incline	(adj.)	spline
shrine	indign	turpentine	ursuline
swine	*moonshine*	uterine	viperine
syne	disincline	valentine	incarnadine
thine	intertwine	adulterine	align
trine	porcupine	almandine	anonyne
twine	superfine	anserine	ashine
vine	undermine	barkantine	bine
whine	"opine"	caballine	carabine
crystalline	outline	countersign	dyne
interline	outshine	*ensign*	Florentine
palatine	recline	hyaline	langsyne
saturnine	refine	leonine	malign
underline	repine	matutine	pavonine
wine	saline	propine	resign
assign	*sunshine*	resupine	sibylline
calcine	supine	spine	sycamine
canine	*woodbine*	trephine	vaticine
carbine	untwine	vespertine	vuturine
carmine	alkaline		

ING

bring	enring	murmuring	entering
cling	spring	offering	evening
ding	string	scaffolding	gardening
fling	swing	breakfasting	gathering
ging	thing	christening	issuing
king	wing	coloring	chambering
ling	wring	reasoning	muttering
ring	unsling	scattering	opening
sing	unstring	seasoning	reckoning
chitterling	ping	uttering	smoldering
underling	sling	covering	westering
sting		wondering (*and any other partici-*	
scatterling (*and other nouns with German diminutive*)		*ples ending in* ING *with the accent on the antepenultimate*).	

INGE

cringe	mindge	twinge	befringe
dinge	springe	unhinge	impinge
fringe	stinge	scringe	infringe
hinge	swinge	astringe	constringe
singe	tinge	attinge	perstringe
syringe			

INK

blink	mink	stink	forethink
brink	pink	think	cinque
chink	ink	tink	jink
drink	shrink	twink	hoodwink
rink	sink	bethink	appropinque
kink	zinc	enlink	trink
wink	skink	interlink	"gink"
link	slink	bobolink	tiddledewink

INT (*short*)

dint	lint	calamint	asquint
flint	sprint	*footprint*	imprint
hint	print	mezzotint	peppermint
mint	quint	vint	glint
reprint	splint	stint	misprint
septuagint	squint	tint	"soda mint"

INT (*long*)

pint	ahint (*Scotch*)

Inth

plinth	colocynth	labyrinth	terebinth
hyacinth			

Inx, Inks

lynx	minx	*larynx*	blinks (*and add s to nouns and verbs in* Ink)

Ip

chip	whip	jip	outstrip
clip	atrip	trip	unrip
dip	quip	pip	battleship
drip	rip	grippe	hip
flip	scrip	kip	tip
gip	shrip	ship	nip
grip	sip	equip	dog-whip
gyp	skip	*horsewhip*	hyp
strip	slip	inship	outstrip
lip	snip	landslip	

fellowship, horsemanship (*and all words with prefix* Ship *with accent on antepenultimate*).

Ipe

gripe	electrotype	*tintype*	antitype
pipe	tripe	guttersnipe	linotype
ripe	type	stipe	stereotype
snipe	wipe	*windpipe*	daguerreotype
stripe	*bagpipe*	unripe	kipe
monotype	*hornpipe*	archetype	swipe
autotype	prototype		

Ipse, Ips

eclipse	ellipse	apocalypse	chips (*and add s to nouns and verbs in* Ip)

Ique, *see* **Eak**

Ir, *see* **Er**

Irch, *see* **Earch**

Ird, *see* **Eard**

ĪRE

briar	sigher	entire	stupefier
buyer	shire	esquire	verifier
byre	shyer	expire	indemnifier
choir	sire	grandsire	indentifier
crier	slyer	inspire	liquefier
dire	skier	inquire	occupier
drier	spire	perspire	"speechifier"
dyer	squire	*quagmire*	trior
fire	tire	relier	fructifier
flier	trier	replier	qualifier
friar	tyre	retire	multiplier
gyre	wire	supplier	pacifier
hire	acquire	*umpire*	petrifier
higher	admire	amplifier	prophesier
ire	respire	crucifier	purifier
liar	*satire*	edifier	putrefier
lyre	transpire	enquire	terrifier
mire	*wildfire*	vire	villifier
nigher	certifier	classifier	intensifier
require	dignifier	exemplifier	mystifier
sapphire	afire	eyer	revivifier
suspire	swire	lammergeier	spryer
untier	clarifier	mystifier	versifier
beautifier	decryer	"skyer"	mollifier
deifier	aspire	spyer	ratifier
falsifier	attire	fortifier	rectifier
spitfire	bemire	mortifier	sanctifier
applier	*bonfire*	gratifier	satisfier
complier	conspire	glorifier	scarifier
plyer	defier	horrifier	simplifier
prior	denier	justifier	specifier
pryer	desire	magnifier	testifier
pyre	*empire*	modifier	vivifier
quire			

IRGE, *see* ERGE

IRK, *see* ERK

IRL, *see* EARL

IRM, *see* ERM

IRP, *see* URP

IRST, ERST, URST

burst	durst	becursed (t)	abstersed
curst	erst	thirst	accurst
cursed (*and*	first	versed	amerced
past of verbs	hurst	worst	athirst
in ERCE)			

IRT, *see* ERT

IRTH, *see* EARTH

IS (*soft*), IZ

biz	viz	whiz	quiz
fizz	his	befrizz	friz
'tis	is	phiz	

Also plurals of nouns in Y (*short*), as possible rhymes. There are
several thousand of these, but a working list will be found under
Y.

IS, ISS, ICE (*hard*)

hiss	dehisce	dentifrice	*anabasis*
kiss	fortalice	edifice	analysis
miss	"siss"	emphasis	antithesis
spiss	y-wis	generis	aphæresis
this	"bis"	genesis	diæresis
wis	bliss	metastasis	hypostasis
abyss	*armistice*	necropolis	hypothesis
amiss	artifice	clematis	metathesis
dismiss	interstice	dialysis	paralysis
premiss	liquorice	nemesis	*apotheosis*
remiss	avarice	verdigris	abiogenesis
metabasis	benefice	orifice	cuisse
metropolis	chrysalis	precipice	diathesis
parenthesis	cicatrice	prejudice	*periphrasis*
metamorphosis	cockatrice	synthesis	vis
cropolis	cowardice		

ISE (*hard*), *see* ICE

ISE (*soft*) IZE

ayes	prize	comprise	excise
buys (*and add s*	rise	demise	incise
to verbs and	size	despise	*likewise*
nouns in Y	wise	devise	mainprise
(*long*))	advise	disguise	misprise
guize	allies	emprise	reprise

Ise (*soft*) Ize—*Cont.*)

revise
eulogize
surmise
surprise
unwise
uprise
advertise
agonize
catechize
cauterize
centralize
certifies
christianize
circumcise
civilize
clarifies
compromise
colonize
criticize
crystallize
dogmatize
egotize
emphasize
enterprise
equalize
exercise
exorcize
fertilize
formalize
fossilize
fraternize
apprise
apprize
arise
assize
avise
baptize
capsize
chastise
idolize
legalize
localize

manumise
merchandise
minimize
organize
otherwise
patronize
alkalize
anglicize
authorize
bastardize
brutalize
canonize
improvise
magnetize
memorize
mesmerize
mobilize
oxidize
pauperize
pluralize
galvanize
gluttonize
gormandize
harmonize
humanize
hypnotize
jeopardize
latinize
mercerize
methodize
modernize
moralize
neutralize
ostracize
penalize
pyetize
polarize
presurmise
pulverize
philosophize
realize
rebaptize

recognize
rhapsodize
satirize
scandalize
scrutinize
signalize
solemnize
specialize
sterilize
stigmatize
naturalize
popularize
sanctuarize
singularize
systematize
ventriloquize
anathematize
particularize
improvise
summarize
supervise
syllogize
symbolize
sympathize
nationalize
synchronize
tantalize
temporize
tranquillize
tyrannize
utilize
victimize
villanize
vocalize
vulcanize
vulgarize
weatherwise
allegorize
analogize
antagonize
anatomize
apologize

apostatize
astrologize
phlebotomize
secularize
solidifies
systematize
visualize
epigrammatize
revolutionize
astronomize
capitalize
characterize
contrariwise
demoralize
deodorize
desilverize
economize
epitomize
eternalize
evangelize
extermorize
familiarize
generalize
geologize
geometrize
idealize
idolatrize
immortalize
italicize
macadamize
materialize
monopolize
plagiarize
rationalize
sensualize
soliloquize
synonymize
volatilize
municipalize
spiritualize
internationalize

Ish

cuish
dish
fish
pish
wish
womanish
empoverish
swish
dowdyish
ogreish
unwish
anguish
cleverish
devilish
feverish
vaporish
forewish
babyish
kittenish
Quakerish
gibberish
heathenish
interwish
licorice
willowish
yellowish
slish
bitterish
mammonish
vizenish
squish

Isk

bisque
brisk
disc
odalisque
frisk
risk
whisk
tamarisk
fisc
asterisk
basilisk
obelisk
bisk
fisk

Ism, Ysm

chrism
prism
schism
altruism
atheism
anarchism
aneurism
Anglicism
aphorism
archaism
barbarism
Calvinism
cataclysm
catechism
criticism
Darwinism
despotism
egoism
egotism
euphemism
euphuism
exorcism
Gallicism
libertinism
patriotism
polytheism
radicalism
unionism
Armenianism
imperialism
Presbyterian-
 ism
absolutism
achromatism
agonism
alienism
Aromism
asterism
atomism
boobyism
centralism
communism
demoniacism
dogmatism
emotionalism
etherealism
exoticism
Hebraism
Hellenism
heroism
hibernism
hypnotism
mechanism
Ibsenism (etc)
Judaism
laconism
Latinism
magnetism
mesmerism
Methodism
modernism
monarchism
Mormonism
mysticism
occultism
optimism
organism
ostracism
paganism
pantheism
paroxysm
parallelism
plagiarism
Protestantism
ritualism
Wesleyanism
Malthusianism
Congregation-
 alism
academism
actinism
agariarism
anatomism
asceticism
astigmatism
biblicism
brutalism
chloralism
cretinism
demonism
dualism
equestrianism
etherism
exquisitism
priapism
pyrrhonism
quietism
realism
rheumatism
syllogism
sabbatism
scepticism
socialism
solecism
stoicism
synchronism
tritheism
vandalism

Ism, Ysm—(*Cont.*)

vulgarism	classicism	somnolism	vitalism
witticism	cynicism	terrarism	Yankeeism
agnosticism	devilism	unionism	fogeyism
Catholicism	eclecticism	verbalism	frivolism
conservatism	esotericism	feudalism	idiotism
empiricism	euphonism	fossilism	italicism
epicurism	fanaticism	humanism	localism
evangelism	feticism	intellectualism	mannerism
fanaticism	formalism	literalism	monasticism
liberalism	galvanism	lyricism	naturalism
paralogism	individualism	metacism	pauperism
polyphonism	journalism	mativism	peonism
Puritanism	loyalism	nominalism	pietism
Shavianism	materialism	pedantism	prelatism
Americanism	moralism	physicism	pugilism
colloquialism	neologism	pragmatism	rationalism
Orientalism	peanism	provincialism	romanticism
abolitionism	philosophism	pythonism	ruralism
accidentalism	platonism	revivalism	sciolism
æstheticism	proverbialism	ruffianism	sentimentalism
alcoholism	religionism	savagism	syncretism
antiquarianism	puppyism	sensualism	tribalism
asteism	royalism	subtilism	ventriloquism
atavism	satanism	totemism	vocalism
bogeyism	scoundrelism	vampirism	zanyism
cabalism			

Isp

crisp	whisp	lisp	wisp
encrisp			

Ist, Issed, Yst

cist	twist	glist	exist
cyst	whist	triste	insist
fist	wist	accompanist	persist
gist	absist	agamist	resist
grist	dramatist	allopathist	subsist
hissed (*and past*	egoist	apothist	untwist
of verbs in Is	ecorcist	apologist	alchemist
hard)	formalist	agist	amethyst
hist	herbalist	assist	amorist
list	idolist	consist	anarchist
mist	entravist	desist	dualist

Ist, Issed, Yst—(*Cont.*)

egotist
fabulist
Hebraist
humanist
atravist
enlist
schist
tryst
Æolist
agonist
animist
aphorist
arabalist
annalist
aorist
atheist
bicyclist
bigamist
botanist
cabalist
Calvinist
casuist
catechist
coexist
colonist
colorist
dogmatist
duelist
eucharist
fatalist
Hellenist
humorist
bemist
frist
sist
absolutist
aërologist
allegorist
antipathist
apiarist
balladist
biblicist

cabalist
circumlocu-
 tionist
colonist
cremationist
despotist
equilibrist
eulogist
fictionist
fossilist
illusionist
journalist
lapidist
Latinist
loyalist
medalist
metalist
Methodist
millenist
moralist
motorist
novelist
oculist
optimist
organist
pessimist
pianist
pluralist
pre-exist
pugilist
realist
rhapsodist
satirist
schematist
entomologist
genealogist
materialist
nationalist
physiognomist
rationalist
biologist

canonist
classicist
communist
dactylist
destinist
essayist
euphirist
formalist
harmonist
intertwist
sciolist
suffragist
symmetrist
syncopist
theorist
vocalist
votarist
academist
acolothist
analogist
antomist
chirographist
chronologist
diplomatist
economist
emblematist
enigmatist
epitomist
eternalist
evangelist
externalist
geologist
idealist
metallurgist
epigrammatist
imperialist
martyrologist
mineralogist
physiologist
religionist
devotionalist

botanist
choralist
colloquist
contortionist
demonist
elegist
ethicist
feudalist
fossilist
hyperbolist
scientist
misogamist
misogynist
monogamist
monopolist
mythologist
naturalist
ontologist
philologist
phlebotomist
phrenologist
polygamist
ritualist
sensualist
separatist
sexualist
socialist
tautologist
theologist
theomachist
tobacconist
ventriloquist
anagrammatist
anti-socialist
etymologist
malthusianist
memorialist
opinionist
protectionist
spiritualist
meteorologist

It, Ite (short)

bit	refit	transmit	omit
bitt	twit	nit	intermit
chit	whit	pit	Jesuit
fitt	wit	quit	perquisite
demit	writ	sit	recommit
fit	acquit	skit	*indefinite*
flit	outsit	slit	unfit
grit	cit	counterfeit	apposite
hit	outwit	infinite	benefit
kit	misfit	intromit	definite
knit	favorite	opposite	exquisite
lit	pewit	pretermit	hypocrite
smit	tit	admit	plebiscite
spit	remit	befit	manumit
split	submit	*bowsprit*	preterite
frit	*titbit*	commit	requisite
permit	tomtit	emit	prerequisite
sprit			

Itch, Ich

bitch	enrich	hemstitch	witch
ditch	itch	chich	inditch
fitch	lych	stitch	miche
flitch	niche	switch	quitch
hitch	pitch	twitch	scritch
bewitch	rich	which	

Ite (long), Ight

bite	might	trite	enlight
bight	night	white	excite
blight	pight	wight	*foresight*
bright	plight	wright	ignite
cite	quite	write	incite
dight	right	accite	indict
fight	rite	affright	indite
flight	sight	alight	insight
fright	site	aright	invite
height	sleight	bedight	*midnight*
hight	slight	benight	*moonlight*
kite	smite	contrite	*outright*
knight	spite	delight	polite
light	sprite	despite	recite
mite	tight	*downright*	requite

Ite (*long*), Ight—(*Cont.*)

sunlight	overnight	aërolite	grapholite
twilight	oversight	aluminite	ichnolite
unite	parasite	angelite	mammonite
upright	proselyte	aright	meteorite
aconite	recondite	anthracite	overdight
acolyte	reunite	behight	plebiscite
anchorite	satellite	beknight	sideralite
appetite	second-sight	blatherskite	*starlight*
bedlamite	*stalactite*	copyright	tonight
bipartite	*stalagmite*	crystallite	toxophilite
Carmelite	sybarite	*daylight*	tripartite
chrysolite	troglodyte	dolomite	undight
cœnobite	underwrite	ebonite	unright
disunite	yesternight	electrolyte	unsight
dynamite	archimandrite	entomolite	malachite
eremite	cosmopolite	enwrite	vulcanite
expedite	hermaphrodite	erudite	zoolite
impolite	theodolite	forthright	zoophyte
midshipmite	actinodite	good-night	unwrite
neophyte			

Ith, Yth

acrolith	frith	sith	forthwith
aerolith	kith	smith	herewith
lith	myth	with	therewith
monolith	pith	withe	wherewith
palæolith			

Ithe

blithe	lithe	tithe	withe
hithe	scythe	writhe	

Ive (*long*), Yve

dive	shive	arrive	revive
drive	I've	*beehive*	survive
five	shrive	connive	overdrive
gyve	strive	contrive	devive
hive	thrive	deprive	skive
live	wive	derive	undive
rive	alive		

Ive (*short*)

give	sieve	misgive	ablative
live	forgive	outlive	causative

Ive (*short*)—(*Cont.*)

curative
formative
fugitive
genitive
lambative
laxative
lenitive
lucrative
narrative
negative
nutritive
positive
primitive
privative
punitive
purgative
putative
relative
sanative
semblative
sensitive
substantive
talkative
tentative
vocative
abdicative
accusative
acquisitive
affirmative
alterative
alternative
appellative
applicative
cogitative

comparative
copulative
consecutive
conservative
contemplative
contributive
correlative
declarative
definitive
demonstrative
deprecative
derivative
derogative
desiccative
diminutive
distributive
emanative
executive
explicative
figurative
generative
illustrative
imitative
imperative
inchoative
indicative
infinitive
inquisitive
intuitive
legislative
meditative
operative
palliative
preparative

prerogative
preservative
procreative
provocative
recitative
recreative
reparative
restorative
retributive
speculative
superlative
accumulative
administrative
argumentative
authoritative
commemora-
 tive
communicative
co-operative
corroborative
deliberative
determinative
discriminative
eradicative
illuminative
imaginative
inoperative
insinuative
interrogative
justificative
remunerative
representative
significative
opinionative

ratiocinative
overlive
admonitive
amative
coercitive
combative
compellative
compensative
competitive
complimenta-
 tive
compulsative
confirmative
dispensative
disputative
exclamative
expletive
impedetive
imputative
incarnative
incrossative
insensitive
intensative
laudative
nominative
premonitive
prohibitive
pulsative
quantitive
reformative
sedative
siccative
transitive
vibrative

Ix, Ics, Icks

bricks (*and add
 s to nouns
 and verbs in
 Ic*)
fix
mix

nix
pyx
six
styx
admix
affix

matrix
prefix
prolix
transfix
unfix
cicatrix

commix
inheritrix
crucifix
intermix
sardonyx
executrix

O, Ow, Eau, Oe

beau	stow	domino	archipelago
boh	strow	embryo	bateau
bow	though	folio	besnow
blow	throe	furbelow	"bo"
co	throw	indigo	bravissimo
crow	toe	mistletoe	bungalow
doe	tow	nuncio	tremolo
dough	trow	oleo	cachalot
floe	woe	overflow	canivaux
flow	ago	overgrow	de trop
foe	although	overthrow	do
fro	arow	portico	eau
glow	*banjo*	*portmanteau*	embow
go	below	ratio	escrow
grow	bestow	undergo	fortissimo
ho	*bureau*	vertigo	haricot
hoe	chapeau	adagio	impresario
know	château	imbroglio	indigo
lo	*cocoa*	incognito	trousseau
low	depot	intaglio	oboe
mow	forego	magnifico	nobo
no	foreknow	malapropos	morceau
oh	foreshow	mustachio	oratorio
O	heigh-ho	papilio	outflow
owe	hello	pistachio	overstrow
pro	outgo	punctilio	pianissimo
roe	outgrow	seraglio	portfolio
row	plateau	braggadocio	*rainbow*
sew	rondeau	duodecimo	rondeau
shew	*soho*	internuncio	sabot
show	*allegro*	generalissimo	studio
sloe	apropos	in statu quo	tableau
slow	buffalo	quid pro quo	ultimo
snow	calico	aglow	undertow
so	cameo	alow	upthrow
sow	comme il faut		

OBE

conglobe	enrobe	Job	probe
disrobe	globe	lobe	robe

Oₐcₕ

broach	abroach	roach	encroach
brooch	loach	approach	reproach
encroach	poach		

Oₐd, Oᴅᴇ, Oᴡᴇᴅ

bode	hoed	node	snowed (*and*
code	load	ode	*past of verbs*
goad	mode	road	*in* Oᴡ)
roed	rode	episode	antipode
strode	corrode	folioed	arrode
toad	erode	incommode	discommode
toed	explode	overload	lode
woad	forebode	porticoed	lycopode
abode	unload	portmanteau'd	pigeon-toed
bestrode	à la mode	mustachio'd	unowed
commode	dominoed		

Oₐf

loaf	oaf	sauf	goaf

Oₐᴋ, Oᴋᴇ

bloke	sloke	bespoke	masterstroke
broke	smoke	besmoke	asoak
choke	soak	convoke	cloke
cloak	spoke	invoke	coak
coke	stoke	provoke	counterstroke
croak	stroke	revoke	evoke
folk	toque	unyoke	outbroke
joke	woke	artichoke	poak
moke	yoke	equivoke	"toke"
oak	yolk	gentlefolk	unbroke
poke	awoke		

Oₐᴋs, Oᴋᴇs, Oₐx

hoax	coax

oaks (*and add s to nouns and verbs in* Oₐᴋ, Oᴋᴇ)

Oₐʟ, Oʟᴇ, Oʟ, Oʟʟ, Oᴜʟ, Oᴡʟ

bole	goal	poll	soul
bowl	hole	role	stole
coal	jole	roll	stroll
dole	knoll	scroll	thole
droll	mole	shoal	toll
foal	pole	sole	troll

OAL, OLE, OL, OLL, OUL, OWL—(*Cont.*)

vole	pistole	boll	gloriole
whole	unroll	camisole	inscroll
cajole	aureole	carambole	koll
comptrol	capriole	cole	oriole
condole	caracole	enbowl	pinole
console	girandole	foliole	rigmarole
control	girasole	fumarole	seghol
creole	rantipole	furole	unwhole
enroll	bacarolle	fusarole	uproll
parole	bibliopole	ghole	virole
patrol			

OAM, OME

clomb	tome	befoam	metronome
comb	aërodome	brome	monochrome
dome	catacomb	chrome	ohm
foam	currycomb	endome	polychrome
holme	harvest-home	gastronome	"pome"
home	hippodrome	gloam	sloam
loam	palindrome	gnome	aërodrome
mome	afoam	heliochrome	"no'm"
roam	aplome	holm	

OAN, ONE

bone	sown	unsown	dispone
blown	stone	unthrone	eau-de-cologne
cone	tone	antepone	electrophone
crone	throne	chaperone	enzone
drone	thrown	cornerstone	*flagstone*
flown	zone	grindlestone	interpone
groan	alone	gramophone	impone
grown	atone	knucklebone	lirocone
hone	bemoan	monotone	*lodestone*
known	depone	telephone	microphone
moan	dethrone	undertone	*millstone*
own	disown	*backbone*	mown
prone	enthrone	baritone	morone
roan	intone	begroan	overthrown
sewn	postpone	bestrown	pone
shewn	unknown	cicerone	propone
shown	unsewn	condone	saxophone

OAP, *see* OPE

OAR, ORE, *see also* OR

blore	pour	claymore	sycamore
boar	roar	deplore	troubadour
bore	score	encore	albacore
core	shore	explore	chore
corps	snore	forbore	crore
door	soar	forswore	folklore
floor	sore	ignore	footsore
fore	splore	implore	frore
four	store	restore	galore
gore	swore	abhor	heartsore
hoar	tore	battledore	outpour
lore	whore	blackamoor	outroar
more	wore	commodore	outsoar
nore	yore	evermore	pinafore
oar	adore	furthermore	sagamore
o'er	afore	hellebore	semaphore
ore	ashore	heretofore	sophomore
pore	before	matadore	stevedore
			Terpsichore

also possible rhymes in OWER (2-syllables)

OARD, ORED, ORD (*long*)

board	fiord	horde	aboard
floored (*and*	gourd	sword	afford
past tense of	hoard	toward	untoward
verbs in OAR)			

OARSE, *see* ORCE

OAST, OST (*long*)

boast	roast	nethermost	aftermost
coast	toast	outermost	riposte
ghost	almost	undermost	dosed (*and past*
host	hindermost	uppermost	*of verbs in*
most	innermost	uttermost	OSE *sharp*)
post	lowermost		

OAT, OTE

bloat	goat	anecdote	mote
boat	gloat	antidote	note
coat	groat	asymptote	oat
cote	outvote	slote	quote
dote	promote	lote	rote
float	remote	moat	smote

OAT, OTE—(*Cont.*)

stoat	troat	connote	overcoat
petticoat	throat	denote	scoat
table d'hôte	tote	devote	shote
afternote	vote	misquote	sloat
bedote	wrote	commote	underwrote
bequote	afloat	*footnote*	unsmote
capote			

OATH, OTH (*long*)

both	oath	quoth	*troth*
growth	loth	sloth	*betroth*
loath			

OATHE, OTHE

clothe	loathe	betrothe

OAX, *see* OAKS

OB

bob	cabob	nob	athrob
cob	job	quab	*hobnob*
fob	lob	rob	*nabob*
gob	knob	sob	thingumbob
hob	mob	snob	athrob
blob			

OBE

globe	probe	conglobe	enrobe
lobe	robe	disrobe	

OCK

block	lock	laughing-stock	drock
brock	lough	stumbling-	*forelock*
cock	mock	block	half-cock
clock	pock	weathercock	interlock
crock	rock	amok	laverock
dock	shock	baroque	lok
flock	smock	belock	ploc
frock	sock	bemock	roc
hock	stock	billicock	soc
hough	*padlock*	bock	unfrock
knock	*pibroch*	chock	unlock
loch	hollyhock	*deadlock*	

OCKS, *see* OX

Oct, Ocked

concoct	decoct	recoct	blocked (and past of verbs in Ock)

Od

cod	pod	tod	goldenrod
clod	prod	trod	lycopod
god	quad	wad	platypod (etc.)
hod	quod	untrod	slipshod
nod	rod	demigod	squad
odd	shod	begod	ungod
plod	sod	dry-shod	unshod

Ode, see Oad

Odge

hodge	unlodge	lodge	dislodge
hodge-podge	bodge	podge	*hodgepodge*
horologe	dodge		

Oe, see O and Ew

Off

cough	toph	shroff	trough
doff	off	"*soph*"	golf
cloff	scoff	toff	*philosophe*

Oft

coughed	scoffed	oft	sloft
croft	loft	soft	toft
doffed			

Og, Ogue (short)

bog	jog	epilog	"incog"
clog	log	monolog	mystagog
cog	prog	pedagog	nog
dog	shog	synagog	pettifog
flog	slog	"travelog"	philolog
fog	agog	analog	scrog
frog	catalog	apolog	"theolog"
gog	decalog	befog	trogue
grog	demagog	egg-nog	unclog
hog	dialog		

Ogue (*long*)

brogue	prorogue	astralogue	embogue
rogue	apologue	collogue	pirogue
vogue			

Oice

choice	voice	invoice	rejoice

Oid

buoyed	alkaloid	anthropoid	negroid
cloyed (*and*	asteroid	crystalloid	ovoid
past tense of	unemployed	deltoid	pyramidoid
verbs in Oy)	paraboloid	dendroid	tabloid
void	actinoid	hyaloid	unalloyed
avoid	albuminoid	metalloid	varioloid
devoid	aneroid		

Oil

assoyle	uncoil	moil	despoil
counterfoil	upcoil	oil	embroil
entoil	boil	soil	recoil
estoil	broil	spoil	turmoil
overtoil	coil	toil	disembroil
roil	foil		

Oin

eloin	foin	adjoin	rejoin
frankalmoigne	groin	benzoin	sainfoin
sejoin	join	conjoin	sirloin
tenderloin	loin	disjoin	subjoin
coign	proin	enjoin	interjoin
coin	quoin	purloin	

Oint

adjoint	joint	appoint	disjoint
coverpoint	oint	aroint	counterpoint
deadpoint	point	conjoint	disappoint
dry-point	anoint		

Oir, *see* Or

Oise, Oys

avoirdupois	noise	enjoys (*and add*	counterpoise
erminoise	poise	*s to nouns and*	equipoise
froise	boys	*verbs in* Oy)	

Oist
foist	joist	roist	*poised*
hoist	moist	*noised*	

Oit
coit	adroit	exploit	droit
doit	dacoit	introit	maladroit
quoit			

Oke, *see* Oak

Ol (*short*), Oll
doll	alcohol	protocol	*consol*
loll	*capitol*	vitriol	entresol
"Poll"	*parasol*	*atoll*	kroal

Ol (*long*), Ole, Oll (*long*), *see* Oal

Old, Ould
bold	scold	*threshold*	*foothold*
cold	sold	unfold	*household*
coaled (*and*	told	untold	interfold
past of verbs	wold	uphold	mold
in Oal	behold	withhold	multifold
fold	cuckold	copyhold	overbold
gold	enfold	manifold	*stronghold*
hold	foretold	marigold	twice-told
mould	*freehold*	acold	twofold
old	retold	ahold	

Olk, *see* Oak

Olt
bolt	jolt	volt	lavolt
colt	moult	revolt	smolt
dolt	poult	thunderbolt	unbolt
holt			

Olve
solve	devolve	exsolve	revolve
absolve	dissolve	involve	circumvolve
convolve	evolve	resolve	intervolve

Om
bomb	pompom	*hecatomb*	swom
from	dom	rhomb	

Om (*as in* martyrdom), *see* Um

Omb, *see* **Oam** *and* **Oom**

Ome, *see* **Oam** *and* **Um**

Omp

pomp	swamp	tromp	"comp"
romp			

On

con	echelon	bonbon	stereopticon
don	encephalon	hereon	dies non
gone	gonfalon	thereon	sine qua non
on	Helicon	whereon	bonne
shone	irênicon	pantechnicon	cretonne
swan	mastodon	parthenon	upon
wan	agone	prolegomenon	automaton
yon	anon	quarteron	Amazon
antiphon	begone	Rubicon	

See also **Un** for words of three syllables and over ending in **On**.

Once, **Onse**

nonce	sconce	ensconce	response

Once (*as* wunce), *see* **Unce**

Ond, **Onned**

bond	yond	conned	vagabond
fond	beyond	donned	blond
pond	abscond	respond	frond
wand	despond	correspond	

One, *see* **Oan**

One, *see* **Un**

Ong

daylong	jong	prong	along
dugong	lifelong	song	belong
erelong	prong	strong	dingdong
evensong	singsong	thong	diphthong
gong	scuppermong	throng	oblong
headlong	wong	tong	prolong
headstrong	long	wrong	overlong

Ongue, *see* **Ung**

Ons, *see* **Onze**

ONSE, *see* ONCE

ONT (*short*)

font	want	Hellespont

ONT (*long*)

don't	wont	won't

ONZE

bronze	pons	swans (*and add s to nouns and*
bonze		*verbs in* ON)

Oo (*as in* boo); *see note after* EW

boo	true	drew	taboo
blue	undo	grew	ragoût
clue	accrue	shrew	début
coup	bamboo	cockatoo	woo
fou	who	Kangaroo	ado
untrue	accrue	who	bamboo
slew	bamboo	unglue	flue
through	do	shampoo	tattoo
two	"gout"	imbrue	billet-doux
zoo	shoo	chew	hitherto
woo	threw	loo	hullabulloo
ado	to	rue	entre nous
moo	*impromptu*	shrew	rendezvous
screw	yahoo	flew	halloo
crew	surtout	*Zulu*	cuckoo
glue	eschew	withdrew	pooh
shoe	blue	beshrew	pooh-pooh
strew	brew	bestrew	gnu
too	coo	canoe	

Add to these, as possible rhymes, all words in UE

OOB

boob	"rube"

Add to these, as imperfect rhymes, other words in UBE

OOD (*as in* blood), *see* UD

OOD (*as in* good)

could	firewood	withstood	misunderstood
good	stood	agood	unhood
hood	wood	understood	*wildwood*
should	would	underwood	

Ood (*as in* mood)

brood	rude	extrude	seclude
food	snood	include	shrewd
crude	conclude	intrude	brewed (*and*
mood	cuckooed	obtrude	*past tense of*
prude	detrude	preclude	*verbs in* Oo)
rood	exclude	protrude	

Add to these, as imperfect rhymes, all words in Ude

Oof

hoof	spoof	approof	reproof
oof	woof	behoof	loof
proof	aloof	disproof	fire-proof
roof			

Ook; *see also* Uke *for imperfect rhymes*

spook	peruke	chibouque

Ook (*short*)

book	look	forsook	undertook
brook	nook	mistook	snook
cook	rook	overlook	*outlook*
stook	shook	Chinook	partook
crook	took	overtook	rukh
hook	betook		

Ool; *see also* Ule *for imperfect rhymes*

cool	school	who'll	drool
fool	spool	befool	footstool
pool	stool	misrule	ghoul
rule	tool	overrule	lool

Ool, *as in* wool (*see* Ul)

Oom; *see also* Ume *for imperfect rhymes*

bloom	plume	dining-room	disentomb
boom	rheum	drawing-room	enbloom
broom	room	elbow room	foredoom
coomb	tomb	addoom	heirloom
doom	whom	anteroom	jibboom
flume	womb	begloom	predoom
gloom	beplume	brume	spoom
groom	deplume	combe	grume
loom	entomb	coom	

Oon; see also Une for imperfect rhymes

boon	bassoon	poltroon	bridoon
chewn	batoon	pontroon	caissoon
coon	bestrewn	quadroon	forenoon
croon	buffoon	racoon	frigatoon
June	cartoon	shalloon	gambroon
loon	cocoon	simoon	gazon
moon	doubloon	typhoon	godroon
noon	dragoon	afternoon	fossoon
prune	eftsoon	honeymoon	maroon
rune	eschewn	macaroon	overstrewn
screwn	festoon	musketoon	patroon
shoon	galoon	octoroon	quateroon
soon	harpoon	oversoon	ratoon
spoon	jejeune	pantaloon	saloon
strewn	lagoon	picaroon	seroon
swoon	lampoon	rigadoon	spadroon
baboon	monsoon	aswoon	spittoon
balloon	platoon	barracoon	walloon

Oop, Oup

coop	poop	troop	roop
croup	scoop	whoop	scroup
droop	sloop	nincompoop	troupe
group	soup	aggroup	unhoop
hoop	stoop	drupe	*dupe*
houp	stoup	liripoop	"supe"
loop	swoop	recoup	

Oor; see also Ure for imperfect rhymes

boor	truer	cocksure	paramour
bluer	wooer	conjure	reinsure
brewer	abjure	contour	altambour
doer	adjure	detour	blackamoor
fluor	amour	ensure	reassure
moor	*sewer*	insure	spoor
poor	assure	unsure	"who are"
sure	brochure	evildoer	"you are" (etc.)
tour			

Oor (as in floor), see Oar

Oose (sharp), see also Use (sharp) for imperfect rhymes

goose	loose	noose	spruce
juice	moose	sluice	truce

Oose (*sharp*)—(*Cont.*)

abstruse	recluse	vamose	calaboose
occluse	unloose	caboose	pappoose

Oose (*flat*), **Ooze**; *see also* **Use** (*flat*) *for imperfect rhymes*

blues,	bruise	peruse	choose
brews (*and*	booze	ruse	whose
plurals	lose	snooze	who's
in Oo)	ooze	cruise	

Oost; *see also past of verbs in* **Uce** *for imperfect rhymes*

boost	noosed	unloosed	spruced
juiced	roost	joust	vamoosed
loosed	sluiced		

Oot (*short*)

foot	put	afoot	soot

Oot (*long*); *see also* **Ute** *for imperfect rhymes*

baldicoot	en route	hoot	cheroot
cahoot	soot	jute	outroot
chute	upshoot	loot	recruit
enroot	bruit	moot	uproot
imbrute	brute	root	overshoot
marabout	coot	shoot	parachute
mahout	flute	adjute	waterchute

Ooth (*hard*) **Outh, Uth**

ruth	truth	forsooth	insooth
sooth	booth	uncouth	sleuth
tooth	youth	untruth	

Ooth (*soft*)

smooth	besmooth	soothe

Oove, Ove

move	approve	improve	disapprove
groove	behoove	remove	amove
prove	disprove	reprove	ingroove
you've			

Ooze, *see* **Oose** (*flat*)

Op

chop	crop	flop	hop
cop	drop	fop	lop

Op—(*Cont.*)

mop	stop	overtop	*snowdrop*
plop	strop	underprop	swap
pop	top	eavesdrop	tiptop
prop	atop	estop	unstop
shop	bedrop	forestop	whop
slop	co-op	knop	"wop"
sop	aftercrop	lollipop	

Ope

afterhope	stope	slope	hygroscope
agrope	unpope	soap	interlope
astroscope	cope	tope	microscope
dispope	dope	trope	misanthrope
electroscope	grope	aslope	polyscope
Ethiope	hope	elope	telescope
galvanoscope	lope	antelope	thermoscope
gyroscope	mope	antipope	anemoscope
hydroscope	ope	baroscope	helioscope
polariscope	pope	envelope	heliothrope
seismoscope	rope	bioscope	kaleidoscope
spectroscope	scope	horoscope	polemoscope
stethescope			

Or; *see also, for passable rhymes,* **Oar**

for	minotaur	*emperor*	*contributor*
lor	mortgagor	*escritoir*	*excelsior*
nor	*devoir*	*governor*	*executor*
or	*memoir*	*meteor*	*expositor*
tor	*ancestor*	*orator*	*exterior*
war	*auditor*	*reservoir*	*inferior*
abhor	*bachelor*	*senator*	*inheritor*
lessor	*chancellor*	*warrior*	*inquisitor*
señor	*conqueror*	*ambassador*	*interior*
vendor	*corridor*	*anterior*	*posterior*
servitor	*creditor*	*apparitor*	*progenitor*
terpsichore	*counselor*	*competitor*	*solicitor*
louis d'or	*councilor*	*compositor*	*superior*
metaphor	*editor*	*conspirator*	*vice-chancellor*
seignior			

Orce, Oarse, Ourse

coarse	force	source	discourse
course	hoarse	concourse	divorce

ORCE, OARSE, OURSE—(Cont.)

enforce	intercourse	horse	corse
perforce	reinforce	unhorse	gorse
recourse	retrorse	torse	endorse
resource	watercourse	morse	remorse

ORCH (short)

porch	scorch	torch

ORD (long), see OARD

ORD (short)

chord	ward	record	aboard
cord	warred	reward	board
ford	abhorred	clavichord	bord
horde	accord	harpsichord	gourd
lord	afford	monochord	hoard
ord	concord	pentachord	sword
sward	discord	perigord	

ORE, see OAR

ORGE

forge	disgorge	regorge	overgorge
gorge	engorge		

ORK

ork	fork	stork	York
New York	pork		

ORLD, see URLED

ORM

form	deform	chloroform	thunderstorm
storm	inform	cruciform	uniform
swarm	perform	cuneiform	vermiform
warm	reform	misinform	iodoform
conform	transform	multiform	

ORN, ORNE

born	scorn	worn	barley-corn
borne	shorn	adorn	capricorn
corn	sorn	forborne	heaven-born
horn	sworn	forsworn	overborne
lorn	thorn	forlorn	peppercorn
morn	torn	lovelorn	unicorn
norn	warn	suborn	foresworn

Orn, Orne—(*Cont.*)

mourn	bemourn	bourne	weatherworn
forewarn	betorn		

Orp

dorp	thorp	warp	"corp"

Orse, *see* Orce

Ort

fort	porte	exhort	decourt
mort	sport	deport	forte
short	comport	disport	*passport*
snort	assort	export (verb)	*seaport*
sort	cohort	import (verb)	report
tort	consort (verb)	rapport	support
wart	contort	extort	transport
court	distort	resort	misreport
port	escort (verb)	retort	disport

Orth

fourth	swarth	thenceforth	setter-forth
north	henceforth		

Os, *see* Oss

Ose (*sharp*)

close (adj.)	annulose	floccose	glubose
dose	engross	foliose	glucose
gross	jocose	verbose	grandiose
actuose	morose	bellicose	nodose
adipose	cellulose	comatose	otiose
albuminose	cose	gibbose	overdose
animose	diagnose		

Ose (*flat*), Oze, Ows

beaus (*and*	oppose	transpose	*depots*
plurals in O)	propose	unclose	disclose
chose	repose	discompose	dispose
close	suppose	indispose	enclose
clothes	nose	interpose	predispose
froze	pose	arose	presuppose
glose	prose	compose	recompose
hose	rose	depose	tuberose
foreclose	those	decompose	punctilios
impose	expose		

Oss

boss	loss	cerebos	floss
cross	moss	setebos	foss
doss	toss	bos	fosse
dross	across	colosse	lacrosse
gloss	emboss	encephalos	*rhinoceros*
joss	albatross		

Ost (*long*), *see* Oast

Ost (*short*), Ossed

accost	bossed, (*and*	cost	*wast*
geognost	*past of verbs*	frost	Pentecost
unlost	*in* Oss)	lost	exhaust
			holocaust

Ot, Otte

asquot	blot	slot	aliquot
beauty-spot	clot	sot	apricot
besot	cot	spot	bergamot
bott	dot	squat	camelot
cachalot	got	swot	chariot
calotte	grot	tot	counterplot
capot	hot	trot	eschalot
forget-me-not	jot	what	gallipot
Huguenot	knot	wot	heriot
kumquot	lot	yacht	idiot
love-knot	not	allot	misbegot
shallot	plot	begot	patriot
somewhat	pot	boycott	polyglot
underplot	quot	cocotte	unbegot
unforgot	rot	forgot	undershot
wat	scot	garotte	*compatriot*
witenagemot	shot	gavotte	

Otch

blotch	potch	watch	hotch
botch	scotch	hotch-potch	splotch
crotch	swatch	gotch	Scotch
notch			

Ote, *see* Oat

Oth (*long*), *see* Oath

OTH (*short*)

broth	moth	Ashtaroth	thoth
cloth	betroth	Goth	troth
froth	wroth	saddlecloth	visigoth

OTHE, *see* **OATHE**

OU, *see* **EW** *and* **OW**

OUCH

mouch	ouch	grouch	disvouch
couch	pouch	vouch	*scaramouch*
crouch	slouch	avouch	

OUD, OWED

bowed (*and*	crowd	aloud	becloud
past of verbs	loud	enshroud	beshroud
in Ow)	proud	o'ercloud	encloud
cloud	shroud	o'ershroud	overcrowd

OUGH, *see* **OFF, UFF, OW, OCK, EW, O**

OUGT, *see* **AUGHT**

OUL, *see* **OLE, OWL**

OULD, *see* **OLD** *and* **OOD**

OUNCE

bounce	ounce	announce	renounce
flounce	pounce	denounce	enounce
frounce	trounce	pronounce	rounce

OUND, OWNED

bound	wound	outbound	superabound
crowned (*and*	abound	profound	*background*
past of verbs	aground	propound	hell-bound
in Own)	around	rebound	(etc.)
found	astound	redound	*hidebound*
ground	compound	renowned	*icebound*
hound	confound	resound	impound
mound	dumfound	surround	merry-go-
pound	expound	unbound	round
round	imbound	unsound	unground
sound	inbound	underground	

Ount

count	amount	recount	paramount
fount	discount (verb)	remount	tantamount
mount	dismount	surmount	catamount
account	miscount		

Oup, see Oop

Our, see also Oor

bower	our	embower	imbower
cower	power	endower	lower
dour	scour	empower	horse-power
dower	shower	cauliflower	overtower
flour	sour	overpower	vower
flower	tower	besour	"kowtower"
glower	avower	allower	plower (etc.),
hour	deflower	enflower	(see Ow)
lour	devour		

Ourn; see also Orn and Earn
bourn	mourn

Ourse, see Orce

Ous, see Us

Ouse (sharp)

chouse	louse	souse	custom-house
dowse	mouse	charnel-house	chapterhouse
grouse	nous	counting-house	(etc.)
house			

Ouse (flat), Owze

bowse	bows (and add	house (verb)	carouse
drowse	s to nouns	rouse	espouse
blouse	and verbs in	spouse	unhouse
blowze	Ow)	touse	uprouse
boughs	browze		

Out

bout	grout	shout	trout
clout	lout	snout	about
doubt	out	spout	devout
flout	pout	sprout	misdoubt
glout	rout	stout	redoubt
gout	scout	tout	throughout

Out—(*Cont.*)

without	whereabout	drinking bout	out-and-out
roundabout	beshout	gadabout	roustabout
sauerkraut	bespout	hereabout	stirabout
thereabout	diner-out (etc.)	knout	drouth

Outh (*short*); *see also* Ooth

drouth	mouth	south	bemouth

Ove (*as in* prove), *see* Oove

dove	love	lady-love	turtledove
glove	shove	above	unglove
belove			

Ove (*long*)

clove	rove	wove	inwove
cove	stove	*alcove*	dove
drove	strove	behove	mauve
grove	throve	interwove	shrove
hove	trove	treasure-trove	

Ow (*as* O), *see* O

Ow (*diphthong*)

bough	row	bow-wow	anyhow
bow	slough	endow	disavow
brow	sow	enow	dhow
cow	thou	kowtow	mow
frau	trow	powwow	overbrow
how	vow	somehow	scrow
now	allow	disallow	scow
plough	avow	disendow	landau
prow			

Owl; *see also* Oal

cowl	growl	scowl	dowle
foul	howl	befoul	rowl
fowl	owl	afoul	water-fowl
ghoul	prowl	behowl	jowl

Own; *see also* Oan

brown	drown	town	upside-down
clown	frown	adown	decrown
crown	gown	embrown	discrown
down	noun	renoun	eider-down

Own; *see also* Oan—(*Cont.*)

godown	tumble-down	uptown	downtown
reach-me-down	ungown		

Owse, *see* Ouse (*flat*)

Ox, Ocks

box	cocks (*and*	fox	equinox
cox	*add s to*	ox	orthodox
	nouns and	phlox	paradox
	verbs in Ock)	pox	heterodox

Oy

ahoy	boy	alloy	envoy
corduroy	buoy	annoy	savoy
dalmahoy	cloy	convoy	sepoy
deploy	coy	decoy	misemploy
foy	joy	destroy	overjoy
paduasoy	toy	employ	pomeroy
soy	troy	enjoy	saveloy

Oze, *see* Ose (*flat*)

U, *see* Ue

Ub

blub	dub	slub	hubbub
bub	grub	snub	sillabub
chub	hub	stub	beelzebub
club	rub	sub	fub
cub	scrub	tub	nub
drub	shrub	rub-a-dub	

Ube; *see also* Oob *for imperfect rhymes* (*note, p.* 114)

cube	tube	jujube

Uce, Use; *see also* Oose *for imperfect rhymes* (*note, p.* 114)

adduce	use (noun)	excuse	seduce
pertuse	abduce	induce	subduce
retuse	abuse	misuse	traduce
transluce	conduce	obduce	introduce
calaboose	deduce	obtuse	reproduce
cruse	diffuse	produce	hypotenuse
deuce	disuse (noun)	profuse	superinduce
puce	educe	reduce	

Uch, Utch

clutch	mutch	retouch	cutch
crutch	such	inasmuch	scutch
hutch	slutch	insomuch	amutch
much	touch	overmuch	

Uck

amuck	stuck	luck	struck
beduck ill-luck	buck	muck	suck
misluck pov-	chuck	pluck	truck
erty-struck	sluck	puck	tuck
shuck	duck	ruck	thunderstruck

Uct

duct	instruct	usufruct	misconstruct
abduct	obstruct	viaduct	reduct
conduct	aqueduct	construct	subduct
deduct	misconduct	eruct	substruct
induct	(verb)	bucked (*and past of verbs in* Uck)	

Ud

blood	flood	scud	thud
bud	mud	spud	bestud
cud	rud	stud	fud

Ude, Ued, Eud, Ewed; *see also* **Ood** *for imperfect rhymes (note p. 114)*

cued	transude	parvitude	exactitude
dewed (*and	acritude	platitude	inaptitude
past tense of*	altitude	plenitude	incertitude
all verbs in	amplitude	promptitude	ineptitude
Ue)	aptitude	pulchritude	infinitude
dude	attitude	quietitude	ingratitude
feud	certitude	rectitude	mansuetude
lewd	crassitude	sanctitude	necessitude
nude	finitude	servitude	serenitude
you'd	fortitude	solitude	similitude
allude	gratitude	torpitude	solicitude
collude	habitude	turpitude	vicissitude
delude	interlude	assuetude	inexactitude
denude	lassitude	beatitude	dissimilitude
elude	latitude	consuetude	abatude
exude	longitude	decrepitude	acerbitude
illude	magnitude	desuetude	amaritude
prelude	multitude	disquietude	claritude

Ude, Ued, Eud, Ewed—(Cont.)

inquietude	mallitude	subnude	vastitude
interclude	occlude	unpursued	verisimilitude
lenitude	retrude	unrenewed, etc.	abstrude
limitude	senectitude		

Udge

budge	judge	trudge	prejudge
drudge	nudge	adjudge	rejudge
fudge	sludge	forejudge	begrudge
grudge	smudge	misjudge	

Ue, Ew, Eu, U; *see also* Oo *for imperfect rhymes* (*note, p.* 114)

cue	pew	bedew	detinue
dew	spue	bellevue	parvenu
due	stew	endue	avenue
ewe	sue	ensue	*impromptu*
few	thew	imbue	residue
hew	view	mildew	barbecue
hue	yew	purlieu	interview
knew	you	pursue	retinue
mew	adieu	renew	revenue
lieu	anew	review	*Jew*
new	askew	subdue	

Uff

bluff	slough	snuff	fluff
buff	blindman's buff	*sough*	powder-puff
chough	gruff	stuff	scuff
chuff	huff	counterbuff	tuff
clough	luff	bepuff	tough
cuff	muff	besnuff	enough
ruff	puff	duff	rebuff
scruff	rough		

Ug

trug	jug	rug	sug
bug	lug	shrug	thug
drug	mug	slug	tug
dug	pug	smug	humbug
hug	plug	snug	

Uice, *see* **Uce**

Uise, *see* **Use** (*flat*)

Uɪᴛ, *see* Uᴛᴇ

Uᴋᴇ; *see also* Ooᴋ *for imperfect rhymes* (*note, p.* 114)

duke	puke	archduke	beduke
fluke	stuke	rebuke	pentateuch
juke			

Uʟ, Uʟʟ (*as in* bull)

worshipful

tulle	bountiful	fanciful	(etc.) (*Words*
bull	dutiful	merciful	*ending in*
full	masterful	plentiful	ғuʟ, *having*
pull	pitiful	powerful	*accent on the*
wool	thimbleful	sorrowful	*antepenulti-*
brimful (etc.)	weariful	wonderful	*mate, are pos-*
beautiful			*sible rhymes*)

Uʟ, Uʟʟ (*as in* cull)

cull	skull	strull	pinnacle
dull	trull	stull	spectacle
gull	annul	barnacle	vehicle
hull	bulbul	chronicle	versicle (*adjec-*
lull	numskull	kehul	*tives with*
mull	disannul	miracle	*suffix* ғuʟ
null	shull	monocle	*are imperfect*
scull	picul	obstacle	*rhymes*)

Uʟᴇ, *see* Ooʟ *for imperfect rhymes* (*note, p.* 114)

buhl	you'll	ridicule	vestibule
mule	yule	vermicule	mewl
pule	reticule		

Uʟɢᴇ

bulge	emulge	promulge	effulge
divulge	indulge		

Uʟᴋ

bulk	hulk	skulk	sulk

Uʟᴘ

gulp	pulp	sculp	sulp

Uʟsᴇ

appulse	dulse	convulse	insulse
bulse	mulse	expulse	repulse
compulse	pulse	impulse	

Ult

cult	incult	occult	catapult
adult	exult	indult	*difficult*
consult	insult	result	uncult

Um, Umb

chum	*radium*	rhumb	sum
come	rascaldom	"scrum"	swum
crumb	rebeldom	stum	thrum
drum	cumbersome	sugar-plum	thumb
dumb	*frolicsome*	*tedium*	tum
from	humorsome	*gymnasium*	become
glum	kettledrum	*millennium*	benumb
grum	laudanum	*crematorium*	minimum
gum	mascimum	*equilibrium*	misbecome
hum	meddlesome	*pandemonium*	modicum
mum	*medium*	*pericranium*	*odium*
mumm	mettlesome	*sanatorium*	*opium*
numb	venturesome	*epithalamium*	overcome
plum	worrisome	*ad libitum*	pendulum
plumb	wranglesome	*adytum*	premium
rum	quarrelsome	*aquarium*	*opprobrium*
scum	speculum	*bumbledom*	*palladium*
slum	troublesome	*Christendom*	*petroleum*
some	tympanum	*chrysanthemum*	*residuum*
fee-fo-fum	wearisome	*curriculum*	*sensorium*
crum	adventuresome	*drearisome*	*solatium*
humdrum	compendium	*flunkydom*	*symposium*
succumb	delirium	*geranium*	*auditorium*
burdensome	effluvium	*heatherdom*	*pelargonium*
cranium	emporium	*pabulum*	*vacuum*
platinum	encomium	strum	*viaticum*
quietsome	exordium		

Ume; *see also* Oom *for imperfect rhymes* (note, p. 114)

fume	exhume	presume	reassume
spume	illume	relume	infume
assume	inhume	resume	legume
consume	perfume		

Ump

bethump	bump	crump	hump
sump	chump	dump	jump
tump	clump	frump	lump

Ump—(*Cont.*)

mump	pump	slump	thump
plump	rump	stump	trump

Un

bun	spun	*cinnamon*	overdone
done	stun	*comparison*	overrun
dun	sun	everyone	euroclydon
fun	ton	fanfaron	*oblivion*
gun	tun	antiphon	*simpleton*
none	won	ganglion	*singleton*
nun	begun	*garrison*	*skeleton*
one	forerun	*halcyon*	*tarragon*
pun	outrun	*lexicon*	*ternion*
run	undone	*myrmidon*	*unison*
shun	anyone	*orison*	*venison*
son	*benison*	*orthogon*	*caparison*

(*See also words of three syllables and over, ending in* An *and* En *with accent on antepenultimate, for possible rhymes*)

Unce

dunce	once	unce	stunts (*and add s to nouns and verbs in* Unt)

Unch

brunch	hunch	munch	scrunch
bunch	lunch	punch	clunch
crunch			

Und

bund	punned (*and*	rotund	immund
fecund	*past of verbs*	rubicund	matafund
jocund	*in* Un, On)	orotund	retund
obrotund	refund	verecund	

Une; *see also* Oon *for imperfect rhymes (note, p. 114)*

attune	lacune	stewn	subduen
commune	lune	suen	triune
dune	oppugn	tune	untune
excommune	picayune	viewn	importune
expugn	hewn	immune	opportune
impugn	lune	persuen	inopportune

Ung

bung	sprung	wrung	betongue
clung	underhung	young	high-strung
dung	strung	overhung	lung
flung	stung	unstrung	mother tongue
hung	sung	among	pung
rung	swung	unsung	unwrung
slung	tongue	behung	upsprung

Unge

allonge	emplunge	plunge	spunge
blunge	lunge	sponge	expunge
dispunge			

Unk

bunk	junk	skunk	sunk
chunk	monk	slunk	trunk
drunk	plunk	spunk	flunk
funk	punk	stunk	quidnunc
hunk	shrunk		

Unt

blunt	hunt	shunt	confront
bunt	lunt	sprunt	"won't"
brunt	punt	stunt	exeunt
front	runt	affront	forefront
grunt			

Up

cup	sup	up	crup
pup	tup	buttercup	

Upe; see Oop for imperfect rhymes (note, p. 114)

dupe	pupe	"supe"	"cupe"

Upt

cupped	abrupt	incorrupt	disrupt
pupped	corrupt	interrupt	erupt
supped			

Ur, see **Er**

Urb, see **Erb**

Urch, see **Earch**

Urd, see **Eard**

URE; *see also* OOR *for imperfect rhymes* (*note, p.* 114)

abature	tablature	impure	forfeiture
abbreviature	vestiture	inure	furniture
amateur	cure	manure	garniture
aperture	dure	obscure	immature
breviature	ewer	ordure	insecure
candidature	fewer	procure	ligature
caricature	hewer	pursuer	overture
colure	lure	renewer	portraiture
connoisseur	newer	reviewer	premature
divestiture	pure	secure	sepulture
enmure	sewer	subduer	signature
expenditure	skewer	voiture	sinecure
garmenture	your	armature	discomfiture
geniture	you're	calenture	entablature
liqueur	allure	comfiture	investiture
mature	*azure*	coverture	literature
perdure	demure	curvature	miniature
perendure	endure	cynosure	temperature
quadrature	immure	epicure	primogeniture

URF, *see* ERF

URGE, *see* ERGE

URK, *see* ERK

URL, *see* EARL

URLED, ORLD, IRLED, EARLED

curled (*and past of verbs in* EARL)	world	old-world	underworld

URN, *see* EARN

URP

chirp	discerp	extirp	usurp

URSE, *see* ERCE

URST, *see* IRST

URT, *see* ERT

URVE, *see* ERVE

Us, Uss, Ous

bus
fuss
plus
pus
thus
truss
us
discuss
nonplus
amorous
platypus
credulous
courteous
aqueous
arduous
arquebus
barbarous
beauteous
bibulous
blasphemous
blunderbuss
curious
crapulous
boisterous
bounteous
calculous
cautelous
cavernous
chivalrous
clamorous
congruous
copious
dangerous
devious
dexterous
dolorous
dubious
duteous
emulous
envious
exodus
fabulous

fatuous
frivolous
furious
garrulous
generous
globulous
glorious
glutinous
gluttonous
hazardous
hideous
humorous
igneous
impetus
impious
incubus
infamous
jeopardous
languorous
lecherous
libelous
ligneous
ludicrous
luminous
marvelous
membranous
mischievous
mountainous
murderous
mutinous
nauseous
nautilus
nebulous
nucleus
numerous
obvious
odious
odorous
ominous
omnibus
onerous
overplus

pendulous
perilous
pervious
phosphorus
phosphorous
piteous
plenteous
poisonous
polypus
ponderous
populous
posthumous
previous
prosperous
querulous
radius
rancorous
ravenous
resinous
rigorous
riotous
ruinous
scandalous
scrofulous
scrupulous
scrutinous
scurrilous
sedulous
sensuous
serious
sinuous
sirius
slanderous
sonorous
spurious
stimulus
strenuous
studious
succubus
sulphurous
sumptuous
syllabus

synchronous
tartarus
tedious
thunderous
timorous
tortuous
traitorous
treacherous
treasonous
tremulous
tyrannous
vacuous
valorous
various
venomous
vigorous
villainous
virtuous
abaculus
abacus
Angelus
animus
buss
caduceus
convolvulus
cumulus
"cuss"
denarius
excuss
incuss
minimus
muss
octopus
percuss
platypus
repercuss
rhus
tantalus
terminus
untruss
acclivitous
ecephalous

Us, Uss, Ous—*(Cont.)*

acidulous	imposturous	unscrupulous	deciduous
albuminous	incendious	uproarious	delirious
aliferous	incommodious	vagarious	diaphanous
aligerous	inconspicuous	valetudinous	discourteous
alimonious	indecorous	vaporous	erroneous
alkalious	inebrious	vegetous	exiguous
alluvious	infelicitous	verdurous	extraneous
aluminous	inharmonious	verminous	fastidious
amatorius	inquisitorious	vernaculous	felicitous
anfractuous	insensuous	vertiginous	felonious
angulous	meticulous	viperous	ferruginous
anserous	monogamous	vitreous	fortuitous
antipathous	monotonous	voraginous	fuliginous
arborous	murmurous	vortiginous	gelatinous
armigerous	nectareous	vulturous	gratuitous
augurous	pendulous	abstemious	gregarious
balsamiferous	periculous	acephalous	harmonious
bicephalous	perjurous	adventurous	herbaceous
bigamous	pesterous	adulterous	hilarious
bipetalous	petalous	ambiguous	homologous
bituminous	platinous	amphibious	idolatrous
blusterous	polygamous	analogous	illustrious
burdenous	pseudonymous	androgynous	impetuous
bulbiferous	quarrelous	anomalous	imperious
burglarious	rapturous	anonymous	impervious
cancerous	roysterous	asparagus	imponderous
cankerous	sanguineous	assiduous	incestuous
circuitous	savourous	cadaverous	incongruous
contrarious	scintillous	calamitous	incredulous
covetous	sibilous	calcareous	incurious
criminous	slumberous	cantankerous	indigenous
doloriferous	stentorious	carnivorous	indubious
dulciphluous	stridulous	censorious	industrious
endogenous	tautologous	chrysoprasus	ingenious
eponymous	tenebrous	commodious	ingenuous
equilibrious	tenuous	conspicuous	inglorious
ethereous	timidous	contemptuous	iniquitous
fatuitous	tintinnabulous	conterminous	injurious
flumious	torturous	contiguous	innocuous
fossiliferous	tuberculous	continuous	inodorous
imaginous	unchivalrous	*courageous*	insidious
immeritous	undulous	cretaceous	invidious

Us, Uss, Ous—*(Cont.)*

laborious
lascivious
leguminous
Leviticus
libidinous
litigious
lugubrious
luxurious
magnanimous
mellifluous
melodious
miraculous
multivious
mysterious
necessitous
nefarious
notorious
oblivious
obsequious
obstreperous
œsophagus
omnivorous
opprobrious
outrageous
penurious
perfidious
perspicuous

pestiferous
precarious
precipitous
predaceous
preposterous
presumptuous
promiscuous
punctilious
ranunculus
rebellious
ridiculous
salacious
salubrious
sarcophagus
setaceous
solicitous
somniferous
spontaneous
sulphurous
superfluous
synonymous
tempestuous
tenebrious
tumultuous
ubiquitous
umbrageous

unanimous
ungenerous
usurious
uxurious
vainglorious
vicarious
victorious
vociferous
voluminous
voluptuous
acrimonious
advantageous
atrabilious
ceremonious
contumelious
deleterious
disingenuous
farinaceous
graminivorous
hippopotamus
homogeneous
hydrocephalus
ignis fatuus
ignominious
impecunious
instantaneous

meritorious
metalliferous
miscellaneous
mucilaginous
multifarious
multitudinous
odoriferous
oleaginous
pachyderma-
 tous
parsimonious
pusillanimous
sanctimonious
saponaceous
simultaneous
subterraneous
supercilious
temerarious
contempora-
 neous
disadvanta-
 geous
extemporane-
 ous
heterogeneous
zoöphagous

Use *(sharp)*, *see* Uce

Use *(flat)*; *see also* Oose *for imperfect rhymes* (*note, p.* 114)

affuse
fuze
guze
incuse
interfuse
cues
dews (*and add*
 s *to nouns*
 and verbs in
 Ue) (*and* Oo
 for imperfect
 rhymes)

fuse
muse
news
use (verb)
-abuse
accuse
amuse
bemuse
confuse
contuse

diffuse
disuse
effuse
enthuse
excuse
infuse
intuse
misuse

perfuse
refuse
suffuse
transfuse
circumfuse
disabuse
impromptus
revenues

Usʜ (*as in* bush)

bush	push	*ambush*	"cush"

Usʜ (*as in* blush)

blush	hush	outrush	tush
brush	lush	rush	mush
crush	plush	slush	underbrush
flush	outblush	thrush	"shush"
gush			

Usᴋ

busk	husk	rusk	adusk
dusk	lusk	subfusk	denusk
fusc	musk	tusk	

Uss (*as in* fuss), *see* Us

Uss (*as in* puss)

puss	"à la Russe"	"au jus" (etc.)

Usᴛ

bust	thrust	entrust	dost
crust	trust	incrust	fust
dust	adjust	mistrust	bussed
gust	august (adj.)	nonplused	fussed
just	disgust	robust	trussed
lust	distrust	unjust	discussed
must	adjust	bedust	mussed
betrust	combust	angust	cussed
rust	coadjust	untoussed	unmussed

Uᴛ, Uᴛᴛ

but	nut	outshut	englut
butt	putt	uncut	rebut
crut	rut	smut	cocoanut (etc.)
cut	scut	strut	halibut
glut	shut	stut	occiput
gut	slut	tut	waterbutt
hut	astrut	abut	clear-cut (etc.)
jut	besmut	catgut	

Uᴛ (*as in* put), *see* Oᴏᴛ

Uᴛᴄʜ, *see* Uᴄʜ

Ute, Uit; *see also* Oot *for imperfect rhymes* (*note, p.* 114)

astute	newt	pollute	destitute
cornute	suit	pursuit	dissolute
emeute	acute	refute	disrepute
hirsute	arbute	repute	execute
immute	argute	salute	institute
involute	commute	transmute	persecute
meute	compute	volute	prosecute
solute	confute	absolute	prostitute
subacute	depute	attribute	resolute
suppute	dilute	comminute	substitute
versute	dispute	constitute	irresolute
cute	impute	"beaut"	Ute
lute	minute (adj.)	*contribute*	Piute
mute	permute		

Uth, *see* Ooth

Ux, Ucks

crux	conflux	reflux	bucks (*and*
dux	efflux	superflux	*add s to*
flux	influx	afflux	*nouns and*
lux			*verbs in* Uck)

Y (*long*), Igh

aye (yes)	rye	defy	amplify
buy	sky	deny	beautify
by	sigh	descry	brutify
cry	sly	espy	by-and-by
die	spy	foreby	candify
dry	sty	go-by	certify
dye	thigh	good-bye	clarify
eye	thy	hereby	crucify
fie	tie	imply	deify
fry	try	outcry	dignify
guy	vie	outfly	dulcify
hie	why	outvie	edify
high	wry	rely	falsify
lie	ally	reply	fortify
my	apply	supply	frenchify
nigh	awry	thereby	fructify
pie	belie	untie	glorify
ply	comply	whereby	gratify
pry	decry	alkali	horrify

Y (*long*), I_{GH}—(*Cont.*)

justify	scarify	alkalify	termini
labefy	signify	angelify	incubi (etc.),
lenify	simplify	anglify	*see nouns*
liquefy	specify	assai	*from the*
lullaby	stupefy	ay	*Latin, in* Us
magnify	tabefy	bedye	lazuli
modify	terrify	bespye	lignify
mollify	testify	butterfly	mystify
mortify	typify	classify	nye
multiply	verify	codify	passer-by
notify	versify	countrify	preachify
nullify	vilify	damnify	quantify
occupy	vivify	dandify	revivify
ossify	beatify	demy	saccharify
pacify	disqualify	dissatisfy	scye
petrify	diversify	electrify	shy
prophesy	exemplify	emulsify	sny
(verb)	fecundify	ensky	spry
purify	harmonify	eternify	stellify
putrefy	indemnify	*firefly*	stultify
qualify	intensify	fossilify	torpify
ramify	personify	gasify	torrefy
rarefy	preoccupy	genii	underlie
ratify	solidify	gry	unify
rectify	acidify	heigh	verbify
rubefy	adry	humanify	vitrify
sanctify	alacrify	hushaby	wye
satisfy	alibi	identify	

Y (*short*)

(*NOTE.*—There are several thousand words ending in Y short, with the accent on the antepenultimate. As these are not good rhymes either to one another or to words with any other ending, only a partial list is given here. They are, however, freely used by all poets as rhymes to words ending in E *long*, Ea and Ee.)

academy	battery	canopy	courtesy
agony	bigamy	charity	cruelty
amity	bigotry	clemency	decency
anarchy	blasphemy	colony	destiny
apathy	bribery	comedy	dignity
artery	brevity	company	drapery
augury	calumny	constancy	drollery

Y *(short)*—*(Cont.)*

drudgery	monarchy	treasury	dexterity
ecstasy	mummery	trinity	disparity
embassy	mutiny	trumpery	diversity
enemy	mystery	tyranny	divinity
energy	nicety	unity	doxology
equity	novelty	usury	duplicity
eulogy	nunnery	vacancy	emergency
euphony	nursery	vanity	enormity
factory	penalty	victory	eternity
family	penury	villainy	etymology
fallacy	perfidy	votary	extremity
fecundity	perjury	absurdity	familiarity
flattery	pillory	activity	fatality
foolery	piracy	adversity	felicity
gaiety	pleurisy	affinity	ferocity
gallantry	policy	agility	fertility
gallery	poverty	ambiguity	fidelity
galaxy	primary	anatomy	frivolity
granary	privacy	animosity	frugality
history	prodigy	antiquity	genealogy
idolatry	quality	anxiety	gratuity
industry	quantity	apostasy	hostility
injury	raillery	apostrophe	hospitality
infamy	rectory	aristocracy	humanity
jollity	remedy	austerity	hypocrisy
knavery	ribaldry	authority	idiosyncrasy
laxity	rivalry	calamity	immortality
legacy	robbery	capacity	impetuosity
leprosy	royalty	captivity	impiety
lethargy	salary	catastrophe	impossibility
levity	sanctity	complexity	importunity
liberty	secrecy	concavity	impurity
livery	slavery	conformity	inability
lottery	sorcery	congruity	incapacity
loyalty	subsidy	conspiracy	incivility
lunacy	surgery	credulity	inclemency
majesty	symmetry	curiosity	incongruity
malady	sympathy	declivity	inconsistency
melody	symphony	deformity	inconstancy
memory	tapestry	democracy	indemnity
misery	tragedy	discovery	inequality
modesty	treachery	dishonesty	infidelity

Y (*short*)—(*Cont.*)

infinity	nobility	satiety	theology
infirmary	nonconformity	security	theosophy
instability	obscurity	seniority	timidity
integrity	opportunity	sensibility	tranquillity
intensity	partiality	sensuality	transparency
liberality	perplexity	severity	unanimity
magnanimity	philosophy	simplicity	uncertainty
malignity	pomposity	sincerity	uniformity
maturity	probability	sobriety	university
mediocrity	prodigality	society	vacuity
mendacity	profanity	solemnity	variety
minority	profundity	solidity	veracity
mortality	propensity	soliloquy	verbosity
municipality	prosperity	sovereignty	vicinity
mutability	rascality	sublimity	virginity
nationality	reality	supremacy	visibility
nativity	reciprocity	stupidity	vivacity
neutrality	rotundity	temerity	volubility

TWO-SYLLABLE RHYMES

ABARD, ABBARD, ABBERED

scabbard	tabard	jabbered	beslabbered

ABBER

blabber	slabber	dabber	knabber
drabber	stabber	grabber	nabber
jabber	beslabber		

ABBET, ABBIT, ABIT

habit	rabbit	riding-habit	"grab it" (etc.)
rabbet	cohabit	(etc.)	inhabit

ABBLE

babble	scrabble	brabble	grabble
dabble	bedabble	cabble	(ribble-rabble)
gabble	bedrabble	drabble	scabble
rabble			

ABBLE (*as in* squabble, *see* OBBLE)

ABBLER, ABBLING, etc., *see* ABBLE

ABBOT

abbot	*sabot*

ABBEY, ABBY

abbey	scabby	"babby"	grabby
cabby	shabby	dabby	*rabbi*
crabby	slabby	drabby	rabi
flabby	tabby		

ABIES

rabies	scabies

ABLE, ABEL

able	gabel	table	unstable
babel	label	disable	flabel
cable	sable	enable	Abe'll (etc.)
fable	stable	unable	

ABLISH, ABBLISH

babblish	establish	disestablish	stablish
rabblish			

ABOR, ABOUR, ABRE

labor	saber	belabor	caber
neighbor	tabor		

ABY

baby	gaby	maybe

ACCY, *see* **ACKEY**

ACELESS, graceless (etc.) *see* **ACE**

ACELY, *see* **ASELY**

ACEMENT, *see* **ASEMENT**

ACENT

adjacent	circumjacent	naissant	"daycent"
complacent	interjacent	renaissant	"raycent"
complaisant	jacent	superjacent	(etc.)
subjacent			

ACEOUS, ASEOUS, ATIOUS

caseous	edacious	predaceous	ungracious
gracious	fallacious	procacious	veracious
spacious	herbaceous	pugnacious	vexatious
audacious	linguacious	rapacious	vivacious
bibacious	loquacious	sagacious	voracious
bulbaceous	mendacious	salacious	contumacious
capacious	minacious	sequacious	disputatious
cetaceous	mordacious	setaceous	efficacious
cretaceous	palacious	tenacious	farinaceous

Aceous, Aseous, Atious—(*Cont.*)

incapacious
ostentatious
perspicacious
pertinacious
pervicacious
saponaceous
disgracious
feracious
fugacious
fumacious
inefficacious
malgracious
meracious
misgracious

rampacious
execratious
flirtatious
acanaceous
acanthaceous
alliaceous
amylaceous
arenaceous
cactaceous
camphoraceous
capillaceous
carbonaceous
corallaceous
coriaceous

crustaceous
erinoceous
faboceous
ferulaceous
filaceous
folioceous
fungaceous
gemmaceous
lappaceous
lardaceous
liliaceous
marlaceous
micaceous
olivaceous

orchidaceous
palmaceous
pearlaceous
perlaceous
pomoceous
resinaceous
rosaceous
rutaceous
sebaceous
setaceous
testaceous
tophaceous
vinoceous
violaceous

Acer
facer (etc.), *see* **Ace**

Acet, *see* **Asset**

Achment, Atchment
hatchment attachment catchment ratchment
patchment detachment despatchment

Acic, *see* **Assic**

Acid
acid placid flacid

Acious, *see* **Aceous**

Acis, Asis
basis crasis phasis *spaces* (etc.), *see*
glacis oasis *faces* **Ace** *for im-*
antanaclasis *perfect rhymes*

Acit, *see* **Asset**

Acken
blacken bracken slacken cracken

Acker, Acquer
clacker knacker slacker (etc.), "attack her"
cracker lacquer *see* **Ack** (etc.)
hijacker packer

ACKET

bracket	placket	flacket	tacket
jacket	racket	packet	"hic jacet"

ACKEY, ACKY, ACCY

"baccy"	lackey	tacky	knacky
blacky	"cracky"		

ACKISH

blackish	quackish	knackish	slackish
brackish			

ACKLE

cackle	quackle	tackle	"whack'll"
crackle	macle	ramshackle	(etc.)
hackle	shackle		

ACKLER, ACKLING (etc.), *see* **ACKLE**

ACKLESS
sackless (etc.), *see* **ACK**

ACKLY
blackly (etc.), *see* **ACK**

ACKNEY, ACNE

acne	hackney

ACKY, *see* **ACKEY**

ACNE, *see* **ACKNEY**

ACON, *see* **AKEN**

ACRE, *see* **AKER**

ACTER, ACTOR

abstracter	detractor	enacter	climacter
compacter	phylacter	exacter	extractor
distracter	refractor	transactor	protractor
infractor	retractor	actor	benefactor
olfactor	subtracter	factor	malefactor
contractor	tractor	attractor	

ACTIC

tactic	emphractic	lactic	stalactic
didactic	empractic	parallactic	syntactic
prophvlactic	galactic	protactic	

ACTILE

tactile	attractile	protactile	retractile
tractile	contractile		

ACTING

subtracting, (etc.), *see* ACT

ACTION

action	exaction	calefaction	interaction
faction	extraction	liquefaction	labefaction
fraction	inaction	malefaction	lubrifaction
paction	infraction	petrifaction	modifaction
taction	protraction	putrefaction	patefaction
traction	reaction	rarefaction	redaction
abstraction	refraction	retroaction	rubefaction
attraction	retraction	satisfaction	tabefaction
coaction	subaction	stupefaction	tepefaction
contaction	subtraction	dissatisfaction	torrefaction
contraction	transaction	assuefaction	tremefaction
detraction	arefaction	compaction	tumefaction
distraction	benefaction	counteraction	

ACTISED, ACTIST, ACTEST

actest	exactist (etc.),	practised
	see ACT	

ACTIVE

active	calefactive	contractive	olfactive
abstractive	petrifactive	counteractive	retractive
attractive	putrefactive	detractive	satisfactive
inactive	retroactive	distractive	subtractive
protractive	stupefactive	enactive	tractive
refractive	coactive		

ACTLESS

tactless (etc.), *see* ACT

ACTLY

abstractly	tactly	matter-of-	exactly
compactly		factly	

ACTOR, *see* ACTER

ACTRESS

actress	benefactress	detractress	factress
contractress	exactress	malefactress	

ACTURE

fracture	compacture	manufacture	vitrifacture
facture			

ACY

lacy	racy	spacy

ADAM

madam	Adam	"had 'em"	"bade 'em"
macadam			(etc.)

ADDEN

"bad un"	engladden	madden	sadden
gladden			

ADDER

adder	gladder	sadder	"had her"
bladder	ladder	padder	(etc.)
gadder	madder	step-ladder	

ADDING, ODDING

wadding	podding	codding	nodding
plodding	prodding		

ADDLE

addle	spaddle	astraddle	raddle
faddle	straddle	daddle	staddle
paddle	skedaddle	fiddle-faddle	unsaddle
saddle	"dad'll" (etc.)		

ADDLER, ADDLING (etc.), *see* **ADDLE**

ADDOCK

haddock	paddock	raddock	shaddock

ADDY

caddy	faddy	Finnan-haddie	*cadi*
daddy	laddy	paddy	waddy

ADENCE, AIDANCE

aidance	cadence	decadence

ADENT, *see* **AIDANT**

ADER, *see* **ADIR**

ADGER

badger	padger	spadger	agger
cadger			

ADIANT, ADIENT
gradient radiant

ADING
fading (etc.), *see* ADE

ADIR
nadir aider (etc.), *see* ADE

ADISH, ADDISH
radish baddish caddish (etc.), *see* AD

ADLE
cradle ladle stadle encradle

ADLY, ADDLY
straddly badly (etc.), *see* AD

ADNESS
badness (etc.), *see* AD

ADO (*pronounced either* ā *or* ä, *except* dado)
dado stoccado camisado grenado
bravado strappado carbonado imbrocado
crusado tornado desperado muscovado
gambado ambuscado El Dorado renegado
passado barricado fumado travado
scalado bastinado

ADOW
cadeau foreshadow

ADY, ADI
cadi belady "fady" (etc.), landlady
lady braidy *see* ADE "played he,"
maidie cascady glady (etc.)
shady irade

AERIE, *see* AIRY

AFE, *see* AFFY

AFER
safer chafer cockchafer "strafer"
afer wafer

AFFER, AFFIR
chaffer graffer laugher (etc.), zaffre
gaffer kaffir *see* AFF

Affic, Affick, Aphic

graphic	cacographic	heterographic	monographic
maffick	calligraphic	hierographic	orthographic
traffic	cartographic	holographic	pantographic
seraphic	chirographic	hydrographic	paragraphic
phonographic	choregraphic	hyetographic	pasigraphic
photographic	clinographic	ichnographic	petrographic
pornographic	cosmographic	ideographic	polygraphic
telegraphic	cryptographic	stylographic	scenographic
cinemato-	diagraphic	topographic	sciagraphic
graphic	epigraphic	idiographic	seismographic
autobiographic	epitaphic	lexicographic	stenographic
autographic	ethnographic	lexigraphic	stratigraphic
biographic	geographic	lithographic	xylographic
bibliographic	heliographic	logographic	zoöagraphic

Affle

baffle	gaffle	kaffle	yaffle
raffle	haffle	scraffle	"calf'll" (etc.)
snaffle			

Affless, *see* **Aff**

Affled, Affold

raffled (etc.) *scaffold*
 see **Affle**

Affy

baffy	draffy	taffy	"daffy"
chaffy			

After

after	draughter	rafter	thereafter
dafter	hafter	hereafter	"chaffed her"
grafter	laughter	ingrafter	(etc.)

Afty

crafty	draughty	grafty

Ageless

pageless (etc.), *see* **Age**

Agely

pagely	sagely	stagely

Agement

engagement	encagement	gagement	presagement
assuagement	enragement	gaugement	suagement

AGEOUS, AGIOUS

contagious	umbrageous	disadvan-	oragious
courageous	advantageous	tageous	rampageous
outrageous		ambagious	

AGER, *see* **AJOR**

AGGARD, AGGERED

haggard	staggered	swaggered	staggard
laggard			

AGGER

bragger	swagger	carpet-bagger	nagger
dagger	wagger (etc.),	gagger	ragger
lagger	*see* AG	jagger	sagger
fagger	"three-bagger"	"magger"	tagger
stagger	"two-bagger"		

AGGISH

naggish	haggish	staggish	waggish

AGGLE

daggle	haggle	bedaggle	waggel
draggle	straggle	bedraggle	"hag'll" (etc.)
gaggle	waggle	raggle	

AGGOT

faggot	maggot

AGGY
baggy (etc.), *see* AG

AGIC

magic	archipelagic	hemorrhagic	pelagic
tragic	ellagic		

AGILE

agile	fragile

AGLESS
bagless (etc.), *see* AG

AGO

sago	farrago	lumbago	vorago
imago	plumbago	virago	"they go" etc.

AGON

dragon	flagon	snapdragon	wagon
pendragon			

AGRANT

flagrant	infragrant	vagrant	fragrant

AIC

mosaic	archaic	Pharisaic	stanzaic
alcaic	algebraic	Paddusaic	tesseraic
alhambraic	deltaic	saic	trochaic
prosaic	laic	sodaic	voltaic
altaic	paradisaic	spondaic	

AIDANT

aidant	cadent	abradant	decadent

AILER, AOLER

gaoler	jailer (etc.),	whaler	tailor
	see AIL	sailor	

AILIFF, *see* **ALIPH**

AILING, AYLING

ailing (etc.),	grayling
see AIL	strayling

AILMENT
ailment (etc.), *see* AIL

AILY, AILLY, *see* **ALY**

AIGHTEN, *see* **ATAN**

AIMANT, AMANT, AIMENT, AYMENT

claimant	payment	defrayment	displayment
clamant	raiment		

AIMLESS
shameless (etc.), *see* AIM

AINDER

attainder	remainder

AINFUL, ANEFUL

baneful	painful	disdainful	complainful
gainful			

AINING

raining	entertaining (etc.), *see* AIN

AINLESS
painless (etc.), *see* AIN

AINLY, *see* ANELY

AINTER
fainter tainter (etc.), *see* AINT

AINTING
painting (etc.), *see* AINT

AINTLESS
taintless (etc.), *see* AINT

AINTLING
faintling saintling

AINTLY
faintly quaintly unsaintly

AINTY
dainty fainty feinty "ain't he,"
 etc.

AINY, *see* ANY (*long*)

AIRY, ARY

airy	arbitrary	epistolary	military
chary	beneficiary	estuary	momentary
dairy	capillary	extraordinary	monetary
eyrie	cautionary	evolutionary	mortuary
fairy	centenary	fiduciary	necessary
hairy	commentary	formulary	obituary
snary	commissary	fragmentary	ordinary
vary	confectionary	functionary	passionary
wary	constabulary	hereditary	pecuniary
canary	contemporary	honorary	planetary
ablutionary	contrary	imaginary	prairie
accidentiary	corollary	incendiary	prebendary
accustomary	contributary	intermediary	proprietary
actuary	culinary	Janissary	pulmonary
additionary	customary	January	questuary
adminculary	depositary	legendary	reliquary
adversary	dictionary	legionary	residuary
ancillary	dietary	literary	salivary
antiquary	dignitary	luminary	salutary
apothecary	dromedary	mercenary	sanctuary

Airy, Ary—(*Cont.*)

sanguinary	seminary	tertiary	unwary
sanitary	solitary	titulary	vagary
scapulary	stationary	tributary	visionary
secondary	statuary	tumulary	vocabulary
voluntary	sublunary	tutelary	voluptuary
secretary	sumptuary	ubiquitary	vulnerary
sedentary	temporary	unchary	

Aisance

complacence	*obeisance*	nascence	renascence
complaisance			

Aisant, *see* Acent

Aiser, *see* Azer

Aisin, *see* Azen

Aisy, *see* Azy

Aiter, *see* Ator

Aiten, *see* Atan

Aithful

faithful	scathful

Aitiff, *see* Ative

Aitress

creatress	waitress	imitatress	spectatress
traitress	dictatress		

Aity, *see* Aiety

Ajor, Ager

ager	major	sager	wager (etc.),
gauger	pager	stager	*see* Age

Aler

squalor	paler (etc.),	"fail her"
	see Ail	(etc.)

Allic

fallic	Gallic	metallic	oxalic

Alment

instalment	appalment	disenthral-	epaulement
enthralment		ment	

ALMEST, ALMIST

calmest	palmist	psalmist (etc.), *see* ALM

ALMLESS

balmless	psalmless	palmless	qualmless (etc.), *see* ALM

ALMON, *see* **AMMON**

ALMY

balmy	palmy

ALOE, *see* **ALLOW**

ALON, ALLON

ballon	gallon	talon

ALOP, ALLOP

gallop	shallop	escalop	jalop
scallop			

ALOR, ALLOR

pallor	valor	caballer

ALSAM

balsam	brawlsome	"call some," etc.

ALTAR, ALTER, AULTER

altar	palter	assaulter	unalter
alter	psalter	defaulter	"halt her"
falter	salter	drysalter	(etc.)
halter	vaulter	exalter	

ALTRY

paltry	psaltery	drysaltery

ALTY, *see* **AULTY**

ALY, AILY, ALELY

bailie	maily	stalely	halely
baily	palely	taily	capercailie
daily	scaly	traily	pali
frailly	shaly	*vale*	rationale
gaily	snaily	waly	shillaly
greyly			

AMA
drama	diorama	neorama	rama
llama	georama	panorama	yama
lama	kaama	pyjama	cosmorama
melodrama	kama		

AMANT, *see* AIMANT

AMBEAU, *see* AMBO

AMBER
amber	camber	clamber	tambour

AMBIT
ambit	gambit

AMBLE, AMBOL
amble	ramble	wamble	tramble
bramble	scamble	preamble	skimble-
gamble	scramble	shamble	skamble
gambol			

AMBLER, AMBLING, etc., *see* AMBLE

AMBO, AMBEAU
crambo	Sambo	ambo	Zambo
flambeau			

AMBOL, *see* AMBLE

AMEFUL
blameful	shameful	flameful

AMEL, AMMEL
camel	enamel	hammel	mammal
trammel	entrammel		

AMELESS
shameless (etc.), *see* AIM

AMELY
gamely	lamely	namely	tamely

AMENESS, *see* AIM

AMER, *see* AIM

AMFER, AMPHOR
camphor	chamfer

AMINE
famine examine reëxamine "am in" (etc.)
gamin cross-examine

AMISH
famish lambish enfamish rammish
hammish affamish

AMLET
camlet hamlet samlet

AMMAR, AMMER, AMOR
clamor hammer enamour slammer
crammer rammer ninnyhammer sledge-hammer
gammer shammer yellowhammer "damn her"
glamour stammer dammer (etc.)
grammar yammer

AMMOCK
cammock hammock mammock

AMMON, ALMON
gammon salmon *damon* ammon
mammon backgammon Shamon

AMMY
clammy hammy gammy tammy
Sammy mammy shammy chamois
drammie ramie tamis "damme"

AMOR, *see* AMMAR

AMPAS, *see* AMPUS

AMPER
damper scamper stamper (etc.), "vamp her"
hamper tamper *see* AMP (etc.)
pamper

AMPHOR, *see* AMFER

AMPIAN, AMPION
campian champion grampian

AMPING
camping (etc.), *see* AMP

AMPLE
ample trample ensample example
sample

Ampler, Ampling, *see* **Ample**

Amply

amply	damply	tramp!,

Ampus, Ampas

grampus	pampas	campus	"vamp us" (etc.)

Amus, Amous

camus	squamous	biramous	"shame us"
famous	mandamus	hamous	(etc.)
ramous	ignoramus	Shamus	

Amy, *see* **Aim**

Ana, Anna

banana	liana	bandanna	savannah
sultana	zenana	hosannah	tanna
befana	anna	ipecacuanha	Hannah
iguana	Anna	manna	Havana
kerana			

Anate, Anet, Anite

granite	pomegranate	tannate	"can it" (etc.)
planet	khanate		

Ancel

chancel	handsel

Anceless

chanceless (etc.), *see* **Ance**

Ancer, Answer

answer	geomancer	anser	glancer
cancer	chiromancer	merganser	prancer
dancer	necromancer	advancer	"advance her"
lancer	enhancer	chancer	(etc.)
romancer	entrancer		

Ancet, Ansit

lancet	transit	"chance it" (etc.)

Anchion, *see* **Ansion**

Anchor, *see* **Anker**

Anchored, *see* **Ankard**

Ancor, *see* **Anker**

ANCY

chancy	alphitomancy	sideromancy	myomancy
fancy	anthropomancy	significancy	occupancy
mischancy	astragalomancy	spodomancy	œnomancy
acromancy	austromancy	stichomancy	oneiromancy
arithmancy	axinomancy	dancy	ophiomancy
chiromancy	belomancy	enoptomancy	ornithomancy
hesitancy	bibliomancy	exorbitancy	pedomancy
geomancy	botanomancy	extravagancy	pessomancy
lithomancy	catoptromancy	exuberancy	petulancy
necromancy	ceromancy	gastromancy	precipitancy
onomancy	chaomancy	gyromancy	psychomancy
rhabdomancy	cleromancy	hieromancy	sciomancy
termagancy	consonancy	hydromancy	sibilancy
aldermancy	coscinomancy	lecanomancy	supplicancy
alectoromancy	crithomancy	mendicancy	sycophancy
alectryomancy	crystallomancy	meteoromancy	tephramancy
aleuromancy	dactyliomancy	militancy	unchancy
alomancy			

ANDAL, *see* ANDLE

ANDANT, ANDENT
candent · commandant · demandant

ANDATE, ANDIT
bandit · mandate · "demand it," etc.

ANDEM, –OM, –UM
random · avizandum · tandem · "hand 'em"
memorandum · mandom · · (etc.)

ANDENT, *see* ANDANT

ANDER, ANDOR

candor	slander	meander	oleander
dander	bystander	philander	salamander
gander	"land her"	pomander	back-hander
grander (etc.),	(etc.)	coriander	dittander
see AND	commander	jerrymander	glander
pander			

ANDERS
glanders · sanders · ganders (*and add s to nouns and verbs above*)

ANDEUR, *see* ANDIER

ANDID

bandied	candid	candied	uncandid
brandied	"man did," etc.		

ANDING

landing notwithstanding banding (etc.), *see* AND

ANDISH

blandish	standish	outlandish	grandish
brandish			

ANDIT, *see* **ANDATE**

ANDLE, ANDAL

candle	handle	scandal	vandal
dandle	sandal		

ANDLER

chandler	dandler	handler	tallow-chandler

ANDLING, *see* **ANDLE**

ANDOM, *see* **ANDAM**

ANDOUR, *see* **ANDER**

ANDSOME, *see* **ANSOM**

ANDUM, *see* **ANDAM**

ANDY

bandy	dandy	sandy	jackadandy
brandy	handy	unhandy	pandy
candy	randy	jaborandi	"Andy"

ANEFUL, *see* **AINFUL**

ANEL, ANIL, ANNEL

anil	flannel	empanel	stannel
cannel	panel	annal	trannel
channel	scrannel	pannel	unpannel

ANELY, AINLY

gainly	sanely	profanely	inanely
mainly	vainly	ungainly	insanely
plainly	humanely	mundanely	

ANEOUS (*pronounced two or three syllables*)

cutaneous	instantaneous	subterraneous	extempor-
extraneous	miscellaneous	contempor-	aneous
spontaneous	simultaneous	aneous	

ANER, AINER

| plainer | stainer (etc.), see AIN | chicaner | attainer |

ANET, see ANATE

ANGAR, see ANGER (hard G)

ANGELY

| changely | strangely |

ANGER (hard G), ANGAR, ANGOR, ANGUOR, ANGUER

| anger | sangar | | hangar |
| languor | angor | | |

ANGER (silent G)

banger	hanger	paper-hanger	"bang her"
clangor	haranguer	(etc.)	(etc.)
ganger		whanger	

ANGER (soft G)

danger	money-changer	deranger	granger
manger	arranger	disarranger	interchanger
ranger	bushranger	estranger	"change her"
stranger	changer	exchanger	(etc.)
endanger			

ANGING

hanging (etc.), see ANG

ANGLE

angle	spangle	embrangle	untangle
bangle	strangle	phalangle	disentangle
dangle	intertangle	quackangle	bemangle
fangle	twangle	wrangle	bespangle
interjangle	brangle	entangle	triangle
mangle			

ANGLED, ANGOLD

| angled | new-fangled | *mangold* | dangled (etc.), see ANGLE |

ANGLER, ANGLING, see ANGLE

ANGLESS

fangless (etc.), see ANG

ANGOLD, see ANGLED

ANGUOR, *see* ANGER (*hard* G)

ANGUISH

anguish languish

ANGOR, *see* ANGER (*hard* G)

ANGY

changy mangy rangy

ANIC, ANNIC

panic	charlatanic	talismanic	stannic
tannic	ferricyanic	interoceanic	Sultanic
Britannic	galvanic	lexiphanic	tetanic
botanic	Germanic	Messianic	tympanic
mechanic	hydrocyanic	organic	valerianic
Alcoranic	tyrannic	Ossianic	volcanic
aldermanic	satanic	Puritanic	vulcanic
Aristophanic	diaphanic	quercitannic	Espanic
Brahmanic	oceanic	rhodanic	

ANICS, *see* ANNEX

ANIL, *see* ANEL

ANION, ANON

canyon companion banyan

ANISH, ANNISH

| banish | mannish | vanish | evanish |
| clannish | planish | | |

ANITE, *see* ANATE

ANKARD, ANCHORED, ANKERED

| anchored | rancored | tankard | "drank hard" |
| cankered | hankered | brancard | (etc.) |

ANKER, ANCOUR

blanker	unanchor	hanker	spanker
clanker	anchor	rancor	"thank her"
danker (etc.),	canker	ranker	(etc.)
see ANK			

ANKLE

ankle rankle crankle hankle

ANKLY

ankly	crankly	rankly	lankly
blankly	frankly	dankly	

ANLESS

manless, planless (etc.), *see* AN

ANNA, *see* ANA

ANNALS

annals	channels (etc.), *see* ANEL

ANNER, ANOR

banner	manor	lanner	planner (etc.),
manner	tanner	"fan her," etc.	*see* AN

ANNEX, ANICS

annex	panics	mechanics	humanics

ANNY

branny	clanny	manny	uncanny
cranny	granny	canny	"can he," etc.

ANON, *see* ANION

ANOR, *see* ANNER

ANSION, ANCHION

panchion	stanchion	mansion	expansion
scansion			

ANSIT, *see* ANCET

ANSOM, ANDSOME

handsome	ransom	transom	unhandsome
hansom			

ANSWER, *see* ANCER

ANSY

pansy	tansy	*chimpanzee*

ANTAM, ANTOM, ANTUM

bantam	phantom	*quantum*	*tantum*

ANTE, ANTY

ante	janty	dilettante	"Santy"
anti	scanty	infante	"can't he"
chanty	shanty	pococurante	(etc.)
auntie	andante	zante	

ANTEL, *see* **ANTLE**

ANTER

descanter	recanter	chanter	enchanter
implanter	transplanter	grantor	almacanter
instanter	trochanter	planter	"plant her"
levanter	banter	ranter	(etc.)
panter	canter	decanter	

ANTHER

anther	panther

ANTI, *see* **ANTE**

ANTHIC

œnanthic	zanthic

ANTIC

antic	romantic	corybantic	necromantic
frantic	sycophantic	geomantic	onomantic
Atlantic	bullantic	hierophantic	pyromantic
gigantic	chiromantic	hydromantic	spodomantic
pedantic	consonantic	mantic	transatlantic

ANTINE

adamantine	chryselephan-	dragantine	*Levantine*
elephantine	tine	gigantine	*Byzantine*

ANTLE

cantle	mantel	dismantle	scantle
hantle	mantle	immantle	

ANTLER

antler	mantler	pantler	dismantler

ANTLESS
pantless (etc.), *see* **ANT**

ANTLING

bantling	mantling	scantling	dismantling

ANTLY

scantly	slantly	ignorantly (etc.), *see* **ANT**

ANTO, ANTEAU

canto	couranto	Esperanto	quo-warranto
panto	portmanteau	pro-tanto	

ANTOM, *see* **ANTAM**

ANTRESS

enchantress	supplantress	covenantress	chantress

ANTRY

chantry	gantry	pantry

ANTY, see ANTE

ANUAL, ANNUAL

annual	manual	Emmanuel

ANY (*short*), see ENNY

ANY (*long*), AINY

brainy	drainy	rainy	veiny
cany	grainy	trainy	zany

ANZA

stanza	bonanza	extravaganza	Sancho Panza

APAL, see APLE

APEL, see APPLE

APELESS

capeless (etc.), see APE

APEN, APON

capon	misshapen	unshapen	tapen

APER, APIR, APOUR

caper	taper	aper	sky-scraper
draper (etc.),	tapir	sapor	"escape her"
see APE	vapour	chaper	(etc.)
paper			

APHIC, see AFFIC

APID

rapid	sapid	vapid

APIR, see APER

APIST

papist	shapest (etc.),	landscapist	redtapist
	see APE		

APLE, APAL

maple	papal	staple	caple

APLESS

capless hapless (etc.), *see* AP

APLING, APPLING

chapelling	papling	thrappling	lapling
grappling	sapling	dappling	tapling
knappling	scrapling		

APNEL

grapnel shrapnel

APON, *see* APEN

APOUR, *see* APER

APPER

capper	wrapper	dapper	understrapper
entrapper	"yapper"	flapper	whipper-
(etc.), *see* AP	clapper	sapper	snapper
fly-sapper			

APPET

lappet tappet "wrap it," etc.

APPIE, *see* APPY

APPING

strapping (etc.), *see* AP

APPLE, APEL

apple	knapple	thrapple	rappel
chapel	love-apple	dapple	scapple
grapple			

APPY, APPIE

chappie	mappy	sappy	scrappy
flappy	nappy	unhappy	snappy
happy	pappy	knappy	

APSION, *see* APTION

APTER, APTOR

apter	chapter	rapter	"slapped her"
captor	adapter	recaptor	

APTION

caption	collapsion	contraption	recaption
adaption			

APTIST, APTEST
aptest	adaptest	inaptest	raptest
baptist	anabaptist		

APTOR, *see* APTER

APTURE
capture	rapture	recapture	enrapture

ARAB
Arab	scarab

ARAGE, *see* ARRIAGE

ARASS, *see* ARRAS

ARBER, ARBOR
arbor	enharbor	harbor	unharbor
barber			

ARBLE, ARBEL
barbel	marble	garbel	enmarble
garble			

ARBLESS
barbless (etc.), *see* ARB

ARBOARD
larboard	starboard

ARBOIL
garboil	parboil

ARBOR, *see* ARBER

ARCEL, ARSEL
parcel	tarsel	sarcel

ARCHER
archer	starcher (etc.),	clear-starcher	departure
marcher	*see* ARCH		

ARCHLESS, *see* ARCH

ARCHLY
archly	starchly

ARDEN, ARDON
garden	bear-garden	bombardon	gardon
harden	case-harden	enharden	Arden
pardon			

Arder
harder (etc.),　　larder　　　　ardor　　　　"guard her"
　see Ard　　　　　　　　　　　　　　　　　　(etc.)

Ardless, *see* **Ard**

Ardon, *see* **Arden**

Ardy
hardy　　　　　lardy　　　　foolhardy　　　tardy

Arel, Arrel
barrel　　　　　apparel　　　　*carol*

Areless, *see* **Air**

Arely, Airly
barely　　　　　rarely　　　　warely　　　　debonairly
fairly　　　　　squarely　　　yarely　　　　unfairly

Arent, *see* **Arrant**

Arer
fairer (etc.), *see* **Air**

Aret, Arat, Arret
arret　　　　　carat　　　　claret　　　　garret

Arfless
scarfless (etc.), *see* **Arf**

Argent, Ergeant
argent　　　　　margent　　　sergeant　　　serjeant

Arger
charger　　　　larger (etc.), *see* **Arge**

Argle, Argol
gargle　　　　　gargol　　　　argle-bargle

Argo
argot　　　　　embargo　　　supercargo　　botargo
cargo　　　　　potargo　　　largo　　　　"far go" (etc.)

Aric
barbaric　　　　pindaric　　　cinnabaric

Arid, Arried
arid　　　　　harried　　　married　　　parried
carried　　　　intermarried　tarried　　　miscarried

ARING, AIRING

airing	seafaring	outdaring	unsparing
bearing	wayfaring	outstaring	tale-bearing
daring	(etc.)	outswearing	upbearing
fairing (etc.),	chairing	outwearing	upstaring
see AIR	charing	overbearing	uptearing
hair-ring	forswearing	unbaring	

ARION, ARRION

clarion	carrion	"marry on," etc.

ARIOUS

various	gregarious	precarious	temerarious
bifarious	nefarious	vicarious	"carry us"
contrarious	ovarious	multifarious	(etc.)

ARISH

barish	fairish	rarish	squarish
bearish	garish	sparish	debonairish

ARKEN

darken	hearken

ARKER

barker (etc.), *see* ARK

ARKISH

"clerkish"	darkish	larkish	sparkish

ARKLE

sparkle	disembarkal	patriarchal	darkle
monarchal			

ARKLESS

sparkless (etc.), *see* ARK

ARKLING

darkling	sparkling

ARKLY

"clerkly"	parkly	sparkly	starkly
darkly			

ARKY

barky	*parquet*	hierarchy	oligarchy
"clerky"	parky	matriarchy	patriarchy
heark'ee	sharky	darky	markee
larky	sparky (etc.),	heterarchy	
	see ARK		

ARLER, ARLOR

| marler | parlor | snarler | gnarler |

ARLESS
starless (etc.), *see* AR

ARLET

| scarlet | varlet | carlet | starlet |

ARLEY, ARLY

| barley | parley | gnarly | particularly |
| marly | snarly | | (etc.), *see* AR |

ARLIC

| garlic | harlech | pilgarlick | sarlik |

ARLING

| darling | marling | sparling | starling |
| gnarling | snarling | | |

ARLOR, *see* ARLER

ARLY, *see* ARLEY

ARMER

| armor | farmer (etc.), | baby-farmer | "harm her" |
| charmer | *see* ARM | snake-charmer | (etc.) |

ARMING

| uncharming | farming | alarming (etc.), |
| | | *see* ARM |

ARMLESS
harmless (etc.), *see* ARM

ARMOR, *see* ARMER

ARNAL, ARNEL

| carnel | uncharnel | carnal | charnel |
| darnel | | | |

ARNER

| garner | yarner (etc.), *see* ARN |

ARNESS

| farness | harness |

ARNISH

| garnish | tarnish | varnish |

ARON, *see* ARREN

ARPER
harper (etc.), *see* ARP

ARRACK
arrack barrack carrack

ARRANT, ARENT
arrant apparent transparent

ARRAS, ARRASS, ARASS
arras harass embarrass

ARREL, *see* AREL *and* ORAL (*short*)

ARREN, ARON
baron barren fanfaron charon

ARRET, *see* ARET

ARROT
carrot parrot

ARRIAGE, ARAGE
carriage disparage miscarriage intermarriage
marriage

ARRIER
barrier harrier parrier charier
carrier marrier tarrier warier
farrier

ARRION, *see* ARION

ARRIOR, *see* ORRIER

ARROT, *see* ARET

ARROW
arrow marrow yarrow *caballero*
barrow narrow rest-harrow faro
farrow sparrow bolero *sombrero*
harrow

ARRY (*long*)
sparry tarry barry charry
starry aracari carbonari scarry

ARRY (*as in* marry)
harry parry intermarry charivari
marry miscarry cassowary harri-karri

ARRY (*as in* marry)—(*Cont.*)

ablutionary	apothecary	commentary	carry
accessary	arbitrary	commissary	culinary
accustomary	beneficiary	confectionary	customary
actuary	canary	constabulary	dairy
additionary	capillary	contemporary	dictionary;
adversary	cautionary	contrary	*see also* ERRY
ancillary	centenary	contributary	*and* AIRY
antiquary	chary	corollary	

ARSEL, *see* ARCEL

ARSELY, *see* ARSLEY

ARSHAL

marshal	partial	impartial	immartial
martial			

ARSLEY

parsley	sparsely

ARSON

arson	parson	"Kit Carson"

ARTAN, ARTEN

hearten	Spartan	kindergarten	carton
marten	tartan	barton	enhearten
smarten	dishearten		

ARTAR, ARTER, ARTYR

barter	garter	bemartyr	upstarter
carter (etc.),	martyr	"darter"	"start her"
see ART	tartar	protomartyr	(etc.)
charter			

ARTEL, *see* ARTLE

ARTER, *see* ARTAR

ARTEST, *see* ARTIST

ARTFUL

artful	cartful	heartful

ARTIST

artist	smartest (etc.), *see* ART

ARTLE, ARTEL
cartel startle dartle

ARTLESS
heartless (etc.), *see* ART

ARTLET
martlet partlet tartlet heartlet

ARTLY
smartly partly tartly

ARTNER
partner heartener smartener disheartener

ARTRIDGE
cartridge partridge

ARTURE, *see* **ARCHER**

ARTY
hearty smarty tea-party ex parte
party astarte (etc.)

ARVEL
carvel marvel *larval*

ARVEST
carvest harvest starvest

ARVING
carving starving

ARY, *see* **AIRY**

ASAL, ASIL, AZEL
nasal basil jazel witch-hazel
hazel appraisal

ASCAL, ASCHAL
mascle paschal rascal

ASCAR, *see* **ASKER**

ASCENT
nascent adnascent indurascent "daycent"
depascent connascent violascent complaisant
renascent enascent adjacent subjacent
renaissant jacent complacent circumjacent
naissant interjacent "raycent"

ASCHISH

haschish	flashish	rashish

ASELESS

baseless (etc.), *see* ACE

ASELY

basely	spacely	common-placely

ASEMENT

casement	effacement	belacement	interlacement
abasement	embracement	displacement	misplacement
debasement	basement	enlacement	retracement
defacement	begracement	erasement	

ASEOUS, *see* ACEOUS

ASHEN, ASHION, ASSION, ATION (*short*)

ashen	passion	compassion	dispassion
fashion	ration	empassion	impassion

ASHER (*short*)

flasher (etc.), *see* ASH	rasher	haberdasher

ASHER (*long*)

washer (etc.), *see* OSH

ASHES

ashes	spatterdashes (etc.), *see* ASH

ASHION, *see* ASHEN

ASHIE, ASHY

ashy	plashy	splashy	trashy
flashy	sachet	mashy	"hashy"
mashie	slashy		

ASHLESS

hashless (etc.), *see* ASH

ASIL, *see* AZZLE, *also* ASAL

ASIN, *see* ASTEN

ASION

abrasion	invasion	evasion	pervasion
dissuasion	occasion	*Caucasian*	suasion
evasion	persuasion	Asian	Eurasian

ASIS, *see* **ACIS**

ASIVE

suasive	dissuasive	invasive	pervasive
assuasive	evasive	persuasive	quasive

ASKER, ASCAR

lascar	basker (etc.), *see* **ASK**	"ask her" (etc.)

ASKET

basket	flasket	gasket	lasket
casket			

ASKLESS
taskless (etc.), *see* **ASK**

ASON, *see* **ASTEN**, *also* **AZEN**

ASPER

asper	jasper (etc.), *see* **ASP**

ASPLESS
haspless (etc.), *see* **ASP**

ASSAL, *see* **ASTLE**

ASSAIL, *see* **OSTLE**

ASSES

asses	molasses (etc.), *see* **ASS**

ASSET, ACET, ACIT

asset	facet	tacit	fascet
basset	placet	brasset	

ASSIC, ACIC

classic	quaiacic	liassic	sebacic
boracic	jurassic	potassic	triassic
thoracic			

ASSING

passing	surpassing (etc.), *see* **ASS**

ASSION, *see* **ASHEN**

ASSIVE

massive	passive	impassive

ASSLESS
gasless (etc.), *see* Ass

ASSOCK

bassock	cassock	hassock

ASSY, ACE, ASSIE, ASSE

brassie	glassy	classy	brassy
chassé	grassy	massy	gassy
glacé	lassie	passé	morassy

ASTARD, ASTERED

bastard	castored	beplastered	plastered(etc.),
dastard	mastered		*see* ASTER

ASTEFUL

wasteful	distasteful	tasteful

ASTEN, ASIN, ASON

basin	hasten	enchasten	caisson
chasten	mason		

ASTER (*long*)

baster	haster	foretaster	"chased her"
chaster	paster	waster	(etc.)

ASTER (*short*)

aster	disaster	band-master	interpilaster
caster	emplaster	beplaster	latinitaster
castor	piastre	blaster	medicaster
master	alabaster	cadaster	oleaster
pastor	burgomaster	sticking-plaster	overmaster
plaster	poetaster	criticaster	schoolmaster
vaster (etc.),	quartermaster	"flabbergaster"	taskmaster
see AST	balastre	goniaster	

ASTIC

drastic	chiliastic	bombastic	docimastic
mastic	clastic	ceroplastic	dynastic
plastic	ecclesiastic	dentoplastic	emplastic
elastic	enthusiastic	dichastic	encomiastic
fantastic	amphiblastic	onomastic	esemplastic
gymnastic	anaclastic	orgiastic	galvanoplastic
monastic	antiphrastic	paraphrastic	gelastic
sarcastic	antonomastic	paronomastic	iconoclastic
scholastic	bioplastic	peirastic	inelastic

ASTIC—(*Cont.*)

metaphrastic	periphiastic	proplastic	scholiastic
neoplastic	plagioclastic	protoplastic	spastic
pepastic	pleonastic		

ASTEING

hasteing (etc.), *see* AST

ASTING

lasting	everlasting (etc.), *see* AST

ASTLE, ASSAL, ASSEL

castle	entassel	wrastle	*wassail*
tassel	anvassal		

ASTLESS

castless (etc.), *see* AST

ASTLING

castling (etc.), *see* ASTLE

ASTLY

ghastly	lastly	vastly

ASTOR, *see* ASTER

ASTY (*long*)

hasty	pasty	tasty

ASTY (*short*)

nasty	vasty	epinasty	masty
pasty	blasty	genioplasty	

ASURE, AZURE, AZIER

azure	glazier	erasure	embrasure
brazier	grazier		

ATA (*English* A)

strata	errata	postulata	ultimata
albata	data	imbrocata	invertebrata
batata	dentata	serenata	pro rata

ATA (*continental* A) *Any of above, also*

sonata	inamorata	reata	regatta
cantata	matamata		

ATAL

datal	natal	ante-natal	statal
fatal	"fate 'll" (etc.)	post-natal	

ATAN, AIGHTEN, AITEN
Satan straighten straiten

ATANT, ATENT
blatant latent natant patent

ATCHER, *see* ATURE (*short*)

ATCHET
hatchet latchet ratchet "catch it" (etc.)

ATCHLESS
matchless (etc.), *see* ATCH

ATCHMAN, OTCHMAN
Scotchman watchman

ATELESS, *see* AIT

ATELY, AITLY
greatly accurately (etc.), *see* AIT *long and* ATE *short*

ATEN, *see* ATTEN

ATENT, *see* ATANT

ATER (*as in* later), *see* ATOR

ATER (*as in* water), *see* AUGHTER

ATHER (*long*)
father rather *bother* *pother*

ATHER (*short*)
blather foregather upgather lather

ATHING, *see* AYTHING

ATHLESS
pathless (etc.), *see* ATH

ATHELESS
scatheless (etc.), *see* ATHE

ATIAL, ACIAL
glacial craniofacial palatial spatial
abatial racial prelatial unifacial

ATIC, ATTIC
attic dogmatic erratic pragmatic
static dramatic fanatic prismatic
asthmatic ecstatic phlegmatic quadratic
chromatic emphatic pneumatic rheumatic

Atic, Attic—(*Cont.*)

schismatic	acroatic	dichromatic	idiosyncratic
stigmatic	acrobatic	dilemmatic	isodiabatic
aërostatic	adiabatic	diplomatic	pinematic
emblematic	agnatic	problematic	lavatic
hydrostatic	anagrammatic	protatic	lymphatic
mathematic	anastatic	rhematic	megastatic
muriatic	aphorismatic	sabbatic	melodramatic
pancreatic	aplanatic	schematic	miasmatic
symptomatic	aquatic	sciatic	mobocratic
systematic	aristocratic	villatic	morganatic
epigrammatic	arithmocratic	ecbatic	noematic
idiomatic	aromatic	eleatic	numismatic
pathematic	astatic	endermatic	ochlocratic
phosphatic	autocratic	enigmatic	operatic
piratic	automatic	fluviatic	palatic
plutocratic	axiomatic	geostatic	pancratic
poematic	bureaucratic	grammatic	sulphatic
vatic	caryatic	hepatic	sylvatic
viatic	clematic	hieratic	thematic
achromatic	commatic	hyperbatic	timocratic
acousmatic	dalmatic	hypostatic	traumatic
acroamatic	democratic	idiocratic	truismatic

Atid

hydatid	caryatid	fatted	matted, etc.

Atin

Latin	patin	satin	platin
matin			

Ating

skating (etc.), *see* Ait

Ation, Atian

nation	frication	quartation	carnation
ration	gunation	quassation	cassation
station	lallation	reptation	castration
ablation	laudation	tralation	causation
climation	monstration	afflation	cessation
efflation	palpation	agnation	citation
flotation	pausation	Alsatian	cognation
fluxation	phonation	aration	collation
friation	predation	cantation	creation

Ation, Atian—(*Cont.*)

conflation
cremation
cubation
cunctation
curtation
curvation
dalmatian
damnation
deflation
delation
dictation
dilation
donation
dotation
duration
elation
equation
falcation
filtration
fixation
flagration
flammation
flirtation
formation
foundation
gestation
gradation
gustation
gyration
hortation
illation
inflation
lactation
lavation
legation
libation
libration
ligation
location
luctation
lunation
lustration

mactation
mandation
migration
mutation
narration
natation
negation
nodation
notation
novation
nudation
nugation
oblation
oration
orbation
ovation
perflation
piscation
plantation
plication
potation
prelation
privation
probation
prolation
prostration
pulsation
purgation
quotation
relation
rigation
rogation
rotation
saltation
salvation
scrutation
sensation
serration
siccation
signation
stagnation
stellation

sudation
taxation
temptation
tentation
translation
vacation
venation
vexation
vibration
vocation
abdication
aberration
abjuration
abnegation
abrogation
acceptation
acclamation
accubation
accusation
adaptation
admiration
adoration
adulation
adumbration
advocation
aëration
affectation
affidation
affirmation
agitation
aggravation
aggregation
allegation
allocation
alteration
altercation
alternation
amputation
anhelation
animation
annexation
annotation

ablactation
absentation
acceptation
acervation
actitation
actuation
adequation
adhortation
adjuration
adornation
adversation
aërostation
ambulation
ampliation
angulation
angentation
arrestation
assentation
attrectation
auscultation
blusteration
bombilation
botheration
cameration
cantillation
castellation
coaxation
colligation
compellation
concertation
crenellation
crimination
cupellation
debarkation
decantation
decollation
decoration
decubation
decussation
deflagration
defraudation
dehortation

ATION, ATIAN—(*Cont.*)

denization	hibernation	presensation	captivation
denotation	ideation	profligation	castigation
dentilation	impugnation	propination	celebration
deplication	induration	radication	circulation
deploration	inchoation	reclamation	cogitation
deputation	incremation	recusation	collocation
depuration	inculpation	regelation	coloration
deterration	incurbation	remanation	combination
disculpation	infestation	remonstration	commendation
disputation	infiltration	ruination	commination
divulgation	inhalation	rustication	commutation
ejulation	innervation	salination	compensation
equitation	innovation	segmentation	compilation
ereptation	instauration	sibilation	complication
eructation	insufflation	sideration	compurgation
evolation	insultation	sinuation	computation
exculpation	intensation	suspensation	concentration
exhumation	intrication	syncopation	condemnation
exploitation	irritation	temeration	condensation
expugnation	isolation	tremulation	condonation
exsiccation	jubilation	ultimation	confirmation
exsufflation	lamination	vaccination	confiscation
fasciation	lancination	vellication	conflagration
federation	laniation	appellation	conformation
feneration	levitation	application	confrontation
fenestration	liberation	approbation	confutation
fibrination	lubrication	arbitration	congelation
filiation	malformation	arrogation	conglobation
fissipation	malleation	aspiration	congregation
flagitation	marmoration	assignation	conjugation
floccillation	maturation	attestation	conjuration
flucteration	matuation	augmentation	connotation
faliation	obscuration	auguration	consecration
fraternation	obstination	aviation	conservation
frequentation	obviation	avocation	consolation
gemination	oneration	balneation	constellation
glandulation	orchestration	bifurcation	consternation
glomeration	otiation	cachinnation	consultation
gloriation	panellation	calcination	consummation
gratulation	pestination	calculation	contemplation
gravidation	perfectation	cancellation	conversation
hebetation	pestillation	capitation	convocation

ATION, ATIAN—(Cont.)

copulation	detestation	explanation	inclination
coronation	detonation	explication	incrustation
corporation	detruncation	exploration	incubation
correlation	devastation	exportation	inculcation
corrugation	deviation	expurgation	indentation
coruscation	digitation	extirpation	indication
crepitation	dilatation	extrication	indignation
culmination	dislocation	exudation	induration
cultivation	dispensation	exultation	infeudation
cumulation	disportation	exundation	inflammation
decimation	dissertation	fabrication	information
declamation	dissipation	fascination	inspiration
declaration	distillation	fecundation	installation
declination	divagation	festination	instigation
dedication	divination	fermentation	instillation
defalcation	domination	figuration	intimation
defamation	dubitation	flagellation	intonation
defecation	duplication	fluctuation	inundation
defloration	education	fomentation	invitation
defœdation	elevation	fornication	invocation
deformation	elongation	fulmination	irrigation
degradation	emanation	fumigation	jactitation
degustation	embarkation	generation	jaculation
delectation	embrocation	germination	judication
delegation	emendation	glaciation	laceration
dementation	emigration	graduation	lamentation
demonstration	emulation	granulation	lapidation
denudation	enervation	gravitation	laureation
depilation	estimation	gubernation	legislation
deportation	estivation	habitation	levigation
depravation	evagation	hesitation	supplication
deprecation	evocation	illustration	suppuration
depredation	exaltation	imitation	suspiration
deprivation	excavation	implantation	sustentation
derivation	excitation	implication	limitation
derogation	exclamation	importation	lineation
desecration	execration	imprecation	litigation
desiccation	exhalation	impregnation	lucubration
designation	exhortation	imputation	maceration
desolation	expectation	incantation	machination
desperation	expiation	incarnation	maculation
destination	expiration	incitation	malversation

ATION, ATIAN—(*Cont.*)

manducation	perturbation	retardation	abbreviation
mastication	population	retractation	abomination
mediation	postulation	revelation	acceleration
medication	predication	revocation	abbacination
meditation	preparation	rumination	adjudication
mensuration	termination	salutation	acclimatation
ministration	titillation	scintillation	accreditation
misrelation	toleration	segregation	accrimination
mitigation	presentation	semination	agglutination
moderation	preservation	separation	aggrandization
modulation	proclamation	sequestration	alimentation
molestation	procreation	simulation	alineation
mordication	procuration	situation	analyzation
mutilation	profanation	speculation	anglification
navigation	prolongation	spoliation	annunciation
nidulation	propagation	sternutation	antilibration
numeration	prorogation	stimulation	appreciation
obduration	prosternation	stipulation	asphyxiation
obfuscation	protestation	subornation	averruncation
objurgation	provocation	sublimation	basification
obligation	publication	suffocation	brutalization
observation	punctuation	transformation	calcification
occultation	radiation	transmutation	calumniation
occupation	recantation	transplantation	caprification
operation	recitation	transportation	carbonization
ordination	recreation	trepidation	castramatation
oscillation	recubation	tribulation	catechization
osculation	reformation	triplication	codification
pabulation	refutation	niceration	columniation
palliation	registration	usurpation	commiseration
palpitation	regulation	vacillation	contravallation
peculation	relaxation	valuation	cornification
penetration	relagation	variegation	deconsecration
percolation	renovation	variation	decrepitation
perduration	reparation	vegetation	delimitation
perforation	replication	veneration	deltafication
permeation	reprobation	ventilation	deoppilation
permutation	reputation	vesication	deosculation
peroration	reservation	vindication	deposition
perpetration	resignation	violation	depreciation
personation	respiration	visitation	devirgination
perspiration	restoration	vitiation	diffarreation

ATION, ATIAN—(*Cont.*)

dimidiation
discoloration
disintegration
disseveration
dissociation
documentation
domestication
edulcoration
effectuation
effemination
effoliation
electrization
emaciation
endenization
enucleation
equalization
equilibration
eradication
eternization
evacuation
eventuation
evisceration
exacervation
excogitation
excruciation
exercitation
exfoliation
expatiation
expoliation
expropriation
exsuscitation
extravasation
facilitation
ferrumination
fertilization
feudalization
florification
flossification
foreordination
fortification
fossilization
galvanization

gasification
gelatination
geniculation
habilitation
habituation
harcolation
harmonization
Hellenization
horrification
hypothecation
illoquation
inanimation
infeodation
intoleration
jollification
legalization
licentiation
lignification
manipulation
modernization
moralization
mystification
nasalization
necessitation
predomination
protuberation
quantification
realization
recalcitration
recuperation
rejuvenation
reticulation
vaticination
vivification
accentuation
accommodation
accumulation
adjudication
administration
adulteration
affiliation
alienation

alleviation
alliteration
amalgamation
amplification
annihilation
anticipation
appropriation
approximation
argumentation
articulation
assassination
asseveration
assimilation
association
attenuation
authorization
canonization
capitulation
circumvallation
clarification
coagulation
cohabitation
coindication
commemora-
 tion
commensura-
 tion
communication
concatenation
conciliation
confabulation
confederation
configuration
conglomeration
congratulation
consideration
consolidation
contamination
continuation
co-operation
co-ordination
corroboration

crystallization
debilitation
decortication
degeneration
deification
deliberation
delineation
denomination
denunciation
depopulation
despoliation
deterioration
determination
dignification
dilapidation
disapprobation
discrimination
disfiguration
disinclination
disobligation
dissemination
dissimulation
divarication
dulcification
edification
ejaculation
elaboration
elicitation
elimination
elucidation
emancipation
emasculation
enumeration
enunciation
equivocation
evaporation
exacerbation
exaggeration
examination
exasperation
excoriation
exhilaration

ATION, ATIAN—(Cont.)

exoneration
expectoration
expostulation
extenuation
extermination
falsification
felicitation
fortification
gesticulation
glorification
gratification
hallucination
humiliation
illumination
imagination
immaculation
immoderation
impropriation
inapplication
inauguration
incarceration
incineration
incorporation
incrimination
inebriation
infatuation
ingemination
initiation
inoculation
insemination
insinuation
intercalation
interpolation
interpretation
interrogation
intoxication
investigation
irradiation
justification
legitimation
ludification
manifestation

matriculation
melioration
mellification
misinformation
modification
mollification
mortification
multiplication
negotiation
nidification
notification
obliteration
organization
origination
ossification
pacification
participation
perambulation
peregrination
perpetuation
precipitation
predestination
prefiguration
prejudication
premeditation
preoccupation
preponderation
prevarication
procrastination
prognostication
prolification
pronunciation
propitiation
purification
qualification
ramification
ratification
recommenda-
 tion
recrimination
rectification

reciprocation
redintegration
reduplication
refrigeration
regeneration
regurgitation
reiteration
remuneration
renunciation
representation
repudiation
resuscitation
retaliation
reverberation
sanctification
scarification
signification
solemnization
sophistication
specification
subordination
subtilization
symbolization
tergiversation
testification
thurification
versification
vitrification
vituperation
vociferation
beatification
circumnaviga-
 tion
contraindica-
 tion
cross-examina-
 tion
discontinua-
 tion
disqualification
diversification

excommunica-
 tion
inconsideration
indemnification
indetermina-
 tion
individuation
interlineation
lapidification
maladministra-
 tion
misrepresenta-
 tion
naturalization
personification
predetermina-
 tion
ratiocination
recapitulation
reconciliation
seminification
spiritualization
superannuation
supererogation
transubstantia-
 tion
undervaluation
volatilization
abalienation
allegorization
amelioration
demonetization
deterioration
differentiation
domiciliation
economization
electrification
exemplification
experimenta-
 tion
extemporiza-
 tion

ATION, ATIAN—(*Cont.*)

externalization identification sensualization specialization
idealization

ATISH

latish slatish straightish sedatish

ATIST, *see* ATTEST

ATIVE, AITIFF

caitiff	dilative	vegetative	designative
dative	emulative	legislative	suffocative
native	estimative	meditative	violative (*and*
creative	generative	operative	*the suffix* tive
procreative	hesitative	quantitative	*in place of*
cogitative	imitative	sative	tion *on other*
continuative	innovative	stative	*words under*
cumulative	terminative	speculative	ATION)

ATLESS

hatless (etc.), *see* AT

ATLING, ATTLING

gatling battling (etc.), fatling
 see ATTLE

ATLY, ATTLY

flatly patly rattly (etc.), *see* ATTLE

ATO (*English* A)

plato potato tomato literato

ATO (*continental* A)

staccato obligato "got to" "ought not to"
tomato (etc.)

ATOR, ATER, AITER, AITOR

cater	collaborator	creator	testator
crater	(etc.), *and*	cunctator	agitator
gaiter	*verbs in* ATE	curator	alligator
mater	later (etc.), *see*	dictator	commentator
pater	AIT	equator	alma mater
greater	traitor	scrutator	satyr
hater	waiter	spectator	conservator

ATRIX

cicatrix	matrix	impropriatrix	administratrix
generatrix	testatrix	mediatrix	spectatrix

imitatrix (*and the suffix* atrix *may be arbitrarily substituted for* ATOR *in most cases*)

ATRON

matron	natron	patron

ATTEN, ATON, ATEN

baton	fatten	paten	platen
batten	flatten	patten	ratten

ATTER

batter	latter	smatter	bepatter
blatter	matter	spatter	bescatter
chatter	patter	tatter	blatter
clatter	platter	bespatter	ratter
fatter	scatter	attar	*satyr*
flatter	shatter	beflatter	splatter
hatter	"at her" (etc.)		

ATTERN, ATURN

pattern	lattern	Saturn	slattern

ATTEST, ATIST, ATTICED

bratticed	statist (etc.), *see* AT	flattest (etc.), *see* AT	latticed

ATTLE

battle	prattle	battel	rattle
tittle-tattle	cattle	tattle	chattel
embattle			

ATTLER, ATTLING, etc., *see* ATTLE

ATTO, ATEAU

plateau	chateâu	mulatto	annatto

ATTRESS

mulattress	mattress	flatteress

ATTY

batty	chatty	natty	catty
patty	matty	gnatty	ratty
fatty			

Atum

| datum | substratum | erratum | pomatum |
| desideratum | stratum | ultimatum | postulatum |

Ature (*long*)

| nature | legislature | unnature | nomenclature |
| plicature | | | |

Ature (*short*), **Atcher**

stature	patcher	hatcher	despatcher
thatcher	scratcher	snatcher	matcher
detacher	catcher	"detach her" (etc.)	

Aturn, *see* **Attern**

Atus

literatus	afflatus	hiatus	"berate us"
apparatus	saleratus	senatus	(etc.)
stratus	status		

Aty, Eighty, Atey

| eighty | praty | weighty | platy |
| matey | slaty | | |

Aubless

daubless (etc.), *see* **Aub**

Auchion, *see* **Aution**

Auction, *see* **Oction**

Audal, Audle, Awdle

| caudal | bicaudal | caudle | dawdle |

Audit

| audit | plaudit |

Audlin

| maudlin | "dawdlin'" |

Audy, Awdy

| bawdy | gaudy | dawdy |

Aughless

laughless (etc.), *see* **Aff**

Aughter, Ater, Auter (*for rhymes to* laughter *see* **After**)

daughter	slaughter	firewater	"taught her"
manslaughter	backwater	"hadn't	(etc.)
water	tauter	oughter" (etc.)	

AUGHTY, OUGHTY
doughty haughty naughty

AUKLESS
chalkless (etc.), *see* ALK

AULIC
aulic interaulic hydraulic *Gallic*

AULING, *see* ALLING

AULTER, *see* ALTAR

AULTY, ALTY
faulty malty walty salty
vaulty

AUNCHLESS, *see* AUNCH

AUNDER
launder maunder

AUNDRY
laundry maundry

AUNLESS
dawnless (etc.), AWN

AUNTER
haunter vaunter (etc.), saunter taunter
 see AUNT

AUNTLESS, *see* AUNT

AUPER, *see* ORPOR

AUREL, *see* ORAL, (*short*)

AUSELESS
causeless (etc.), *see* AUSE

AUSEOUS, AUTIOUS
precautious cautious nauseous "wash us" (etc.)

AUSTIC, *see* OSTIC

AUSTLESS
exhaustless (etc.), *see* AUST

AUSTRAL
austral claustral

Aution, Auchion

| caution | incaution | fauchion | precaution |

Autious, *see* **Auseous**

Ava

| brava | lava | guava | Nava |
| cassava |

Avage

| ravage | savage | scavage |

Avel (*short*), **Avil**

| cavil | travel | gavel | travail |
| unravel | gravel | cavil | ravel |

Aveless

naveless (etc.), *see* **Ave**

Avelin

| javelin | ravelin | "travelin'" (etc.) |

Aveling

| knaveling | shaveling | waveling |

Avely

| bravely | gravely | suavely | knavely |
| slavely |

Avement

| depravement | lavement | pavement | enslavement |
| engravement |

Aven

| craven | haven | raven | shaven |
| engraven | graven |

Aver

| cadaver | claver | "have her" (etc.) |

Aver (*as in* quaver, *see* **Avor**)

Avern

| cavern | tavern |

Avid

| avid | impavid | gravid | pavid |

Avier, *see* **Avior**

AVIL, *see* AVEL

AVIOR

pavior	wavier	behavior	"save yer"
savior	misbehavior	clavier	(etc.)
havier			

AVISH (*long*)

bravish	knavish	slavish

AVISH (*short*)

lavish	enravish	MacTavish

AVIT

cessavit	affidavit	"save it" (etc.)	davit
indicavit			

AVO

bravo	octavo

AVOR, AVER

claver	papaver	haver	slaver
craver	waiver	quaver	disfavor
enslaver	favor	savor	engraver
graver (etc.),	flavor	shaver	semiquaver
see AVE			

AVY

gravy	navy	slavey	peccavi
wavy	cavy		

AWDRY

bawdry	tawdry

AWDY, *see* AUDY

AWER
drawer (etc.), *see* OR *and* AW

AWFUL

awful	lawful	unlawful	"jawfull" (etc.)

AWKER, *see* ALKER

AWLER
trawler (etc.), *see* ALL

AWLESS
lawless (etc.), *see* AW

Awling, *see* Alling

Awning
awning spawning yawning (etc.) *see* Aun

Awnless
dawnless (etc.), *see* Awn

Awny
brawny lawny scrawny mulligatawny
fawny tawny yawny

Awy
flawy pawy strawy thawy
jawy *See also* Oy—*one syllable*

Awyer
lawyer sawyer topsawyer

Axen, Axon
flaxen Saxon waxen klaxon

Axless, *see* Ax

Axy
flaxy taxi ataraxy waxy

Ayday, Eyday
heyday pay-day May-day play-day
layday

Ayer, Eyor (*for rhymes to* prayer *see* Air)
purveyor payer layer surveyor (etc),
 see Ay

Ayey, Eyey
clayey sprayey wheyey

Ayfish, Afish
crayfish safish

Ayful
playful dismayful "gayful"(etc.) "trayfull"(etc.)

Aying
saying (etc.), *see* Ay

Ayling, *see* Ailing

AYLESS
dayless (etc.), *see* AY

AYMAN
layman "matinée man" drayman bay-man
highwayman

AYMENT, *see* AIMANT

AYORESS, *see* EIRESS

AYTHING
plaything scathing (etc.), *see* ATHE

AZARD
hazard mazard haphazard

AZEL, *see* ASAL

AZELESS
praiseless (etc.), *see* AISE

AZEN, AZON, ASON, AISIN
blazon gazon diapason glazen
brazen raisin emblazon "gazin'"
scazon

AZEMENT
amazement erasement *casement* (etc.) *see* ASEMENT

AZER, AISER, AZOR
blazer phaser stargazer (etc.), "amaze her"
razor *see* AISE (etc.)

AZIER, *see* ASURE

AZZLE, ASIL
basil razzle-dazzle frazzle bedazzle
dazzle drazel razzle

AZY, AISY
crazy lackadaisy lazy jasey
daisy hazy sleazy mazy

EA
Althæa dahabieh spiræa panacea
cavalleria (dyspnœa) zea ratafia
cypræa obeah idea onomatopœia

EACELESS
peaceless (etc.), *see* EACE

EACHER, EATURE

breacher	creature	preacher	impeacher
breecher	defeature	reacher	entreature
screecher	feature	teacher	"beat yer"
beacher	peacher	beseecher	(etc.)
bleacher			

EACHLESS
peachless (etc.), *see* EACH

EACHMENT

peachment	beseechment	impeachment	preachment

EACHY, *see* EECHY

EACON, *see* EAKEN

EADEN, (*short*)

deaden	threaden	leaden	redden

EADER
leader (etc.), *see* EAD

EADLE, EEDLE

needle	*pedal*	beadle	tweedle

EALMENT

concealment	revealment	congealment	repealment

EALMLESS
helmless (etc.), *see* EALM

EALOT

helot	zealot

EALOUS

jealous	procellous	entellus	Marcellus
zealous	apellous	vitellus	

EALY, EELY, ELY

chely	peely	squealy	wheely
freely	seely	steely	genteely
mealy			

EAMON, ÆMON, EEMAN, EMAN, EMON

beeman	demon	leman	gleeman
dæmon	freeman	teaman	seaman

EAMER, EEMER, EMER, EMIR, EMUR

emir	steamer	streamer	redeemer (etc.),
femur			*see* EAM

EAMISH

beamish	squeamish

EAMLESS

steamless (etc.), *see* EAM

EAMSTER, *see* EEMSTER

EAMY

seamy (etc.), *see* EAM

EAN, EIAN, IEN

lien	epicurean	astrean	pampean
pæan	adamantean	didrochean	perigean
plebian	amœbean	epistolean	phalangean
pygmean	amorean	gigantean	plumbean
empyrean	amphigean	lethean	protean
European	anomean	lyncean	terpischorean
hymenean	antipodean	mausolean	zoilean
tartarean	apogean	mymphean	

EANER, *see* EANOR

EANING, ENING

gleaning	damascening (etc.), *see* EAN—*one syllable*
meaning	

EANLESS

queenless (etc.), *see* EAN—*one syllable*

EANLING, EENLING

queenling	weanling	yeanling

EANLY, *see* ENELY

EANOR, EENER, ENER

cleaner	misdemeanor (etc.), *see* EAN—*one syllable*
greener	
demeanor	

EAPEN, EEPEN

cheapen	deepen	steepen

EAPER, EEPER

deeper	leaper (etc.), *see* EAP

EAPLY
cheaply deeply steeply

EAPY, *see* EAP

EARANCE, ERENCE
clearance reappearance perseverance disappearance
adherence coherence interference inherence
appearance incoherence arrearance

EARCHER, *see* ERCHER

EAREST, *see* ERIST

EARFUL, EERFUL
uncheerful unfearful tearful sneerful
cheerful earful

EARIER, *see* EERIER

EARING, EERING
cheering ear-ring hearing (etc.), *see* EAR

EARLESS
cheerless (etc.), *see* EAR

EARLLESS
pearl-less (etc.), *see* EARL

EARLING, *see* ERLING

EARLY, IRLY, URLY
churly curly pearly whirly
knurly early surly hurly-burly
burly girly twirly

EARNER, OURNER, URNER
adjourner sojourner
burner (etc.), *see* EARN

EARNEST
earnest furnaced learnest (etc.), *see* EARN

EARNING, URNING, ERNING
burning (etc.), book-learning undiscerning
 see EARN

EARSAL, ERSAL
controversal ursal rehearsal transversal
tercel versal reversal universal

EARSELESS
purseless (etc.), *see* ERCE

EARTEN, *see* ARTAN

EARTLESS
artless (etc.), *see* ART

EARY, EERY, ERY

beery	peri	aweary	jeery
cheery	query	*miserere*	leary
dearie	smeary	aërie	quære
dreary	sneery	bleary	sphery
eerie	weary	foreweary	veery

EASAN, *see* ESEN

EASAND

reasoned	unseasoned	treasoned	weasand
seasoned			

EASANT, ESENT

displeasant	pheasant	present	omnipresent
peasant	pleasant	unpleasant	

EASEL

easel	weasel	teasel	Lady Teazle

EASELESS
ceaseless (etc.), *see* EACE

EASIER, *see* EASY

EASING
unpleasing sneezing (etc.), *see* EASE

EASLES

easels	measles	weasels

EASON

reason	season	treason	"pleasin'"
unreason	unseason		(etc.)

EASONED, *see* EASAND

EASONING
reasoning seasoning

EASTER
Easter feaster southeaster "down-easter"
northeaster

EASTING
beasting bee-sting unpriesting feasting
easting

EASTLESS
feastless (etc.), *see* EAST

EASTLY
beastly priestly

EASURE, EISURE
admeasure leisure pleasure displeasure
entreasure measure treasure outmeasure

EASY, EESY, EEZY
breezy queasy wheezy greasy
cheesy sleazy freezy uneasy
easy sneezy

EATEN
overeaten beaten sweeten worm-eaten
storm-beaten heaten wheaten weather-beaten
unbeaten seton eaten

EATER, *see* ETOR

EATHER (*long*), **EETHER, EITHER**
bequeather wreather either seether (etc.),
enwreather breather neither *see* EATHE
sheather

EATHER (*short*), **ETHER**
aweather blether nether whether
patent-leather feather tether belwether
pinfeather heather weather together
whitleather leather wether altogether

EATHING, EETHING
breathing seething, (etc.), "wee thing" "tea-thing"
 see EATHE

EATHY
heathy lethy Lethe wreathy
sheathy

EATEST, *see* **ETIST**

EATHLESS
deathless (etc.), *see* **EATH**

EATING, EETING
greeting (etc.), *see* **EAT**

EATLESS
meatless (etc.), *see* **EAT**

EATLY (*see* **EETLY, ATELY**)

EATMENT

| treatment | completement | entreatment | maltreatment |

EATURE, *see* **EACHER**

EATY

| meaty | sweety | entreaty | *spermaceti* |
| sleety | treaty | peaty | |

EAVER

enfever	reaver	fever	unbeliever
beaver	reiver	lever	achiever
keever	weever	weaver	believer (etc.),
liever	beaver	coalheaver	*see* **EAVE**
livre	cleaver		

EAVEN

| heaven | leaven | seven | eleven |

EAVOUR, *see* **EVER**

EAVY, *see* **EVY**

EBBLE, EBEL, EBLE

| pebble | rebel | treble | djebel |

EBBLY, EBLY

| pebbly | trebly | | |

EBBLESS, EBLESS
webless (etc.), *see* **EB**

EBTOR, *see* **ETTER**

ECANT, *see* **IQUANT**

ECENT

| decent | puissant | recent | indecent |

ECHER, ETCHER

fletcher	lecher	stretcher	sketcher
etcher	fetcher	retcher	Fletcher

ECHO

echo	Necco	secco

ECIAN, *see* ETION, (*long*)

ECIOUS (*long*)

specious	facetious

ECIOUS (*short*)

precious	"refresh us" (etc.)

ECKER, EQUER

checker	exchequer	wrecker (etc.),	"peck her"
chequer	woodpecker	*see* ECK	(etc.)

ECKLACE, *see* ECKLESS

ECKLE, EKEL

befreckel	keckle	bespeckle	deckle
heckle	shekel	speckle	seckel

ECKLESS, ECKLACE

feckless	reckless	speckless	fleckless
necklace			

ECKLING

heckling (etc.), *see* ECKLE

ECKON

beckon	reckon

ECKONED, ECOND

beckoned	unreckoned	second	*fecund*
reckoned			

ECKONING

beckoning	reckoning	unreckoning

ECOND, *see* ECKONED

ECTANT, ECTENT

expectant	reflectent	disinfectant (etc.), *see* ECT

ECTAR, *see* ECTOR

ECTENT, *see* ECTANT

ECTFUL

neglectful respectful disrespectful

ECTIC

actalectic cachectic pectic apoplectic
analectic electic dialectic catalectic
brachycatalec- hectic ecectic
tic

ECTILE

insectile projectile sectile

ECTION, EXION

flexion misdirection injection coninsection
lection prospection inspection disaffection
section provection neglection genuflexion
vection rection objection imperfection
abjection vivisection perfection indirection
adjection connection prelection insurrection
affection correction profection intellection
aspection deflection projection interjection
bisection defection protection intersection
collection dejection reflection introspection
complexion detection rejection predilection
confection dilection selection recollection
convection direction subjection re-election
disinfection dissection subsection resurrection
effection ejection trajection retrospection
evection election trisection venesection
implexion erection by-election incircumspec-
incorrection infection circumspection tion
irreflection inflexion circumvection superinjection

ECTIVE

deflective selective elective protective
erective affective infective reflective
humective collective inflective respective
introspective corrective invective subjective
neglective defective objective circumspective
recollective detective perfective ineffective
refective directive perspective irrespective
rejective effective prospective retrospective
sective

ECTLY
correctly incorrectly indirectly circumspectly
directly

ECTOR, ECTRE, ECTAR
hector sector vector director (etc.),
nectar flector specter *see* ECT
rector lector

ECTURE
lecture projecture belecture "expect yer"
conjecture architecture confecture (etc.)
prefecture

EDAL, *see* EDDLE

EDDEN, *see* EADEN

EDDING
bedding redding wedding (etc.), *see* ED

EDDLE, EDAL
medal peddle treadle heddle
meddle reddle intermeddle tripedal
pedal

EDDLING
shredling meddling (etc.), *see* EDDLE

EDDY, *see* EADY

EDELESS
needless (etc.), *see* EAD

EDENCE
credence precedence antecedence intercedence

EDENT
credent needn't precedent retrocedent
intercedent decedent antecedent sedent

EDGLESS
hedgeless (etc.), *see* EDGE

EDGER
ledger dredger (etc.), *see* EDGE

EDGING
dredging edging (etc.), *see* EDGE

EDIAN
encyclopedian median comedian tragedian

EDIENCE
expedience obedience disobedience inexpedience

EDIENT
expedient obedient disobedient inexpedient
ingredient

EDING (*long*)
preceding (etc.), *see* E**AD**

EDIT
credit discredit sub-edit accredit
edit miscredit "fed it" (etc.)

EDIUM
medium tedium

EDLAR
medlar meddler pedlar treadler
medaler pedaler peddler intermeddler

EDLEY, E**ADLY**
deadly medley redly

EDNESS, E**ADNESS**
redness (etc.), *see* E**D**

EDO
credo toledo stampedo teredo
torpedo

EECELESS
fleeceless (etc.), *see* E**ACE**

EECHES, *see* I**CHES**

EECHLESS
speechless (etc.), *see* E**ACH**

EECHY
beachy preachy speechy bleachy
beechy queachy Campeachy breachy
peachy screechy *Medici* reechy

EECY
fleecy greasy creasy, *see also* E**ASY**

EEDER
feeder (etc.), *see* EAD "treed her" (etc.)

EEDFUL

unheedful	deedful	speedful	needful
unneedful	meedful	heedful	

EEDLE, *see* EADLE

EEDLESS
heedless (etc.), *see* EAD

EEDLING

feedling	seedling	tweedling	reedling
needling	sweedling	wheedling	

EEDOM

freedom	sedom	"heed 'em" (etc.)

EEDY, EADY

deedy	beady	reedy	speedy
"encyclopedy"	greedy	"indeedy"	weedy
heedy	needy	seedy	unheedy
predy			

EEFLESS
beefless (etc.), *see* EEF

EEFY
beefy (etc.), *see* EAFY

EEKLESS
cheekless (etc.), *see* EAK

EEKLY

freakly	weakly	obliquely	treacly
meekly	weekly	bleakly	uniquely
sleekly			

EELER, *see* EALER

EELING, *see* EALING

EELLESS
heelless (etc.), *see* EAL

EEMLY, *see* EMELY

EEMSTER, EAMSTER

deemster	dreamster	teamster	seamster

EENISH, EANISH

cleanish	leanish	keenish	meanish
greenish	spleenish		

EENLESS
spleenless (etc.), *see* EAN

EENLY, *see* ENELY

EENY

fantoccini	greeny	sheeny	teeny
genie	queenie	tweeny	weeny
visne			

EEPEN, *see* EAPEN

EEPER, *see* EAPER

EEPIER

creepier	sleepier

EEPLE, EOPLE

people	steeple	empeople	unpeople

EEPLY, *see* EAPLY

EEPY
sleepy (etc.), *see* EAP

EERAGE

peerage	arrearage	clearage	pierage
steerage			

EERESS, *see* EAR

EERLESS
peerless (etc.), *see* EAR

EERLY, *see* ERELY

EERY, *see* EARY

EESELESS
cheeseless (etc.), *see* EASE

EESTONE

freestone	keystone

EETEN, *see* EATEN
EETLE

beetle	betel	decretal	fœtal

EETLESS, *see* EATLESS *and* EAT

EETLY, *see* ETELY

EETY, *see* EATY

EEVISH, IEVISH
peevish thievish

EEZELESS, *see* EASELESS *and* EASE

EEZER
friezer leaser teaser tweezer
easer pleaser freezer wheezer (etc.),
greaser sneezer squeezer *see* EASE
"geezer"

EYSER, *see* ISER

EFACED, *see* EAFEST

EFTLESS
deftless (etc.), *see* EFT

EFTY
clefty hefty wefty

EGAL, *see* EAGLE

EGGY
dreggy eggy leggy peggy

EGGLESS, EGLESS
legless (etc.), *see* EG

EGIAN, EGION
legion collegian glaswegian Norwegian
region

EGNANT
regnant pregnant impregnant

EGRESS
egress negress regress

EIAN, *see* EAN—*two syllables*

EIFER, EAFER
deafer heifer feoffor zephyr

EIGHBOR, *see* ABER

EIGHTY, *see* ATY

EILING, *see* EALING

EING, *see* EA—*one syllable*

EIRESS
heiress mayoress

EIST
deist seest theist (etc.), *see* EA—*one syllable*

EIZURE
seizure *easier* (etc.), *see* EASY *for doubtful rhymes*

EKEL, *see* ECKLE

ELATE
prelate appellate debellate interpellate
stellate constellate flabellate ocellate

ELCHER, ELSHER
belcher welsher squelcher

ELDAM, ELDOM
beldam seldom "swelldom"

ELDER
elder gelder welder

ELDEST
eldest heldest (etc.), *see* ELD

ELDING
gelding welding

ELDOM, *see* ELDAM

ELEON, *see* ELIAN

ELFISH
elfish pelfish shell-fish unselfish
selfish

ELFLESS
selfless (etc.), *see* ELF

ELIAN, ELEON, ELION
pelion chameleon perihelion carnelian
aphelion cornelian anthelion

ELIC

relic	evangelic	nickelic	pimelic
angelic	imbellic	parhelic	telic
bellic	melic	pentelic	

ELINE

bee-line	feline	sea-line

ELION, *see* **ELIAN**

ELISH, ELLISH

hellish	disrelish	embellish	"swellish"
relish			

ELLAR, ELLER

cellar	dweller (etc.), *see* ELL	stellar	saltcellar
		teller	interstellar

ELLEST, ELLISED

quellest	trellised (etc.), *see* ELL

ELLI, ELLY

cancelli	smelly	felly	shelly
helly	belly	jelly	vermicelli
rakehelly	Donatelli	Kelly	

ELLING
cloud-compelling (etc.), *see* ELL

ELLISED
see **ELLEST**

ELLO, ELLOE, ELLOW

brocatello	bellow	mellow	prunello
good-fellow	cello	*hello*	punchinello
niello	felloe	yellow	"well O"
saltarello	fellow	duello	violoncello
scrivello			

ELLUM

skellum	vellum	cerebellum	flabellum

ELLY, *see* **ELLI**

ELMLESS
helmless (etc.), *see* EALM

ELON

felon	melon	enfelon	watermelon (etc.)

ELOP, ELOPE

develop envelope (verb)

ELOT, EALOT

helot zealot

ELPER

helper (etc.), *see* ELP

ELPLESS, *see* ELP

ELTER

melter	felter	smelter	helter-skelter
pelter	inshelter	spelter	"pelt her"
belter (etc.),	kelter	swelter	(etc.)
see ELT	shelter	welter	

ELTING

belting felting melting (etc.), *see* ELT

ELTLESS

beltless (etc.), *see* ELT

ELVING

delving helving shelving

EMBER

| ember | December | November | September |
| member | dismember | remember | disremember |

EMBLE

| semble | assemble | dissemble | resemble |
| tremble | | | |

EMBLER

dissembler (etc.), *see* EMBLE temblor

EMBLY

trembly assembly

EMELESS

schemeless (etc.), *see* EAM

EMELY, EEMLY

seemly supremely unseemly extremely

EMER, *see* EAMER

EMIC
chemic
endemic
polemic
academic

epidemic
alchemic
anaemic

pandemic
platychemic
strategemic

systemic
theoremic
totemic

EMISH
blemish

clemmish

flemish

EMIST, EMMEST
chemist

stemmest (etc.), *see* EM

EMLESS
hemless (etc.), *see* EM

EMMER, EMNER, *see* EMOR

EMON (*long*), *see* EAMAN

EMON (*short*)
gemman

lemon

EMOR, EMMER, EMNER
clemmer

tremor

condemner

contemner
(etc.), *see* EM

EMPLAR
templar

exemplar

EMSTRESS
dempstress

sempstress

EMPTER
tempter
attempter

exempter

unkempter

pre-empter

EMPTION
emption
ademption

coemption
exemption

pre-emption
redemption

diremption

EMUR, *see* EAMER

ENA, INA
arena
catena
cavatina
farina
galena

gena
maizena
philopena
scarlatina

scena
semolina
verbena
hyena

subpœna
Tsarina
concertina
signorina

ENACE, ENNIS

menace Dennis tennis Venice
tenace

ENAL

penal venal plenal weanel
renal machinal

ENANT, ENNANT

pennant tenant lieutenant

ENATE, see ENNET

ENCELESS

defenceless (etc.), see ENCE

ENCER, ENSER, ENSOR

censer condenser commencer intenser
censor dispenser denser prehensor
fencer extensor incensor tensor
Spencer "contents her" (etc.)

ENCEFORTH

henceforth thenceforth

ENCHER, ENSURE

bencher clencher trencher blencher (etc.),
censure quencher wencher see ENCH

ENCHES, see ENSIOUS

ENCHLESS

benchless (etc.), see ENCH

ENCIL, see ENSAL

ENDAM, see ENDUM

ENDANCE, ENDENCE

attendance condescendence impendence pendence
dependence independence interdepend- tendance
resplendence ascendance ence tendence
transcendence

ENDANT, ENDENT

pendant splendent dependent transcendent
pendent appendant descendant independent
dependant ascendant descendent interdepend-
equipendent attendant impendent ent
interscendent contendent intendant superintendent
transplendent defendant resplendent

ENDER, ENDOR

fender	slender	surrender	perpender
gender	splendor	vendor	reprehender
lender	tender	amender	tail-ender (etc.)
render	engender	offender (etc.),	week-ender
sender	pretender	*see* END	

ENDING

pending pretending (etc.), *see* END

ENDLESS, *see* END

ENDLY

friendly *reverendly* unfriendly

ENDOR, *see* ENDER

ENDOUS

stupendous tremendous

ENDUM, ENDAM

addendum	commendam	referendum	"mend 'em"
agendum	corrigendum	credendum	(etc.)

ENELY, EANLY, EENLY

greenly	leanly	queenly	serenely
keenly	meanly	obscenely	cleanly

ENEOUS, *see* ENIUS

ENER, *see* EANOR

ENET, *see* ENNET

ENGLISH, INGLISH

English jinglish tinglish

ENGTHEN

lengthen strengthen

ENIAL

genial (etc.), *see three-syllable rhymes*

ENIC

scenic	arsenic (adj.)	mandarinic	phenic
splenic			

ENISH

plenish rhenish replenish wennish

ENIST, EENEST (etc.)

gleanest	plenist	magazinist	routinist (etc.),
greenist	machinist		*see* EAN

ENLESS, *see* EN

ENNA

senna	gehenna	henna	antenna
duenna			

ENNANT, *see* ENANT

ENNEL, ENOL

antennal	pennal	gennel	phenol
fennel	unkennel	kennel	

ENNER

penner	tenner	tenor	tenour

ENNET

gennet	rennet	senate	tenet
jennet			

ENNIS, *see* ENACE

ENNIUM

millennium	quinquennium
	(etc.)

ENNON, ENON

pennon	tenon

ENNY, ANY

any	many	wenny	tenney
fenny	penny		

ENSAL, ENCIL, ENSIL, ENSILE

mensal	pensile	stencil	utensil
pencil	extensile	pensil	tensile
prehensile	Hensel		

ENSELY

densely	immensely	intensely

ENSER, *see* ENCER

ENSIL, *see* ENSAL

ENSILE, *see* ENSAL

Ension, *see* Entian

Ensious, Entious

pestilentious	contentious	sententious	silentious
pretentious	dissentious	conscientious	licentious

Ensive

pensive	ostensive	incomprehen-	inexpensive
ascensive	apprehensive	sive	influencive
defensive	comprehensive	unapprehensive	protensive
expensive	condescensive	descensive	recompensive
extensive	inoffensive	distensive	suspensive
intensive	reprehensive	incensive	tensive
offensive		indefensive	

Ensor, *see* Encer

Ensure, *see* Encher

Entail

entail	ventail	entrail

Ental, *see* Entle

Entance, Entence

sentence	repentance	unrepentance	representance

Entaur, Entor

bucentaur	succentor	centaur	mentor, *see also*
stentor			Entre

Ente, Enty

plenty	scenty	"fermenty"	"tormenty,"
twenty	"went he" (etc)		*see* Ent

Enter, *see* Entre

Entest, *see* Entist

Entful

contentful	relentful	repentful	resentful
eventful			

Ential

agential	eminential	inconsequential	obediential
bigential	expediential	indulgential	omnipresential
conferential	evidential	inferential	precedential
confidential	experiential	intelligential	preferential
deferential	exponential	jurisprudential	presidential

ENTIAL—(*Cont.*)

provencial
querulential
referential
reminiscential
residential
sapiential
sciential

sentential
sequential
superessential
tangential
torrential
credential

essential
potential
prudential
consequential
differential
influential

penitential
pestilential
providential
quintessential
reverential
unessential

ENTIAN, ENTION, ENSION

deprehension
descension
inapprehension
incension
incomprehen-
 sion
inextension
ostension
prehension
presention
propension
recension
subvention
thermo-tension

gentian
mention
pension
tension
abstention
accension
ascension
attention
contention
convention
declension
detention
dimension
dissension

distension
extension
intension
intention
invention
obvention
obtension
perpension
portension
pretension
prevention
retention
suspension
apprehension

circumvention
coextension
comprehension
condescension
contravention
inattention
intervention
reprehension
subtervention
misapprehen-
 sion
preapprehen-
 sion

ENTIC

authentic identic

ENTICE, ENTIS

appentis prentice pentice apprentice

ENTICED, *see* ENTIST

ENTILE

gentile pentile dentile

ENTING

unrelenting fomenting (etc.), *see* ENT

ENTION, *see* ENTIAN

ENTIST, ENTEST, ENTICED

dentist
penticed

prenticed
sentest

apprenticed

preventist
 (etc.), *see* ENT

ENTIVE

attentive	retentive	assentive	presentive,
incentive	irretentive		*see* ENT

ENTLE, ENTAL, ENTIL

dental	monumental	atramental	labiodental
gentle	Occidental	bidental	ligamental
lentil	Oriental	cental	linguadental
mental	ornamental	coincidental	medicamental
rental	regimental	complemental	nutrimental
trental	rudimental	complimental	parliamental
parental	sacramental	continental	pedimental
ungentle	supplemental	departmental	pigmental
accidental	transcendental	developmental	placental
detrimental	experimental	documental	predicamental
elemental	temperamental	fragmental	recremental
firmamental	alimental	governmental	sagmental
fundamental	antecedental	impedimental	tenemental
incidental	argental	intercontinental	testamental
instrumental	argumental	kentle	tridental

ENTLESS

centless (etc.), *see* ENT

ENTLY

gently	evidently (etc.), *see* ENTLE *and* ENT
intently	

ENTMENT

contentment	resentment	relentment	representment
presentment	discontentment		

ENTOR, *see* ENTAUR *and* ENTRE

ENTOUS

immomentous	pedentous	sarmentous	momentous
ligamentous	pigmentous	unguentous	portentous

ENTRE, ENTER, ENTOR

centre	lentor	inventor	tormentor
enter	tenter	denter	(etc.), *see*
mentor	dissenter	precentor	ENT

ENTRIC

eccentric	anthropocentric	concentric	paracentric
enteric	barrycentric	geocentric	selenocentric
acentric	centric	heliocentric	

ENTRY
| entry | gentry | sentry |

ENTURE
| venture | debenture | misadventure | tenture |
| adventure | indenture | peradventure | |

ENTY, *see* ENTE

ENU, ENUE
| menu | venue | "detain you" or "seen you" (etc.) |

ENUS (*short*), *see* ENACE

ENZA
| cadenza | faenza | influenza |

EOPARD, EPHERD, EPPERED
| jeopard | leopard | peppered | shepherd |

EOPLE, *see* EEPLE

EPER, *see* EPPER

EPHERD, *see* EOPARD

EPPER, EPER
| leper | pepper | high-stepper | hepper |

EPSY
| apepsy | enpepsy | paralepsy | epilepsy |
| catalepsy | metalepsy | "dyspepsy" | |

ERELY, EARLY, EERLY
cheerly	merely	sheerly	yearly
clearly	nearly	severely	austerely
dearly	peerly	sincerely	insincerely
drearly	queerly	cavalierly	

ERENCE, *see* EARANCE

ERENT, *see* ERRANT

ERFLESS, *see* ERF

ERGENCE
| convergence | emergence | resurgence | submergence |
| divergence | deturgence | | |

ERGENT, URGENT

assurgent	vergent	abstergent	divergent
insurgent	turgent	convergent	emergent
resurgent	urgent	detergent	

ERGEON, *see* URGEON

ERGER, ERJURE, ERDURE, URGER

merger	urger	converger	submerger
perjure	verdure	diverger	"urge her"
purger	verger	emerger	(etc.)
scourger			

ERGING (etc.)

| urging | converging | diverging (etc.), *see* ERGE |

ERGY, URGY

clergy	scourgy	surgy	metallurgy
dirgy	sergy	liturgy	periergy
thaumaturgy	dramaturgy		

ERIC, ERRIC, ERRICK

derrick	neoteric	endexoteric	myrrhic
ferric	aceric	enteric	numeric
spheric	alexiteric	ephemeric	peripheric
generic	amphoteric	helispheric	phylacteric
hysteric	anisomeric	homeric	piperic
climacteric	atmospheric	icteric	planspheric
esoteric	chimeric	isomeric	suberic
exoteric	chromospheric	masseteric	valeric
hemispheric	cleric	mesmeric	

ERIES

| series | forewearies | queries | wearies |
| dearies | | | |

ERIL, ERILE, ERYL

| beryl | peril | sterile | |

ERISH

| cherish | perish | | |

ERIST, EAREST

| dearest | querist | *theorist* (etc.), *see* EAR | |

ERIT

| merit | inherit | disinherit | ferret |
| demerit | | | |

ERJURE, *see* ERGER

ERKER, *see* IRKER

ERKIN, IRKIN
| firkin | jerkin | merkin | "lurkin'" |
| gherkin | | | (etc.) |

ERKLESS, *see* ERK

ERKY, *see* URKEY

ERLING, EARLING, IRLING, URLING
| curling | furling (etc.), | merling | herling |
| uncurling | *see* EARL | sterling | |

ERMAN, ERMON
| German | sermon | firman | merman |

ERMENT
| affirmant | deferment | referment | preferment |
| ferment | determent | averment | disinterment |

ERMER, *see* IRMER

ERMIN, ERMINE
| ermine | determine | predetermine | "squirmin'" |
| vermin | | | (etc.) |

ERMLESS, *see* ERM

ERMLY, *see* IRMLY

ERMON, *see* ERMAN

ERNAL, ERNEL, OLONEL, OURNAL, URNAL
colonel	diurnal	internal	quartisternal
journal	external	maternal	supernal
kernel	eternal	nocturnal	hodiernal
vernal	infernal	paternal	sempiternal
cavernal	fraternal	lucernal	sternal
coeternal	hesternal	paraphernal	urnal
dinternal	hibernal		

ERNATE
| alternate | cathurnate | ternate |

ERNEL, *see* ERNAL

ERNION, *see* URNIAN

ERNLESS
sternless (etc.), *see* EARN

ERNLY, EARNLY
dearnly sternly (etc.),
 see EARN

ERNNESS, *see* URNACE

ERNY, *see* OURNEY

ERO (*long*)
hero zero Nero

ERO (*short*)

pierrot	montero	paterero	pederero
campero	dishero	sombrero	primero
cavalero			

ERPLE, *see* URPLE

ERRAND, ERUND
errand gerund

ERRANT, ERENT
errant gerent knight-errant vicegerent

ERRET, *see* ERIT

ERRIC, ERRICK, *see* ERIC

ERRIER
burier terrier merrier (etc.), *see* ERRY

ERRING
derring erring deterring preferring
herring (etc.), *see* ER

ERROR
error terror

ERRULE, *see* ERULE

ERRY

beriberi	ferry	sherry	monastery
cemetery	lerry	very	presbytery
berry	merry	wherry	skerry
bury	perry	lamasery	stationery; *see*
cherry	serry	millinery	*also* ARRY
derry			

ERSELESS
verseless (etc.), *see* ERCE

ERSEY, URZY

furzy	jersey	kersey

ERSIAL, *see* ERCIAL

ERSIAN, ERSION, ERTION, URSION, ERCION

mersion	contravertion	eversion	nastertion
Persian	coercion	extersion	obversion
tertian	conversion	emersion	recursion
version	demersion	excursion	perversion
abstersion	desertion	exertion	reversion
aspersion	detersion	immersion	subversion
assertion	dispersion	incursion	intersertion
apertion	diversion	insertion	interspersion
aversion	contraversion	inversion	animadversion
circumversion	disconcertion	inspersion	retroversion
concertion	discursion	introversion	submersion

ERSIVE, *see* ERCIVE

ERSON, ORSEN

person	worsen

ERTAIN, URTAIN

certain	encurtain	incurtain	uncertain

ERTER

asserter	converter (etc.), *see* ERT

ERTEST, *see* ERTIST

ERTFUL, *see* URTFUL

ERTHLESS, *see* EARTH

ERTIAN, *see* ERSIAN

ERTING
diverting (etc.), *see* ERT

ERTION, *see* ERSIAN

ERTIST (etc.)

controvertist	hurtest (etc.), *see* ERT

ERTIVE

assertive	divertive	enertive	furtive
revertive			

ERTLY, URTLY

curtly	apertly	inertly	malapertly
pertly	inexpertly	overtly	alertly

ERULE, ERRULE

ferule	ferrule	spherule	perule

ERVANT, ERVENT

fervent	servant	eye-servant	unobservant
conservant	recurvant	curvant	

ERVELESS
nerveless (etc.), *see* ERVE

ERVER, *see* ERVOR

ERVID

fervid	scurvied	perfervid

ERVING
time-serving (etc.), *see* ERVE

ERVISH

dervish	nervish

ERVOR, ERVER

fervor	unnerver (etc.),	preserver	nerver
server	*see* ERVE	time-server	

ERVY, URVY

nervy	scurvy	swervy	topsy-turvy

ERY, *see* EARY *and* ERRY

ERYL, *see* ERIL

ESAGE, ESSAGE

message	presage	expressage	pesage

ESCENCE, ESSENCE

accrescence	contabescence	erubescence	fremescence
aborescence	defervescence	feminescence	frondescence
calescence	deliquescence	florescence	frutescence
candescence	delitescence	fluorescence	glaucescence
concrescence	emollescence	essence	hyalescence

ESCENCE, ESSENCE—(*Cont.*)

incalescence
incandescence
iridescence
juvenescence
lactescence
lapidescence
latescence
opalescence
petrescence

phosphores-
 cence
ramollescence
recrudescence
revalescence
reveriscence
rubescence
spumescence
supercrescence
torpescence

tumescence
virvidescence
virilescence
vitrescence
excrescence
pubescence
putrescence
quiescence
quintessence

senescence
turgescence
acquiescence
adolescence
coalescence
convalescence
effervescence
efflorescence
absolescence

ESCIENCE

nescience prescience

ESELESS

breezeless (etc.), *see* EASE

ESENCE, EASANCE

pleasance presence omnipresence

ESENT, *see* EASANT

ESHER, *see* ESSURE

ESHLESS

fleshless (etc.), *see* ESH

ESHLY

fleshly freshly

ESHY

fleshy meshy

ESION

lesion adhesion Ephesian Silesian
inadhesion cohesion inhesion trapezian

ESIS

thesis synteresis ochlesis catachresis
anæthesis exegesis tmesis diegesis
deesis anamnesis aposiopesis mathesis
diesis diaporesis anthesis schesis
mimesis erotesis

ESOM

besom "threesome" "gleesome" "see some"
 (etc.)

Essant, Escent

crescent	liquescent	deliquescent	recrudescent
decrescent	nigrescent	effervescent	ignescent
excrescent	putrescent	efflorescent	jessant
incessant	quiescent	evanescent	papescent
cessant	convalescent	obsolescent	senescent
cremescent			

Essel, *see* Estle

Esser, Essor

dresser	confessor	successor	intercessor
lesser	depressor	transgressor	predecessor
lessor	oppressor	(etc.), *see*	"address her"
aggressor	possessor	Ess	(etc.)
assessor	professor	antecessor	

Essful

distressful	successful	unsuccessful

Essing

blessing	dressing	pressing (etc.), *see* Ess

Ession, Etion

cession	suppression	discretion	possession
freshen	intercession	exgression	precession
ingression	retrocession	expression	procession
incession	accession	transgression	profession
introcession	aggression	introgression	progression
lococession	compression	retrogression	recession
session	concession	impression	succession
pression	confession	obsession	indiscretion
repossession	depression	oppression	prepossession
supersession	digression		

Essive

accessive	regressive	expressive	recessive
compressive	transgressive	impressive	redressive
concessive	aggressive	oppressive	repressive
concrescive	congressive	retrogressive	successive
cressive	digressive	possessive	suppressive
depressive	excessive	progressive	

Essless

guessless (etc.), *see* Ess

Essor, *see* **Esser**

Essure, Esher
pressure tressure fresher refresher (etc.),
thresher *see* **Esh**

Estal, Estle
pestle vestal festal

Ester
fester pester vester protester (etc.),
jester tester mid-semester *see* **Est**
nester semester wrester "pressed her"
trimester sequester digester (etc.)

Estial
bestial celestial

Estic
agrestic aposiopestic gestic domestic
anamnestic asbestic telesic majestic
anapestic catachrestic telestich

Estine
destine clandestine intestine "rest in" (etc.)
predestine

Estive
attestive estive restive suggestive
congestive festive digestive tempestive
infestive

Estle (T *sounded*), *see* **Estal**

Estle (*silent* T), **Essel**
nestle trestle vessel unnestle
chessel redressal pestle Cecil

Estler
wrestler nestler

Estless
restless (etc.), *see* **Est**

Esto
presto manifesto "west O!" (etc.)

Estral, Estrel

ancestral	*kestrel*	campestral	trimestral
fenestral	orchestral		

Estry

vestry	festery	"semestery"	"sequestery"

Esture

gesture	revesture	divesture	"lest your"
investure			(etc.)

Esty

breasty	resty	yesty	cresty
chesty	testy		

Etail

detail	sweet-ale	retail	sea-tale

Etal, *see* **Ettle**

Etchless
stretchless (etc.), *see* **Etch**

Etchy

sketchy	"tetchy"	stretchy	fetchy
vetchy			

Etely, Eatly, Eetly

featly	obsoletely	completely	discreetly
fleetly	neatly	concretely	indiscreetly
meetly	sweetly		

Etement, *see* **Eatment**

Eteor, *see* **Eature**

Etful

fretful	netful	forgetful	unforgetful
regretful			

Ether (*short*), *see* **Eather**

Eti, *see* **Etty**

Etic

æsthetic	emetic	poetic	arithmetic
ascetic	magnetic	prophetic	(adj.)
athletic	pathetic	synthetic	dietetic
cosmetic	phrenetic		energetic

Etic—(*Cont.*)

hypothetic	antithetic	eugenetic	nosopoetic
plethoretic	apathetic	exegetic	ochletic
sympathetic	auletic	frenetic	pangenetic
theoretic	baphometic	gangetic	parathetic
apologetic	biogenetic	genetic	parenthetic
peripatetic	caechetic	geodetic	paretic
abietic	colletic	hermetic	philetic
allopathetic	cometic	homiletic	phonetic
aloetic	diamagnetic	idiopathic	quercetic
alphabetic	diaphoretic	inergetic	splenetic
amuletic	docetic	kinetic	syncretic
anæsthetic	emporetic	masoretic	tabetic
anchoretic	epigenetic	mimetic	threnetic
anetic	epithetic	mythopoetic	puretic
antipathetic	erotetic	noetic	zetetic

Etion, Ecian

Grecian	impletion	repletion	concretion
accretion	depletion	interecion	deletion
completion	excretion	secretion	

Etion (*short*), *see* Ession

Etious (*short*), *see* Ecious

Etish, *see* Ettish

Etist, Eatest, Eetest

eatest	sweetest	defeatist	decretist (etc.), *see* Eat

Etive

expletive	secretive	accretive

Etless, *see* Et

Etor, Etre, Eter

eater	litre	prætor	beefeater
heater	meter	centimeter	saltpetre
sweeter (etc.), *see* Eat	metre	(etc.)	

Etsam, Etsome

jetsam	fretsome	"wet some" (etc.)

Etten

threaten	wetten	fretten

Etter, Ettor, Ebtor

better	getter	whetter	enfetter
bettor	letter	abettor	forgetter
debtor	setter	begetter (etc.),	unfetter
fetter	wetter	*see* Et	

Etti, *see* **Etty**

Ettish, Etish

fetish	pettish	coquettish	Lettish
frettish	wettish		

Ettle, Etal

abettal	kettle	nettle	settle
foresettle	metal	petal	unsettle
fettle	mettle		

Ettling

settling (etc.), *see* **Ettle**

Etto

petto	amadetto	amoretto	terzetto
corvetto	lazaretto	ghetto	zuchetto
palmetto	allegretto	libretto	"met, O" (etc.)
stiletto			

Ettor, *see* **Etter**

Etty, Eti, Etti

Betty	petty	confetti	petit
fretty	sweaty	spermaceti	netty
jetty			

Eudal, *see* **Oodle**

Eudless, feudless (etc.), *see* **Ood**

Eum

museum	mausoleum	amœbæum	prytaneum
Te Deum	peritoneum	athenæum	"see 'em" etc.
bronteum	colosseum	lyceum	

Eval, Evil (*long* E)

evil	primeval	jongeval	shrieval
weevil	medieval	retrieval	upheaval
co-eval			

EVAL (*short* E)

beval	level	bedevil	kevel
devil	revel	dishevel	

EVELESS, *see* EVE

EVEN (*short*), *see* EAVEN

EVER (*long*), *see* EAVER

EVER (*short*), EAVOR

clever	endeavor	whoever	whensoever
ever	however	whatsoever	wheresoever
never	whatever	howsoever	whichever
sever	whenever	unsever	whomsoever
assever	wherever	whencesoever	whosoever
dissever			

EVIL, *see* EVAL

EVIOUS

devious	previous

EVY, EAVY

bevy	clevy	top-heavy	levy
chevy	levee	heavy	

EWAGE, *see* UAGE

EWAL, *see* UAL

EWARD, EWERED

leeward	sewered	*cured* (etc.), *see past of verbs in*
steward	skewered	OOR—*for imperfect rhymes*

EWDLY, UDELY

crudely	lewdly	rudely	shrewdly

EWER, *see* OOR—*one syllable*

EWESS, *see* EWIS

EWISH, UEISH

blueish	Jewish	shrewish	truish

EWIS

brewis	Jewess

EWLESS

pewless, (etc.), *see* EW

EWLY, *see* ULY

EWRY, *see* URY

EWTER, *see* OOTER

EWY, *see* UEY

EXER, *see* EXOR

EXILE
exile flexile

EXION, *see* ECTION

EXLESS
sexless (etc.), *see* EX

EXOR, EXER
flexor annexer convexer perplexer
yexer complexer

EXTANT
extant sextant

EXTILE
sextile textile bissextile

EXY
hecksy "prexy" sexy apoplexy
hemiplexy "genuflexy" kyriolexy pyrexy

EYANCE
seance conveyance purveyance

EYDAY, *see* AYDAY

EYELESS
skyless (etc.), *see* Y

EYLESS
keyless (etc.), *see* E *and* AY

EYSER, *see* EEZER

IAL, YAL
basihyal supplial trial decrial
espial dial vial denial
gayal phial viol retrial
rial (*see also* ILE, *one syllable, for imperfect rhymes*)

IANCE, IENCE

science	appliance	defiance	misalliance
affiance	compliance	reliance	suppliance
alliance	incompliance		

IANT, IENT

client	compliant	self-reliant	calorifient
giant	defiant	affiant	scient
pliant	reliant	alliant	

IAR, see **IRE**—*one syllable*

IAS, IOUS

bias	lias	ananias	eyas
pious	nisi prius		

IAT, IATE, IET, IOT, YOT

diet	quiet	*ryot*	disquiet
fiat	*riot*	striate	

IBAL, see **IBLE**

IBALD (*long*)

piebald	ribald

IBALD, IBBLED (*short*)

dibbled	nibbled	ribald	cribbled
dribbled	quibbled	scribbled	

IBBER

bibber	gibber	dibber	nibber
cribber	glibber	jibber	squibber
fibber	winebibber		

IBBET, IBIT

gibbet	exhibit	prohibit	adhibit
cohibit	inhibit	zibet	

IBBLE

cribble	fribble	scribble	sibyl
dibble	nibble	gribble	thribble
dribble	quibble	kibble	

IBBLER
scribbler (etc.), see **IBBLE**

IBEL, see **IBLE**

IBELESS
jibeless (*etc.*), *see* **IBE**

IBER, *see* **IBRE**

IBIT, *see* **IBBET**

IBLE, IBAL, IBEL

Bible	libel	tribal

IBLESS
bibless (etc.), *see* **IB**

IBLET

driblet	giblet	triblet

IBLY, IBBLY

dribbly	glibly	quibbly	tribbly
fribbly	nibbly	scribbly	

IBRE, IBER

briber	tiber	giber	subscriber
fibre	liber	imbiber	(etc.), *see* **IBE**

ICAR, ICKER, IQUOR

dicker	slicker	liquor	wicker
knicker	bicker	snicker	sicker (etc.),
licker	flicker	vicar	*see* **ICK**

ICELESS
diceless (etc.), *see* **ICE**

ICELY, ISELY

nicely	pricely	concisely	precisely

ICHEN, *see* **IKEN**

ICHES, EECHES, ITCHES

breeches	riches	witches (etc.), *see* **ICH**

ICHLESS
ditchless (etc.), *see* **ITCH**

ICHLY, ITCHLY

richly	witchly

ICIAL, ITIAL

initial	official	beneficial	superficial
judicial	artificial	prejudicial	accrementitial

ICIAL, ITIAL—(*Cont.*)

comitial
edificial
exitial
extrajudicial

futuritial
getilitial
interstitial
natalitial

policial
recrementitial
rusticial
sacrificial

solstitial
tribunitial
veneficial

ICIAN, ITION, ISSION

abannition
abliguition
accrementition
acoustician
adhibition
affinition
aglutition
apician
atomician
bipartition
delinition
demission
departition
deperdition
dialectician
dismission
dissilition
electrician
epenicion
evanition
extradition
fission
futurition
hydrostatician
illinition
imbibition
immission
inition
magnetician
metrician
mnemonician
neoplatonician
nolition
obdormition
obstetrician
perquisition

practician
punition
rebullition
redition
resilition
reunition
rubrician
simplician
sortition
sublition
statistician
submonition
superaddition
tactician
proposition
readmission
requisition
supposition
predisposition
tradition
tralatition
tribunician
tripartition
vendition
vomition
mission
addition
adition
admission
ambition
attrition
audition
cognition
coition
commission
condition

contrition
dentition
edition
emission
fruition
ignition
insition
logician
magician
monition
munition
musician
arithmetician
contraposition
decomposition
geometrician
nutrition
omission
optician
partition
patrician
perdition
permission
petition
physician
position
prodition
reddition
remission
rendition
sedition
submission
recognition
repetition
rhetorician
transposition

presupposition
suspicion
transition
transmission
tuition
volition
abolition
acquisition
admonition
indisposition
interposition
juxtaposition
mathematician
metaphysician
ammunition
apparition
apposition
circuition
coalition
composition
competition
definition
demolition
deposition
disposition
disquisition
ebullition
emolition
erudition
exhibition
expedition
exposition
imposition
inanition
inhibition
inquisition

ICIAN, ITION, ISSION—(*Cont.*)

intermission	opposition	premunition	repetition
intromission	parturition	preposition	reposition
intuition	politician	preterition	superstition
manumission	precognition	pretermission	academician
mechanician	premonition	prohibition	recomposition

ICIENT

deficient	sufficient	beneficent	objicient
efficient	all-sufficient	calorificient	perficient
omniscient	coefficient	inefficient	volitient
proficient	insufficient	malificient	

ICION, *see* ICIAN

ICIOUS, ITIOUS

vicious	seditious	advectitious	obstetricious
ambitious	suspicious	arreptitious	piceous
auspicious	adventitious	ascititious	profectitious
capricious	avaricious	ascriptitious	pumiceous
cilicious	inauspicious	deglutitious	puniceous
delicious	injudicious	deletitious	satellitious
factitious	insuspicious	exitious	secretitious
fictitious	meretricious	expeditious	sericeous
flagitious	suppositious	gentilitious	silicious
judicious	superstitious	impropitious	stillatitious
malicious	surreptitious	inofficious	tractitious
nutritious	supposititious	lateritious	tralatitious
officious	addititious	multiplicious	veneficious
pernicious	adjectitious	natalitious	vermicious
propitious	adscititious	obreptitious	

ICKEN

quicken	stricken	chicken	wicken
sicken	thicken		

ICKENING (*two syllables*)

quickening	sickening	thickening	*strychnine*

ICKER, *see* ICAR

ICKET

clicket	smicket	wicket	snicket
cricket	thicket	picket	"stick it"
pricket	ticket	piquet	

ICKETS

rickets tickets (etc.), *see* ICKET

ICKING

licking ticking (etc.), "viking" (British)
 see IC

ICKLE

fickle prickle strickle trickle
mickle sickle tickle nickel
pickle stickle

ICKLER

tickler (etc.), *see* ICKLE

ICKLING

chickling pickling prickling trickling,
tickling *see* ICKLE

ICKLY

fickly quickly slickly thickly
prickly sickly stickly trickly

ICKSET

quickset thickset

ICKSHAW

kickshaw rickshaw

ICKSY

dixie pixie tricksy nixie
kicksy

ICKY

bricky kicky thicky dicky
chicky sticky tricky

ICON, *see* IKEN

ICTER, ICTOR

lictor inflicter afflicter fictor
victor predicter conflicter pictor
constricter boa-constrictor contradicter stricter

ICTION, IXION

confliction suffixion fiction adstriction
depiction transfixion friction afflixion
reliction diction addiction affriction

ICTION, IXION—(*Cont.*)

astriction	infliction	contradiction	malediction
commixion	obstriction	crucifixion	valediction
constriction	prediction	dereliction	affliction
conviction	reviction	interdiction	prefixion
eviction	benediction	jurisdiction	restriction
indiction			

ICTIVE

afflictive	jurisdictive	benedictive	fictive
astrictive	inflictive	predictive	indictive
constrictive	restrictive	conflictive	interdictive
convictive	vindictive	contradictive	

ICTLESS, *see* ICT

ICTMENT, *see* ITEMENT

ICTUAL, *see* ITTLE

ICTURE

picture	depicture	impicture	"inflict yer"
stricture			(etc.)

ICY

icy	spicy

IDAL, *see* IDLE

IDAY, *see* IDY

IDDEN

bidden	midden	priest-ridden	forbidden
chidden	ridden	(etc.)	slidden
hidden	hag-ridden	unbidden	stridden

IDDING

bidding	ridding (etc.), *see* ID

IDDLE

diddle	riddle	griddle	twiddle
fiddle	tiddle	kiddle	idyll
middle	taradiddle	quiddle	

IDDLER

fiddler (etc.), *see* IDDLE

IDDY

| giddy | niddy | biddy | stiddy |
| kiddy | "chickabiddy" | middy | |

IDELESS
tideless (etc.), *see* IDE

IDELY, *see* IDLY

IDEN, IDON

| guidon | widen | "chidin' " | "abidin' " |
| | | | (etc.) |

IDENT, IDANT

| guidant | strident | dividant | bident |
| rident | trident | | |

IDER

| cider | spider | provider | glider (etc.), |
| guider | backslider | lider | *see* IDE |

IDGELESS
bridgeless (etc.), *see* IDGE

IDGEON, *see* YGIAN

IDGET

| fidget | midget | digit |

IDGY

| midgy | ridgy |

IDING
siding (etc.), *see* IDE

IDINGS

| tidings | ridings (etc.), *see* IDE |

IDLE, IDAL, IDOL, IDYL

bridal	idol	fratricidal	suicidal
bridle	idyl	homicidal	regicidal
idle	sidle	parricidal	tyrannicidal

IDLER, *see* IDLE

IDLESS
skidless (etc.), *see* ID

IDLING (*long*), *see* IDLE

IDLING (*short*), **IDDLING**

fiddling	middling	tiddling	twiddling
kidling	riddling		

IDLY

idly	widely

IDOW

widow	lever-de-rideau	"amid, O!" (etc.)

IDY, IDAY

Friday	tidy	vide	bona fide
sidy			

IEFLESS, *see* **EEF**

IEFLY

briefly	chiefly

IELESS
eyeless (etc.), *see* **Y**

IENDLESS
friendless (etc.), *see* **END**

IENT, *see* **IANT**

IER, *see* **IRE**—*one syllable*

IERLESS
fearless (etc.), *see* **EAR**

IERS
pliers (etc.), *see* **IRE**—*one syllable*

IERY, *see* **IRY**

IESTLY, *see* **EASTLY**

IET, *see* **IAT**

IEVELESS
sleeveless (etc.), *see* **EAVE**

IFELESS
lifeless (etc.), *see* **IFE**

IFELY

rifely	wifely

IFER, *see* **IPHER**

IFFIN

griffin	tiffin	biffin

IFFLE

piffle	whiffle	riffle

IFFLESS

cliffless (etc.), *see* IF

IFFLY

piffly	stiffly	whiffly

IFIC, YPHIC

horrific	soporific	finific	mirific
pacific	acidific	glyphic	morbific
prolific	pulsific	grandific	mercific
rubific	algific	honorific	somnific
specific	anaglyphic	humorific	vivific
beatific	aurific	sacrific	omnific
terrific	classific	lactific	ossific
calorific	damnific	lapidific	pontific
hieroglyphic	deific	lucific	salvific
scientific	dolorific	magnific	sensific

IFLE

rifle	stifle	trifle

IFLING

rifling	stifling	trifling	wifeling

IFTER

shifter	swifter	sifter	"lift her"
drifter	shoplifter	uplifter	(etc.)

IFTLESS

shiftless thriftless (etc.), *see* IFT

IFTY

fifty	shifty	clifty	drifty
rifty	thrifty		

IGATE, IGOT

vigot	*frigate*	gigot	spigot

IGEST

digest (noun) obligest

IGEON, *see* YGIAN

Iggard, Igured, Iggered

"figured" (British)	jiggered	niggard	triggered (etc.) *see* Igger

Igger, Igour, Igure

ligger	bigger	rigor	vigor
digger (etc.), *see* Ig	sprigger	trigger	"configure"
	"figure" (British)	outrigger	"disfigure"
snigger		market-rigger	"prefigure"
swigger	jigger	rigger	"transfigure"
twigger	nigger		

Iggin

biggin	piggin

Igging

rigging	wigging (etc.), *see* Ig

Iggle

giggle	wiggle	jiggle	riggle
higgle	wriggle	niggle	squiggle
sniggle			

Iggly, *see* **Igly**

Igher

higher (etc.), *see* Ire—*one syllable*

Ighland, Island

highland	island	"dry land," etc.

Ighless

sighless, eyeless (etc.), *see* Y

Ighly, *see* **Ily**

Ighness, Iness

highness (etc.), *see* Y, *long*

Ighten, Iten

brighten	lighten	frighten	whiten
heighten	tighten	Titan	enlighten

Ighter, Itre

lighter	backbiter	inditer	writer (etc.), *see* Ite
mitre	prize-fighter	triter	
nitre	underwriter		

IGHTLESS
sightless (etc.), *see* ITE

IGHTLY, *see* ITELY

IGHTNING

brightening	whitening	frightening	tightening
lightning			(etc.), *see* ITE

IGHTY

blighty	mitey	whitey	highty-tighty
flighty	nightie	almighty	Aphrodite
mighty			

IGIL

strigil	sigil	vigil

IGION, *see* YGIAN

IGIOUS

litigious	irreligious	sacrilegious	prodigious
religious			

IGLESS
pigless (etc.), *see* IG

IGLY, IGGLY

bigly	higgly	sniggly	wriggly
giggly	niggly	"piggly-wiggly"	

IGMA

stigma	enigma	sigma

IGMENT

figment	pigment	strigment

IGNANT

benignant	indignant	malignant

IGNEOUS

igneous	ligneous

IGNING, *see* INING

IGNLESS
signless (etc.), *see* INE

IGNLY, *see* INELY

IGNMENT, INEMENT

alignment	consignment	designment	inclinement
assignment	refinement	entwinement	resignment
confinement			

IGOT, *see* **IGATE**

IGOUR, *see* **IGGER**

IGUER, *see* **EAGER**

IGUOUS

ambiguous	contiguous	exiguous	irriguous

IGURE, *see* **IGGER**

IKELESS
spikeless, *see* **IKE**

IKEN, ICON, ICHEN

icon	"lichen"	liken

IKING

biking	piking	striking	disliking
diking	spiking	viking	misliking
liking			

ILAX, ILACS

lilacs	smilax	"eye lacks" (etc.)

ILDER

rebuilder	guilder	wilder	"killed her"
begilder	bewilder		(etc.)

ILDING

rebuilding	unbuilding	gilding

ILDISH

childish	mildish	wildish

ILDLY

mildly	wildly	childly

ILDREN, *see* **ILDERING**

ILELESS
guileless (etc.), *see* **ILE**

ILER
smiler (etc.), *see* **ILE**

ILLFUL

skillful	willful	unskillful	"fill full" (etc.)

ILIAN, ILLION, ILION, ILLON

billion	carillon	pavilion	vermilion
million	civilian	postillion	mandilion
pillion	cotillon	reptilian	stillion
Manilian	"villian"		

ILIENT, *see* **ILLIANT**

ILING

filing (etc.), *see* **ILE**

ILION, *see* **ILIAN**

ILIOUS

bilious	punctilious	atrabilious	supercilious

ILKEN

milken	silken

ILKLESS

milkless (etc.), *see* **ILK**

ILKY

milky	silky

ILLA

villa	armilla	cedilla	guerrilla
vanilla	barilla	chinchilla	mantilla
sarsaparilla	camarilla	flotilla	sabadilla
anilla	cascarilla	gorilla	seguidilla

ILLAGE

pillage	tillage	village	grillage
stillage			

ILLAR, ILLER

chiller	miller	pillar	filler (etc.),
caterpillar	maxillar	griller	*see* **ILL**

ILLET

billet	millet	rillet	gillet
fillet	quillet	skillet	willet

ILLIANT

brilliant	resilient	dissilient	transilient

ILLIARD

billiard	milliard	mill-yard

ILLING

shilling	willing	unwilling (etc.), *see* ILL

ILLION, *see* ILIAN

ILL-LESS

hill-less (etc.), *see* IL

ILLO

billow	peccadillo	killow	pulvillo
pillow	embillow	*kilo*	"will, O!"
willow	grenadillo	negrillo	(etc.)
armadillo			

ILLON, *see* ILIAN

ILLY, ILY (*short*)

grilly	chilly	lily	Piccadilly
illy	filly	shrilly	daffy-down-
piccalilli	frilly	silly	dilly
skilly	gillie	stilly	"will he" (etc.)
billy	hilly	willy-nilly	

ILOM, *see* YLUM

ILTER, ILTRE

infilter	milter	quilter	wilter
jilter	philtre	tilter	kilter

ILTLESS

guiltless (etc.), *see* ILT

ILY (*long*), **ILELY**

drily	shily	vilely	ancile
highly	slily	wily	cubile
nighly	tily	*servilely*	wryly

ILY (*short*), *see* ILLY

IMAGE

image	scrimmage

IMATE

climate	primate	acclimate

IMBER
limber	timber	timbre	unlimber
imber			

IMBLE, YMBAL, YMBOL
cymbal	nimble	thimble	wimble
gimble	symbol	tymbal	fimble

IMBO
limbo	akimbo	kimbo

IMELESS
timeless (etc.), *see* IME

IMELY
primely	timely	sublimely	untimely

IMER (*short*), *see* IMMAR

IMER, YMER, *see* IME

IMIC, YMIC
alchymic	etymic	metronymic	chymic
cacochymic	homonymic	pantomimic	mimic
cherubimic	leipothymic	synonymic	patronymic
eponymic	metonymic	zymic	

IMID
timid	jimmied

IMING, YMING
priming	rhyming	chiming	climbing, *see* IME

IMLESS, *see* IM

IMLY
dimly	trimly	primly	slimly
grimly			

IMMER, IMER
brimmer	nimmer	skimmer (etc.),	shimmer
dimmer	primer	*see* IM	gimmer
glimmer	simmer		

IMMING
brimming	swimming	trimming (etc.), *see* IM

IMPER

gimper	shrimper	whimper	scrimper (etc.),
limper	simper	crimper	*see* IMP

IMPLE

crimple	pimple	simple	bewimple
dimple	rimple		

IMPLESS, *see* IMP

IMPLING

crimpling	impling	rimpling	shrimpling
dimpling	pimpling		

IMPLY

crimply	limply	pimply	simply
dimply			

IMSY

flimsy	whimsy	brimsey	slimsy

IMY

"blimey"	rimy	grimy	thymy
limy	slimy	stymie	

INAL

acclinal	crinal	officinal	trinal
anticlinal	declinal	piscinal	final
binal	equinal	shinal	spinal
caninal	matutinal		

INBORN

inborn	twinborn

INCELESS

princeless (etc.), *see* INCE

INCERS

pincers	convincers	wincers (etc.), *see* INCE

INCEST

incest	wincest (etc.), *see* INCE

INCHER

clincher	flincher	pincher	lyncher (etc.), *see* INCH

INCHLESS, *see* INCH

INCOME, INKUM

crinkum	income	"sink 'em" (etc.)

INCTLY

distinctly	succintly	indistinctly

INCTURE

cincture	tincture	vincture	lincture
distincture	encincture		

INDER (*long*)
finder (etc.), *see* IND

INDER

cinder	flinder	rescinder	"pinned her"
hinder	pinder	"winder"	(etc.)
tinder			

INDING
finding (etc.), *see* IND

INDLE

brindle	spindle	rekindle	"wind 'll"
dwindle	windle	enkindle	(etc.)
kindle			

INDLESS
mindless (etc.), *see* IND

INDLY

blindly	kindly	unkindly

INDNESS
blindness (etc.), *see* IND

INDY

findy	shindy	windy	Lindy

INEAR, INNIER

finnier	linear	skinnier	whinnier

INELESS
spineless (etc.), *see* INE

INELY, IGNLY

caninely	divinely (etc.), *see* INE	*masculinely*

INER, IGNER

diner	liner	minor	assigner (etc.),
finer	miner		*see* INE

INET, INNET, INUTE

ginnet	minute	spinet	pinet
linnet	"in it," etc.		

INEW, INUE

unsinew	continue	discontinue	"spin you" (etc.)

INEYARD

vineyard	winyard

INFUL

sinful	skinful

INGELESS

hingeless (etc.), *see* INGE

INGENT

constringent	refringent	stringent	contingent
fingent	ringent	tingent	pertingent
impingent	restringent	astringent	

INGER (*hard* G)

finger	mallinger

INGER (*silent* G)

singer (etc.), *see* ING

INGER (*soft* G), **INJURE**

cringer	twinger	ginger	infringer (etc.),
fringer	singer	injure	*see* INGE
hinger			

INGING

ringing (etc.), *see* ING

INGLE

cingle	mingle	swingle	intermingle
cringle	shingle	tingle	gingle
dingle	single	commingle	jingal
jingle	springle	surcingle	tringle

INGLESS

wingless (etc.), *see* ING

INGLING
kingling singling wingling (etc.), *see* INGLE

INGLY (*hard* G)
jingly shingly singly tingly (etc.),
mingly *see* INGLE

INGLY (*silent* G)
kingly (etc.), *see* ING

INGO
lingo eringo flamingo jingo
stingo dingo

INGY (*hard* G)
clingy stringy wingy stingy
springy swingy

INGY (*soft* G)
cringy stingy twingy dingy
fringy swingy

INIAN, *see* INION

INIC
aclinic finic platinic rabbinic
actinic fulminic polygynic clinic
delphinic narcotinic quinic cynic

INING, IGNING
lining designing undesigning dining (etc.),
 see INE

INION, INIAN
minion dominion opinion *Virginian*
pinion

INISH (*short*), **INNISH**
finish thinnish diminish tinnish
minish

INISH (*long*)
brinish swinish

INJURE, *see* INGER

INKER
drinker thinker tinker (etc.), *see* INK

INKING
thinking (etc.), *see* INK

INKLE

crinkle	twinkle	wrinkle	periwinkle
sprinkle	winkle	besprinkle	inkle
tinkle			

INKLESS
blinkless (etc.), *see* INK

INKLING

inkling	sprinkling	twinkling (etc.), *see* INKLE

INKUM, *see* INCOME

INKY

chinky	inky	blinky	zinky
dinky	pinky	kinky	

INLESS
sinless (etc.), *see* IN

INLY

inly	thinly	McKinley

INNER

dinner	sinner	winner	grinner (etc.),
inner	spinner	finner	*see* IN
pinner	tinner		

INNET, *see* INET

INNEY, *see* INNY

INNING
beginning (etc.), *see* IN

INNINGS
innings (etc.), *see* IN

INNOW

minnow	winnow	"begin, O!" (etc.)

INNY, INNEY

finny	squinny	whinny	pickaninny
hinny	pinny	tinny	skinney
jinny	skinny	ignominy	vinny
ninny	spinney	guinea	

INO

| lino | rhino | albino | "fine, O!" (etc.) |

INOR, *see* **INER**

INSTER

| minster | spinster |

INTAL, **INTEL**

| lintel | quintal | pintle |

INTER

dinter	printer	sprinter	squinter
hinter	splinter	winter	stinter
minter			

INTLESS

printless (etc.), *see* **INT**

INTRY

| splintery | vintry | wintry |

INTY

| dinty | linty | squinty | shinty |
| flinty | minty | glinty | |

INUE, *see* **INEW**

INUS, **INOUS**

binous	lupinus	minus	vinous
declinous	pinus	sinus	echinus
linous	salinous	spinous	

INUTE, *see* **INET**

INY

miny	viny	liny	tiny
piney	whiney	shiny	twiny
sunshiny	briny	spiny	winy

ION

| lion | Orion | ion | "lie on" (etc.) |
| scion | dandelion | | |

IORESS, *see* **IRIS**

IOT, *see* **IAT**

IOUS, *see* **IAS**

Iped

biped	parallelopiped	stripèd	"wipèd" ('etc.)
			see Ipe

Ipeless, *see* **Ipe**

Ipend, Ipened

ripened	stipend

Iper, Yper

piper	striper	viper	griper
riper	typer	wiper	swiper
sniper			

Ipher, Ifer

cipher	rifer	decipher	fifer
lifer			

Iphon, *see* **Yphen**

Iping

piping (etc.), *see* **Ipe**

Iple (*long*), **Ypal**

disciple	archetypal	ectypal

Iple (*short*), **Ipple**

cripple	stipple	triple	sipple
nipple	tipple	grippal	swiple
ripple			

Ipless

lipless (etc.), *see* **Ip**

Ipling, Ippling

crippling	stripling	stipling	tippling
rippling			

Ipper

clipper	shipper	skipper	slipper (etc.),
dipper			*see* Ip

Ippet

sippet	tippet	whippet	snippet
skippet			

Ipping

chipping	dripping	shipping	tripping (etc.),
			see Ip

IPPLE, *see* IPLE

IPPY

chippy	slippy	trippy	lippy
drippy	snippy	whippy	shippy
nippy	strippy		

IPSTAFF

tipstaff	whipstaff

IPSY

gipsy	tipsy	ipse

IPTIC, YPTIC

cryptic	elliptic	diptych	eatroliptic
styptic	anaglyptic	glyptic	triptych
ecliptic	apocalyptic	holocryptic	

IQUANT, ECANT

precant	secant	cosecant	intersecant
piquant			

IQUELY, *see* EEKLY

IQUOR, *see* ICAR

IRANT, IRENT, YRANT

expirant	gyrant	tyrant	aspirant
girant	spirant	virent	conspirant

IRATE, YRATE

gyrate	dextrogyrate	irate	lyrate
circumgyrate	*pirate*		

IRCHEN, URCHIN

birchen	urchin	"searchin' " (etc.)

IRCHLESS, *see* EARCH

IRCLING, URKLING

circling	turkling

IRDAR, IRDER, URDER

girder	murder	sirdar	absurder (etc.),
herder	thirder		*see* EARD

IRDLE, URDLE

curdle	begirdle	hurdle

IRDLESS
birdless (etc.), *see* EARD

IRDLY, URDLY

birdly	hurdly	thirdly	absurdly
curdly			

IRELING

hireling	squireling

IRELY

direly	squirely	entirely

IREN, IRON

siren	lepidosiren	palaeosiren	"admirin' "
environ			(etc.)

IRENT, *see* IRANT

IRER, *see* IRE

IRGELESS
dirgeless (etc.), *see* ERGE

IRIC, YRIC (*short*)

lyric	panegyric	satiric	satyric
empiric (adj.)	butyric		

IRILE, IRREL

squirrel	virile

IRIS

iris	Osiris	"admiress"

IRKER, ERKER, ORKER, URKER

jerker	shirker	burker	smirker
lurker	worker	jerquer	

IRKLESS
smirkless (etc.), *see* ERK "work less" (etc.}

IRKSOME, URKSOME

irksome	murksome

IRLESS
firless (etc.), *see* ER

IRLING, *see* ERLING

IRLISH, URLISH
churlish girlish

IRLLESS
girlless (etc.), *see* EARL

IRLY, *see* EARLY

IRMER, ERMER, URMUR
firmer affirmer infirmer squirmer
termer confirmer bemurmur termor
murmur

IRMISH
firmish squirmish wormish infirmish
skirmish

IRMLESS
squirmless (etc.), *see* ERM

IRMLY
firmly termly wormly

IRMY
squirmy wormy gurmy taxidermy

IRON, *see* IREN

IROUS, *see* IRUS

IRPER, ERPER, URPER
chirper (etc.), *see* URP

IRRAH
sirrah tirra-lirra *Lyra*

IRRUP, YRUP
stirrup syrup chirrup

IRTHLESS
mirthless (etc.), *see* EARTH

IRTLE, YRTLE, URTLE
hurtle myrtle turtle whortle
kirtle spirtle fertile

IRTLESS
skirtless (etc.), *see* ERT

Irty, Urty

dirty	spurty	thirty	"curt he"
flirty	squirty	cherty	(etc.)
shirty			

Irus

apyrous	papyrus	virus	desirous

Iry, Iary, Iery, Iory

briery	miry	wiry	eyrie
diary	*priory*	enquiry	squiry
fiery	spiry	acquiry	*friary*

Isal

reprisal	surprisal	comprisal	paradisal
revisal			

Iscount

discount	miscount

Iscous, *see* **Iscus**

Iscuit, *see* **Isket**

Iscus

abaciscus	lemniscus	meniscus	discus
discous	lentiscus	trochiscus	viscous
hibiscus			

Isel, *see* **Izzle**

Isely, *see* **Icely**

Iser, Isor, Izar

miser	divisor	erisor	"try, sir"
sizar	incisor	geyser	(etc.)
visor	supervisor	guiser (etc.),	"surprise her"
adviser	Kaiser	*see* **Ise**	(etc.)

Isher, Issure

disher	wisher	kingfisher	"wish her"
fisher	well-wisher	swisher	(etc.)
fissure			

Ishful

dishful	wishful

Ishless

fishless (etc.), *see* **Ish**

Ishy

dishy fishy swishy

Isian, see Ision

Isic

phthisic physic metaphysic paradisic

Ising

sunrising surprising (etc.), see Ise

Ision, Isian, Ysian, Ission

precision vision elision prevision
allision scission Elysian provision
concision abscission excision recision
illision collision incision rescission
invision decision misprision revision
irrision derision Parisian circumcision
supervision division precision subdivision

Isis

crisis isis phthisis

Isive

decisive incisive cicatrisive divisive
derisive undecisive collisive precisive

Isker

brisker frisker (etc.), see Isk whisker

Isket, Iscuit

biscuit wisket "whisk it" trisket
brisket (etc.)

Iskey, see Isky

Iskless

diskless (etc.), see Isk

Iskly

briskly *fiscally*

Isky, Iskey

frisky risky whiskey

Isly, Izzly

drizzly grisly chisley sizzly
frizzly grizzly

Ismal, Ysmal

dismal	aneurismal	chrismal	paroxysmal
abysmal	cataclysmal	embolismal	rheumatismal
baptismal	catechismal		

Ison, *see* **Izzen** *and* **Izen**

Isor, *see* **Iser**

Isper

crisper	lisper	whisper

Issal, *see* **Istle**

Issant, *see* **Ecent**

Issile, *see* **Istle**

Ission, *see* **Ician** *and* **Ision**

Issless

blissless (etc.), *see* **Is**

Issor, Izzer

scissor	whizzer

Issored, *see* **Izzard**

Issue

issue	tissue

Issure, *see* **Isher**

Istance, Istence

distance	insistence	inconsistence	desistance
assistance	resistance	non-existence	equidistance
consistence	subsistence	non-resistance	inexistence
existence	coexistence	pre-existence	persistence

Istant, Istent

distant	existent	coexistent	non-resistant
distent	insistent	equidistant	pre-existent
assistant	resistant	inconsistent	persistent
consistent	subsistent	non-existent	

Isten

christen	glisten	listen

ISTER

agister	glister	twister	persister
bistre	mister	"kissed her"	resister (etc.)
magister	sister	(etc.)	see IST
blister			

ISTENCE, see ISTANCE

ISTENING
listening (etc.), see ISTEN

ISTENT, see ISTANT

ISTHMUS, see ISTMAS

ISTIC, YSTIC

cystic	altruistic	fatalistic	pietistic
fistic	anachronistic	humanistic	pugilistic
mystic	animistic	humoristic	puristic
hemistic	annalistic	idealistic	quietistic
anarchistic	aoristic	illuministic	rationalistic
atheistic	artistic	individualistic	realistic
cabalistic	bibliopolistic	intermistic	ritualistic
communistic	cameralistic	journalistic	sensualistic
pantheistic	canonistic	juristic	simplistic
socialistic	casuistic	linguistic	solecistic
syllogistic	catechistic	logistic	simplistic
tritheistic	deistic	materialistic	sophistic
characteristic	egoistic	nihilistic	stylistic
polytheistic	egotistic	optimistic	theistic
absolutistic	eristic	pessimistic	touristic
agonistic	euphuistic		

ISTINE, YSTINE

pristine	amethystine	Christine

ISTING
listing (etc.), see IST

ISTLE, ISSAL, ISSILE, ISSEL

bristle	abyssal	thistle	dismissal
gristle	missel	scissel	epistle
missal	missile	whistle	sissile

ISTLESS

listless	resistless (etc.), see IST

ISTLY

| bristly | whistly | gristly | thistly |

ISTMAS, ISTHMUS

| Christmas | isthmus |

ISTOL, *see* **YSTAL**

ISTY

| christy | misty | twisty |

ISY, *see* **IZY**

ITCHER, ICHER

| ditcher | pitcher | richer (etc.), | "ditch her" |
| hitcher | itcher | *see* ICH | (etc.) |

ITCHLESS

witchless (etc.), *see* ITCH

ITCHY

| hitchy | twitchy | pitchy | switchy |
| itchy | nichy | stitchy |

ITEFUL, IGHTFUL

| frightful | spiteful | despiteful | sprightful |
| rightful | delightful | mightful |

ITELESS

miteless (etc.), *see* ITE

ITELY, IGHTLY

| brightly | knightly (etc.), | sprightly | unsightly |
| | *see* ITE | unknightly |

ITEM, ITUM

| item | *ad infinitum* | "bite 'em" (etc.) |

ITEMENT, ICTMENT

| excitement | indictment | affrightment | "frightment" |
| incitement | invitement |

ITEN, *see* **IGHTEN**

ITEY, *see* **IGHTY**

ITHELY

| blithely | lithely |

ITHER (*long*)

blither	scyther	mither	neither
either	lither	writher	tither

ITHER (*short*)

blither	whither	slither	swither
dither	hither	wither	thither

ITHING (*long*), **YTHING**

scything	writhing (etc.),	nithing	trithing
tithing	see **ITHE**		

ITHLESS
mithless (etc.), *see* **ITH**

ITHESOME

blithesome	lithesome

ITHY

smithy	stithy	withy	pithy

ITIAL, *see* **ICIAL**

ITIC

critic	cenobitic	granitic	selenitic
aconitic	conchitic	hematitic	stalactitic
adamitic	dendritic	lignitic	syenitic
aërolitic	diacritic	mephitic	tonsilitic
anthracitic	dialytic	volitic	zeolitic
biolytic	dolomitic	pleuritic	arthritic
carolytic	enclitic	proclitic	hypocritic
catalytic	eremitic	rachitic	paralytic

ITID, ITIED

nitid	pitied (etc.), *see* **ITTY**

ITING

biting	whiting	writing (etc.),	handwriting
		see **ITE**	

ITION, *see* **ICIAN**

ITIOUS, *see* **ICIOUS**

ITISH (*long*), **IGHTISH**

eremitish	lightish	whitish	tightish
anchoritish			

Itle, Ital

title	entitle	detrital	requital
vital	marital	recital	parasital
cital			

Itless
fitless (etc.), *see* It

Itling, Ittling
witling	whittling	belittling

Itness
fitness	witness

Itre, Iter
biter	mitre	nitre (etc.), *see* Ite	"bite her" (etc.)

Ittal, *see* Ittle

Ittance
pittance	admittance	remittance	permittance
quittance	acquittance	omittance	transmittance

Ittee, *see* Itty

Itten, Itan
bitten	mitten	witan	written
kitten	smitten		

Itter
bitter	glitter	litter	twitter
fitter	hitter	pitter	*zither*
fritter	knitter (etc.), *see* It	quitter	committer
flitter		titter	embitter

Itti, *see* Itty

Itting
fitting	flitting	sitting	befitting (etc.), *see* It

Ittish, Itish
British	fittish	skittish

Ittle, Ital, Ittal, Ittol, Ictual
brittle	spital	victual	transmittal
knittle	spittle	whittle	committal
little	tittle	wittol	remittal
acquittal	belittle		

ITTY, ITY, ITTI, ITTEE

bitty	gritty	pretty	committee
chitty	nitty	witty	flitty
city	pity	banditti	kitty
ditty			

ITUM, *see* **ITEM**

ITY, *see* **ITTY**

IUS, *see* **IAS**

IVAL

rival	outrival	imperatival	conjunctival
adjectival	arrival	salival	nominatival
estival	archival	revival	survival

IVANCE

connivance	survivance	contrivance	arrivance

IVEN

driven	riven	scriven	thriven
forgiven	given	shriven	

IVEL, IVIL

civil	rivel	snivel	uncivil
drivel	shrivel	swivel	

IVELY

lively	wively

IVER (*long*)

cliver	fiver	shriver	reviver
diver	hiver	conniver	surviver (etc.),
driver	liver	deriver	*see* IVE

IVER (*short*)

giver	river	deliver	freeliver
liver	shiver	cantaliver	misgiver
quiver	sliver	forgiver	outliver

IVERS (*long*)
divers (etc.), *see* **IVER** (*long*)

IVET

civet	trivet	privet	unrivet
rivet	grivet		

Ivid

livid	vivid

Ivil, see Ivel

Iving (short)

thanksgiving	unforgiving (etc.), see Ive (short)

Ivot

divot	pivot

Ivy (short), Ivi

chivy	privy	tivy	tantivy
divi			

Ixie, see Icksy

Ixer, Ixir

fixer	mixer (etc.), see Ix	elixir

Ixture

fixture	admixture	intermixture	afficture
mixture	commixture	immixture	

Izar, see Iser

Izard, Izzard, Issored

blizzard	lizard	vizard	bizard
gizzard	scissored	wizard	visored
izzard			

Izeless

sizeless (etc.), see Ize

Izen, Izon (long)

bison	horizon	ptison	"pizen"
bedizen			

Izier, see Izzier

Izy

misy	nizy	sizy

Izzer, see Issor

Izzen, Ison, Izen (short)

mizzen	wizen	arisen	mizzen
prison	imprison	bedizen	

IZZIER, IZIER, USIER

busier	dizzier	vizier

IZZLE, ISEL

chisel	grizzle	crizzle	mizzle
drizzle	swizzle	fizzle	sizzle
frizzle			

IZZER, see IZZLE

IZZY, USY

busy	mizzy	tizzy	frizzy
dizzy	"is he" (etc.)		

OACHER
roacher (etc.), see OACH

OACHFUL

coachful	reproachful

OACHLESS
roachless (etc.), see OACH

OADLESS
toadless (etc.), see OAD

OAFLESS
loafless (etc.), see OAF

OAFY, OPHE, OPHI, OPHY

loafy	sophi	strophe	trophy
oafy			

OAKER, see OCHRE

OAKLESS
soakless (etc.), see OAK

OAKUM, OCUM

locum	oakum

OALLESS
foalless (etc.), see OAL

OALY, OLY, OLELY, OLLY (*long*), OWLY

coaly	lowly	solely	moly
drolly	shoaly	*wholly*	rolly
holy	slowly	roly-poly	

OAMER, see OMER

OAMLESS
roamless (etc.), *see* OAM

OAMY
loamy (etc.), *see* OAM

OANLESS
moanless (etc.), *see* OAN

OAPLESS
soapless (etc.), *see* OAP

OARDLESS
boardless (etc.), *see* OARD

OARISH, OORISH
| boarish | *boorish* | moorish | whorish |

OARLESS
boarless (etc.), *see* OAR

OARSELY
| coarsely | hoarsely |

OARY, ORY, OORY
dory	moory	story	allegory
glory	oary	tory	flory
gory	pory	more (Latin)	promissory
hoary	storey	con amore	shory
lory			

OASTAL, *see* OSTAL (*long*)

OASTER, OSTER
| boaster | poster | toaster | throwster |
| coaster | roaster | bill-poster | |

OASTING
| coasting | ghosting (etc.), *see* OAST |

OASTLESS
toastless (etc.), *see* OAST

OATE
| inchoate | poet | "know it" (etc.) |

OATEN, *see* OTAN

OATER, *see* OTER

OATHING, *see* **OTHING**

OATHLESS

oathless	slothless	growthless

OBBER

cobber	swobber	jobber	swabber
knobber	throbber	robber	"rob her"
snobber	blobber	slobber	(etc.)
sobber	clobber		

OBBET

gobbet	post-obit

OBBIN, OBIN

bobbin	robin	dobbin	robbin

OBBLE

cobble	hobble	squabble	coble
gobble	nobble	wobble	

OBBLER

cobbler squabbler (etc.), *see* **OBBLE**

OBBY

bobby	lobby	pobby	snobby
hobby	mobby	cobby	squabby
knobby	nobby	scobby	

OBELESS

noblesse lobeless (etc.), *see* **OBE**

OBER

disrober	prober	October	"robe her"
enrober	sober		(etc.)

OBIN, *see* **OBBIN**

OBIT, *see* **OBBET**

OBLESS

jobless (etc.), *see* **OB**

OBLESSE, *see* **OBELESS**

OCAL

focal	strocal	phocal	vocal
bocal	local	yokel	socle

OCEAN, *see* **OTION**

Ocer, Oser, Osser

closer	jocoser	moroser	grosser
grocer	engrosser	verboser	

Ochee, Okee, Oky

chokee	joky	roky	choky
hoky	moky	oaky	soaky
smoky	trochee	poky	yoky
croaky			

Ochre, Oaker, Oker

broker	mediocre	evoker	stoker
choker	joker	stroker	cloaker
croaker	ochre	soaker	invoker
provoker	poker	smoker	yoker
convoker	revoker		

Ocious

atrocious	ferocious	precocious	nepotious

Ocker

blocker	shocker (etc.),	soccer	"sock 'er"
cocker	*see* Ock	mocker	"frock her"
knocker	locker	rocker	(etc.)

Ocket

brocket	locket	rocket	cocket
docket	pocket	socket	crocket
sprocket	pickpocket		

Ockey, Ocky

blocky	hockey	stocky (etc.),	flocky
cocky	jockey	*see* Ock	locky
crocky	rocky		

Ocking

shocking stocking (etc.), *see* Ock

Ockle

cockle hockle

Ockless

hockless (etc.), *see* Ock

Ocksy, *see* Oxy

OCO, OCOA, OKO

boko	cocoa	"locofoco"	coco
rococo	baroco	toko	troco

OCTER, see OCTOR

OCTION

auction	concoction	decoction

OCTOR, OCTER

doctor	proctor	concocter	"knocked her" (etc.)

OCTUS

crocus	hocus	locus	hocus-pocus
focus			

OCUST, OCUSSED

crocussed	focussed	hocussed	locust

ODDEN

sodden	trodden	untrodden	hodden

ODDER

dodder	nodder	codder	prodder
fodder	odder	plodder	podder

ODDESS, ODICE

bodice	goddess

ODDLE, ODEL

coddle	noddle	remodel	waddle
model	swaddle	toddle	twaddle

ODDLER, see ODDLE

ODDLING, see ODLING

ODDLY, ODLY

godly	oddly	coddly (etc.), see ODDLE

ODDY, ODY

body	noddy	embody	toddy
cloddy	shoddy	busybody	waddy
hoddy	odsbody	roddy	*wadi*
soddy	squaddy		

ODEL (*Short*), see ODDLE

ODELESS

roadless (etc.), see OAD

ODER, OADER, ODOUR

loader	exploder	foreboder (etc.), *see* OAD
odour		

ODEST (*short*), ODICED

bodiced	noddest	oddest (etc.),	immodest
modest		*see* OD	

ODGELESS
dodgeless (etc.), *see* ODGE

ODGER

bodger	podger	lodger	codger
dodger			

ODGING

dodging	lodging (etc.), *see* ODGE

ODICE, *see* ODDESS

ODIC

odic	parodic	melodic	iodic
episodic	spasmodic	periodic	methodic
exodic	aesthesodic	synodic	rhapsodic
kinesodic	hellanodic	anodic	sarcodic

ODING, OADING

loading	foreboding (etc.), *see* OAD

ODISH, OADISH

modish	show-dish	toadish

ODLING, ODDLING

codling	godling	modeling	toddling
coddling	waddling	swaddling	twaddling

ODLY, *see* ODDLY

ODOUR, *see* ODER

ODOUS, ODUS

modus	nodous

ODY (*short*), *see* ODDY

OELIESS, *see* EW *and* O

OEM

poem	proem	"know him" (etc.)

OER, OWER

crower	lower	sower	overthrower
goer	mower	slower	(etc.), *see* O,
grower	ower	thrower	*also possible*
knower	rower	bestower	*rhymes in*
			OAR

OET, *see* **OATE**

OFFEE

coffee	offee	spoffy

OFFER

coffer	offer	goffer	doffer
cougher	proffer	scoffer	golfer

OFFEST, *see* **OPHIST**

OFFICED, *see* **OPHIST**

OFFING

coughing	offing	scoffing (etc.), *see* **OFF**

OFTEN, ORPHAN

often	soften

OFTENER

oftener	softener

OFTY

lofty	softy

OGEY, OGI, OGUEY

bogey	jogi	roguey	bogie
voguey	fogey		

OGGISH

doggish	hoggish	"froggish"

OGGLE

boggle	coggle	joggle	toggle
goggle			

OGGY

boggy	doggy	soggy	froggy
cloggy	foggy	joggy	*pedagogy*
groggy			

Ogle

bogle	ogle	"fogle"

Ogress

ogress	progress

Oguey, *see* **Ogey**

Ogy (*short*), *see* **Oggy**

Oic

stoic	heroic	melanochroic	hypozoic
benzoic	dichroic	azoic	protozoic
eozoic	hylozoic	dyspnoic	

Oiceless
choiceless (etc.), *see* **Oice**

Oider

moider	embroider	voider	"employed her"
avoider			(etc.)

Oiler
boiler (etc.), *see* **Oil**

Oily, *see* **Oyly**

Oilless
toilless (etc.), *see* **Oil**

Oiner

coiner	enjoiner	purloiner

Oing, Owing

owing	foregoing (etc.), *see* **O**

Oinless
coinless (etc.), *see* **Oin**

Ointal, Ointel

pointel	disjointal

Ointer

pointer	anointer (etc.), *see* **Oint**

Ointless
pointless (etc.), *see* **Oint**

Ointment

anointment	appointment	disjointment	disappointment

OISELESS
noiseless (etc.), *see* OISE

OISON

oison	poison	empoison	toison

OISTER, OYSTER

cloister	oyster	roister	moister
encloister	foister	hoister	

OITER, OITRE

goitre	loiter	reconnoitre	adroiter
exploiter			

OKEN

broken	bespoken	outspoken	unspoken
oaken	betoken	foretoken	free-spoken
spoken	fair-spoken	unbroken	soft-spoken
token	forespoken		

OKER, *see* OCHRE

OKELESS
jokeless (etc.), *see* OAK

OKY, *see* OCHEE

OLAR (*long*), **OLLER, OWLER**

bowler	scroller	doler	coaler
molar	roller	poler	droller
polar	solar	enroller	poller
circumpolar	stroller	comptroller	toller
consoler	cajoler	controller	troller
patroller			

OLAR (*short*), *see* OLLAR

OLDEN

bolden	golden	beholden	withholden
embolden	holden	olden	

OLDER, *see* OULDER

OLDIER

soldier	"hold yer" (etc.)

OLDING
molding (etc.), *see* OLD

OLDLESS
goldless (etc.), *see* OLD

OLDLY
boldly coldly manifoldly

OLEFUL, OULFUL, OWLFUL
bowlful doleful soulful

OLELY, *see* OALY

OLEMN, OLUMN
column solemn

OLEN, *see* OLLEN

OLER, *see* OLLAR

OLESOME
dolesome wholesome

OLFISH, ULLFISH
bullfish wolfish

OLIC, OLLICK
colic symbolic embolic melancholic
frolic bucolic metabolic epipolic
rollick alcoholic systolic eolic
vitriolic apostolic diabolic parabolic
diastolic bibliopolic hyperbolic variolic
epistolic

OLID
solid squalid stolid volleyed
jollied olid

OLISH, OLLISH
dollish abolish demolish tollollish
polish

OLKLESS
folkless (etc.), *see* OAK

OLLAR, OLAR (*short*), OLER, OLOUR
collar loller *squalor* sollar
dollar scholar

OLLARD, OLLARED

collared	dollared	pollard	Lollard
"scholard"	bollard		

OLLEGE, *see* **OWLEDGE**

OLLEN *(long)*, **OLEN, OLON**

colon	stolen	swollen	semicolon

OLLER, *see* **OLAR**

OLLET

collet	swallet	wallet

OLLEY, *see* **OLLY**

OLLIER

collier	jollier

OLLOP

collop	escallop	wallop	lollop
dollop	trollop		

OLLOW

collow	hollow	wallow	hollo
follow	swallow	Apollo	

OLLY *(long)*, *see* **OALY**

OLLY *(short)*, **OLLEY, OLLIE, OLY**

collie	melancholy	Molly	trolley
dolly	holly	folly	volley
golly	jolly	polly	loblolly

OLON, *see* **OLLEN**

OLONEL, *see* **ERNAL**

OLOUR, *see* **OLLAR** *and* **ULLER**

OLSTER

bolster	holster	upholster

OLTER, OULTER

bolter	coulter	revolter	jolter (etc.), *see* OLT

OLTEST, OULTICED

poulticed	revoltest (etc.), *see* OLT

OLTISH
coltish doltish

OLTLESS
coltless (etc.), *see* OLT

OLUMN, *see* OLEMN

OLVER
solver revolver resolver (etc.), "involve her"
absolver *see* OLVE (etc.)

OLY, *see* OALY *and* OLLY (*short*)

OMA
coma diploma sarcoma zygoma
aboma aroma theobroma

OMACH, UMMOCK
hummock stomach

OMACHS, UMMOCKS, UMMAX
flummax hummocks stomachs "hummox"

OMAN (*short*), **OMON, OWMAN**
gnomon Roman showman yeoman
bowman foeman

OMBLESS
combless (etc.), *see* OAM *and* OOM

OMELESS
homeless (etc.), *see* OAM

OMENT
foment (noun) moment bestowment

OMER
homer misnomer beach-comber roamer
omer (etc.), *see* gomer vomer
 OAM

OMET, OMIT
comet vomit domet grommet

OMIC
comic astronomic stereotomic monatomic
agronomic anatomic economic triatomic
entomic diatomic autonomic vomic
nomic isonomic dystomic

OMING (*long*)
roaming (etc.), *see* OAM

OMING (*short*), UMMING

coming	benumbing	becoming	forthcoming
humming		(etc.), *see* UM	unbecoming

OMISH, OAMISH

loamish	Romish

OMIT, *see* OMET

OMON, *see* OMAN

OMPASS, UMPUS

compass	rumpus	encompass	"stump us" (etc.)

OMPTER

compter	prompter	accompter	"prompt her" (etc.)

ONANT, *see* ONENT

ONDANT, *see* ONDENT

ONDAY, *see* UNDAY

ONDANT, ONDENT

fondant	despondent	co-respondent	frondent
respondent	correspondent		

ONDEL, *see* ONDLE

ONDER

bonder	corresponder	yonder	responder
fonder	squander	absconder	hypochonder
ponder	wander	desponder	condor

ONDLE, ONDEL

fondle	rondel

ONDLESS
bondless (etc.), *see* OND

ONDLING

bondling	fondling	rondeling

ONELESS
boneless (etc.), *see* OAN

Onely, Only

lonely	only

Onent, Onant

conant	deponent	opponent	proponent
component	exponent	sonant	

Oner, *see* **Onner** *and* **Onor**

Onest

honest	dishonest	donnest	wannest (etc.),
connest	non est		*see* **On**

Oney (*long*), *see* **Ony**

Oney (*short*), *see* **Unny**

Onger

conger	longer	*prolonger*	*wronger*
stronger			

Ongeous, Ungeous

lungeous	spongeous

Onging (*hard*)

wronging (etc.), *see* **Ong**	longing

Onging (*soft*), *see* **Unging**

Ongless

prongless (etc.), *see* **Ong**

Ongueless

tongueless (etc.), *see* **Ung**

Ongly

longly	strongly	wrongly

Ongy (*soft*)

lungy	plungy	spongy

Onic

chronic	harmonic	symphonic	canonic
conic	ionic	Teutonic	crotonic
tonic	laconic	diatonic	draconic
euphonic	mnemonic	histrionic	ironic
telephonic	architectonic	acronyc	masonic
agonic	antiphonic	atonic	monophonic

ONIC—(*Cont.*)

parsonic	isotonic	colophonic	paratonic
sermonic	metonic	diaphonic	pulmonic
carbonic	neurotonic	hedonic	tectonic
cyclonic	platonic	jargonic	theogonic
geogonic	stratonic	monochronic	Housatonic

ONION, UNNION

onion	ronion	trunnion	munnion
brunion	bunion		

ONNISH, ONISH

donnish	admonish	astonish	wannish
premonish	tonnish		

ONKY, ONKEY

conky	donkey

ONKEY, UNKEY, UNKY

flunkey	monkey	spunky	funky
trunky	chunky		

ONKISH, UNKISH

drunkish	monkish	skunkish

ONLY, *see* ONELY

ONNER, ONER, ONOR

goner	wanner	dishonor	conner
honor	aleconner		

ONNET

bonnet	unbonnet	sonnet	"con it" (etc.)

ONOR, ONER, OWNER

donor	owner	atoner (etc.), *see* OAN	"known her" (etc.)

ONOR, *see* ONNER

ONSAL, ONSIL, ONSUL

consul	enconsal	proconsul	responsal
tonsil			

ONTEST

contest	wantest

ONTRACT

contract	entr'acte

Ony, Oney, Oni

bony	crony	parsimony	antimony
coney	pony	sanctimony	lazzaroni
macaroni	alimony	stony	patrimony
astony	drony	tony	testimony
matrimony	gony	phony	"aloney"

Ooby, Uby

booby	looby	ruby

Oodle, Eudal

boodle	feudal	noodle	udal
flapdoodle	paludal		

Oodless
foodless (etc.), *see* Ood *and* Ud

Oody (*short*)

goody	woody	"could he" (etc.)

Oody (*long*)
moody (etc.), *see* Ood

Oofless
roofless (etc.), *see* Oof

Ookish (*long*)

flukish	spookish

Ookish (*short*)

bookish	rookish, "cookish" (etc.)

Ookless
cookless (etc.), *see* Ook

Ooky (*short*)

booky	cooky	hookey	hooky
rooky			

Ooky (*long*)

fluky	spooky	"Aunt Suky"

Ooler
cooler (etc.), *see* Ool

Oolish, Ulish

coolish	foolish	mulish	schoolish

Oolless
school-less (etc.), *see* Ool

Oolly, *see* **Uly**

Oomer, *see* **Umer**

Oomless
roomless (etc.), *see* **Oom**

Oomy, *see also* **Umy**

bloomy	gloomy	plumy	rheumy
broomy	roomy		

Ooner; *see also* **Unar** *for allowable rhymes*

schooner	spooner	sooner (etc.),
		see **Oon**

Oonful; *see* **Uneful** *for imperfect rhymes*
spoonful "moon full"

Oony, Uny, Uisne

loony	puisne	spoony	tuny
moony	*puny*		

Ooper, Uper, Opor

cooper	super	stupor	trooper (etc.),
hooper			*see* **Oop**

Oorer, *see* **Urer**

Oorly, *see* **Urely** *for imperfect rhymes*
poorly (etc.), *see* **Oor**

Ooseless
gooseless (etc.), *see* **Oose**

Oosely, *see* **Usely** *for imperfect rhymes*
loosely (etc.), *see* **Oose**

Ooser *(flat),* **Uiser, Oozer,** *see also* **User** *for imperfect rhymes*

boozer	chooser	cruiser	loser (etc.),
bruiser			*see* **Oose**

Ooter; *see also* **Uter** *for imperfect rhymes*

mooter	freebooter	"shoot her"
	(etc.), *see* **Oot**	(etc.)

Ooting
shooting (etc.), *see* **Oot**

Ootle; *see also* **Utal** *for possible rhymes*

brutal	footle	tootle	"boot'll" (etc.)

OOTLESS
bootless fruitless (etc.), *see* OOT

OOTLING
footling rootling

OOTY, OOTI; *see also* UTY
booty fruity rooty fluty
dhooti

OOVELESS
grooveless (etc.), *see* OOVE

OOZER, *see* OOSER

OOZLE, OUSEL; *see also* USAL *for imperfect rhymes*
foozle ousel bamboozle perusal

OOZLER
foozler bamboozler

OOZY
boozy oozy *musy* "shoosy"
bruisy snoozy woosy "twosy"

OPAL
copal opal nopal

OPELESS
hopeless (etc.), *see* OAP

OPER (*long*)
sloper toper groper interloper
eloper (etc.), *see*
 OAP

OPER (*short*), *see* OPPER

OPHE, *see* OAFY

OPIC
topic microscopic hydropic canopic
tropic spectroscopic telescopic (etc.) myopic (etc.)
acopic

OPING
coping soaping (etc.), *see* OAP

OPLAR, OPPLER
poplar toppler

OPLESS
topless, (etc.), *see* OP

OPLING, OPPLING
fopling toppling

OPPER, OPER

copper	proper	improper,	whopper
cropper	stopper	chopper	grasshopper
hopper		(etc.), *see* OP	eavesdropper

OPPING
chopping topping whopping (etc.), *see* OP

OPPY, OPY

choppy	droppie	poppy	floppy
copy	moppy	shoppy	hoppy
sloppy	soppy	croppy	loppy

OPSY

dropsy	copsy	autopsy	dysopsy
Topsy			

OPTER
propter adopter helicopter phenicopter

OPTIC
coptic optic synoptic autoptic

OPTION
option adoption

OPY (*long*), OAPY
mopy ropy soapy slopy

OPY (*short*), *see* OPPY

ORAGE, ORRIDGE, *see also* OURAGE

borage	shorage	*porridge*	storage
gorage			

ORAL (*long*)

choral	horal	sororal	auroral
floral	oral	thoral	trifloral
chloral			

ORAL (*short*), ORRAL, ORREL, AUREL

coral	moral	sorrel	immoral
laurel	quarrel		

ORAN, ORON

koran	moron	oxymoron	"pour on" (etc.)

ORAX

borax	storax	corax	thorax
"show-racks"			

ORBEL

corbel	warble

ORCELESS
forceless (etc.), *see* ORCE

ORCHARD

orchard	tortured

ORCHER

scorcher	torture

ORDER

border	forder	disorder	rewarder (etc.),
order	warder	recorder	*see* ORD

ORDIAL

cordial	primordial

ORDING

lording	according (etc.), *see* ORD

ORDLESS
fordless (etc.), *see* OARD

ORDON

cordon	warden

ORDSHIP

lordship	wardship

ORDURE, *see* ORGER

ORDY, *see* URDY

OREAL, *see* ORIAL

OREIGN, *see* ORIN

ORELESS
doorless (etc.), *see* OAR

ORER
borer (etc.), *see* **OAR**

OREST, ORREST
forest borest floorest ignorest (etc.),
 see **OAR**

ORGAN
organ gorgon Morgan

ORGER
forger gorger ordure disgorger

ORGES
forges gorges disgorges

ORGON, *see* **ORGAN**

ORIC
doric historic perchloric chloric
metaphoric paregoric allegoric roric
choric

ORID, ORRID
florid horrid gloried storied
torrid

ORIN
florin foreign warren

ORIST, OREST
borest florist sorest (etc.), *see* **OAR**

ORKLESS
workless (etc.), *see* **ERK** *and* **ORK**

ORKY
porky (etc.), *see* **ORK**

ORMANT
dormant informant

ORMER
dormer warmer performer reformer (etc.),
former informer *see* **ORM**

ORMING
forming house-warming (etc.), *see* **ORM**

ORMLESS
formless (etc.), *see* ORM

ORMLY
warmly uniformly

ORMOUS
enormous informous "warm us" (etc.)

ORNER
horner warner suborner (etc.), *see* ORN

ORNET
cornet hornet

ORNEY, *see* OURNEY

ORNFUL
hornful mournful scornful

ORNICED, ORNEST
corniced warnest (etc.),
 see ORN

ORNING
morning mourning scorning warning (etc.),
 see ORN

ORNLESS
hornless (etc.), *see* ORN

ORNY
corny horny thorny

OROUGH
borough thorough burrow *burro*

OROUS, *see* ORUS

ORPHAN, *see* OFTEN

ORPOISE, *see* ORPUS

ORPOR
torpor warper

ORPUS
corpus porpoise

ORRAL, ORREL, *see* ORAL (*short*)

ORRENT

torrent	warrant	abhorrent

ORRER, *see* **ORROR**

ORRIDGE, *see* **ORAGE**

ORROR

| horror | adorer | ignorer (etc.), | "bore her" |
| abhorrer | | *see* **OAR** | (etc.) |

ORROW

borrow	morrow	sorrow

ORRY

quarry	sorry

ORRY (*as in* worry), *see* **URRY**

ORSAL, ORSEL

dorsal	foresail	morsel	torsel

ORSELESS
horseless (etc.), *see* **ORSE**

ORSION, *see* **ORTION**

ORSTED, IRSTED

thirsted	worsted	"bursted"

ORTAL, *see* **ORTLE**

ORTAR, ORTER

| mortar | reporter | supporter | extorter (etc.), |
| quarter | | | *see* **ORT** |

ORTEN

quartan	shorten

ORTHLESS
worthless (etc.), *see* **EARTH**

ORTIE, *see* **ORTY**

ORTION

portion	apporion	distortion	retortion
torsion	consortion	extortion	disproportion
abortion	contortion	proportion	

ORTLE

chortle	mortal	portal	immortal

ORTLY, OURTLY

courtly	portly

ORTIVE

sportive	tortive	transportive	abortive

ORTMENT

assortment	disportment	deportment	transportment
comportment			

ORTRESS

fortress	porteress

ORTUNE

fortune	importune	misfortune

ORTURE, *see* **ORCHER**

ORTURED, *see* **ORCHARD**

ORTY

forty	snorty	sortie	warty
rorty			

ORUM

forum	quorum	variorum	"bore 'em"
jorum	indecorum		(etc.)

ORUS, OROUS

chorus	sonorous	pylorus	"before us"
porous	canorous	torous	(etc.)
decorous	imporous	torus	ictheosaurus

ORY, *see* **OARY**

OSEL, *see* **OZZLE**

OSELESS

roseless (etc.), *see* OSE

OSELY, OSSLY

closely	jocosely	morosely	verbosely
grossly			

OSEN, *see* **OZEN**

OSER

poser (etc.), *see* OSE

OSET, OSIT

closet	interposit	posit	reposit
deposit	juxtaposit		

OSHER

josher washer (etc.), *see* OSH

OSHY

boshy	toshy	sloshy	swashy
squashy	washy		

OSIER, *see* OSURE

OSION

corrosion	erosion	ambrosion	explosion
implosion			

OSIT, *see* OSET

OSIVE

corrosive	explosive	erosive

OSLING

gosling	*jostling*	nozzling

OSSACKS

Cossacks	trossachs

OSSAGE

bossage	sausage

OSSING

bossing (etc.), *see* OSS

OSSLESS

bossless (etc.), *see* OSS

OSSLY, *see* OSELY

OSSOM

blossom	opossum	possum	odontoglossum

OSSY

bossy	flossy	lossy	posse
drossy	glossy	mossy	tossy

OSTAL (*long*), **OASTAL**

coastal	postal

OSTAL (*short*), OSTEL, OSTIL

costal	postil	infracostal	Pentecostal
hostel	accostal	intercostal	

OSTER (*long*), *see* OASTER

OSTER (*short*)

coster	accoster	imposter	Pentecoster
foster	paternoster	kloster	roster

OSTESS

ghostess	hostess

OSTIC, AUSTIC

caustic	diagnostic	geognostic	paracrostic
acrostic	prognostic	gnostic	pentacostic
agnostic	ateostic		

OSTLE, OSSIL, ASSAIL

dossil	throstle	colossal	hypoglossal
fossil	wassail	dosel	tossel
jostle	apostle		

OSTLER

hostler	jostler	ostler	wassailer

OSTLESS

costless (etc.), *see* OST

OSTLY

ghostly	mostly

OSTREL, OSTRIL

costrel	nostril	lamellirostral	rostral

OSTRUM

nostrum	rostrum

OSURE, OSIER

cosier	osier	enclosure	disposure
closure	rosier	exposure	foreclosure
crosier	composure	discomposure	reposure
hosier	disclosure		

OSY, OZY

dozy	posy	rosy	cosy
nosy	prosy		

OTAL

dotal	sacerdotal	notal	sclerotal
total	anecdotal	rotal	teetotal
antidotal	extradotal		

OTAN

oaten	Wotan	"verboten"

OTARD, OTORED

dotard	motored

OTCHER

botcher	blotcher	notcher	splotcher
watcher			

OTCHET, OCHET

crochet	rochet

OTCHLESS

scotchless (etc.), *see* OTCH

OTCHY

blotchy	botchy	notchy	**splotchy**

OTELESS

boatless (etc.), *see* OAT

OTEM, *see* OTUM

OTER, OTOR

bloater	quoter	voter (etc.),	locomotor
motor		*see* OAT	

OTEST, OTICED, OTIST

noticed	protest	votest	wrotest (etc.),
			see OAT

OTHER

bother	pother	fother	*father*

OTHER (*as in* other)

brother	other	another	t'other
mother	smother		

OTHING (*long*)

clothing	loathing	betrothing

OTHIE, OTHY

bothie	frothy	mothy

Othless, *see* **Oath**

Otic

chaotic	*anecdotic*	demotic	pyrotic
despotic	carotic	erotic	quixotic
exotic	culottic	glottic	sarcotic
hypnotic	neurotic	idiotic	zoötic
acrotic	osmotic	narcotic	zymotic
anaptotic	patriotic		

Oticed, *see* **Otest**

Otion

lotion	potion	groschen	locomotion
motion	devotion	emotion	nicotian
notion	commotion	promotion	remotion
ocean			

Otive

emotive	votive	promotive	locomotive

Otless
cotless (etc.), *see* **Ot**

Otley, Otly

hotly	motley	squatly

Otor, *see* **Oter**

Ottage

cottage	pottage

Ottar, *see* **Otter**

Ottel, *see* **Ottle**

Otten, Otton

cotton	rotten	forgotten	misbegotten
gotten	begotten		

Otter

clotter	rotter	blotter	jotter
ottar	totter	cotter	knotter
otter	trotter	dotter	spotter
plotter	bog-trotter	garotter	squatter (etc.),
potter	complotter	hotter	*see* **Ot**

Ottier

clottier	cottier	knottier	spottier

Ottische, Ottish
Scottish schottische sottish

Ottle, Ottel

bottle	throttle	glottal	tottle
dottel	wattle	mottle	twattle
pottle			

Ottling
bottling (etc.), *see* **Ottle**

Otto

grotto	motto	Otto	ridotto
lotto	fagotto	risotto	

Otton, *see* Otten

Otty

blotty	knotty	snotty	totty
clotty	potty	spotty	hotty-motty

Otum, Otem
quotum totem factotum

Ouble, Ubble

bubble	grubble	rubble	trouble
double	knubble	stubble	

Oubler
doubler (etc.), *see* **Ouble**

Oubtless, Outless
doubtless (etc.), *see* **Out**

Ouchless
couchless (etc.), *see* **Ouch**

Ouder, *see* Owder

Oudless
cloudless (etc.), *see* **Oud**

Oudly
loudly proudly

Oudy, *see* Owdy

Oughboy, Owboy
cowboy ploughboy "now, boy" (etc.)

OUGHEN

roughen toughen

OUGHLESS, *see* **OFF, UFF, OW, OCK**

OUGHLY, *see* **UFFLY**

OUGHTEN

foughten wroughten "boughten"

OUGHTY, *see* **AUGHTY** *and* **OUTY**

OULDER, OLDER

bolder moulder smoulder older (etc.),
boulder shoulder *see* **OLD**

OULDERING

shouldering mouldring soldering "gold ring"
smouldering

OULING

fouling (etc.), *see* **OUL**

OULTICED, *see* **OLTEST**

OUNCELESS

bounceless (etc.), *see* **OUNCE**

OUNCIL, *see* **OUNSEL**

OUNDER

bounder founder pounder sounder (etc.),
flounder iron-founder rounder *see* **OUND**

OUNDING

bounding (etc.), *see* **OUND**

OUNDLESS

groundless (etc.), *see* **OUND**

OUNDLING

foundling groundling

OUNDLY

roundly unsoundly profoundly

OUNDNESS

roundness (etc.), *see* **OUND**

OUNDARY, OUNDRY

boundary floundery foundry

Oundsel, *see* **Ounsel**

Oungling, *see* **Ungling**

Ounsel
council counsel groundsel

Ountain
fountain mountain catamountain "accountin'"

Ountant
mountant accountant

Ounter
accounter encounter rencounter surmounter
mounter (etc.), *see*
 Ount

Ountless
countless (etc.), *see* **Ount**

Ountries, *see* **Untress**

Ounty
bounty county mounty viscounty

Ourage, Urrage; *see also* **Orage**
borage demurrage discourage encourage
courage

Ouri, *see* **Owry**

Ourish, Urrish
currish flourish nourish

Ourless
hourless (etc.), *see* **Our, Oor, Oar**

Ourly
hourly sourly

Ourney, Erny, Orney, Urney
ferny spurney attorney "churny"
journey tourney "burny" (etc.)

Ourser
courser coarser hoarser (etc.), *see* **Oarse**

Ourseless
courseless (etc.), *see* **Orce**

OURTEOUS, *see* URCHASE

OURTLY, *see* ORTLY

OUSAL, OUSEL

housel	towzle	espousal	ousel
nousel	carousal	crousal	spousal

OUSEL, *see* OOZLE *and* OUSAL

OUSELESS
houseless (etc.), *see* OUSE

OUSER

mouser	rouser	trouser	carouser (etc.),
Towser	"arouse her" (etc.)		*see* OUSE

OUSERS, *see* OUSER

OUSIN, *see* OZEN

OUSING
rousing (etc.), *see* OUSE

OUSY

lousy	drowsy	"sousey"	"carrousy"
mousy	blowsy		

OUTLESS
boutless (etc.), *see* OUT

OUTLY

stoutly	devoutly

OUTRE, UITOR, OOTER (etc.)

suitor	accoutre	shooter (etc.), *see* OOT

OUTY, OUGHTY

droughty	doughty	grouty	snouty
gouty			

OVAL

disapproval	reproval	approval	removal
disproval			

OVEL

grovel	hovel	novel

OVELESS
doveless (etc.), *see* OVE

OVEMENT

movement	approvement	improvement

OVEN (*long*)

cloven	hoven	woven	interwoven
proven			

OVEN (*short*), **OVIN**

covin	oven	sloven	"shovin'" (etc.)

OVING

roving (etc.), *see* **OVE**

OVER (*long*)

clover	over	stover	moreover
drover	rover	trover	half-seas-over

OVER (*short*)

cover	plover	discover	uncover
glover	shover	recover	table-cover
lover			

OVETAIL

dovetail	love-tale

OWARD

coward	flowered (etc.), *see* **OUR**

OWARD (*long O*), *see* **OARD**

OWBOY, *see* **OUGHBOY**

OWDER, OUDER

crowder	powder	chowder	prouder (etc.), *see* **OUD**

OWDY, OUDY

cloudy	dowdy	rowdy	shroudy
crowdy	proudy		

OWEL

bowel	towel	vowel	semi-vowel
dowel	trowel	disembowel	avowal
rowel			

OWER (*long*)

sower	lower	mower, etc., *see* **OW**

Owered
lowered etc.,
see **Ower**

forward

untoward

toward

Owing
flowing

knowing

cock-crowing (etc.), *see* **O**

Owledge, Ollege
college

knowledge

acknowledge

foreknowledge

Owler
bowler (etc.), *see* **Olar** *and* **Oul**

Owless
rowless (etc.), *see* **O** *and* **Ow**

Owling
bowling (etc.), *see* **Oal** *and* **Oul**

Owlless
goalless (etc.), *see* **Oul** *and* **Oal**

Owly, *see* **Oaly**

Owner, *see* **Onor**

Ownish
brownish

clownish

townish

downish

Ower, *see* **Oer**

Ownless
townless (etc.), *see* **Own**

Ownsman
gownsman

townsman

Owny
brownie
browny

downy

towny

frowny

Owry, Ouri, Owery, Oury
bowery
dowry
floury

flowery
houri
showery

towery
avowry

cowry
lowery

Owsy, *see* **Owzy**

Owy (ō)
blowy	showy	snowy	towy
doughy	glowy		

Owy (ŏ)
sloughy	"zowie"	"now he" (etc.)

Owzy, Owsy
blowzy	bowzy	frowzy	mousy
drowsy			

Oxen, Oxswain
coxswain	oxen

Oxy, Ocksy
cocksy	proxy	heterodoxy	foxy
doxy	orthodoxy	cacodoxy	paradoxy

Oyal
loyal	pennyroyal	disloyal	sur-royal
royal			

Oyalty
loyalty	royalty

Oyer
annoyer	destroyer	employer

Oyless
toilless (etc.), *see* OIL *and* OY

Oyly, Oily
coyly	doily	oily	roily

Oyment
cloyment	enjoyment	chatoyment	deployment
employment	unemployment		

Ozen, Osen (*long*)
boatswain	frozen	hosen	rosen
chosen	squozen		

Ozen (*short*), Ousin
cousin	cozen	dozen

Ozzle, Osel
losel	nozzle	sozzle

UAGE, EWAGE

| sewage | escuage | brewage |

UAL, EWAL

| dual | pursual | renewal | subdual |
| eschewal | reviewal |

UANT, UENT

| fluent | truant | pursuant |

UBBARD, UPBOARD

| cupboard | lubbard | blubbered | rubbered |

UBBER

blubber	slubber	grubber (etc.),	"dub her"
lubber	landlubber	see UB	(etc.)
rubber	indiarubber		

UBBISH

| clubbish | grubbish | rubbish | tubbish |
| cubbish |

UBBLE, see OUBLE

UBBLY

| bubbly | knubbly | rubbly | stubbly |
| doubly |

UBBY

| chubby | scrubby | fubby | tubby |
| grubby | shrubby | stubby | cubby |
| hubby |

UBELESS

tubeless (etc.), see UBE

UBLESS

cubless (etc.), see UB

UBTLE, see UTTLE

UBY, see OOBY

UCCOUR, see UCKER

UCENT, USANT

lucent	adducent	interlucent	redusent
recusant	conducent	abducent	traducent
relucent	tralucent	producent	unlucent
translucent			

UCER
looser (etc.), *see* OOSE (*hard*)

UCIAL
crucial fiducial

UCIVE, USIVE

abusive	delusive	inclusive	confusive
allusive	diffusive	infusive	perfusive
collusive	effusive	intrusive	reclusive
conclusive	elusive	obtrusive	seclusive
conducive	exclusive	inconclusive	seducive
deducive	illusive		

UCKER, UCCOR

mucker	succor	sucker	tucker (etc.),
pucker			*see* UCK

UCKING
ducking (etc.), *see* UCK

UCKLE

buckle	knuckle	suckle	honeysuckle
chuckle	muckle	truckle	"luck 'll"
huckle	stuckle	unbuckle	(etc.)

UCKLER

buckler	swashbuckler	knuckler	swingebuckler
chuckler			(etc.), *see* UCKLE

UCKLESS
luckless (etc.), *see* UCK

UCKLING
buckling duckling suckling (etc.), *see* UCKLE

UCKOLD
cuckold suckled (etc.), *see* UCKLE

UCKY

ducky	mucky	plucky	unlucky
lucky			

UCRE, EUCHRE, UKER

euchre	fluker	lucre	rebuker (etc.), *see* UKE

UCTER, *see* UCTOR

UCTION
fluxion	destruction	seduction	conduction
ruction	effluxion	introduction	diduction
suction	induction	misconstruction	duction
abduction	instruction	reproduction	influxion
affluxion	obstruction	superstruction	manuduction
construction	production	superinduction	obduction
deduction	reduction	adduction	traduction
defluxion			

UCTIVE
constructive	instructive	obstructive	introductive
deductive	adductive	productive	reproductive
destructive	conductive	reductive	superstructive
inductive	traductive	seductive	superinductive

UCTOR
abductor	destructor	adductor	eductor
conductor	instructor	ductor	monuductor
constructor	obstructer		

UDDER, OODER
dudder	scudder	rudder	udder
pudder	flooder	shudder	

UDDING (*For rhymes to* budding *see* UD)
hooding	pudding

UDDLE
cruddle	huddle	ruddle	nuddle
cuddle	muddle	buddle	scuddle
uddle	puddle		

UDDLY
cuddley (etc.), *see* UDDLE

UDDY, UDY
bloody	cuddy	ruddy	study
cruddy	muddy	studdy	puddy

UDELESS
foodless (etc.), *see* OOD

UDELY. *see* EWDLY

UDENESS
rudeness (etc.), *see* OOD

UDENT

prudent	imprudent	concludent	occludent
student			

UDER
ruder (etc.), *see* OOD

UDGELESS
smudgeless (etc.), *see* UDGE

UDGELING

cudgelling	drudgeling	judgeling

UDGEON

bludgeon	dudgeon	grudgeon	curmudgeon

UDISH

crudish	"new dish"	nudish	rudish
lewdish	(etc.)	prudish	shrewdish

UDLESS
mudless (etc.), *see* UD

UEL

crewel	duel	newel	jewel
cruel	fuel	gruel	tewel

UELESS
crewless (etc.), *see* EW

UELY, *see* ULY

UENT, *see* UANT

UET

cruet	*pewit*	suet	"knew it"
			(etc.)

UEY, EWY

bluey	dewy	fluey	viewy
cooee	gluey	*roué*	thewy
buoy			

UFFER, OUGHER

buffer	huffer	tougher (etc.),	snuffer
duffer	puffer	*see* UFF	suffer

Uffin

muffin	ragamuffin	"snuffin'"	"enough in"
puffin		(etc.)	(etc.)

Uffing

puffing stuffing (etc.), *see* Uff

Uffle

buffle	ruffle	unmuffle	snuffle
muffle	scuffle	shuffle	duffel
truffle			

Uffly

bluffly	roughly	shuffly	toughly
gruffly	ruffly	snuffly	truffly
muffly	scuffly		

Uffy

buffy	puffy	sloughy	fluffy
huffy	snuffy	stuffy	pluffy
bluffy	chuffy		

Ufti, Ufty

mufti tufty

Ugal, *see* Ugle

Ugely

hugely scroogely

Ugger

lugger	hugger (etc.),	rugger	hugger-mugger
drugger	*see* Ug		

Uggest, Uggist

druggist	snuggest (etc.),
	see Ug

Uggle

guggle	juggle	struggle	snuggle
smuggle			

Uggler

smuggler (etc.), *see* Uggle

Uggly, *see* Ugly

Uggy

buggy	muggy	puggy	sluggy

UGLE, UGAL

bugle	frugal	fugal	fugle

UGLY, UGGLY

guggly	smuggly	struggly	snugly
juggly	smugly	snuggly	ugly

UICELESS, *see* **OOSE** (*hard*)

UICY

juicy	sluicy

UISANCE, USANCE

nuisance	usance

UISER, *see* **OOSER**

UITING

suiting (etc.), *see* **OOT**

UITER, *see* **OOTER**

UITLESS

fruitless, bootless (etc.), *see* **OOT**

UITY, *see* **OOTY**

UKER, *see* **UCRE**

ULELESS

ruleless (etc.), *see* **OOL**

ULER

ruler (etc.), *see* **OOL**

ULGAR

Bulgar	fulgor	vulgar

ULGENCE

effulgence	self-indulgence	refulgence	indulgence

ULGENT

fulgent	indulgent	refulgent	preofulgent
effulgent	circumfulgent	interfulgent	self-indulgent

ULGOUR, *see* **ULGAR**

ULKY

bulky	sulky	hulky

ULLAR, ULLER, OLOR

culler	duller	luller	guller
color	sculler	discolor	tricolor
cruller	annuller	medullar	

ULLET (*as in* bullet)

bullet	pullet

ULLET (*as in* gullet)

gullet	mullet	cullet

ULLEY, ULLY

bully	pulley	*beautifully*	*dutifully* (etc.),
fully	woolly		*see* ULL

ULLION

mullion	scullion	cullion	bullion

ULLY (*as in* bully), *see* ULLEY

ULLY (*as in* sully)

cully	gully	hully	sully
dully	beautifully, *and words in* ULL *for possible rhymes*		

ULSION

compulsion	emulsion	evulsion	appulsion
convulsion	expulsion	impulsion	divulsion
repulsion	revulsion	propulsion	pulsion
avulsion	demulsion		

ULSIVE

compulsive	emulsive	impulsive	divulsive
convulsive	expulsive	propulsive	revulsive
repulsive	appulsive		

ULTED

consulted (etc.), *see* ULT

ULTLESS

cultless (etc.), *see* ULT

ULTRY

sultry	adultery

ULTURE

culture	sepulture	horticulture	pisciculture
vulture	agriculture	aviculture	(etc.)

ULVER
culver pulver

ULY; *see also* OOLY
duly newly (etc.), unduly guly
 see EW

UMAGE
fumage plumage *roomage*

UMAN, UMON, *see* OMAN

UMBAR, UMBER
lumbar slumber encumber disencumber
lumber umber outnumber cumber
number cucumber

UMBENT
accumbent incumbent recumbent superincumbent
decumbent procumbent

UMBLE
bumble fumble scumble rumble
crumble grumble jumble bejumble
drumble humble mumble umbel
stumble tumble

UMBLER
tumbler (etc.), *see* UMBLE

UMBLY (B *sounded*), *see* UMBLE

UMBLY (B *silent*), *see* UMLY

UMBO
gumbo mumbo-jumbo

UMBRATE
adumbrate inumbrate obumbrate

UMBROUS
cumbrous penumbrous slumbrous unslumbrous

UMELESS
fumeless (etc.), *see* OOM

UMEN, *see* UMINE

UMER; *see also* OOMER *for imperfect rhymes*
humor tumor perfumer (etc.), *see* UME

Umid

fumid	humid	tumid	spumid

Umine, Umen

acumen	illumine	relumine	"assumin' "
bitumen	legumen	catechumen	(etc.)

Uming

fuming (etc.), *see* Ume

Umly, Omely

comely	numbly	humoursomely	troublesomely
dumbly	cumbersomely	mettlesomely	wearisomely
grumly	frolicsomely	quarrelsomely	

Ummer, Omer, Umber

comer	summer	scummer	newcomer
drummer	mummer	plumber	hummer (etc.),
dumber	mid-summer	grummer	*see* Um

Ummet, Ummit

plummet	summit	grummet

Umming, *see* Oming

Ummit, *see* Ummet

Ummock

hummock	stomach

Ummon

summon	"rum 'un"

Ummy

crummy	scrummy	plummy	rummy
dummy	gummy	scummy	tummy
crumby	lummy	mummy	thrummy

Umor, *see* Umer

Umous

fumous	humus	dumous	strumous
grumous	plumous	spumous	humous

Umnal

autumnal	columnal

UMPASS
compass	encompass	rumpus	"thump us" (etc.)

UMPER
bumper	mumper	thumper (etc.), *see* **U**MP

UMPET
crumpet	strumpet	trumpet	"thump it" (etc.)

UMPISH
dumpish	lumpish	plumpish	mumpish
frumpish	grumpish		

UMPKIN
bumpkin	*pumpkin*	lumpkin

UMPLE
crumple	rumple

UMPLING
crumpling	dumpling	pumpling	rumpling

UMPTION
gumption	assumption	presumption	subsumption
sumption	consumption	resumption	

UMPTIVE
assumptive	presumptive	resumptive	subsumptive
consumptive			

UMPUS, *see* **O**MPASS

UMPY
dumpy (etc.), *see* **U**MP

UMY; *see also* **O**OMY
fumy	spumy	"knew me" (etc.)

UNAR; *see also* **O**ONER *for imperfect rhymes. Note on p.* 114
lunar	nonilunar	oppugner	communer
importuner	attuner	tuner	lacunar
impugner	interlunar	jejuner	plenilunar

UNBURNT
sunburnt	unburnt	"Hun burnt"

UNCHEON, UNCHION

luncheon	truncheon	puncheon	scuncheon
nunchion			

UNCLE

crunkle	uncle	carbuncle

UNCTION

function	compunction	punction	injunction
junction	conjunction	disjunction	inunction
unction	defunction	expunction	sejunction
adjunction	interjunction		

UNCTIVE

adjunctive	conjunctive	subjunctive	adjunctive
compunctive	disjunctive		

UNCTURE

juncture	puncture	conjuncture	ocupuncture

UNDANCE

superabundance	redundance	"sun dance" (etc.)

UNDANT

abundant	redundant	superabundant

UNDATE

fecundate	inundate	secundate

UNDAY, ONDAY

Monday	Fundy	Sunday	"one day"

UNDER, ONDER

blunder	thunder	asunder	dissunder
plunder	under	fecunder	"stunned her"
sunder	wonder	jocunder	(etc.)
refunder	rotunder	therunder	

UNDIT

pundit	conduit	"shunned it" (etc.)

UNDLE

bundle	rundle	trundle

UNDRY

sundry	thundry

UNEFUL, see **OONFUL** *for imperfect rhymes. Note, p.* **114**
tuneful

UNELESS
tuneless (etc.); *see* UNE; *also* OON *for imperfect rhymes*

UNELY

tunely	jejunely	importunely	opportunely

UNER; *see also* OONER

tuner	propugner (etc.), *see* UNE	"impugn her"
impugner		(etc.)

UNGEON

dungeon	plungeon

UNGER (*soft* G)

lunger	blunger	spunger	expunger
plunger			

UNGER (*hard* G)

hunger	monger	ironmonger	younger (etc.),
enhunger			*see* UNG

UNGEST
youngest (etc.), *see* UNG

UNGLE

bungle	jungle

UNKARD—ERD

drunkard	dunkard	bunkered

UNKER

bunker	flunker	funker	"sunk her"
junker	"punker"	plunker	(etc.)
drunker			

UNKY

chunkey	funky	powder-monkey	"nunky"
flunkey	monkey	spunky	

UNNAGE

dunnage	gunnage	tonnage	"one age" (etc.)

UNNEL

funnel	runnel	tunnel	"one'll" (etc.)
gunwale	trunnel		

UNNING

cunning	dunning (etc.), *see* UN

Unny

bunny	honey	sonny	tunny
funny	money	sunny	unsunny
gunny			

Unster

gunster	punster

Untal

contrapuntal	frontal	gruntle	disgruntle

Unted

shunted (etc.), *see* Ont

Unter

hunter	bunter (etc.), *see* Unt and Ont

Unting

bunting	fronting (etc.), *see* Unt

Upper

cupper	tupper	scupper	crupper
upper	supper		

Uppet

puppet	"up it"	"sup it"

Uppish

puppish	uppish

Upple

couple	supple

Uple

octuple	septuple	subduple	quadruple
quintuple	sextuple	pupil	scruple

Upter

corrupter (etc.), *see* Upt

Upting

erupting (etc.), *see* Upt

Ura

amphidura	Cæsura	legatura	seisura
Angostura	datura	pietra-dura	velatura
appoggiatura	fissura	pleura	vettura
bravura	flexura	"cuta-cura"	

Ural

antemural	interneural	pleural	tellural
Cæsural	intramural	sinecural	crural
commissural	jural	"cure-all"	plural
extramural	mural	sural	rural
intermural	neural		

Urance

allurance	endurance	assurance	reassurance
durance	perdurance	insurance	

Urate

curate	jurat	"endure it" (etc.)

Urban

suburban	urban	turban

Urely; *see* Oorly *for imperfect rhymes. See Note, p.* 114

demurely	obscurely	purely	securely
maturely			

Urchase

purchase	*searches* (etc.)

Urement

abjurement	conjurement	obscurement	procurement
allurement	immurement		

Ureness; *see also* Oor *for imperfect rhymes*
demureness (etc.), *see* Ure

Urer

juror	nonjuror	furor	abjurer (etc.), *see* Ure

Urder

absurder	herder	self-murder	"heard her" (etc.)
engirder	murder	"thirder"	
girder			

Urest

jurist	purist	*tourist, see* Oor *for imperfect rhymes*	adjurest (etc.), *see* Ure

Ureth
abjureth (etc.), *see* Ure

URGENT
abstergent assurgent convergent (etc.), *see* **E**RGE

URGEON
burgeon sturgeon surgeon

URGLE
"burgle" gurgle

URIC
hydrosulphuric purpuric sulphuric telluric
hydrotelluric

URIM
Purim urim

URIN
burin daturin neurin

URING; *see also* **O**OR *for imperfect rhymes*
abjuring (etc.), *see* **U**RE

URIST, *see* **U**REST

URLER
burler hurler "purler" whirler
curler pearler twirler skirler
furler

URLEW
curlew purlieu

URLY
burly early knurly surly
churly hurly-burly pearly whirly
curly

URROW
burrow furrow borough thorough

URSOR
amercer cursor precursor accurser (etc.)
ante-cursor mercer purser

URO
chiaroscuro maduro

Urous

anurous	dolichurus	Eurus	urus
Arcturus			

Urry

burry	furry (etc.),	flurry	scurry
curry	*see* **Ur**	hurry	worry

Ury; *see also* **Erry**

de jure	fury	jewry	jury
ewry			

Usal

refusal	perusal

Useful

juiceful	useful

Useless

juiceless	useless	excuseless (etc.), *see* **Use** *and* **Oose**

Useness

abstruseness	looseness

User

abstruser	user	excuser (etc.),	"you sir"
accuser		*see* **Use** *and*	(etc.)
		Oose	

Usal, Usil

refusal	fusil	musal	hypothenusal
perusal	bamboozle		*see also*
			Oozle

Uses; *see also* **Ooses** *for imperfect rhymes*

abuses	uses	amuses	confuses
excuses	accuses	bruises	fuses

Usest

abstrusest (etc.), *see* **Use**, **Uce** *and* **Oose**

Useth

abuseth	amuseth (etc.), *see* **Use**, **Uce**, *and* **Oose**

Usil

fusil	protrusile, *see* **Usal**

Using
abusing

using, amusing (etc.), *see* Use, Uce, *and* Oose

Usion

abusion	effusion	perfusion	transfusion
affusion	elusion	pertusion	abstrusion
allusion	exclusion	preclusion	detrusion
circumfusion	fusion	profusion	extrusion
collusion	illusion	prolusion	intrusion
conclusion	inclusion	reclusion	obtrusion
confusion	infusion	refusion	protrusion
contusion	interclusion	retrusion	retrusion
delusion	interfusion	seclusion	trusion
diffusion	*Malthusian*	self-delusion	*Carthusian*
dissillusion	occlusion	suffusion	

Usive, *see* **Ucive**

Uscan

Della-cruscan	Etruscan	molluscan	Tuscan
dusken			

Uscate

coruscate	infuscate	obfuscate

Usher

blusher	flusher	husher	rusher
brusher	gusher	plusher	usher
crusher	"rush her" (etc.)		

Ushes
blushes (etc.), *see* Ush

Usker

husker	tusker

Usket

busket	musket

Usky

dusky	husky	musky	tusky

Usoe

Crusoe	whoso	"do so"	"knew so" (etc.)

Usset

gusset	russet

Ussion

concussion	percussion	recussion	Russian
discussion	Prussian	repercussion	incussion

Ussive

concussive	percussive	repercussive	succussive
discussive			

Ussy

fussy	mussy	*hussy*

Usted

adjusted (etc.), *see* Ust

Uster

adjuster	distruster	knuckle-duster	muster
bluster	duster	lack-luster	robuster
buster	filibuster	luster	thruster
coadjuster	fluster	lustre	truster
cluster	juster		

Ustered

blustered	clustered	flustered	mustard
bustard	custard	lustered	mustered

Ustic

fustic	rustic

Ustion

adustion	combustion	fustian

Ustle

bustle	justle	mussel	rustle
hustle	muscle	opuscle	tussle

Ustler

bustler	hustler	rustler	tussler

Ustly

augustly	justly	robustly

Ustment

adjustment	entrustment	enthoustment

Ustrate

augustate	illustrate	incrustate

USTRAL

lacustral	lustral	palustral

USTROUS

blustrous	lustrous	lack-lustrous

USTRUM

flustrum	lustrum

USTY

dusty	gusty	musty	trusty
fusty	lusty	rusty	

USUM

usum (Latin)	*gruesome*	"blew some"	"use 'em"
bosom	*twosome*	(etc.)	(etc.)

USY, *see* IZZY

UTAL, *see* UTILE

UTCHES

clutches (etc.), *see* UTCH

UTATE

circumnutate	immutate	scutate

UTCHER

scutcher	toucher

UTED

unsuited	comminuted	commuted (etc.), *see* UTE *and* OOT

UTEMENT

confutement	imbrutement	recruitment

UTENESS

absoluteness (etc.), *see* UTE

UTER, EUTER

acuter (etc.), *see* UTE *and* OOT	neuter	suitor	*accoutre*
	pewter	tutor	

UTEST

acutest (etc.), *see* UTE *and* OOT

UTETH

commuteth (etc.), *see* UTE *and* OOT

UTHFUL

ruthful	truthful	untruthful	youthful
toothful			

UTHLESS

ruthless	toothless	truthless	uncouthness

UTIC, EUTIC

diazeutic	maieutic	propædeutic	therapeutic
emphyteutic	pharmaceutic	scorbutic	toreutic
hermeneutic			

UTILE, UTAL; *see also* **OOTLE**

futile	rutile	refutal	inutile
sutile			

UTING

commuting (etc.), *see* **UTE** *and* **OOT**

UTION

ablution	destitution	iminution	prosecution
absolution	devolution	insecution	prostitution
allocution	dilution	institution	redargution
attribution	diminution	interlocution	resolution
circumlocution	dissolution	involution	restitution
circumvolution	distribution	irresolution	retribution
collecution	elocution	Lilliputian	revolution
comminution	evolution	locution	solution
constitution	execution	persecution	substitution
contribution	imbution	pollution	volution
convolution			

UTIST

flutist	lutist	pharmaceutist	therapeutist
hermeneutist			

UTIVE

coadjutive	indutive	persecutive	resolutive
constitutive			

UTOR, *see* **UTER**

UTURE

future	puture	suture

UTLER

butler	guttler	subtler	sutler
cutler	scuttler		

UTTER

abutter	flutter	rebutter	stutter
bread-and-	gutter	scutter	utter
butter	mutter	shutter	wood-cutter
butter	nutter	splutter	"cut her"
clutter	pilot-cutter	sputter	(etc.)
cutter	putter	strutter	

UTTAL

abuttal	rebuttal	scuttle	subtle
cuttle	ruttle	shuttle	suttle
guttle			

UTTON

bachelor-button	button	glutton	mutton

UTTY

butty	jutty	putty	smutty
gutty	nutty	rutty	tutty

UTY; *see also* **OOTY**

duty	beauty	fluty	"cutey" (etc.), *see* **UTE**

UZZLE

bemuzzle	guzzle	nuzzle	unmuzzle
fuzzle	muzzle	puzzle	

UZZLER

guzzler	muzzler	puzzler

UZZY

fuzzy	hussy	fuzzy-wuzzy	"does he"

THREE-SYLLABLE RHYMES

ABASIS

anabasis	metabasis

ABBIER

flabbier	shabbier	"gabbier"

ABBIEST

flabbiest	shabbiest

ABBILY

flabbily	shabbily

ABBINESS
flabbiness scabbiness shabbiness slabbiness

ABBLEMENT
babblement dabblement gabblement rabblement
brabblement

ABELER
gabeler labeler

ABIAN
Arabian Fabian Sabian Sorabian

ABICAL
Arabical monosyllabical polysyllabical

ABIDNESS
rabidness tabidness

ABIFY
dissyllabify labefy syllabify tabefy

ABINET
cabinet tabinet

ABITUDE
habitude tabitude

ABLATIVE
ablative bablative

ABLENESS
sableness stableness unstableness

ABOLA
metabola parabola

ABORER
laborer taborer

ABORING
laboring belaboring neighboring

ASABLE
chasable effaceable erasible ineffaceable
retraceable traceable evasible

ABULAR
confabular pabular tabular tintinnabular

ABULATE
"confabulate" tabulate

ABULIST
fabulist vocabulist

ABULOUS
fabulous pabulous sabulous tintinnabulous

ABULUM
acetabulum pabulum tintinnabulum

ACENCY
adjacency complacency interjacency

ACERATE
emacerate lacerate macerate

ACERY
embracery tracery

ACHIAN
batrachian eustachian Noachian

ACHRONISM
anachronism metachronism

ACIATE
emaciate glaciate ingratiate "way she ate"
(etc.)

ACINATE
abbacinate assassinate deracinate exacinate
fascinate

ACINESS
laciness raciness

ACIOUSNESS
audaciousness fallaciousness ostentatious- sagaciousness
capaciousness fugaciousness ness tenaciousness
contumacious- graciousness perspicacious- ungraciousness
ness incapaciousness ness veraciousness
disputatious- inefficacious- pertinacious- vexatiousness
ness ness ness vivaciousness
edaciousness loquaciousness pugnaciousness voraciousness
efficaciousness mendaciousness rapaciousness

AND POETS' HANDBOOK

349

ACITY

audacity
bellacity
bibacity
capacity
contumacity
dicacity
edacity
feracity

fugacity
incapacity
loquacity
mendacity
minacity
mordacity
opacity

"pass it, he"
(etc.)
perspicacity
pertinacity
pervicacity
procacity
pugnacity
rapacity

sagacity
salacity
saponacity
sequacity
tenacity
veracity
vivacity
voracity

ACKERY

hackery

knick-knackery

quackery

"hijackery"

ACKETED

bracketed

jacketed

racketed

ACKETING

bracketing

jacketing

racketing

ACKISHNESS

brackishness

knackishness

ACTIBLE

compactible
attractable
contractible
detractible

distractible
extractible
infractible

intactable
intractable
refractable

retractable
tactable
tractable

ACTEDNESS

abstractedness

contractedness

distractedness

protractedness

ACTICAL

didactical

practical

ACTIONAL

factional

fractional

pactional

ACTIOUSNESS

factiousness

fractiousness

ACTIVENESS

abstractiveness
activeness
attractiveness

contractiveness
detractiveness

distractiveness
protractiveness

putrefactive-
ness
refractiveness

Actory

detractory	lactary	phylactery	satisfactory
dissatisfactory	manufactory	refractory	tractory
factory	olfactory		

Actual

actual	factual	tactual

Acturing

fracturing	manufacturing

Acular

opacular	piacular	supernacular	tentacular
oracular	spectacular	tabernacular	vernacular

Aculate

bimaculate	immaculate	jaculate	maculate
ejaculate			

Aculous

miraculous	oraculous	piaculous	vernaculous
abaculus			

Adable

shadable	evadible	wadeable	tradeable
persuadable			

Adedness

bejadedness	fadedness	persuadedness	shadedness
degradedness	jadedness		

Adian

Acadian	Barbadian	nomadian	Palladian
Arcadian	Canadian		

Aditive

traditive	additive

Adium

palladium	radium	stadium	vanadium

Aëry

aëry	faëry

Aftily

craftily	draughtily

Ageable

assuageable	gaugeable

AGEOUSNESS
advantageous- disadvantage- "rampageous- umbrageous-
ness ousness ness" ness
courageousness outrageousness

AGGEDLY
jaggedly raggedly

AGGEDNESS
craggedness jaggedness raggedness

AGGERER
staggerer swaggerer

AGGERING
staggering swaggering

AGGERY
faggery raggery waggery zigzaggery
jaggery

AGGINESS
bagginess knagginess scragginess shagginess
cragginess

AGIAN
Brobdignagian magian pelagian

AGICAL
magical tragical

AGILENESS
agileness fragileness

AGINAL
imaginal paginal

AGINOUS
cartilaginous lumbaginous octagynous voraginous
farraginous mucilaginous oleaginous

AGONISM
agonism antagonism

AGRANCY
flagrancy fragrancy vagrancy

Aical

algebraical	Hebraical	paradisaical	Pharisaical
archaical	laical		

Aiety, Aity

| gaiety | laity | | |

Ainable

ascertainable	drainable	obtainable	strainable
attainable	explainable	ordainable	sustainable
constrainable	gainable	restrainable	trainable
containable	maintainable	retainable	unattainable
distrainable			

Ainfulness

| disdainfulness | gainfulness | painfulness | |

Ailable

assailable	exhalable	retailable	unassailable
available	mailable	saleable	unavailable
bailable			

Ailery

| nailery | raillery | | |

Airiness

| airiness | chariness | glariness | hairiness |

Airable

| bearable | declarable | unbearable | wearable |
| airable | repairable | unwearable | |

Aisable

| praisable | raisable | suasible | persuasible |

Akable

| breakable | implacable | pacable | undertakable |
| impacable | mistakable | placable | unshakable |

Akerism

| Quakerism | Shakerism | "fakirism" | |

Akery

| bakery | rakery | "fakiry" | |

Akiness

| flakiness | quakiness | shakiness | snakiness |

Algia

| neuralgia | nostalgia | pleuralgia | |

ALIANISM

bacchanalian-
 ism

alienism
Episcopalian-
 ism

saturnalianism
sesquipedalian-
 ism

universalianism

ALIFY

alkalify

calefy

salify

ALINESS

dailiness

scaliness

ALITY

abnormality
accidentality
actuality
alamodality
animality
artificiality
banality
bestiality
biblicality
brutality
carnality
casuality
centrality
circumstanti-
 ality
classicality
comicality
confidentiality
congeniality
conjecturality
conjugality
connubiality
constitutional-
 ity
consubstantial-
 ity
conventionality
conviviality
cordiality
corporality
criminality
curiality

dextrality
duality
egality
elementality
ephemerality
essentiality
ethereality
eventuality
externality
exterritoriality
fantasticality
fatality
feminality
feudality
finality
finicality
formality
frugality
fundamentality
generality
geniality
graduality
gutturality
horizontality
hospitality
ideality
illegality
immateriality
immorality
immortality
impartiality
imperiality

impersonality
inconsequenti-
 ality
individuality
ineffectuality
informality
inimicality
instrumentality
integrality
intellectuality
intentionality
intrinsicality
irrationality
joviality
laicality
laterality
legality
liberality
lineality
literality
locality
logicality
magistrality
magnality
materiality
mentality
meridionality
mesnality
modality
morality
mortality
municipality

mutuality
nasality
nationality
naturality
neutrality
notionality
officiality
Orientality
originality
orthodoxality
parochiality
partiality
pedality
penality
personality
plurality
potentiality
practicality
preternatural-
 ity
primality
principality
prodigality
proportional-
 ity
provinciality
prudentiality
punctuality
radicality
rascality
rationality
reality

Ality—(Cont.)

reciprocality
regality
rivality
rurality
sectionality
sensuality
sentimentality
septentrional-
 ity
seriality
sesquipedality

severality
sexuality
signality
sociality
sodality
speciality
spectrality
spirality
spirituality
substantiality
superficiality

supernaturality
technicality
temporality
theatricality
tonality
totality
traditionality
transcendality
triality
triviality
universality

unusuality
vegetality
venality
veniality
verbality
verticality
visuality
vitality
vocality
whimsicality

Alliate

palliate

malleate

Allery

gallery

raillery

salary

Allidness

impallidness

invalidness

pallidness

validness

Allier

dallier

rallier

sallier

tallier

Allium

pallium

thallium

Allower

callower
hallower

shallower

sallower

tallower

Allowest

callowest

hallowest

shallowest

sallowest

Allowish

sallowish

shallowish

tallowish

Allowness

callowness

fallowness

sallowness

shallowness

Allying

dallying

rallying

sallying

tallying

Almistry

palmistry

psalmistry

ALOGISM
analogism dialogism paralogism

ALOGIST
analogist dialogist mammalogist penalogist
decalogist genealogist mineralogist

ALOGIZE
analogize dialogize genealogize paralogize

ALOGY
analogy genealogy mineralogy pyroballogy
crustalogy genethlialogy paralogy tetralogy
dianoialogy mammalogy petralogy

ALYSIS
analysis catalysis dialysis paralysis

AMABLE
blamable irreclaimable reclaimable unblamable
claimable namable tamable untamable

AMARY
mammary gramary

AMATIST
dramatist grammatist hierogram- lipogrammatist
epigrammatist matist melodramatist

AMATIVE
amative exclamative

AMATIZE
dramatize epigrammatize

AMBULATE
ambulate funambulate perambulate somnambulate
deambulate

AMBULISM
noctambulism somnambulism

AMBULIST
funambulist noctambulist somnambulist

AMEFULNESS
blamefulness shamefulness

Amelessness
aimlessness namelessness shamelessness tamelessness
blamelessness

Ameron
Decameron Heptameron

Ameter
diameter octameter pirameter viameter
dynameter parameter pluviameter voltameter
hexameter pentameter tetrameter

Amical
amical balsamical dynamical

Amina
lamina stamina

Aminate
contaminate laminate

Amity
amity calamity

Ammerer
clamorer hammerer stammerer

Ammering
hammering clamoring stammering

Ammonism
Mammonism Shamanism

Ammonite
Ammonite Mammonite

Amorous
amorous clamorous

Amperer
hamperer pamperer scamperer tamperer

Ampering
hampering pampering scampering tampering

Ampion
campion champion tampion

Amulus
famulus hamulus ramulous

ANABLE
insanable sanable tanable

ANARY
granary panary

ANDABLE
commandable demandable reprimandable understandable

ANDERER
meanderer panderer philanderer slanderer

ANDERING
meandering pandering philandering slandering

ANDEROUS
panderous slanderous

ANDIFY
candify dandify

ANDINESS
handiness sandiness

ANDRIAN
Alexandrian meandrian Menandrian

ANEA
miscellanea succedanea

ANEFULLY
banefully disdainfully painfully

ANEOUS
absentaneous constantaneous instantaneous simultaneous
antecedaneous contemporane- limitaneous spontaneous
araneous ous Mediterraneous subcutaneous
circumforane- cutaneous membraneous subterraneous
 ous dissentaneous miscellaneous succedaneous
circumterrane- extemporane- momentaneous temporaneous
 ous ous porcellaneous terraneous
coëtaneous exterraneous

ANERY
chicanery lanary planary

ANGENCY
plangency tangency

ANGIBLE
frangible intangible refrangible tangible
infrangible

ANGLESOME
tanglesome wranglesome "angle some" (etc.)

ANGULAR
angular quadrangular slangular triangular
octangular rectangular

ANIA
Anglo-mania dipsomania logomania monomania
anthomania eleutheromania mania pyromania
bibliomania erotomania metromania succedanea
decalcomania gallomania miscellanea Titania
demonomania kleptomania

ANIAL
cranial domanial subterraneal

ANIAN
Alcmanian extemporanean Sandemanian Turanian
Equitanian Iranian subterranean volcanian
circumforanean Lithuanian Transylvanian Vulcanian
cyanean Mediterranean

ANICAL
botanical charlatanical mechanical tyrannical
Brahmanical galvanical panicle

ANIFY
humanify insanify sanify

ANIMUS
animus multanimous pusillanimous unanimous
magnanimous

ANISHING
banishing planishing vanishing

ANISHMENT
banishment evanishment vanishment

ANISTER
banister canister ganister

ANITY

aldermanity	inanity	mundanity	subterranity
Christianity	inhumanity	paganity	urbanity
gigmanity	inorganity	profanity	vanity
humanity	insanity	sanity	volcanity
immanity	inurbanity		

ANIUM

cranium	pericranium	titanium	uranium
geranium	succedaneum		

ANKERING

cankering	anchoring	encankering	hankering

ANKEROUS

cankerous	cantankerous

ANIKIN

manikin	pannikin

ANELLING

panelling	channelling

ANNERET

banneret	lanneret

ANERY

charlatanery	granary	stannary	tannery
cannery	panary		

ANNULAR

annular	cannular	penannular

ANULATE

campanulate	annulate	granulate

ANOGRAPH

galvanograph	pianograph

ANOSCOPE

diaphanoscope	galvanoscope

ANSIVENESS

expansiveness	advanciveness

ANSOMER

ransomer	handsomer

ANSOMEST
ransomest handsomest

ANTABLE
grantable plantable

ANTERER
banterer canterer

ANTERING
bantering cantering

ANTHROPIST
misanthropist philanthropist psilanthropist theophilan-
 thropist

ANTHROPY
apanthropy philanthropy psilanthropy theophilan-
lycanthropy phobanthropy theanthropy thropy
misanthropy physianthropy zoanthropy

ANTICIDE
giganticide infanticide

ANTICNESS
franticness giganticness romanticness

ANULA
canula granula

APABLE
capable incapable papable shapeable
drapeable escapeable inescapeable

APERER
caperer paperer vaporer

APERING
capering papering tapering vaporing

APERY
apery grapery papery vapory
drapery napery

APHICAL
autobiographi- bibliographical cartographical ethnographical
 cal biographical cosmographical geographical
autographical calligraphical diagraphical glossographical

Aphical—(*Cont.*)
graphical
lexicographical
lexigraphical
orthographical

palæonto-
 graphical
photographical
physiographi-
 cal

phytographical
pterylographi-
 cal
seraphical

topographical
typographical

Apidly
rapidly

sapidly

vapidly

Apidness
rapidness

sapidness

vapidness

Appier-est
happier

"sappier"

snappier

Appiness
happiness

sappiness

snappiness

Aqueous
aqueous

chylaqueous

subaqueous

terraqueous

Arable
arable

parable

comparible

incomparible

Arative
comparative
declarative

narrative

preparative

reparative

Arbering
barbering

harboring

Arcener
coparcener

larcener

parcener

Arceny
coparceny

larceny

Archical
archical
hierarchical

hylarchical

monarchical

tetrarchical

Ardian
guardian

pericardian

Ardiness
fool-hardiness

hardiness

tardiness

Arefully

carefully prayerfully uncarefully

Arefulness

carefulness sparefulness uncarefulness warefulness
prayerfulness

Aria

adversaria calceolaria dataria malaria
area cineraria digitaria *pariah*
caballaria wistaria

Arial

actuarial diarial nectarial puparial
areal glossarial notarial secretarial
calendarial malarial ovarial vicarial
commissarial

Arian

abecedarian Cæsarian lunarian sanitarian
adessenarian centenarian malarian sectarian
agrarian diarian Megarian sententiarian
alphabetarian dietarian millenarian septuagenarian
altitudinarian disciplinarian miscellanarian sexagenarian
anecdotarian doctrinarian necessarian societarian
antiquarian equalitarian necessitarian stipendarian
antisabbata- estuarian nectarian sublapsarian
 rian experiment- nonagenarian supralapsarian
antitrinitarian arian octagenarian tartarean
apiarian futilitarian ovarian tractarian
apollinarian grammarian Parian trinitarian
aquarian humanitarian parliamentarian ubiquarian
Arian Hungarian platitudinarian ubiquitarian
Aryan Icarian plenitudinarian unitarian
atrabilarian Janizarian predestinarian utilitarian
attitudinarian lapidarian proletarian valetudinarian
barbarian latitudinarian riparian vegetarian
Bavarian libertarian sabbatarian veterinarian
Briarean librarian sacramentarian vulgarian
Bulgarian limitarian

Ariant

contrariant omniparient variant

Ariat

commissariat proletariat prothonotariat secretariat

ARIATE

variate vicariate "where he ate" (etc.)

ARIER

charier warier *See also* ARRIER

ARIES

Aries caries

ARIEST

chariest variest wariest

ARIFORM

peariform scalariform

ARIFY

clarify saccharify scarify

ARINESS

arbitrariness sanguinariness temporariness voluntariness
contrariness sedentariness tumultuariness wariness
salutariness solitariness ubiquitariness

ARINGLY

daringly glaringly sparingly flaringly

ARIO

impresario Lothario

ARIOUS

arbitrarious gregarious omnifarious temerarious
arenarious hilarious precarious testudinarious
Aquarius horarious quadragenari- vagarious
atrabilarious lutarious ous valetudinarious
calcareous malarious retiarius various
contrarious multifarious Sagittarius vicarious
denarius nectareous sequarious viparious
frumentarious nefarious tartareous "carry us" (etc.)

ARITUDE

amaritude claritude

ARITY

angularity circularity familiarity imparity
barbarity clarity fissiparity insularity
cavity disparity gemmiparity irregularity
charity dissimilarity globularity jocularity
debonarity exemplarity hilarity molecularity

Arity—(*Cont.*)

muscularity
omniparity
parity
particularity
peculiarity
perpendicular-
　ity

piacularity
polarity
popularity
pupilarity
rectangularity
rectilinearity

regularity
secularity
similarity
singularity
solidarity
titularity

triangularity
uncharity
vascularity
viviparity
vulgarity

Arium

aquarium
aqua-vivarium
columbarium

glaciarium
honararium
sacrarium

sanitarium
tepidarium

termitarium
vivarium

Arlatan

charlatan　　tarlatan

Armingly

alarmingly　　charmingly

Arnisher

garnisher　　tarnisher　　varnisher

Arnishing

garnishing　　tarnishing　　varnishing

Aronite

Aaronite　　Maronite

Arassing

harassing　　embarrassing

Arassment

harassment　　embarrassment

Arrier

barrier
carrier

farrier
marrier

tarrier
charier

"carry her"
　(etc.)

Arriness

starriness　　tarriness

Arrior

warrior　　quarrier
sorrier

Arrower

harrower　　narrower

Arrowest
harrowest narrowest

Arrowing
harrowing narrowing

Arrowy
arrowy marrowy

Arrying
carrying harrying marrying tarrying

Arterer
barterer charterer

Artering
bartering chartering

Artialism
martialism partialism

Article
article particle

Artiness
swartiness wartiness

Artizan
artizan bartizan partizan

Artlessly
artlessly heartlessly

Artlessness
artlessness heartlessness

Asable
chasable defaceable irreplaceable untraceable
effaceable replaceable traceable

Ashery
fashery haberdashery sashery

Ashiness
ashiness flashiness trashiness

Asia
Asia Aspasia aphasia paronomasia
acacia leucophasia euthanasia Australasia

Asian

Asian	Caucasian	Horatian	Rabelaisian
Alsatian	Eurasian	Latian	sefatian
Athanasian	Galatian	Pancratian	Thracian
Australasian	Hieraçian		

Asiveness

dissuasiveness	persuasiveness	pervasiveness	suasiveness
evasiveness			

Aspingly

gaspingly	raspingly

Assia

cassia	Parnassia	quassia

Assian

Circassian	Parnassian

Assible

impassible	passable	renascible	surpassable
irascible			

Assiness

brassiness	glassiness	grassiness	massiness
"classiness"	"sassiness"		

Assioning

compassioning	fashioning	passioning

Assively

impassively	massively	passively

Assiveness

impassiveness	massiveness	passiveness

Astardy

bastardy	dastardy

Astefully

distastefully	tastefully	wastefully

Astering

beplastering	mastering	overmastering	plastering

Astership

mastership	pastorship

ASTERY

| dicastery | mastery | plastery | self-mastery |

ASTICAL

| ecclesiastical | encomiastical | fantastical | orthodoxasti-cal |
| elastical | enthusiastical | | |

ASTICISM

| ecclesiasticism | fantasticism | monasticism | scholasticism |

ASTILY

| hastily | pastily | tastily |

ASTRIAN

| alabastrian | Lancastrian | Zoroastrian |

ASTROPHE

| catastrophe | epanastrophe |

ATABLE

| abatable | creatable | dilatable | regulatable |
| collatable | debatable | ratable | translatable |

ATCHABLE

| immatchable | attachable | matchable | unmatchable |
| catchable | detachable | | |

ATEFULLY

| fatefully | gratefully | hatefully |

ATEFULNESS

| fatefulness | gratefulness | hatefulness |

ATELLITE

| patellite | satellite |

ATENCY

| latency | patency |

ATERAN

| cateran | Lateran |

ATERER

| waterer | slaughterer |

ATERING

| watering | slaughtering |

ATHERER
foregatherer latherer tax-gatherer upgatherer
gatherer "blatherer"

ATHERING
"blathering" gathering upgathering wool-gathering
foregathering lathering

ATHESIS
diathesis parathesis

ATHIAN
Carpathian Sabbathian

ATIATE
expatiate glaciate insatiate satiate
emaciate ingratiate "way she ate" (etc.)

ATIBLE
compatible combatable incompatible patible
"comeatable" impatible

ATICA
dalmatica sciatica hypatica

ATICAL
abbatical autocratical emblematical phantasmatical
acroamatical automatical emphatical piratical
aërostatical axiomatical enigmatical pragmatical
anathematical bureaucratical epigrammatical primatical
anidiomatical climatical fanatical schismatical
apophtheg- democratical grammatical separatical
 matical diplomatical hebdomatical Socratical
apostatical dogmatical idiomatical spasmatical
aristocratical dramatical leviratical statical
asthmatical ecstatical mathematical vatical

ATICISM
Asiaticism fanaticism grammaticism

ATICIZE
emblematicize fanaticize grammaticize

ATIFY
beatify gratify ratify stratify

ATINATE
gelatinate Palatinate

ATINESS
slatiness weightiness

ATINIZE
gelatinize Latinize platinize

ATINOUS
gelatinous platinous

ATIONAL

international	irrational	national	rational
associational	dissertational	imitational	respirational
congregational	educational	inspirational	rotational
conservational	emigrational	observational	sensational
conversational	gradational	probational	stational
creational	gyrational	relational	terminational
denominational	ideational	representa-	
derivational		tional	

ATIONER
foundationer probationer reprobationer stationer
oblationer

ATIONIST

annexationist	convocationist	emigrationist	repudiationist
annihilationist	cremationist	imitationist	restorationist
annotationist	degenerationist	inflationist	transmuta-
causationist	educationist	innovationist	tionist
conversationist	emancipationist	inspirationist	

ATIONLESS

foundationless	conversation-	educationless	imitationless
temptationless	less	imigrationless	inspirationless

ATITUDE
beatitude gratitude latitude platitude
attitude ingratitude

ATIVENESS
alliterativeness imitativeness nativeness penetrativeness

ATOMOUS
diatomous paratomous

ATOMY
anatomy atomy

Atrical
idolatrical theatrical

Atricide
fratricide matricide patricide

Atronage
matronage patronage

Atronal
matronal patronal

Atronize
matronize patronize

Atterer
batterer clatterer patterer smatterer
blatterer flatterer scatterer splatterer
chatterer

Attering
battering bespattering flattering smattering
beflattering blattering pattering spattering
bepattering chattering scattering splattering
bescattering clattering shattering

Attery
battery flattery shattery slattery
tattery

Attiness
chattiness fattiness nattiness

Attlement
battlement embattlement prattlement tattlement

Atulate
congratulate gratulate spatulate

Aturate
maturate saturate supersaturate

Aucity
paucity raucity

Allable
enthrallable recallable

ALTERER
alterer falterer palterer

ALTERING
altering paltering unaltering unfaltering
faltering

ALTIEST
saltiest faultiest

ALTINESS
saltiness faultiness maltiness

AUGHTIER
haughtier naughtier

AUGHTIEST
haughtiest naughtiest

AUGHTILY
haughtily naughtily

AUGHTINESS
haughtiness naughtiness

AUREATE
aureate baccalaureate laureate poet-laureate
"more he ate"
(etc.)

AUREOLE
aureole laureole

AUTERY
cautery watery

AVAGER
ravager savager scavager

AVAGING
ravaging scavaging

AVANESE
Havanese Javanese

AVELER
raveler traveler unraveler

Aveling
graveling raveling traveling unraveling

Avender
chavender lavender

Averous
cadaverous papaverous

Avian
avian Belgravian Moravian Scandinavian
Batavian

Avishness
knavishness slavishness

Avisher
lavisher ravisher

Avishing
enravishing lavishing ravishing

Avishment
enravishment lavishment ravishment

Avity
cavity depravity pravity suavity
concavity gravity

Avorous
flavorous savorous

Avorer
favorer laverer quaverer waverer
flavorer

Avoring
favoring quavering unwavering wavering
flavoring savoring

Avory
savory gravery slavery unsavory
bravery

Awdiness
bawdiness gaudiness

Awdriness
bawdriness tawdriness

Awfully
awfully lawfully unlawfully

Awfulness
awfulness lawfulness unlawfulness

Awkily
gawkily chalkily pawkily

Awkiness
gawkiness pawkiness squalkiness talkiness
chalkiness

Awniest
brawniest tawniest

Ayable
payable portrayable unpayable unswayable
conveyable repayable unprayable

Aziness
craziness haziness laziness maziness

Axable
relaxable taxable

Eable
agreeable decreeable feeable irremeable
creable disagreeable

Eadership
leadership readership

Eadier
headier readier steadier unsteadier

Eadiest
headiest readiest steadiest unsteadiest

Eadily
headily readily steadily unsteadily

Eadiness
headiness steadiness unsteadiness unreadiness
readiness threadiness

Eagerly
eagerly meagerly overeagerly

Eagerness
eagerness meagerness overeagerness

Eakable
speakable unspeakable

Eakishness
freakishness cliquishness sneakishness

Ealable
concealable healable repealable revealable
congealable inconcealable

Ealize
idealize realize

Ealism
idealism realism

Ealist
idealist realist

Ealously
jealously overzealously zealously

Ealthier
healthier stealthier wealthier

Ealthiest
healthiest stealthiest wealthiest

Ealthily
healthily stealthily wealthily

Ealty
fealty realty

Eanism
epicureanism peanism Pythagoreanism Sabaeanism
Laodiceanism plebeianism

Easable
appeasable feasible indefeasible squeezable
cohesible freezable infeasible unappeasable
creasable releasable increasable
defeasible inappeasible seizable

Easantry
pheasantry pleasantry

EASONING
reasoning seasoning unreasoning

EASTINESS
reastiness yeastiness

EASTLINESS
beastliness priestliness

EASURER
measurer pleasurer treasurer

EASURING
measuring pleasuring treasuring

EATABLE
cheatable entreatable escheatable uneatable
eatable

EATHERING
feathering leathering tethering weathering

EATHERY
feathery heathery leathery weathery

EATHLESSLY
breathlessly deathlessly

EATHLESSNESS
breathlessness deathlessness

EATINESS
meatiness peatiness sleetiness

EBRIOUS
ebrious funebrious inebrious tenebrious

ECCABLE
impeccable insecable peccable

ECENCY
decency indecency recency

ECENTLY
decently indecently recently

EACHABLE
bleachable reachable umimpeachable unteachable
impeachable teachable

Echerous
lecherous treacherous

Echery
lechery treachery

Eciousness
speciousness facetiousness

Eckoning
beckoning dead-reckoning reckoning

Ecrement
decrement recrement

Ectedness
abjectedness dejectedness infectedness unsuspected-
affectedness disaffectedness suspectedness ness

Ectible
affectible detectible indefectible reflectible
collectible dissectible indelectable rejectable
correctible effectible objectable respectable
defectible erectable perfectible suspectable
delectable expectable

Ectical
apoplectical dialectical

Ectify
objectify rectify

Ectional
affectional inflectional interjectional protectional
complexional insurrectional intersectional sectional
correctional

Ectionist
insurrectionist perfectionist protectionist resurrectionist

Ectionize
resurrectionize sectionize

Ectitude
rectitude senectitude

ECTIVENESS
collectiveness ineffectiveness prospectiveness reflectiveness
defectiveness objectiveness protectiveness subjectiveness
effectiveness

ECTORAL
electoral protectoral rectoral sectoral
pectoral

ECTORATE
directorate expectorate protectorate rectorate
electorate

ECTORY
correctory nectary refectory sectary
directory rectory

ECTUAL
effectual ineffectual intellectual lectual

ECTURAL
architectural conjectural

ECTURER
conjecturer lecturer

ECULAR
molecular secular specular

ECULATE
peculate speculate

ECUTIVE
consecutive executive subsecutive

EDABLE
exceedable obedible pleadable readable
impedible

EDDITIVE
redditive sedative

EDERAL
federal hederal

EDFULNESS
heedfulness needfulness unheedfulness unneedfulness

EDIAL

| bimedial | medial | pedial | remedial |
| intermedial | | | |

EDIAN

| comedian | encyclopedian | median | tragedian |

EDIBLE

| credible | dreadable | edible | incredible |

EDICAL

| medical | pedicle | | |

EDICANT

| medicant | predicant | | |

EDICATE

| dedicate | medicate | predicate | |

EDIENCE

| disobedience | expedience | inexpedience | obedience |
| ingredients | expedients | | |

EDIENT

| disobedient | inexpedient | ingredient | obedient |
| expedient | | | |

EDIER

| greedier | needier | seedier | weedier |
| beadier | reedier | speedier | |

EDIEST

| greediest | neediest | seediest | weediest |
| beadiest | reediest | speediest | |

EDILY

| greedily | needily | speedily | |

EDIMENT

| impediment | pediment | sediment | |

EDINESS

| greediness | seediness | speediness | weediness |
| neediness | | | |

EDINOUS

| mucedinous | putredinous | rubedinous | |

EDIOUS
intermedious tedious

EDITED
accredited discredited edited miscredited
credited

EDITING
accrediting discrediting editing miscrediting
crediting

EDITOR
creditor editor

EDIUM
medium tedium

EDLESSLY
heedlessly needlessly

EDLESSNESS
heedlessness needlessness

EDULOUS
credulous incredulous sedulous

EERIER, *see* ERIOR

EFERENCE
cross-reference deference preference reference

EFERENT
deferent efferent

EFICENCE
beneficence maleficence

EFICENT
beneficent maleficent

EFINESS
beefiness leafiness

EGALISM
legalism regalism

EGALNESS
legalness regalness illegalness

Eggable

beggable	legable

Eggary

beggary	eggery

Egginess

dregginess	legginess

Egian

collegian	Fuegian	Norwegian

Egnancy

pregnancy	regnancy

Eity

contempo- raneity	gaseity	incorporeity	seity
corporeity	hæcceity	instantaneity	simultaneity
deity	hermaphro- deity	multeity	spontaneity
diathermaneity	heterogeneity	omneity	sulphureity
extraneity	homogeneity	personeity	terreity
femineity		plebeity	velleity

Eivable

conceivable	believable	deceivable	inconceivable
achievable	cleavable	grievable	irretrievable
perceivable	relievable	unbelievable	undeceivable
receivable	retrievable		

Ekily

cheekily	leakily	sneakily	squeakily
creakily	sleekily		

Ekiness

cheekiness	leakiness	sneakiness	squeakiness
creakiness			

Elegate

delegate	relegate

Elery

celery	stellary

Elfishness

elfishness	selfishness

ELIAN

Aristotelian	Delian	Ismaelian	Mephisto-
carnelian	Hegelian	Machiavellian	phelian
			Mingrelian

ELICAL

angelical	evangelical	helical	pellicle
bellical			

ELION

anthelion	aphelion	chameleon

ELLABLE

compellable	fellable	indelible	spellable
delible	gelable	ingelable	tellable
expellable			

ELLATIVE

compellative	correlative	relative

ELLIAN

Boswellian	Cromwellian	evangelian	selion

ELLICAL

bellical	pellicle

ELLISHING

embellishing	relishing

ELLISHMENT

embellishment	relishment

ELLOWER

bellower	mellower	yellower

ELLOWEST

bellowest	mellowest	yellowest

ELLOWING

bellowing	mellowing	yellowing

ELLULAR

cellular	intercellular	stellular	unicellular

ELONY

felony	melony

ELTERER

shelterer	welterer

Eltering
sheltering weltering

Eltery
sheltery smeltery

Emable
esteemable redeemable

Ematist
emblematist theorematist schematist thematist

Embering
dismembering membering remembering unremembering
"November- "December-
 ing" ing"

Emerist
ephemerist euhemerist

Eamery
creamery dreamery

Emial
academial endemial gremial vindemial

Emian
academian Bohemian

Emical
academical chemical endemical polemical
alchemical electrochemical epidemical

Eamier
beamier creamier dreamier premier

Eamily
beamily creamily dreamily steamily

Eminal
feminal geminal seminal

Eminate
effeminate geminate ingeminate

Eaminess
creaminess dreaminess steaminess

EMION
anthemion procemion

EMNITY
indemnity solemnity

EMONE
Agapemone anemone Gethsemane

EMORAL
femoral nemoral

EMORY
memory gemmery

EMPEROR
emperor temperer

EMULENT
temulent tremulent

EMULOUS
emulous tremulous

ENABLE
amenable convenable

ENARY
centenary denary senary venery
decennary hennery

ENCELESSLY
defencelessly senselessly

ENCELESSNESS
defencelessness senselessness

ENDIBLE
accendible defendable extendible recommendable
amendable dependable invendible rendible
commendable descendable lendable unascendable
comprehendible endable mendable vendible

ENDANCY
ascendancy impendency interdepend- superintend-
attendancy independency ency ency
dependency intendancy resplendency transcendency
equipendency tendency transplendency

Enderer
engenderer slenderer surrenderer tenderer
renderer

Enderest
engenderest slenderest surrenderest tenderest
renderest

Endering
engendering rendering surrendering tendering
gendering

Enderly
slenderly tenderly

Enderness
slenderness tenderness

Endious
compendious incendious

Endlessly
endlessly friendlessly

Endlessness
endlessness friendlessness

Endously
stupendously tremendously

Eneous
ebeneous genius ingenious primigenious
arsenious heterogeneous nitrogeneous selenious
extrageneous homogeneous pergameneous

Enerate
degenerate ingenerate progenerate venerate
generate intenerate regenerate

Enery
deanery machinery plenary scenery
greenery

Enesis
parenesis ontogenesis paragenesis phytogenesis
biogenesis homogenesis abiogenesis polygenesis
eugenesis organogenesis parthenogenesis psychogenesis
genesis palingenesis phylogenesis xenogenesis
heterogenesis pangenesis

ENIA

encenia	gardenia	neurosthenia

ENIAL

congenial	genial	primigenial	venial
demesnial	menial	uncongenial	

ENIAN

Armenian	Cyrenian	Fenian	Madrilenian
Athenian	Estremenian	Hellenian	Ruthenian

ENICAL

arsenical	ecumenical	scenical	sirenical
catechumenical			

ENIENCE

convenience	inconvenience	lenience

ENIENCY

conveniency	inconveniency	leniency

ENIENT

advenient	inconvenient	introvenient	supervenient
convenient	intervenient	lenient	

ENISON

benison	denizen	endenizen	venison

ENITIVE

genitive	lenitive	primogenitive	splenitive

ENITUDE

lenitude	plenitude	serenitude

ENITY

amenity	obscenity	serenity	terrenity
lenity			

ENIUM

proscenium	selenium

ENNIAL

biennial	millennial	perennial	septennial
centennial	novennial	quadrennial	triennial
decennial	octennial	quinquennial	vicennial
duodecennial			

ENNIFORM

antenniform	penniform

Ensative

compensative	defensative	insensitive	pensative
condensative	dispensative	intensative	sensitive

Ensible

comprehensible	distensible	indefensible	reprehensible
condensable	extensible	indispensable	sensible
defensible	incompre-	insensible	subsensible
deprehensible	hensible	ostensible	tensible
dispensable	incondensable		

Ensical

forensical	nonsensical

Ensional

ascensional	descensional	intentional	preventional
conventional	extensional		

Ensionist

extensionist	recensionist

Ensity

condensity	immensity	propensity	tensity
density	intensity		

Ensiveness

comprehensive-	expensiveness	inoffensiveness	offensiveness
ness	extensiveness	intensiveness	pensiveness

Ensory

defensory	incensory	prehensory	suspensory
dispensary	ostensory	sensory	

Entable

fermentable	inventible	preventable	representable
frequentable	presentable	rentable	

Entacle

pentacle	tentacle

Entalism

accidentalism	Orientalism	sentimentalism	transcenden-
elementalism			talism

Entalist

experimentalist	Orientalist	sentimentalist	transcenden-
instrumentalist			talist

ENTALIZE

experimentalize	Orientalize	sentimentalize	

ENTALLY

accidentally	fundamentally	incidentally	sentimentally

ENTALNESS

accidentalness	gentleness	instrumental-	sentimental-
fundamental-	incidentalness	ness	ness
ness			ungentleness

ENTARY

accidentary	elementary	pigmentary	tenementary
alimentary	filamentary	placentary	testamentary
complementary	instrumentary	sacramentary	unparliamen-
complimentary	integumentary	sedimentary	tary
dentary	parliamentary	tegumentary	

ENTATIVE

augmentative	experimenta-	frequentative	preventative
commentative	tive	presentative	representative
complimenta-	fermentative	pretentative	tentative
tive			

ENTIARY

penitentiary	residentiary		

ENTIATE

essentiate	licentiate	potentiate	

ENTICAL

authentical	conventicle	denticle	identical
conventical			

ENTICULE

denticule	lenticule		

ENTIMENT

presentiment	sentiment		

ENTINAL

dentinal	sentinel		

ENTIOUSNESS

conscientious-	contentiousness	licentiousness	pretentiousness
ness			

ENTITY

entity	identity	nonentity	

ENTIVENESS
alimentiveness attentiveness inattentiveness retentiveness

ENTOUSLY
momentously portentously

ENTOUSNESS
momentousness portentousness

ENTUAL
accentual adventual conventual eventual

ENTUATE
accentuate eventuate

ENUANT
attenuant genuant

ENUATE
attenuate extenuate tenuate "when you ate"
 (etc.)

ENUOUS
ingenuous strenuous tenuous disingenuous

EPEROUS
leperous obstreperous prestreperous streperous

EPILY
creepily sleepily weepily

EPINESS
creepiness sleepiness steepiness weepiness

EPTIBLE
deceptible imperceptible perceptible susceptible
acceptable insusceptible receptible

EPTICAL
antiseptical protreptical receptacle sceptical

ERBALISM
herbalism verbalism

ERBALIST
herbalist verbalist

ERBIAL
adverbial proverbial suburbial

ERBULENT

herbulent	turbulent

ERCIAN

Cistercian	lacertian	*Persian, see also* ERTION *(2 syllable)*

ERCULOUS

tuberculous	surculus	surculous

EREROR

verderor	murderer

ERFLUOUS

subterfluous	superfluous

ERFULLY

cheerfully	fearfully	tearfully

ERFULNESS

cheerfulness	fearfulness	tearfulness

ERGENCY

convergency	divergency	insurgency	vergency
detergency	emergency	urgency	

ERIA

diphtheria	eleutheria	hesperia	icteria
Egeria	etheria	hysteria	Valkyria

ERIAL

aërial	diabaterial	funereal	magisterial
arterial	ethereal	immaterial	managerial
cereal	ferial	imperial	manerial
material	presbyterial	serial	vizierial
ministerial	rhinocerial	siderial	

ERIALISM

immaterialism	imperialism

ERIALIST

immaterialist	imperialist

ERIAN

abderian	Hanoverian	phalansterian	Spenserian
Aërian	Hesperian	Pierian	Valerian
Algerian	Iberian	Presbyterian	Valkyrian
Celtiberian	Keplerian	Shakesperian	Wertherian
Cimmerian	Luciferian		

Erical

alexiterical	climacterical	helispherical	rhinocerical
atmospherical	esoterical	hysterical	spherical
chimerical	exoterical	numerical	sphericle
clerical	heliospherical	phylacterical	

Erides

Anterides Hesperides Pierides

Eries

congeries series

Eriest

beeriest	cheeriest	eeriest	weariest
bleariest	dreariest		

Erily

verily merrily

Erion

allerion criterion embaterion Hyperion

Erior

anterior	drearier	interior	ulterior
exterior	eerier	posterior	wearier
cheerier	inferior	superior	

Erious

deleterious	ethereous	mysterious	sidereous
cereous	imperious	serious	

Erishing

cherishing perishing unperishing

Erited

disherited	emerited	inherited	merited
disinherited	ferreted		

Eriting

inheriting meriting ferreting

Erity

ambidexterity	clerity	insincerity	posterity
asperity	dexterity	legerity	procerity
austerity	indexterity	prosperity	sincerity
temerity	verity	severity	

Erium

| acroterium | apodyterium | megatherium | titanotherium |
| agnotherium | dinotherium | palæotherium | |

Erjury

| chirurgery | perjury | purgery | surgery |

Erlessness

| cheerlessness | fearlessness | peerlessness |

Erminal

| germinal | terminal |

Erminant

| determinant | germinant |

Erminate

| determinate | exterminate | indeterminate | terminate |
| germinate | | | |

Erminous

| coterminous | terminus | verminous |

Ernalism

| externalism | journalism | "infernalism" |

Ernalist

| eternalist | journalist |

Ernalize

| eternalize | externalize | journalize |

Ernery

| fernery | turnery |

Ernian

| Avernian | Falernian | Hibernian | Saturnian |

Ernity

alternity	fraternity	modernity	sempiternity
diuternity	maternity	paternity	taciturnity
eternity			

Erpentine

| serpentine | turpentine |

Errable

| conferrable | inferable | referable | transferable |
| demurrable | | | |

ERRANCY

aberrancy currency inerrancy recurrency
concurrency

ERRYMAN

ferryman wherryman

ERSARY

anniversary bursary cursory precursory
aspersory controversary nursery

ERSIBLE

conversable coercible incoercible reimbursable
amerceable immersible irreversible reversible
conversible

ERSIFORM

diversiform ursiform versiform

ERSIONIST

excursionist immersionist versionist

ERSIVENESS

detersiveness coerciveness discursiveness excursiveness

ERTITUDE

certitude incertitude inertitude

ERVANCY

conservancy fervency

ERVATIVE

conservative enervative preservative reservative
curvative observative

ESCENCY

acescency defervescency excrescency quiescency
acquiescency delitescency incalescency recrudescency
adolescency effervescency liquescency rejuvenescency
aekalescency efflorescency pubescency turgescency
convalescency erubescency

ESCIENCE

nescience prescience

ESHINESS

fleshiness meshiness

Esia

æsthesia	anæsthesia	magnesia	Silesia
amnesia	ecclesia	parrhesia	

Esian

geodesian	Megalesian	Melanesian	Peloponnesian
gynæcian			

Esident

president	resident

Esimal

centesimal	millesimal	quadragesimal	sexagesimal
infinitesimal	nonagesimal	septuagesimal	

Essary

confessary	pessary	professory	successary
intercessory			

Essible

accessible	fermentescible	ineffervescible	redressible
compressible	impressible	inexpressible	repressible
concessible	imputrescible	insuppressible	supressible
concrescible	inaccessible	irrepressible	transgressible
effervescible	incessable	marcescible	vitrescible
expressible	incompressible	putrescible	

Essional

accessional	discretional	processional	sessional
confessional	expressional	progressional	successional
congressional	intercessional	recessional	transgressional
digressional	possessional	retrocessional	

Essioner

possessioner	processioner

Essionist

progressionist	secessionist	successionist

Essity

necessity	obesity

Essiveness

aggressiveness	expressiveness	inexpressive-	oppressiveness
depressiveness	impressiveness	ness	progressiveness
excessiveness			

Estering

festering	pestering	westering

Estial
agrestial bestial celestial supercelestial

Estible
comestible detestable incontestable intestable
congestible digestible indigestible testable
contestable divestible

Estinal
destinal intestinal

Estinate
destinate festinate predestinate

Estiness
restiness testiness

Estiveness
festiveness restiveness suggestiveness

Estrial
pedestrial superterrestrial terrestrial trimestrial

Estrian
campestrian palestrian pedestrian sylvestrian
equestrian

Estrious
pedestrious terrestrious

Estural
gestural vestural

Etable
forgetable fetable regrettable

Etaline
petaline metalline acetiline

Etallism
bimetallism monometallism petalism

Etchiness
sketchiness tetchiness

Etfully
forgetfully fretfully regretfully

Etfulness
forgetfulness fretfulness regretfulness

ETIAN

Capetian	Epictetian	Venetian	Grecian, *see*
			also ESION
			(*2 syllable*)

ETICAL

æsthetical	apathetical	emporetical	homiletical
aloetical	apologetical	energetical	hypothetical
alphabetical	arithmetical	epithetical	noetical
anchoretical	catechetical	exegetical	planetical
antipathetical	cosmetical	heretical	poetical
antithetical	dietetical	hermetical	theoretical

ETICISM

| æstheticism | asceticism | athleticism | peripateticism |

ETICULE

| poeticule | reticule |

ETINUE

| detinue | retinue | "met anew" (etc.) |

ETORY

| completory | depletory | repletory | secretory |

ETRICAL

alkalimetrical	geometrical	metrical	pulviometrical
asymmetrical	gnomiometrical	obstetrical	stichometrical
barometrical	graphometrical	perimetrical	symmetrical
craniometrical	horometrical	planimetrical	trigonometrical
diametrical	isoperimetrical		

ETRIMENT

| detriment | retriment |

ETTERING

| bettering | fettering | lettering |

ETTINESS

| jettiness | pettiness | sweatiness |

ETTISHLY

| coquettishly | pettishly |

ETTISHNESS

| coquettishness | pettishness |

Eveller

beveller	disheveller	leveller	reveller

Evellest

bevellest	dishevellest	levellest	revellest

Evelling

bevelling	dishevelling	levelling	revelling

Evelry

revelry	devilry

Evermore

evermore	nevermore

Evelism

levelism	devilism

Evelment

revelment	devilment	bedevilment

Eviate

abbreviate	alleviate	deviate

Evious

devious	previous

Evishly

peevishly	thievishly

Evishness

peevishness	thievishness

Evity

brevity	levity	longevity

Evolence

benevolence	malevolence

Evolent

benevolent	malevolent

Evolute

evolute	revolute

Everer

cleverer	endeavorer	severer

Everest

cleverest	endeavorest	severest

EXIBLE
flexible inflexible nexible reflexible

EXITY
complexity intercom- perplexity reflexity
convexity plexity pexity

EXIVENESS
perplexiveness reflexiveness

ESIAN
artesian Ephesian magnesian Polynesian
cartesian etesian Milesian trapezian
ecclesian

EVELER
leveler reveler bedeviler beveler

EZILY
breezily greasily uneasily wheezily
easily

EZINESS
breeziness easiness queasiness uneasiness
cheesiness greasiness sleaziness wheeziness

EZINGLY
freezingly pleasingly teasingly wheezingly
appeasingly

IABLE
acidifiable fortifiable pacifiable satisfiable
appliable friable petrifiable solidifiable
classifiable impliable pliable triable
compliable justifiable qualifiable tryable
deniable liable rarefiable undeniable
diversifiable liquefiable rectifiable verifiable
electrifiable magnifiable reliable viable
exemplifiable modifiable saponifiable vitrifiable
falsifiable

IACAL
bibliomaniacal encyclopediacal maniacal prosodiacal
cardiacal heliacal monomaniacal simoniacal
demoniacal hypochondri- paradisiacal zodiacal
elegiacal acal

IACISM
demoniacism hypochondri-
 acism

IADES
hamadryades hyades pleiades

IANCY
riancy cliency compliancy pliancy

IANTLY
compliantly defiantly pliantly reliantly

IARCHY
diarchy triarchy

IARY (*see two-syllable rhymes*)

IARIST
diarist piarist

IASIS
elephantiasis hypochondri-
 asis

IATER
archiater psychiater

IBABLE
bribable indescribable scribable undescribable
describable inscribable subscribable

IBIA
amphibia tibia

IBIAL
amphibial stibial tibial

IBIOUS
amphibious bathybius stibious

IBITIVE
exhibitive prohibitive

IBULAR
fibular infundibular mandibular vestibular

ICAMENT
medicament predicament

ICATIVE
abdicative exsiccative indicative siccative
desiccative fricative predicative

ICIALISM
judicialism officialism

ICIALLY
judicially officially prejudicially superficially

ICICLE
icicle bicycle tricycle

ICIENCY
alliciency efficiency insufficiency self-sufficiency
beneficiency inefficiency proficiency sufficiency
deficiency insitiency

ICIEST
iciest spiciest

ICILY
icily spicily

ICINAL
fidicinal officinal vaticinal vicinal
medicinal

ICINESS
iciness spiciness

ICITNESS
explicitness illicitness implicitness licitness

ICITUDE
solicitude spissitude vicissitude

ICITY
accomplicity canonicity complicity elasticity
achromaticity catholicity conicity electricity
authenticity causticity domesticity electrotonicity
benedicite centricity duplicity ellipticity
caloricity clericity eccentricity endemicity
evangelicity lubricity pudicity stypticity
felicity mendicity rubricity tonicity
historicity multiplicity rusticity triplicity
hygroscopicity myonicity simplicity unicity
immundicity pepticity spasticity verticity
impudicity periodicity sphericity volcanicity
inelasticity plasticity spheroidicity vulcanicity
infelicity publicity stoicity

ICKENING
quickening sickening thickening

ICKETER
cricketer picketer

ICKETING
cricketing picketing ticketing

ICKETY
pernicketty rickety thickety

ICKILY
stickily trickily

ICKINESS
stickiness trickiness

ICKLINESS
prickliness sickliness

ICOLIST
agricolist ignicolist plebicolist

ICOLOUS
agricolous sepicolous terricolous

ICOMOUS
auricomous flavicomous

ICTIONAL
contradictional fictional frictional jurisdictional

ICTIVELY
restrictively vindictively

ICTIVENESS
restrictiveness vindictiveness

ICTORY
benedictory interdictory valedictory victory
contradictory

ICULA
canicula fidicula zeticula

ICULAR
acicular	cuticular	ovicular	spicular
adminicular	fascicular	particular	subcuticular
articular	follicular	pellicular	vehicular
auricular	funicular	perpendicular	ventricular
calicular	lenticular	quinquarticular	vermicular
canicular	navicular	radicular	versicular
clavicular	orbicular	reticular	vesicular
cubicular			

ICULATE
articulate	paniculate	reticulate	vehiculate
canaliculate	denticulate	funiculate	gesticulate
matriculate	fasiculate	geniculate	vermiculate
monticulate	particulate	spiculate	vesiculate

ICULUS
dendiculus	folliculous	urbiculous	vermiculous
denticulus	meticulous	ventriculous	vesiculous
fasciculus	ridiculous		

ICULUM
curriculum	geniculum

IDABLE
decidable	dividable	providable

IDDENNESS
forbiddenness	hiddenness

IDINGLY
decidingly	dividingly	abidingly	deridingly

IDIAL
noctidial	presidial

IDIAN
antemeridian	nullifidian	ophidian	quotidian
Lydian	Numidian	Ovidian	rachidian
meridian	obsidian	postmeridian	solfidian

IDIATE
dimidiate	insidiate

IDICAL
druidical	juridical	veridical

IDIFY
acidify · lapidify · solidify

IDINOUS
libidinous · pinguidinous

IDIOM
idiom · iridium · peridium

IDIOUS

avidious	insidious	ophidious	splendidious
fastidious	invidious	parricidious	stillicidious
hideous	lapideous	perfidious	

IDITY

acidity	hispidity	putidity	timidity
acridity	humidity	putridity	torpidity
aridity	hybridity	quiddity	torridity
avidity	limpidity	rabidity	trepidity
cupidity	liquidity	rancidity	tumidity
frigidity	lividity	rapidity	turbidity
insipidity	lucidity	rigidity	turgidity
insolidity	marcidity	sapidity	validity
intrepidity	morbidity	solidity	vapidity
invalidity	pallidity	squalidity	viridity
gelidity	pavidity	stolidity	viscidity
gravidity	pellucidity	stupidity	vividity

IDUAL
individual · residual

IDUATE
assiduate · individuate

IDULATE
acidulate · stridulate

IDULOUS
acidulous · stridulous

IDUOUS

assiduous	prociduous	succiduous	viduous
deciduous	residuous		

IERY
briery · fiery · friary

IETAL
parietal varietal hyetal

IETED
dieted disquieted quieted rioted

IETER
dieter proprietor quieter rioter

IETEST
dietest quietest riotest

IETING
dieting disquieting quieting rioting

IETISM
pietism quietism

IETIST
dietist quietist pietist

IETY
anxiety impropriety notoriety satiety
contrariety inebriety nullibiety sobriety
dubiety insobriety omniety society
ebriety luxuriety piety ubiety
filiety mediety propriety variety
impiety nimiety

IFEROUS
acidiferous conchiferous foraminiferous lactiferous
aliferous coniferous fossiliferous lamelliferous
aluminiferous coralliferous frondiferous laminiferous
ammonitiferous cruciferous frugiferous lanciferous
antenniferous diamantiferous fumiferous laniferous
argentiferous diamondiferous furciferous laticiferous
armiferous doloriferous gemmiferous lauriferous
astriferous ensiferous geodiferous letniferous
auriferous estiferous glandiferous ligniferous
balaniferous fatiferous glanduliferous lucriferous
balsamiferous ferriferous graniferous luminiferous
bulbiferous filiferous granuliferous magnetiferous
calcariferous flammiferous guttiferous maliferous
calciferous fletiferous gypsiferous mammaliferous
carboniferous floriferous hederiferous mammiferous
cheliferous fluctiferous herbiferous margaritiferous
cirriferous foliferous igniferous melliferous

Iferous—(*Cont.*)

membranif-
 erous
metalliferous
monstriferous
mortiferous
multiferous
nectariferous
nickeliferous
nimbiferous
nitriferous
noctiferous
nubiferous
nuciferous
odoriferous
oleiferous
omniferous
oolitiferous
opiferous

ossiferous
ostriferous
ozoniferous
palmiferous
pestiferous
pistilliferous
plantiniferous
plumbiferous
polypiferous
proliferous
pruniferous
pulmoniferous
quartziferous
racemiferous
resiniferous
roriferous
sacchariferous
sacciferous

saliferous
saliniferous
salutiferous
sanguiferous
scopiferous
scutiferous
sebiferous
sensiferous
setiferous
siliciferous
somniferous
soniferous
soporiferous
spiciferous
spiniferous
spumiferous
stameniferous

stanniferous
stelliferous
stoloniferous
succiferous
sudoriferous
tentaculiferous
tergiferous
thuriferous
tuberiferous
umbelliferous
umbraculif-
 erous
umbriferous
vaporiferous
vasculiferous
vaciferous
zinciferous

Ifical
beatifical
delenifical

dolorifical

lanifical

specifical

Ificant
insignificant

mundificant

sacrificant

significant

Ificate
certificate

pontificate

significate

Ificent
magnificent

mirificent

munificent

Ificer
artificer

opificer

Ifluous
dulcifluous
fellifluous

ignifluous

mellifluous

sanguifluous

Ifragous
fedrifragous

ossifragous

saxifragous

Iftable
liftable

shiftable

IFTILY
shiftily thriftily

IFTINESS
shiftiness thriftiness

IFTLESSNESS
shiftlessness thriftlessness

IFUGAL
centrifugal febrifugal vermifugal

IGAMIST
bigamist polygamist trigamist

IGAMOUS
bigamous digamous polygamous trigamous

IGAMY
bigamy digamy polygamy trigamy

IGENOUS
alkaligenous indigenous omnigenous terrigenous
coralligenous lantiginous oxygenous uliginous
epigenous marigenous polygenous unigenous
fuliginous melligenous pruriginous vertiginous
gelatigenous montigenous sanguigenous vortiginous
ignigenous nubigenous

IGERATE
belligerate frigerate refrigerate

IGERENT
belligerent refrigerant

IGEROUS
aligerous crucigerous navigerous piligerous
armigerous dentigerous ovigerous plumigerous
belligerous immorigerous palpigerous proligerous
cirrigerous lanigerous pedigerous setigerous
coralligerous linigerous pennigerous spinigerous
cornigerous morigerous

IGGERY
piggery whiggery wiggery

IGHLANDER
highlander islander

Ightiness
almightiness flightiness mightiness

Ightliness
knightliness spriteliness unsightliness

Igian
Cantabrigian Phrygian Stygian

Igidly
frigidly rigidly

Igidness
frigidness rigidness

Igiousness
litigiousness prodigiousness religiousness

Igmatist
enigmatist stigmatist

Igmatize
enigmatize paradigmatize stigmatize

Ignancy
indignancy malignancy

Igneous
igneous ligneous

Ignify
dignify lignify signify undignify
ignify malignify

Ignity
benignity dignity indignity malignity

Igorous
rigorous vigorous

Igraphy
calligraphy lexigraphy poligraphy stratigraphy
epigraphy pasigraphy pseudepigraphy tachygraphy

Igulate
figulate ligulate

Iguous
ambiguous contiguous exiguous irriguous

ILEFULLY
guilefully · wilefully

ILEFULNESS
guilefulness · wilefulness

ILFULLY
skilfully · wilfully · unskilfully

ILFULNESS
skilfulness · wilfulness · unskilfulness

ILIA
memorabilia · notabilia · sedilia

ILIAD
chiliad · Iliad

ILIAN
Brazilian · crocodilian · perfectibilian · secilian
Castilian · Kurilian · reptilian · Virgilian
Cecelian · lacertilian

ILIARY
atrabiliary · auxiliary

ILIATE
affiliate · domiciliate · filiate · humiliate
conciliate

ILICAL
basilical · filical · silicle · umbilical

ILIFY
fossilify · nobilify · stabilify · vilify

ILIO
pulvilio · punctilio

ILIOUS
atrabilious · bilious · punctilious · supercilious

ILITATE
abilitate · habilitate · militate · rehabilitate
debilitate · impossibilitate · nobilitate · stabilitate
facilitate

Ility
ability
absorbability
accendibility
acceptability
accessibility
accountability
acquirability
adaptability
addibility
admirability
admissibility
adoptability
adorability
advisability
affability
affectibility
agility
agreeability
alienability
alterability
amenability
amiability
amicability
amissibility
anility
appetibility
applicability
assimilability
associability
attainability
attemptability
attractability
audibility
availability
capability
changeability
civility
cognoscibility
cohesibility
combustibility
communi-
 cability

commutability
compatibility
comprehensi-
 bility
compressibility
computability
conceivability
condensability
conducibility
conductability
conformability
confusability
contempti-
 bility
contractibility
contractility
convertibility
corrigibility
corrodibility
corrosibility
credibility
creditability
crocodility
culpability
curability
damnability
debility
deceptibility
deducibility
defectibility
demisability
demonstra-
 bility
deplorability
descendibility
despicability
desirability
destructibility
determinability
detestability
diffusibility
digestibility

dilatability
disability
dissolubility
dissolvability
distensibility
divisibility
docibility
docility
ductility
durability
edibility
educability
eligibility
equability
exchange-
 ability
excitability
exhaustibility
expansibility
extensibility
facility
fallibility
feasibility
fermentability
fertility
fictility
flexibility
flucility
fluctability
fluxibility
formidability
fossility
fragility
frangibility
friability
fusibility
futility
generability
gentility
gracility
gullibility
habitability

hostility
humility
ignobility
illability
imbecility
imitability
immeability
immeasur-
 ability
immiscibility
immovability
immutability
impalpability
impartibility
impassibility
impeccability
impenetrability
impercepti-
 bility
imperdibility
impermeability
imperturb-
 ability
imperviability
implacability
impossibility
impregnability
imprescripti-
 bility
impressibility
impressiona-
 bility
improbability
imputability
inability
inaccessibility
incivility
incogitability
incognosci-
 bility
incombusti-
 bility

[LITY—(*Cont.*)

incommensura-
bility
incommunica-
bility
incommuta-
bility
incompatibility
incomprehensi-
bility
incompressi-
bility
inconceiva-
bility
incondensa-
bility
incontroverti-
bility
inconverti-
bility
incorrigibility
incorrupti-
bility
incredibility
incurability
indefatiga-
bility
indefeasibility
indefectibility
indelibility
indemonstra-
bility
indestructi-
bility
indigestibility
indiscerpibility
indiscerpti-
bility
indispensa-
bility
indisputability
indissolubility
indivisibility

indocibility
indocility
inductility
ineffability
ineffervesci-
bility
ineligibility
inevitability
inexhausti-
bility
inexorability
inexplicability
infallibility
infeasibility
infertility
inflammability
inflexibility
infrangibility
infusibility
inhability
inheritability
inimitability
innumbera-
bility
insanability
insatiability
insensibility
inseparability
insociability
insolubility
instability
insuperability
insurmounta-
bility
insuscepti-
bility
intangibility
intelligibility
interchangea-
bility
intractability
inutility

invendibility
invincibility
inviolability
invisibility
invulnerability
irascibility
irreconcila-
bility
irreductibility
irremovability
irreparability
irresistibility
irresponsibility
irritability
juvenility
lability
laminability
laudability
legibility
liability
malleability
manageability
memorability
mensurability
miscibility
mobility
modifiability
modificability
motility
movability
mutability
navigability
negotiability
neurility
nihility
nobility
notability
nuvility
opposability
organizability
ostensibility
palpability

partibility
passibility
peccability
penetrability
pensility
perceptibility
perdurability
perfectibility
permissibility
persuasibility
perturbability
placability
plausibility
pliability
ponderability
ponibility
portability
possibility
practicability
precipitability
preferability
prescriptibility
preventability
probability
producibility
puerility
quotability
ratability
readability
receivability
receptibility
redeemability
reductibility
reflexibility
refragability
refrangibility
refutability
reliability
remissibility
removability
remunera-
bility

Ility—(*Cont.*)

renewability
reparability
repealability
resistibility
resolvability
respectability
responsibility
reversibility
revocability
risibility
saleability
salvability
sanability
satiability
scurrility
senility
sensibility
separability
servility

sociability
solubility
solvability
sportability
squeezability
stability
sterility
suability
subtility
suitability
susceptibility
suspensibility
tactility
tamability
tangibility
taxability
temptability
tenability

tensibility
tensility
tolerability
torsibility
tractability
tractility
tranquillity
transferability
transmissibility
transmuta-
 bility
transporta-
 bility
unaccounta-
 bility
unbelievability
unutterability
utility

vaporability
variability
vegetability
vendibility
venerability
verisimility
vernility
versability
versatility
viability
vibratility
vindicability
virility
visibility
volatility
volubility
vulnerability
writability

Ilkier
milkier silkier

Ilkiest
milkiest silkiest

Illable
distillable syllable tillable fillable

Illager
pillager villager

Illery
artillery codicillary Hilary pillory
capillary distillery phyllary Sillery
cilery

Illeted
billeted filleted unfilleted

Illeting
billeting filleting

Illiancy
brilliancy resiliency transiliency

ILLIEST
chilliest hilliest silliest stilliest

ILLINESS
chilliness hilliness silliness

ILLINGLY
thrillingly willingly trillingly "killingly"

ILOGIZE
epilogize syllogize

ILOGISM
epilogism episyllogism syllogism

ILLOWING
billowing pillowing

ILLOWY
billowy pillowy willowy

ILOBITE
tilobite stylobite

ILOGY
antilogy dilogy palilogy trilogy
brachylogy fossilogy

ILOQUENCE
blandiloquence grandiloquence somniloquence vaniloquence
breviloquence magniloquence stultiloquence

ILOQUENT
flexiloquent melliloquent stultiloquent vaniloquent
grandiloquent pauciloquent sauviloquent veriloquent
magniloquent sanctiloquent

ILOQUISM
gastriloquism pectoriloquism somniloquism ventriloquism

ILOQUIST
dentriloquist gastriloquist somniloquist ventriloquist

ILOQUIZE
soliloquize ventriloquize

ILOQUOUS
grandiloquous pectoriloquous ventriloquous somniloquous
magniloquous

Iloquy
dentiloquy	pectoriloquy	somniloquy	sauviloquy
gastriloquy	soliloquy	stultiloquy	ventriloquy
pauciloquy			

Imanous
longimanous	pedimanous

Imary
primary	rhymery	sublimary

Imature
climature	limature

Imbricate
fimbricate	imbricate

Imerous
dimerous	polymerous

Imeter
alkalimeter	gravimeter	polarimeter	scimiter
altimeter	limiter	pulsimeter	tasimeter
calorimeter	lucimeter	rhysimeter	trimeter
dasymeter	pelvimeter	saccharimeter	velocimeter
dimeter	perimeter	salimeter	zymosimeter
focimeter	planimeter		

Imetry
alkalimetry	calorimetry	planimetry	saccharimetry
asymmetry	isoperimetry	polarimetry	symmetry
bathymetry	longimetry		

Imical
inimical	homonymical	metonymical	mimical
alchymical			

Iminal
criminal	regiminal	viminal

Iminess
griminess	sliminess

Iminate
accriminate	discriminate	incriminate	recriminate
criminate	eliminate	indiscriminate	

IMINOUS
criminous moliminous

IMINI
nimini-pimini postliminy "gimminy"

IMITY
anonymity magnanimity pseudonymity sublimity
dimity parvanimity pusillanimity unanimity
equanimity proximity sanctanimity

IMPERER
simperer whimperer

IMPERING
simpering whimpering

IMULATE
assimulate dissimulate simulate stimulate

IMULUS
limulus stimulus

INABLE
combinable definable inclinable indefinable
assignable designable indeclinable signable
declinable finable

INAMENT
linament liniment miniment

INATIVE
combinative finative

INDERY
cindery tindery

INERY
alpinery finery quinary swinery
binary pinery refinery vinery
finary

INDICATE
indicate syndicate vindicate

INEAL
consanguineal gramineal lineal pineal
finial interlineal pectineal stamineal

INEOUS
cartilagineous | fulmineous | minious | stramineous
consanguineous | gramineous | sanguineous | testudineous
flamineous | ignominious | stamineous | vimineous

INGENCY
astringency | contingency | refringency | stringency

INGERER
fingerer | lingerer | malingerer

INGERING
fingering | lingering | malingering

INGIAN
Carlovingian | Merovingian | Thuringian | Zingian

INGILY
dingily | stingily

INGINESS
springiness | stringiness | "ringiness"

INGINESS
dinginess | stinginess

INIAN
Abyssinian | Britinian | Delphinian | Sardinian
anthropo- | Carolinian | Eleusinian | serpentinian
 phaginian | Carthaginian | Hercynian | Socinian
Arminian | Czarinian | Justinian | viraginian
Augustinian | Darwinian | Palestinian | Virginian

INIATE
laciniate | delineate | lineate | miniate

INICLE
adminicle | Brahminical | dominical | pinnacle
binnacle | clinical | finical | sinical
binocle | cynical | flaminical | synclinical

INIER
brinier | shinier | spinier | tinier

INIEST
briniest | shiniest | spiniest | tiniest

INIFORM
actiniform aluminiform laciniform

INIKIN
finikin minikin

INISHING
diminishing finishing

INISTER
administer minister sinister

INISTRAL
ministral sinistral

INITY
affinity femininity peregrinity trinity
alkalinity infinity salinity vicinity
asininity Latinity sanguinity viraginity
consanguinity masculinity satinity virginity
divinity patavinity

INKABLE
drinkable undrinkable unsinkable unthinkable
thinkable unshrinkable

INKINESS
inkiness kinkiness pinkiness "slinkincss"

INLANDER
Finlander inlander

INNACLE
binnacle binocle finnical

INOLINE
chinoline crinoline

INQUITY
longinquity propinquity

INTEREST
interest winterest splinterest

INTERY
printery splintery wintery

INTHIAN
absinthian Corinthian hyacinthian labyrinthian

Inuate
continuate insinuate sinuate "whin you ate"

Inuous
continuous sinuous

Iocene
miocene pliocene post-pliocene

Iola
variola viola Iola

Iolet
triolet violet

Iolist
sciolist violist

Iolus
gladiolus sciolus variolus

Iope
Calliope myopy presbyopy

Iparous
biparous frondiparous omniparous sudoriparous
criniparous fructiparous oviparous tomiparous
deparous gemelliparous ovoviviparous uniparous
fissiparous gemmiparous polyparous vermiparous
floriparous larviparous polypiparous viviparous
sebiparous multiparous

Ipathist
antipathist somnipathist

Ipathy
antipathy kinesipathy somnipathy

Ipedal
equipedal solipedal

Iphony
antiphony exyphony polyphony

Iplicate
sesquiplicate triplicate

Ipotence
armipotence ignipotence omnipotence plenipotence

IPOTENT
armipotent ignipotent omnipotent plenipotent
bellipotent multipotent

IPPERY
frippery slippery

IPTEROUS
dipterous peripterous tripterous

IPTICAL
elliptical apocalyptical cryptical

IPULATE
astipulate manipulate stipulate

IQUITOUS
iniquitous ubiquitous

IQUITY
antiquity iniquity obliquity ubiquity

IRABLE
acquirable expirable requirable transpirable
desirable perspirable respirable untirable

IRACY
conspiracy deliracy

IRACY
piracy retiracy

IRCULAR
circular furcular tubercular

IRCULATE
circulate tuberculate

IREFULNESS
direfulness irefulness

YRIAN
Assyrian Styrian Syrian Tyrian

IRICAL
empirical lyrical miracle satirical

IRICISM
empiricism lyricism

IRIOUS
delirious Sirius "weary us" (etc.)

IRIUM, YRIUM, YREUM
collyrium delirium empyreum

IRONY
irony gyronny

IRTHLESSNESS
mirthlessness worthlessness

ISABLE
advisable devisable magnetizable realizable
analysable electrolysable organizable recognizable
crystallizable excisable oxidizable sizable
demisable exercisable prizable vaporizable
despisable

ISCENCY
reminiscency reviviscency

ISIAN
Frisian Paradisean Parisian precisian
Elysian

ISIBLE
acquisible indivisible invisible visible
divisible

ISICAL
metaphysical phthisical physical psychophysical
paradisical

ISITOR
acquisitor inquisitor requisitor visitor

ISIVELY
decisively derisively incisively indecisively

ISIVENESS
decisiveness derisiveness incisiveness indecisiveness

ISKIEST
friskiest riskiest

ISORY
decisory derisory incisory spicery

Isory
advisory
irrisory

provisory

revisory

supervisory

Issible
admissible
amissible
immiscible

incommiscible
irremissible
miscible

omissible
permiscible
permissible

remissible
scissible
transmissible

Issimo
bravissimo
fortissimo

generalissimo

pianissimo

prestissimo

Issory
admissory
dismissory

emissory

remissory

rescissory

Istency
consistency
distancy

existency
inconsistency

persistency
pre-existency

subsistency

Istener
christener

listener

Istening
christening

glistening

listening

unlistening

Istical
agonistical
alchemistical
antagonistical
antarchistical
aoristical
apathistical
aphoristical
artistical
atheistical

cabalistical
Calvinistical
casuistical
catechistical
characteristical
chemistical
deistical
dialogistical
egoistical

egotistical
eucharistical
eulogistical
euphemistical
hemistichal
linguistical
methodistical
mystical

paragraph-
 istical
pietistical
puristical
sophistical
statistical
theistical
theosophistical

Isticate
dephlogisticate

sophisticate

Istlessness
listlessness

resistlessness

Istory
consistory

history

mystery

ITABLE

citable	incitable	lightable	unitable
excitable	indictable	requitable	writable
ignitible			

ITATIVE

excitative	incitative	writative

ITCHERY

bewitchery	michery	stitchery	witchery

ITCHINESS

itchiness	pitchiness

ITEFULLY

spitefully	delightfully	frightfully	rightfully

ITERATE

illiterate	literate	reiterate	transliterate
iterate	obliterate		

ITHERWARD

hitherward	thitherward	whitherward

ITHESIS

antithesis	epithesis

ITHESOMELY

blithesomely	lithesomely

ITHESOMENESS

blithesomeness	lithesomeness

ITIATE

initiate	novitiate	patriciate	vitiate
maleficiate	officiate	propitiate	

ITICAL

Abrahamitical	critical	hypercritical	political
acritical	diacritical	hypocritical	pulpitical
anchoritical	electrolytical	Jesuitical	soritical
cosmopolitical	hermitical	Levitical	thersitical

ITIGANT

litigant	mitigant

ITIGATE

litigate	mitigate

ITIONAL

additional	dispositional	positional	suppositional
commissional	disquisitional	prepositional	traditional
conditional	inquisitional	propositional	transpositional
definitional	intuitional	repetitional	volitional

ITIONER

admonitioner	commissioner	missioner	træditioner
coalitioner	exhibitioner	practitioner	

ITIONIST

abolitionist	exhibitionist	oppositionist	requisitionist
coalitionist	expeditionist	prohibitionist	traditionist

ITIOUSNESS

adventitious-ness	expeditiousness	maliciousness	seditiousness
auspiciousness	fictiousness	meretricious-ness	superstitious-ness
avariciousness	flagitiousness	perniciousness	suspiciousness
capriciousness	inauspicious-ness	propitiousness	viciousness
deliciousness	judiciousness		

ITTABLE

admittable	irremittable	quittable	transmittable
fittable	knittable		

ITTANY

dittany	litany	"kitteny"

ITTEREST

bitterest	embitterest	fritterest	glitterest

ITTERING

bittering	frittering	glittering	tittering
embittering	twittering		

ITTILY

grittily	prettily	wittily

ITTINESS

flittiness	grittiness	prettiness	wittiness

ITTLENESS

brittleness	littleness

ITUAL

habitual	obitual	ritual

ITUATE
habituate lituate situate

ITULAR
capitular titular

IVABLE
forgivable givable livable unforgivable

IVABLE (long)
contrivable deprivable derivable revivable

IVALENT
equivalent omnivalent trivalent univalent
multivalent quinquivalent

IVANCY
connivancy survivancy

IVATIVE
derivative privative

IVILLER
civiller driveller sniveller

IVERER
deliverer quiverer shiverer

IVERING
delivering quivering shivering

IVERY
delivery jail-delivery rivery shivery
goal-delivery livery

IVIAL
convivial oblivial quadrivial trivial
lixivial

IVIDNESS
lividness vividness

IVIOUS
bivious lixivious multivious oblivious
lascivious

IVITY

absorptivity	conductivity	nativity	proclivity
acclivity	declivity	negativity	productivity
activity	festivity	objectivity	receptivity
captivity	impassivity	passivity	relativity
causativity	incogitativity	perceptivity	sensitivity
cogitativity	instinctivity	positivity	subjectivity
collectivity	motivity	privity	

IVOCAL

equivocal	univocal

IVOROUS

carnivorous	graminivorous	omnivorous	piscivirous
equivorous	granivorous	ossivorous	sanguinivorous
frugivorous	herbivorous	panivorous	vermivorous
fucivorous	insectivorous	phytivorous	

IVORY

ivory	vivary

IXABLE

fixable	mixable

IXITY

fixity	prolixity	siccity

IZZIER

dizzier	busier	frizzier

IZZIEST

dizziest	busiest

IZZILY

dizzily	busily

OBBERING

clobbering	slobbering

OBBERY

bobbery	robbery	snobbery	stock-jobbery
jobbery	slobbery		

OBINET

robinet	bobbinet

OBULAR
globular lobular

OCALISM
localism vocalism

OCALIZE
focalize localize vocalize

OCATIVE
locative provocative

OCHROMY
heliochromy metallochromy monochromy stereochromy

OCHRONOUS
isochronous tautochronous

OCINATE
patrocinate ratiocinate

OCIOUSNESS
atrociousness ferociousness precociousness

OCKERY
crockery mockery rockery

OCKINESS
"cockiness" rockiness stockiness

OCRACY
aristocracy gynæcocracy neocracy shopocracy
arithmocracy hagiocracy nomocracy slavocracy
autocracy hierocracy ochlocracy snobocracy
cottonocracy hypocrisy pantisocracy stratocracy
democracy idiocrasy pedantocracy theocracy
demonocracy logocracy plantocracy theocrasy
despotocracy mobocracy plousiocracy timocracy
gernotocracy monocracy plutocracy

OCRATISM
democratism Socratism

OCTORSHIP
doctorship proctorship

OCULAR
binocular	locular	ocular	vocular
jocular	monocular		

ODDERING
doddering	foddering

ODIAL
allodial	episodial	prosodial	thenodial
custodial	palinodial		

ODIAN
custodian	Herodian	prosodian	Rhodian

ODICAL
codical	monodical	prosodical	spasmodical
episcodical	nodical	rhapsodical	synodical
methodical	periodical		

ODIFY
codify	modify

ODIOUS
commodious	incommodious	melodious	odious

ODITY
commodity	incommodity	oddity

ODIUM
odium	sodium

ODULAR
modular	nodular

OFFERING
offering	peace-offering	proffering

OGAMIST
deuterogamist	misogamist	monogamist	neogamist

OGAMOUS
endogamous	heterogamous	phænogamous	phanerogamous
exogamous	monogamous		

OGAMY
cœnogamy	endogamy	misogamy	monogamy
deuterogamy	exogamy		

OGATIVE
derogative	interrogative	prerogative

OGENIST

| abiogenist | beterogenist | monogenist | philogynist |
| biogenist | misogynist | | |

OGENOUS

| endogenous | hydrogenous | lithogenous | pyrogenous |
| exogenous | hypogynous | nitrogenous | thermogenous |

OGENY

abiogeny	heterogeny	odontogeny	photogeny
anthropogeny	histogeny	ontogeny	phylogeny
biogeny	homogeny	osteogeny	progeny
embryogeny	hymenogeny	pathogeny	zoögeny
ethnogeny	misogyny	philogyny	
geogeny	monogeny		

OGEYISM

| bogeyism | fogeyism | | |

OGIAN

| archæologian | gambogian | mythologian | philogian |
| astrologian | geologian | neologian | theologian |

OGICAL

aërological	etiological	odontological	selenological
amphibiological	etymological	organological	semeiological
amphibological	genealogical	ornithological	sinological
analogical	geological	orological	sociological
anthological	glossological	osteological	spectrological
anthropological	glottological	palæontological	symbological
archæological	homological	pantological	synagogical
astrological	hydrological	paralogical	tautological
bibliological	ichnological	penological	technicological
biological	ideological	perissological	technological
bryological	illogical	petrological	teleological
chronological	lithological	philological	teratological
climatological	logical	phraseological	terminological
conchological	mazological	phrenological	theological
cosmological	metalogical	physiological	toxicological
craniological	meteorological	phytological	tropological
demagogical	mythological	pneumato-	universological
deontological	necrological	logical	zoölogical
dialogical	neological	pomological	zoöphytological
doxological	neurological	psychological	zymological
Egyptological	nosological		

OGNOMY
craniognomy pathognomy physiognomy

OGONIST
cosmogonist theogonist

OGONY
autogony geogony physiogony zoögony
cosmogony pathogony theogony

OGRAPHER
autobiographer ethnographer hymnographer palæographer
bibliographer geographer iambographer petrographer
biographer glossographer lexicographer photographer
calcographer glyphographer lichenographer psalmographer
cartographer glyptographer lithographer selenographer
chartographer haliographer logographer sphenographer
chorographer heresiographer mimographer stenographer
chronographer hierographer monographer topographer
cosmographer historiographer mythographer typographer
cryptographer horologiog- nomographer zylographer
crystal- rapher orthographer zincographer
lographer hydrographer osteographer zoögrapher

OGRAPHIST
chirographist metallogra- palæographist sphenographist
lichenogra- phist phonographist steganographist
phist monographist photographist topographist
mechanogra- museographist psalmographist uranographist
phist organographist selenographist zoögraphist
orthographist siderographist

OGRAPHY
anthography chirography chromoxylog- galvanography
anthropog- chorography raphy geography
raphy Christianog- climatography glossography
autobiography raphy cosmography glyphography
autography chromatog- cryptography glyptography
balneography raphy crystallography gypsography
bibliography chromophotog- dactyliography hagiography
biography raphy demography haliography
cacography chromotypog- dendrography heliography
calcography raphy epistolography heliotypog-
chartography ethnography raphy

Ography—(*Cont.*)

hematography
heresiography
hetersiography
hierography
histography
historiography
horography
horologiog-
 raphy
hyalography
hydrography
hyetography
hymnography
ichnography
ichthyography
iconography
ideography
isography
lexicography
lichenography
lithography
logography
mechanog-
 raphy
metallography

microcosmog-
 raphy
monography
neography
neurography
nomography
nosography
numismatog-
 raphy
odontography
ophiography
oreography
organography
orography
orthography
osteography
palæography
palæontog-
 raphy
paneiconog-
 raphy
pantography
perspectog-
 raphy

petrography
phantasmatog-
 raphy
pharmacog-
 raphy
phonography
photography
phycography
physiography
phytography
plastography
pneumography
pornography
potamography
psalmography
pseudography
psychography
pterylography
rhyparography
scenography
sciography
seismography
selenography
semeiography

siderography
sphenography
steganography
stelography
stenography
stereography
stereotypog-
 raphy
stratography
stylography
symbolæog-
 raphy
tacheography
thermography
topography
toreumatog-
 raphy
topography
uranography
xylography
xylopyrography
zincography
zoögraphy

Ointedly

disjointedly pointedly

Oistering

cloistering roistering

Oical

egoical heroical stoical

Okenly

brokenly outspokenly

Olable

consolable controllable rollable tollable

Olarize

polarize solarize

OLARY
bolary polery solary volary
cajolery

OLATER
bibliolater iconolater mariolater pyrolater
heliolater idolater

OLATROUS
idolatrous symbolatrous

OLATRY
anthropolatry gyneolatry litholatry pyrolatry
astrolatry heliolatry lordolatry symbolatry
bibliolatry hierolatry mariolatry thaumatolatry
cosmolatry ichthyolatry necrolatry topolatry
demonolatry idiolatry ophiolatry zoölatry
geolatry idolatry physiolatry

OLEFULNESS
dolefulness soulfulness

OLEUM
linoleum petroleum

OLIA
magnolia melancholia

OLIAN
Æolian Creolean metabolian Pactolian
capitolian melancholian Mongolian

OLIATE
foliate infoliate spoliate

OLICAL
apostolical catholical hyperbolical symbolical
bibliopolical diabolical parabolical

OLICSOME
frolicsome rollicksome

OLIDLY
solidly squalidly stolidly

OLIER
holier lowlier unholier

Oliest
holiest lowliest

Olify
idolify mollify qualify

Oliness
holiness lowliness shoaliness unholiness

Olio
folio olio portfolio

Olisher
abolisher demolisher polisher

Olishing
abolishing demolishing polishing

Olity
frivolity inequality isopolity polity
equality interpolity jollity quality

Olium
scholium trifolium

Ollified
qualified mollified unqualified

Ollower
follower hollower swallower wallower

Ollowing
following hollowing swallowing wallowing
holloing

Ologer
astrologer geologer philologer physiologer
acknowledger horologer phonologer "sockdolager"
botanologer mythologer phrenologer theologer
etymologer osteologer

Ologist
aërologist biologist demonologist embryologist
agriologist campanologist deontologist entomologist
anthropologist chronologist dendrologist ethnologist
apologist conchologist dermatologist ethologist
archæologist cosmologist ecclesiologist etymologist
Assyriologist craniologist Egyptologist galvanologist
battologist crustaceologist electro-biologist geologist

OLOGIST—(*Cont.*)

glossologist
glottologist
gypsologist
hagiologist
hierologist
histologist
horologist
hydrologist
hymnologist
hypnologist
ichthyologist
ideologist
lexicologist
lithologist
mantologist
martyrologist
mazologist
meteorologist
monologist
morphologist
mycologist

myologist
necrologist
neologist
neurologist
noölogist
nosologist
numismatolo-
 gist
oneirologist
onomatologist
ontologist
oölogist
ophiologist
orchidologist
ornithologist
orologist
osteologist
palæoethnolo-
 gist
palæologist
palæontologist

palætiologist
pantheologist
pantologist
pathologist
petrologist
pharmacologist
philologist
phonologist
photologist
phraseologist
phrenologist
physiologist
phytolitholo-
 gist
phytologist
phytopatholo-
 gist
pneumatologist
pomologist
pseudologist
psychologist

pteridologist
pyrologist
quinologist
runologist
saintologist
sarcologist
seismologist
sinologist
sociologist
symbologist
tautologist
technologist
teleologist
teratologist
theologist
thereologist
therologist
toxicologist
universologist
vulcanologist
zoölogist

OLOGIZE

apologize
astrologize
battologize

doxologize
entomologize
etymologize

geologize
mythologize
neologize

philologize
tautologize
theologize

OLOGOUS

heterologous

homologous

isologous

tautologous

OLOGY

actinology
conchology
conchyliology
cosmology
craniology
cryptology
dactyliology
dactylology
demonology
dendrology
deontology
dermatology

desmology
dialectology
dicæology
dittology
dosology
doxology
ecclesiology
Egyptology
electro-biology
electrology
electro-physi-
 ology

embryology
emetology
emmenology
endemiology
enteradenology
enterology
entomology
entozoölogy
epidemiology
epistemology
eschatology
ethnology

ethology
etiology
etymology
filicology
fossilology
fungology
galvanology
gastrology
genesiology
geology
giantology
glossology

Ology—(*Cont.*)

glottology
gnomology
graphiology
gynæcology
gypsology
hagiology
heterology
hierology
histology
historiology
homology
horology
hydrology
hyetology
hygiology
hygrology
hylology
hymenology
hymnology
hypnology
hysterology
ichnolithnology
ichnology
ichorology
ichthyology
iconology
ideology
insectology
kinology
laryngology
leptology
lexicology
lichenology
lithology
liturgiology
macrology
malacology
mantology
martyrology
mastology
mateology
mazology

membranology
menology
meteorology
methodology
metrology
miasmology
microgeology
micrology
misology
monadology
monology
morphology
muscology
mycology
myology
mythology
necrology
neology
nephrology
neurology
neurypnology
nomology
noölogy
nosology
numismatology
oceanology
odontology
ology
oneirology
onology
onomatology
oölogy
ophiology
ophthalmology
orchidology
organology
orismology
ornithichnology
ornithology
orology
osmonosology
osteology

otology
ourology
ovology
palæothenology
paleology
palæontology
palæophy-
 tology
palæozoölogy
palætiology
pantheology
pantology
paradoxology
parasitology
parisology
paromology
parthenology
pathology
patronomatol-
 ogy
penology
periodology
perissology
petrology
pharmacology
pharology
pharyngology
phenomenol-
 ogy
philology
phlebology
phonology
photology
phraseology
phrenology
phycology
physiology
phytolithology
phytology
phytopathology
phyto-physiol-
 ogy

pneumatology
pneumology
pomology
ponerology
posology
potamology
protophytol-
 ogy
psilology
psychology
psychonosology
pteridology
punnology
pyretology
pyritology
pyrology
quinology
runology
sarcology
seismology
selenology
sematology
semeiology
sinology
sitology
skeletology
sociology
somatology
soteriology
spasmology
speciology
spectrology
spermatology
spermology
splanchnology
splenology
statistology
stoichiology
stromatology
symbology
symptomatol-
 ogy

OLOGY--(*Cont.*)

synchronology	terminology	threpsology	uranology
syndesmology	termonology	tidology	urology
systematology	testaceology	topology	uronology
tautology	thanatology	toreumatology	vulcanology
taxology	theology	toxicology	zoölogy
technology	thereology	tropology	zoöphytology
teleology	thermology	typology	zymology
teratology	therology	universology	

OLUBLE

insoluble	soluble	voluble

OLUTIVE

evolutive	revolutive	solutive	supervolutive

OLVABLE

absolvable	indissolvable	resolvable	solvable
dissolvable	insolvable		

OLVENCY

insolvency	revolvency	solvency

OMACHY

alectoromachy	iconomachy	monomachy	sciomachy
alectryomachy	logomachy	psychomachy	theomachy
gigantomachy			

OMANY

bibliomany	erotomany	Romany

OMATHY

chrestomathy	philomathy	pharmacom- athy

OMATISM

achromatism	chromatism	diplomatism

OMENA

antilegomena	paralipomena	phenomena	prolegomena

OMENON

phenomenon	prolegomenon

OMEROUS

glomerous	isomerous

OMETER

absorptiometer
barometer
chronometer
actinometer
altometer
astrometer
audiometer
bathometer
cephalometer
chartometer
chromatometer
clinometer
craniometer
declinometer
dendrometer
drosometer
dynamometer
echometer
electrometer
endosmometer

eudiometer
galvanometer
geometer
geothermom-
 eter
goniometer
graphometer
heliometer
horometer
hydrometer
hygrometer
hypsometer
lactometer
logometer
macrometer
magnetometer
micrometer
micronometer
monometer
nauropometer

odometer
oleometer
ombrometer
optometer
ozonometer
pantometer
pedometer
phonometer
photometer
piezometer
planometer
platometer
pluviometer
pneumatometer
pulsometer
pyrometer
radiometer
refractometer
rheometer

saccharometer
salinometer
seismometer
sepometer
sonometer
spectrometer
spherometer
stereometer
stethometer
stratometer
tachometer
tannometer
thermometer
tribometer
trochometer
udometer
vinometer
volumenometer
zymometer

OMETRY

barometry
biometry
chronometry
craniometry
eudiometry
galvanometry
gasometry
geometry
goniometry

helicometry
horometry
hydrometry
hygrometry
hypsometry
Mahometry
micrometry
odometry

orthometry
ozonometry
pathometry
photometry
planeometry
phanometry
pneumometry
polygonometry

pyrometry
rheometry
saccharometry
seismometry
stereometry
stichometry
stoichiometry
trigonometry

OMICAL

agronomical
amphidromical
astronomical

atomical
comical
coxcombical

domical
economical

iconomical
tragi-comical

OMINAL

abdominal
cognominal

nominal

prenominal

surnominal

OMINANCE

dominance

predominance

prominence

Ominant

dominant predominant	prominent	subdominant	superdominant

Ominate

abominate	comminate	nominate	predominate
agnominate	denominate	ominate	prenominate
annominate	dominate		

Ominy

hominy	dominie		

Ominous

abnominous dominus	hypomenous	ominous	prolegomenous

Onable

lonable	tonable	unatonable	

Onderer

ponderer	squanderer	wanderer	

Ondering

pondering	squandering	unwandering	wandering

Onia

Adonia	aphonia	bryonia	valonia
ammonia	begonia	pneumonia	

Oniac

demoniac	simoniac		

Onial

baronial	demonial	monial	sanctimonial
ceremonial	intercolonial	oxygonial	testimonial
colonial	matrimonial	patrimonial	

Onian

Amazonian	Chelonian	Gorgonean	Newtonian
ammonian	Ciceronian	Grandisonian	Oxonian
Aonian	colophonian	halcyonian	Patagonian
Ausonion	Cottonian	Heliconian	Plutonian
Babylonian	Daltonian	Ionian	Pyrrhonian
Baconian	demonian	Johnsonian	Sardonian
bezonian	Devonian	Laconian	Serbonian
Caledonian	Draconian	Livonian	Simonian
Cameronian	Etonian	Macedonian	Slavonian
Catonian	Favonian	Myrmidonian	Thessalonian

ONICA
harmonica veronica

ONICAL

antichronical	chronicle	harmonical	tautophonical
antiphonical	conical	iconical	thrasonical
architectonical	diaphonical	ironical	tonical
Babylonical	euphonical	Sorbonnical	uncanonical
canonical	geoponical	synchronical	

ONICISM
histrionicism laconicism Teutonicism

ONICON
chronicon harmonicon

ONIOUS

acrimonious	euphonious	matrimonious	simonious
alimonious	felonious	parsimonious	symphonious
ceremonious	harmonious	querimonious	ultroneous
erroneous	inharmonious	sanctimonious	

ONISHING
admonishing astonishing monishing

ONISHMENT
admonishment astonishment premonishment

ONIUM

| harmonium | pelargonium | stramonium | zirconium |
| pandemonium | | | |

ONOGRAPH
chronograph monograph

ONOMIST

| agronomist | demonomist | eponymist | synonymist |
| autonomist | economist | gastronomist | |

ONOMIZE
astronomize economize

ONOMY

agronomy	Deuteronomy	heteronomy	phytonomy
astronomy	economy	isonomy	taxonomy
autonomy	gastronomy	morphonomy	toponomy
dactylonomy	geonomy	nosonomy	zoönomy

Onymous

anonymous	heteronymous	paronymous	pseudonymous
autonomous	homonymous	polyonymous	synonymous
eponymous			

Onymy

| homonymy | paronymy | polyonymy | synonymy |
| metonymy | | | |

Ookery

| bookery | cookery | rookery | |

Oominess

| gloominess | roominess | | |

Oonery

| buffoonery | cocoonery | pantaloonery | poltroonery |

Ootery

| freebootery | fruitery | rootery | |

Opathist

| allopathist | hydropathist | hylopathist | somnopathist |
| homœopathist | | | |

Opathy

allopathy	hydropathy	monopathy	theopathy
enantiopathy	ideopathy	neuropathy	somnopathy
heteropathy	isopathy	psychopathy	leucopathy
homœopathy			

Opery

| popery | ropery | | |

Ophagi

| androphagi | cardophagi | hippophagi | Lotophagi |
| anthropophagi | heterophagi | lithophagi | sarcophagi |

Ophagist

| galactophagist | hippophagist | ichthyophagist | pantophagist |
| geophagist | | | |

Ophagous

androphagous	hippophagous	ophiophagous	sarcophagous
batrachopha-	hylophagous	pantophagous	sarcophagus
gous	lithophagous	phytophagous	xylophagous
galactophagous	necrophagous	saprophagous	zoöphagous
geophagous	œsophagous		

Oᴘʜᴀɢʏ
anthropophagy hippophagy pantophagy xerophagy
chthonophagy ichthyophagy phytophagy

Oᴘʜɪᴄᴀʟ
philosophical theosophical trophical

Oᴘʜɪʟɪsᴍ
bibliophilism necrophilism Russophilism

Oᴘʜɪʟɪsᴛ
bibliophilist Russophilist zoöphilist

Oᴘʜᴏɴᴏᴜs
cacophonous hydrophanous megalophonous pyrophanous
homophonous hygrophanous monophanous

Oᴘʜᴏɴʏ
cacophony microphony photophony tautophony
homophony orthophony satanophany theophany
laryngophony

Oᴘʜᴏʀᴏᴜs
actinophorous galactophorous mastigophorous pyrophorous
adenophorous isophorous phyllophorous zoöphorous
electrophorous

Oᴘɪᴀ
Ethiopia myopia presbyopia Utopia

Oᴘɪᴀɴ
Esopian Ethiopian Fallopian Utopian
Carnopean

Oᴘɪᴄᴀʟ
allotropical metoposcopical misanthropical topical
extropical microscopical subtropical tropical

Oᴘɪɴᴇss
ropiness soapiness dopiness

Oᴘɪsʜɴᴇss
mopishness popishness

Oᴘᴏʟɪs
acropolis metropolis necropolis

Oᴘᴏʟɪsᴛ
bibliopolist monopolist pharmacopolist

OPOLITE
cosmopolite metropolite

OPPERY
coppery foppery

OPPINESS
choppiness sloppiness soppiness

OPSICAL
dropsical mopsical

OPTEROUS
lepidopterous macropterous orthopterous

OPTICAL
autoptical optical

OPULATE
copulate populate

ORABLE
adorable deplorable explorable restorable

ORATIVE
explorative restorative

ORCEABLE
divoreable enforceable forcible

ORDERING
bordering ordering

ORDIAL
cordial exordial primordial

ORDINATE
co-ordinate insubordinate ordinate subordinate
foreordinate

ORDIAN
Gordion accordion

ORGANIZE
organize gorgonize

ORIA
aporia infusoria scoria victoria
dysphoria phantasmagoria

ORIAL

accessorial
accusatorial
adaptorial
admonitorial
amatorial
ambassadorial
ancestorial
arboreal
armorial
assessorial
auditorial
authorial
boreal
censoria
commentatorial
compromis-
 sorial
compurgatorial
consistorial
corporeal
cursorial
dedicatorial
dictatorial

directorial
disquisitorial
editorial
electorial
equatoreal
executorial
expurgatorial
exterritorial
factorial
fossorial
gladiatorial
grallatorial
gressorial
gubernatorial
historial
immemorial
imperatorial
improvisatorial
incorporeal
infusorial
inquisitorial
insessorial

intercessorial
inventorial
legislatorial
manorial
marmoreal
mediatorial
monitorial
motorial
oratorial
phantasma-
 gorial
pictorial
piscatorial
preceptorial
prefatorial
proctorial
procuratorial
professorial
proprietorial
protectorial
purgatorial
raptorial

rasorial
rectorial
reportorial
risorial
sartorial
scansorial
sectorial
seigniorial
senatorial
sensorial
spectatorial
sponsorial
speculatorial
suctorial
territorial
textorial
tinctorial
tonsorial
tutorial
uxorial
victorial
visitatorial

ORIAN

amatorian
Bosphorian
censorian
consistorian
dictatorian

Dorian
gladiatorian
Gregorian
hectorian
historian

hyperborean
marmorean
nestorian
oratorian
prætorian

purgatorian
salutatorian
senatorian
stentorian
valedictorian

ORIATE

excoriate

professoriate

ORICAL

allegorical
categorical
coracle

historical
metaphorical
oracle

oratorical
pictorical

rhetorical
tautegorical

ORIFY

glorify

historify

scorify

ORINESS
desultoriness	goriness	hoariness	peremptoriness
dilatoriness			

ORIOLE
gloriole	oriole

ORIOUS
amatorious	inglorious	oratorious	stertorious
arboreous	inquisitorious	purgatorious	suctorious
censorious	laborious	raptorious	uproarious
circulatorious	lorious	saltatorious	ustorious
desultorious	lusorious	scorious	uxorious
expiatorious	meritorious	senatorious	vainglorious
expurgetorious	notorious	stentorious	victorious
glorious			

ORIOUSLY
gloriously	meritoriously	uproariously	vaingloriously
ingloriously	notoriously	uxoriously	victoriously
laboriously	stentoriously		

ORITY
anteriority	inferiority	meliority	seniority
authority	interiority	minority	superiority
deteriority	juniority	posteriority	sorority
exteriority	majority	priority	

ORIUM
aspersorium	emporium	scriptorium	thorium
auditorium	prætorium	sensorium	triforium
digitorium	sanatorium	sudatorium	

ORMATIVE
afformative	formative	reformative	transformative
dormitive	informative		

ORMITY
abnormity	deformity	inconformity	nonconformity
conformity	enormity	multiformity	uniformity

OROUSLY
decorously	porously	sonorously

ORRIDLY
horridly	floridly	torridly

Orrify
horrify torrefy

Orrower
borrower sorrower

Orrowing
borrowing sorrowing

Ortical
cortical vortical

Ortify
fortify mortify

Ortliness
portliness courtliness uncourtliness

Ortunate
fortunate importunate

Oscopist
metoposcopist oneiroscopist stereoscopist stethoscopist
microscopist ornithoscopist

Oscopy
cranioscopy horoscopy oneiroscopy stereoscopy
geloscopy meteoroscopy organoscopy stethoscopy
geoscopy metoposcopy ornithoscopy uranoscopy
hieroscopy omoplatoscopy retinoscopy

Osia
ambrosia symposia

Osial
ambrosial roseal

Osier
crosier hosier osier "nosier"
cosier prosier rosier

Osiest
cosiest prosiest rosiest "nosiest"

Osily
cosily prosily rosily "nosily"
 "dosily"

Osiness

cosiness	doziness	prosiness	rosiness
"nosiness"			

Osity

actuosity	gibbosity	nervosity	serosity
anfractuosity	glandulosity	nodosity	sinuosity
angulosity	glebosity	oleosity	speciosity
animosity	globosity	otiosity	spicosity
anonymosity	glutinosity	pilosity	spinosity
aquosity	grandiosity	plumosity	tenebrosity
atrocity	gulosity	pomposity	torosity
caliginosity	gummosity	ponderosity	tortuosity
callosity	hideosity	porosity	tuberosity
carnosity	impecuniosity	preciosity	tumulosity
curiosity	impetuosity	precocity	unctuosity
docity	ingeniosity	pretiosity	varicosity
dubiosity	inunctuosity	reciprocity	velocity
ebriosity	libidinosity	religiosity	verbosity
fabulosity	litigiosity	ridiculosity	viciosity
ferocity	lugubriosity	rimosity	villosity
foliosity	luminosity	rugosity	vinosity
fuliginosity	monstrosity	sabulosity	virtuosity
fumosity	muscosity	saporosity	viscosity
furiosity	musculosity	scirrhosity	vitiosity
gemmosity	nebulosity	scrupulosity	vociferosity
generosity	negotiosity	sensuosity	

Osiveness

corrosiveness	explosiveness

Osopher

philosopher	psilosopher	theosopher

Osophist

chirosophist	gymnosophist	philosophist	theosophist
deipnosophist			

Osophize

philosophize	theosophize

Osophy

gymnosophy	philosophy	theosophy

Osphorus

Bosphorus	phosphorus

Ossiness
drossiness glossiness mossiness

Otable
potable quotable notable votable
floatable

Otalism
sacerdotalism teetotalism

Otany
botany bottony cottony monotony

Otary
notary rotary votary

Otative
connotative denotative rotative

Otedly
devotedly bloatedly notedly

Otherhood
brotherhood motherhood

Othering
brothering mothering smothering

Otherlike
brotherlike motherlike

Otherly
brotherly southerly unbrotherly unmotherly
motherly

Othery
mothery smothery

Otian
Bœotian Nicotian notion (*see* Otion, *2 syl. rhymes*)

Otical
anecdotical despotical exotical zealotical
bigotical erotical

Otional
devotional emotional notional

OTOMIST
ichthyotomist phlebotomist phytotomist zoötomist

OTOMY
apotomy dichotomy phlebotomy stereotomy
bronchotomy encephalotomy phytotomy tracheotomy
dermotomy ichthyotomy scotomy zoötomy

OTTERY
lottery pottery tottery

OTTINESS
dottiness knottiness spottiness

OUGHTINESS
doughtiness droughtiness goutiness

OUNDABLE
compoundable soundable unsoundable

OUNDEDNESS
astoundedness dumfounded- unboundedness ungrounded-
confoundedness ness ness

OUNDLESSLY
boundlessly groundlessly soundlessly

OUNDLESSNESS
boundlessness groundlessness soundlessness

OUNTABLE
countable insurmount- mountable unaccountable
discountable able surmountable

OURISHING
flourishing nourishing

OVABLE
approvable irremovable provable reprovable
immovable movable

OVELLING
grovelling hovelling

OVIAL
jovial synovial

OVIAN
Cracovian Jovian

Owable

allowable	avowable	endowable

Owdedness

crowdedness	overcrowded- ness	cloudedness	uncloudedness

Owdiness

dowdiness	cloudiness	rowdiness

Owdyism

dowdyism	rowdyism

Owering

cowering	flowering	overpowering	showering
dowering	glowering	overtowering	towering
empowering	lowering		

Owery

bowery	flowery	showery	towery
dowery	lowery		

Owlery

owlery	prowlery

Owziness

drowsiness	frowziness

Oyable

employable	enjoyable

Oyalism

loyalism	royalism

Oyalist

loyalist	royalist

Oyally

loyally	royally

Oyalty

loyalty	royalty	viceroyalty

Oxical

orthodoxical	paradoxical	toxical

Uable

pursuable	reviewable	suable	subduable
renewable			

UBBINESS
chubbiness scrubbiness stubbiness shrubbiness
grubbiness

UBEROUS
protuberous suberous tuberous

UBIAN
Danubian rubian

UBILATE
enubilate jubilate obnubilate volubilate

UBRIOUS
insalubrious lugubrious salubrious

UCEAN
caducean Confucian

UCIBLE
adducible educible producible seducible
conducible inducible reducible traducible
deducible irreducible

UCIDLY
ducidly deucedly mucidly pellucidly

UCKERING
puckering succouring

UCKILY
luckily pluckily

UCTIBLE
conductible destructible indestructible instructible

UCTIONAL
constructional fluxional inductional instructional

UCTIONIST
constructionist destructionist fluxionist

UCTIVELY
constructively destructively instructively productively

UCTIVENESS
constructive- destructiveness instructiveness productiveness
ness

Uctory
conductory introductory reproductory

Uculent
luculent muculent

Uddery
duddery shuddery studdery

Uddily
muddily bloodily ruddily

Uddiness
ruddiness bloodiness muddiness

Udency
concludency pudency

Udible
eludible includible

Udinize
attitudinize platitudinize

Udinous
fortitudinous multitudinous platitudinous vicissitudinous
latitudinous paludinous solicitudinous

Udious
preludious studious

Udity
crudity rudity nudity

Ueller
dueller fueller jeweller

Uelling
duelling bejewelling fuelling

Uffiness
fluffiness huffiness puffiness stuffiness

Uggery
snuggery puggerie

Uginous
lanuginous salsuginous

UINESS

dewiness gluiness

UINOUS

pruinous ruinous

UITOUS

circuitous fortuitous gratuitous pituitous
fatuitous

UITY

acuity	contiguity	ingenuity	strenuity
ambiguity	continuity	innocuity	suety
annuity	discontinuity	perpetuity	superfluity
assiduity	exiguity	perspicuity	tenuity
circuity	fatuity	promiscuity	vacuity
conspicuity	gratuity		

ULEAN

herculean Julian

ULITY

credulity incredulity sedulity

ULKINESS

bulkiness sulkiness

ULLERY

gullery medullary scullery

ULMINANT

culminant fulminant

ULMINATE

culminate fulminate

ULSIVELY

convulsively impulsively repulsively

ULSIVENESS

compulsiveness convulsiveness impulsiveness repulsiveness

ULTERY

adultery consultary

ULTURISM

agriculturism vulturism

ULVERIN
culverin pulverin

UMBERER
cumberer lumberer numberer slumberer
encumberer

UMBERING
cumbering lumbering outnumbering unslumbering
encumbering numbering slumbering

UMBERY
slumbery umbery

UMBINGLY
benumbingly becomingly numbingly unbecomingly

UMERAL
humeral numeral

UMEROUS
humorous humerus numerous tumorous

UMERY
perfumery plumery

UMINATE
acuminate catechumenate illuminate luminate

UMINOUS
aluminous fluminous luminous voluminous
bituminous leguminous

UMMERY
flummery nummary summary summery
mummery plumbery

UMULATE
accumulate tumulate

UMULOUS
tumulous cumulus

UMPISHNESS
dumpishness frumpishness lumpishness mumpishness

UMPTIOUSLY
bumptiously "scrumptiously"

UNABLE
tunable expugnable

UNDERSONG
undersong wonder-song

UNDER-WORLD
under-world wonder-world

UNDITY
fecundity jucundity rotundity rubicundity
jocundity profundity

UNGERING
hungering mongering

UNICATE
communicate excommunicate tunicate

UNIFORM
cuniform luniform uniform

UNITIVE
punitive unitive

UNITY
community impunity intercom- opportunity
immunity inopportunity munity triunity
importunity jejunity unity

UNNERY
gunnery nunnery

UNNILY
funnily sunnily

UNTEDLY
stuntedly affrontedly unwontedly wontedly

UPERATE
recuperate vituperate

URABLE
curable endurable procurable assurable
durable incurable securable insurable

URALISM
pluralism ruralism

Uralist
pluralist ruralist

Urative
curative maturative

Urdily
sturdily wordily

Urgical

| chirurgical | demiurgical | liturgical | theurgical |
| clergical | energical | surgical | |

Urial

| augurial | figurial | mercurial | purpureal |

Urian

| Asturian | Etrurian | scripturian | silurian |
| centurian | | | |

Urient

| esurient | paturient | scripturient | |

Uriate

| infuriate | luxuriate | muriate | parturiate |

Urify
purify thurify

Urious

curious	injurious	perjurious	sulphureous
furious	luxurious	spurious	usurious
incurious	penurious	strangurious	

Urity

demurity	insecurity	obscurity	purity
immaturity	maturity	prematurity	security
impurity	naturity		

Urliest

| burliest | curliest | pearliest | surliest |
| churliest | earliest | | |

Urliness

| burliness | earliness | pearliness | surliness |
| curliness | | | |

Urlishly
churlishly girlishly

URLISHNESS
churlishness girlishness

URNABLE
burnable indiscernible overturnable returnable
discernible learnable

URNISHER
burnisher furnisher

URNISHING
burnishing furnishing

URRIER
furrier currier hurrier worrier

URRIEST
furriest hurriest worriest

URRYING
currying hurrying scurrying worrying
flurrying

USCULAR
bimuscular corpuscular crepuscular muscular

USCULOUS
corpusculous crepusculous musculous

USIBLE
fusible amusable inexcusable transfusible
confusable excusable infusible usable
diffusible

USIVENESS
abusiveness delusiveness illusiveness inobtrusiveness
allusiveness diffusiveness inconclusive- intrusiveness
conclusiveness effusiveness ness obtrusiveness
conduciveness exclusiveness

USKILY
duskily huskily muskily

USORY
collusory elusory illusory prelusory
conclusory exclusory lusory reclusory
delusory

Ustering

| blustering | clustering | flustering | mustering |

Ustfully

| distrustfully | lustfully | mistrustfully | trustfully |

Ustible

| adjustable | combustible | incombustible | dustable |

Ustiest

| crustiest | fustiest | lustiest | rustiest |
| dustiest | gustiest | mustiest | trustiest |

Ustily

| crustily | fustily | lustily | rustily |
| dustily | gustily | mustily | trustily |

Ustiness

| crustiness | fustiness | lustiness | rustiness |
| dustiness | gustiness | mustiness | trustiness |

Ustrious

| illustrious | industrious |

Utable

commutable	executable	mutable	transmutable
computable	immutable	permutable	inscrutable
confutable	imputable	refutable	mootable
disputable	incommutable	suitable	scrutable

Utative

| commutative | disputative | putative | sternutative |
| confutative | imputative | sputative |

Uteous

| duteous | luteous |

Uthfully

| ruthfully | truthfully | youthfully |

Uthfulness

| truthfulness | youthfulness |

Uthlessly

| ruthlessly | truthlessly |

Utical

| latreutical | pharmaceutical | scorbutical | therapeutical |
| cuticle |

UTIFUL
beautiful dutiful

UTINOUS
glutinous mutinous velutinous

UTIONAL
circumlocu- constitutional institutional substitutional
tional evolutional

UTIONER
executioner resolutioner revolutioner

UTIONIST
circumlocu- constitutionist evolutionist revolutionist
tionist elocutionist resolutionist

UTLERY
cutlery sutlery

UTTERER
flutterer splutterer stutterer utterer
mutterer sputterer

UTTERING
buttering guttering spluttering uttering
fluttering muttering sputtering stuttering

UTTONY
buttony gluttony muttony

UVIAL
alluvial diluvial exuvial postdiluvial
antediluvial effluvial fluvial

UVIAN
antediluvian Peruvian postdiluvian Vesuvian
diluvian

UZZINESS
fuzziness muzziness "wuzziness"

Y *see* **I**

Appendix

𝕻𝖗𝖞𝖒𝖊𝖗𝖘 𝖋𝖔𝖗 𝕽𝖍𝖞𝖒𝖊𝖗𝖘

But prime the pump and it will keep on flowing

The training of a rhymester is like the training for any other artistic skill: subjection to rule, and constant practice. But practicing can become so monotonous as to lose value, as any young pianist will admit, or any singer who is exercising his vocal chords up and down the scales. To avoid such monotony in the practice of verse writing there are games which provide entertainment as well as training.

THE GAME OF LIMERICKS

For more than two centuries limericks (or British nonsense rhymes) have been built around the names of persons or places. Let each member of the assembled company be assigned the name of one of his associates. He may use the surname or given name or nickname; any name in fact which is identifying. He must, within a limited time, compose a limerick built around that name. This means it must be the final word in the first line of that limerick and, if the pattern of Lear's "nonsense rhymes" is followed, the final line must end with that word. (The task is made a little harder if the name is not repeated in the final line, but a rhyme for it is used.)

The winner is that one who first completes his limerick without flaw in rhyme or meter. A prize may also go to the one who composes the cleverest. The game may be varied by assigning to each the name of a place instead of a person. But the game has little disciplinary value if there is not insistence upon a time limit, and upon accuracy of rhythm and rhyme; although perfection of rhyme might be balanced by ingenuity of rhyming, as for instance in the following:

> There was a young woman in Grinnich
> Who had a great weakness for spinach.
> When it slipt down her chin
> She would lap it all in,
> Initch by initch by initch.

The compiler of this book has accumulated five limericks having as many perfect rhymes for Schenectady.

If the company is capable of it, the winning limerick should be sung in chorus to a simple tune which has been traditional for many generations.

THE GAME OF SONNETS

As noted earlier in this book there have been many variations in the form of the sonnet. The most ancient, the Petrarchan, is best for the purpose for rigidity's sake and because of tradition. The rhyme-scheme may be found on page 38 of this book.

It is only fair to warn the company that the rhyme-sounds ending the first two lines are repeated three times in the sonnet so that the first two words dictated should be simple words having many rhymes.

Each player should be provided with pencil and paper and should write down in a column all the words as they are dictated. The first person in order proposes a word, such as "boy"; the second must suggest a word which does not rhyme with boy, as for instance "house." The third person must suggest a word which rhymes with house, such as "mouse." The next a word rhyming with boy, such as "joy." The fifth a word rhyming again with boy, such as "ahoy." The sixth another word rhyming with house, such as "louse." And so on, until there are fourteen words following the Petrarchan rhyme scheme—abbaabbacdecde.

Words may be challenged by any member of the company on the ground that they are unrhymable or, as in the case of "louse," that they limit the range of fancy for all the players. However, even that word might be defended on the ground that Bobby Burns wrote a serious poem on the subject. When all have their word lists, they retire into their several corners or nooks and fill in their sonnets.

The following samples prove that such a poetic achievement is not out of the reach either of a young student or a professional who ordinarily approaches his task in different fashion.

Set of words dictated by students themselves in a certain class-room:

Whole-sweet-greet-goal-role-feet-neat-soul-sleep-pass-know-deep-
alas-go. Resulting sonnet, from a student, chosen at random:

> This world, if we survey it as a whole
> Is quite as full of bitter as of sweet.
> So learn to laugh and love; and learn to greet
> Each passing phase, though it is not the goal.
> I play my part as if it were a role;
> The path which I must tread beneath my feet
> Is thorny sometimes, sometimes smooth and neat
> And soothes that spirit which I call my soul.
> So, if I am awake or if I sleep,
> From phase to phase I am required to pass.
> I know no reason why, nor do you know;
> I taste the froth, and then must I drink deep—
> Of sorrow more than happiness alas;
> And thus through life we all of us must go.

The same set of words sent to Louis Untermeyer, the poet, who
responded by return mail:

> Let's kiss and say it's over. On the whole
> It wasn't bad—but that is life, my sweet.
> You've had your last of me; I'm glad to greet
> The last of you. With freedom as my goal
> The time has come for me to pack my roll
> And learn once more how to employ my feet.
> Shake hands and laugh: let's keep the ending neat—
> Remember how we joked at "Body—Soul"?
> Now what they call the soul has gone to sleep
> And the poor body's scarcely worth a pass.
> We never knew the things we ought to know;
> We were afraid, we said, to get in deep.
> So here we are—too late to cry "Alas!"
> For when you gotta go, you gotta go.

The same words sent to Arthur Guiterman, the poet, who made
instant response:

> To him who builds a sonnet, on the whole
> The needful toil is arduous, if sweet:
> Though neither laurels nor applauses greet
> The poetaster at his lyric goal.

He takes delight in choosing words that roll,
 In finding rhymes and smooth Iambic feet,
 In coining metaphors correct and neat
And giving meter everything but soul.

Yes, Homer nods, the Muses often sleep
 And dabblers boast "That's good enough to pass!"
 But "good enough" let every dabbler know
Is ten times damned, ten billion fathoms deep,
 Beyond the seventh tier of Hell. Alas,
 No farther down the sorry thing can go.

Another set of words dictated by students in a classroom:
 Sonnet by a young student:

When I was but a tiny thoughtless boy
 I wandered idly through the meadow hay,
 To watch the soaring, dipping larks at play
And find a rusty trap, a passing toy,
And baby rabbits, curious and coy,
 My mother'd warned me that I must not stay,
 But cloud-ships beckoned down the airy way
And air-born voices challenged me "Ahoy!"
The world drew in, the heavens swelled with rain,
 Shot darts of steel down toward the valley floor.
I fled back stumbling through the soaking grass;
 The rusty trap jaws snapped, I howled with pain,
But somehow found my way to that kind door
 Where home was, in the town of Reading, Mass.

Sonnet with the same words, required of the teacher:

As irresponsible as any boy
 Who turns a somersault upon the hay
I tossed these words to you, and bid you play
 As merry rhymesters with a new-found toy.
But some of you have found the muse too coy
 Who at your call would neither stop nor stay;
 While some have sailed along the Milky Way
And to the Pleiades have cried "Ahoy!"
And some have walked unwitting in the rain
 And some with measured beat have trod the floor;

And some in frenzy rolled upon the grass.
And when I hear their sonnets, wrought with pain,
In deep remorse I seek some holy door,
Beg absolution, and attend a mass.

THE GAME OF CAPPING RHYMES

In the days when English literature was approaching the height of its glory, it was a fad among cultured folk to play at "capping rhymes" and familiar quotations. Apparently, when any such company had got together, if one of them contributed to the conversation some familiar bit of verse, or some classic quotation, it was a challenge to any other member of the company to "cap" it by quoting some other equally notable lines which must begin with the same initial letter. An impromtu line of verse was also acceptable.

One of the first references to this social custom is dated 1588, and it seems to have been continued in the coffee houses and at private banquets and social gatherings down through the centuries, and is said still to survive in the classrooms of some British Latin schools.

Conversation was a fine art throughout those Shakespearean days, and the capping of rhymes was a flowering of that art. Whether it might be revived in prosaic America remains to be seen. All it requires is a social group assembled around a dinner table, and aware that they are about to revive a historic custom. They must not be thrown into awkward self-consciousness by the realization that if any member of the company happens to quote a familiar line of poetry someone is expected to cap it.

If, let us assume, the host is about to sever a drumstick from the duck, some guest remarks "Woodman, spare that tree!" some other guest must remark "What ugly sights of death within mine eyes!" (Shakespeare). Since both quotations begin with W, he is triumphant. But with no quotation at hand, an impromptu line of verse would have served, as for instance "Whoever carves a duck is like to run amuck"—for the initial is still imperative.

From small beginnings great events are born; and who knows but that a revival of forgotten Shakespearean pastimes may bring us again to Shakespearean achievement.

PARODY

Parody deserves place in this handbook though it is not any single poetic form but plays with all forms. The serious-minded poet might think of it as a poor relation of poetic writing and even a disreputable one, were it not for the fact that there are famous parodies handed down to us through the years written by poets or versifiers of high repute.

The worth of a parody depends upon the closeness of its resemblance to the poem which it mimics; its skill is measured by the extent to which it can make use of the exact words of the original and completely alter their meaning.

The wickedness of parody lies in the fact that it can so completely distort a beautiful poem and do it so cleverly that one may find it hard ever again to read the original without smiling at the memory of the distorted version.

A famous example is a parody by J. K. Stephen which is not only a burlesque but a bit of sharp criticism, parodying Wordsworth's sonnet "Two Voices Are There." This parody first appeared in *Punch* and may be found in the article on "Parody" in the *Encyclopaedia Britannica.*

Two voices are there: one is of the deep;
It learns the storm-cloud's thunderous melody,
Now roars, now murmurs with the changing sea,
Now bird-like pipes, now closes soft in sleep:

And one is of an old half-witted sheep
Which bleats articulate monotony,
And indicates that two and one are three,
The grass is green, lakes damp and mountains steep;

And, Wordsworth, both are thine: at certain times
Forth from the heart of thy melodious rhymes,
The form and pressure of high thoughts will burst:

At other times—Good Lord! I'd rather be
Quite unacquainted with the A B C
Than write such awful twaddle as thy worst.

Despite a tendency toward rowdyism, parody has all the dignity of age. A parody in ancient Greek is ascribed to Homer himself; Shakespeare was parodied by Marston, and Dryden by Buckingham,

and so on, to our own times. Owen Seaman, editor of *Punch*, was a
master of the art; and many of the verses in *Alice's Adventures in
Wonderland* are parodies of serious British poetry. As for parodies in
prose, nothing can surpass those condensed novels by Thackeray and
by Bret Harte.

The writing of parody is good practice for the versifier, for it forces
him to fit his thoughts into accepted patterns of rhyme and rhythm,
though it may make a satirist of him, or a disrespecter of sacred
things.

The following parody of Mrs. Hemans' deathless lines may serve
as a warning.

> The gnashing teeth bit hard
> On a firm and rib-bound roast,
> And boarders 'gainst a table scarred
> The leaden biscuit tossed.
>
> And they frowned with inward storm
> As they scanned the dishes o'er
> And recognized in a chowdered form
> The things they'd seen before.
>
> Not as the conqueror comes,
> Stirred by the trumpet's yell,
> They came at the call of empty tums,
> And the sounding supper bell.
>
> Amid the meal they sang
> Small tales of tardy ones,
> And eyed with ill-concealed pang
> Each other's sauce and buns.
>
> A dame in watered silk
> Who sat beside the urn
> Smiled coldly as she thinned the milk
> And doled to each in turn.
>
> There were men with hoary hair
> Amid that hungry group,
> Why had they come to wither there
> And mumble o'er their soup?
>
> There was woman's hungry eye
> Seeking an extra roll;
> There was manhood's brow serenely high
> Guarding the sugar bowl.

What sought those reaching arms?
Fat pickings 'mid the dearth?
The wealth of seas, the spoil of farms?
They sought their money's worth.

Save here a stain of broth
And there a gravy trace,
They left a barren crumbless cloth
Within that boarding place.

—B. J.

ARTIFICIAL RHYMES

Scattered throughout this dictionary are a few manufactured or artificial rhymes of the more obvious sort; but no attempt has been made to assemble many of them. They are a product of the ingenuity of any skilled rhymester who makes a necessary rhyme by putting two or three small words together, or by shameless but recognizable mispronunciation. Generally they add to the humor of humorous verse, but would be offensive in serious poetry.

W. S. Gilbert plays with them in the opening song of The Major General in *The Pirates of Penzance: din afore* and *Pinafore; sat a gee* and *strategy; javelin* and *ravelin'; commissariat* and *wary at.*

The rhymester who is ambitious to write humorous verse would do well to familiarize himself with that British classic written more than a century ago, *The Ingoldsby Legends*, and with the ingenious and delightful rhyming distortions of Ogden Nash. And he might add to his rhyming games an interchange of challenges to find rhymes for the unrhymable!

"MORE POETS YET!"

"More Poets yet!"—I hear him say,
Arming his heavy hand to slay;—
"Despite my skill and swashing blow,
They seem to sprout where'er I go;—
I killed a host but yesterday!"

Slash on, O Hercules! You may.
Your task's, at best, a hydra-fray;
And though *you* cut, not less will grow
More Poets yet!

—AUSTIN DOBSON